Making It New

MAKING IT NEW
Essays, Interviews, and Talks

Henry Geldzahler

A Harvest Book
Harcourt Brace & Company
San Diego New York London

Requests for permission to make copies
of any part of the work should be mailed to:
Permissions Department, Harcourt Brace & Company,
6277 Sea Harbor Drive, Orlando, Florida 32887-6777.

Library of Congress Cataloging-in-Publication Data
Geldzahler, Henry.
Making it new: essays, interviews, and talks/Henry Geldzahler.
p. cm.—(A Harvest book)
Reprint. Originally published: New York: Turtle Point, 1994.
ISBN 0-15-600439-9
1. Art, Modern—20th century. I. Title.
N6490.G35 1996
709'.04'5—dc20 96-1334

The author and publisher would like to thank
the publications listed on pages 369–70
for permission to reprint from copyrighted
and previously published material.

Design and composition: Wilsted & Taylor

Printed in the United States of America

First Harvest edition 1996
A C E F D B

Contents

Foreword
by David Hockney

I met Henry Geldzahler in Andy
Warhols studio thirty years ago.
(May 1963). We got on instantly.
He had brought Dennis Hopper, and
his then wife Brooke Hayward to buy
a Mona Lisa. Andy had just made
a few.

I never did get to know Andy very
well, but Henry became my 'best
friend.' I used to stay with him
on my visits to New York and Henry
would come and stay with me
in London or Paris.

We have spent many hours in the
large + small museums of Europe.
one couldn't have a better companion
looking at and searching out art.
His eye is terrific, and, trained as
an Art Historian differant to mine,
but between us we had a very
rich time.

His taste is wide, so we took
trips to very out of the way places
just to see one thing Henry had
heard of. It was always worth

it

To travel with an enthusiast seems
to double ones pleasure, for sharing
aesthetic pleasure is a joy that
I love — and I'm sure Henry
does too as at times he expresses
it in writing.

About Art, he is like me an
amateur, — one who loves it,
with a passion.

Acknowledgments

The essays reprinted in this volume were written over a period of thirty years. My friends and allies along the way are here cited with affection and gratitude; in their various ways they made this book possible: Kay Bearman, Christopher Scott, Alan Rosenbaum, Jonathan Weinberg, Raymond Foye, and Matko Tomicic.

It was Jonathan Rabinowitz at the instigation of Larry Wolfson who proposed this volume and who has believed in it for the year it has taken to produce it. As lone editor, publisher, and general factotum he has done it all. He deserves and has earned my special thanks.

An Interview with Henry Geldzahler

by Ingrid Sischy

[July 6, 1993]

Ingrid Sischy held this interview in her office at *Interview* magazine. Also present was Matko Tomicic, Henry Geldzahler's assistant.

INGRID SISCHY *Henry, the essays collected in this book cover thirty years. They show that clearly you're a person who hasn't just related to one moment in art. You didn't identify with one style or movement or have sympathies with just one generation. In fact, your openness to art is famous. Such constant receptivity turns out to be unusual for an art historian, a curator, or an art critic; even though one might think it would be otherwise. What is it that you think you have in you that has created this possibility for your eyes and mind to stay so curious?*

HENRY GELDZAHLER This is something that I have worked on consciously. When I was about nineteen I noticed that people's minds froze at a certain early point. I went to an Episcopal priest in New Haven, and said, is it possible to remain alert after you're thirty? He said it's difficult, but it's possible; he also giggled—I suppose at my perspective on age. At one time I was thinking of going into Byzantine art because I thought, what a deep field, look at how many languages you need, et cetera. But then it struck me that if I

1

really wanted to be challenged, and remain alert, the way to do this is to test yourself again every year. So I chose contemporary art.

I.S. *How did you make your way into the field?*

H.G. I was studying at Harvard and the then director of the Metropolitan Museum, James Rorimer, came to the Fogg Museum. I met him and he asked me if I wanted a job at the Met. I said no, because I was only concerned with contemporary art and they didn't have any. I told him something like: "You guys skipped all the art in the last volume of the encyclopedia. Can you get me a job at the Whitney?" He went pale with rage and six months later hired me at $5,000 a year. I began with the license to go out and look. Actually, I consider the years 1960 to 1963 as my continued graduate program paid for by the Met. They called me an Assistant Curator, but in effect I went out to find out what was going on, to be the eyes of the Met.

Talking about this reminds me of a story about me and the Met and an artist called Pop Hart, H-A-R-T.

I.S. *Pop Hart?*

H.G. Yes, he was an illustrator in the twenties and thirties, and worked for liberal magazines, *The Nation* and *The New Republic*, magazines like that. One day when I'd only been at the Met for a short while I asked, "Is it okay if I go down to the Museum of Modern Art and defend Pop Art against the curators at the Modern?" And my boss thought I was completely nutty. "Is that still an issue?" he said. He thought I meant Pop Hart. That day at the Modern was a real moment, a public announcement of the fact that I was at the Met and yet at the same time was somehow on the side of what was going on.

Being in the know worked against me sometimes, too. The Met almost got rid of me a couple of times for it, like when I was shown in a pool smoking a cigar with Barbara Rose pulling me on a raft. Two trustees tried to have me fired.

I.S. *What do you mean you were shown?*

H.G. There was a full-page picture of this in *Life* magazine. It was

all part of a Claes Oldenburg happening, in a place that came to be called The Continental Baths.

I.S. *In essence it was necessary for you to be an outsider and an insider at the same time. I know that one, it's tough.*
H.G. Yes, but it was in my background. All my life, I'd been prepared for being a mediator of some kind. I had learned a lot about it being a European child in New York. At five I came to America, changed languages . . . also, I'd been Jewish at Yale.

I.S. *From where did you come?*
H.G. Antwerp, Belgium, March 1940—six weeks ahead of the Germans' entry into Belgium.

I.S. *Do you think you chose your relationship to art—as a kind of mediator—because of mediation being so much in your blood?*
H.G. Once I was telling John Cage about my father being a diamond dealer, and he was talking about his father, who was an inventor. We were walking on the beach, at Jasper Johns's place in South Carolina. Cage said, "I'm going to be a composer." And I said, "I'm going to be the furthest thing from a diamond dealer I can be, I'm going to work with art." Then Cage laughed, realizing what we'd just said. "We both do the same things that our fathers did," he stated. It's true. My father knew the value of everything, he knew how to bring gems to Harry Winston from his sources in the community. There are lots of parallels between what he did and what I've done.

I.S. *Henry, can you remember the first moments between you and your kind of diamonds? Describe the excitement.*
H.G. You know what was so exciting? It wasn't the excitement of something new. It was the excitement of understanding the historical continuity, at the very instant that I first saw the work. I walked into Andy Warhol's studio and saw him watching television and I thought of Stuart Davis playing jazz while he painted. I went to Frank Stella's and with his help I saw the connection with manuscript illumination and how you begin at the outer edge of the page and work your way in.

I.S. *Have you ever felt excitement because you were in front of something that seemed new?*
H.G. Three times I've thrown up.

I.S. *Thrown up?*
H.G. Yes, literally thrown up. I threw up because of a Robert Irwin painting called *Mind Condition*, mint colored in the background and pink in three parallel lines. It came out of Rothko, I was aware of that, and it predated Minimalism which didn't become a phrase until two years later. It was an attempt to strip down, rather than complicate, which was the preferred Abstract Expressionist impulse. I was looking at a unified surface, evidently harmonious, while at the same time there was a visual struggle. The feeling I felt was not of swimming, but of floating. I must have internalized it immediately. That's the leap. I don't understand how it happens. I'm looking at something and being it at the same time.

I.S. *But—why did you throw up?*
H.G. I wasn't ready to accept it. I was challenged. I had to accustom myself to an unfamiliar, an astonishing new way of seeing. I had to face it over a period of time: I realized that I had to own it, even though I knew I couldn't afford it. The work cost $2,000, and by then I was making $7,000 a year at the Met. I called John Chamberlain in New York, saying, "John, I just saw a painting that I have to have, it's making me sick." He sent a sculpture to Bob Irwin's dealer, and Bob Irwin sent back the painting, and I lived with it for ten years before giving it to the Boston Museum of Fine Arts.

I.S. *What other paintings have made you throw up?*
H.G. When I was fifteen, I saw a show of Arshile Gorky's at the Whitney. I stayed three hours, came home, threw up, slept for eighteen hours, then, two years later announced my ambition to become a curator. I was dizzy and disoriented at the time because I saw things swimming. I didn't know underwater photography. I didn't even know about his Armenian background. I knew the concept of Surrealism, but I never thought to associate it with the living dream I felt. There was also an element of sickening nightmare in

the sense that I was no longer standing on two legs looking at a flat surface. I felt as though I was falling down a coal chute backward. Maybe you are too young to remember when they used to deliver coal down a chute. My horror was always to imagine going down one of those things backward.

I.S. *To listen to you talk, we can recover some of the shock value we felt on first seeing this work. What about the shock of Pop Art? That's A-R-T, not Hart.*

H.G. Something happened around 1960. And it had to do with the way that whole Pop thing coincided with what was going on in the media. Together the two made an explosion that nobody expected. It was like putting two chemicals together. Each one is innocent by itself, but together they reach a critical mass and blow up. And this affected everything. Before then, for instance, curators weren't famous. Well, I was the Pop curator. That was my luck, my good luck. A curator in 1958 wouldn't have dreamed of attention like that. Which was also why Frank O'Hara and that generation were always a bit suspicious of me. I walked in the door in '60, instead of 1952. They were already committed to certain artists. They were already involved with people like Larry Rivers and the second-generation Abstract Expressionists. Due to serendipitous circumstances I walked through the door and found Frank Stella and Andy Warhol. I got swept up in the wave. A media explosion probably would have happened with another art movement; at that moment the time was ripe. But no other art movement was so easy to verbalize, and to visualize, as Pop Art was in '60, '61, '62. We used to go to those openings at Sidney Janis and Leo Castelli, and you couldn't move, not just because of the people, but because of the cameras. The Europeans were there. The Japanese were there. They all got there, it seemed, in the first minute. Andy [Warhol] and I would get scared sometimes. Such as one time in Philadelphia, at his first museum one-man show where there were so many people we'd fled up to a balcony which in our panic didn't feel safe either. We said, "Let's get out of here."

MATKO TOMICIC Can I say something?

H.G. and I.S. Sure.

M.T. I think it's important to know the scope of insider status that Henry had by then. While he was still in college he'd spent time in Provincetown and met lots of artists. Go into that a bit, Henry.

H.G. Okay. In 1957 I had graduated from Yale and I went to Harvard for three years, during which time I stayed in Provincetown for the summers. I had already met Ben Shahn because his son was my roommate for a while in Cambridge. But there I also got to know Franz Kline, Helen Frankenthaler and Bob Motherwell, David Smith, Hans Hofmann, and the young art dealers Richard Bellamy and Ivan Karp. All these people. I felt very easy with them. I remember being at a party one night, I think it was the summer of 1958. I said something to Franz Kline about Jackson Pollock, and a tough hippie woman said, "Fucking Jackson. Fucking Pollock." Kline threw her against a wall. When she sat down again she asked, "What the hell does he know?" Kline put his hand on my shoulder and said, "He knows." It was a kind of benediction.

I.S. *And quite an example of the physical way that arguments were worked out among the art crowd back then, huh?*

H.G. *[laughs]* Exactly.

M.T. *I wanted to make sure this came up because Henry's easy entrance into the studio also came from the fact that artists trusted him. He fitted in, he was comfortable with them.*

H.G. That's true. I think I knew how to listen to artists, and to learn from them, and to have a dialogue that is helpful on both sides, and that broke down the barriers that are often there.

I.S. *What would you answer people who say that such insider familiarity as yours makes one too close and not able to have a clear critical view? I'm talking about all those views that push distance as a way to have a clear perspective on art. What do you say to those people who talk about the importance of "critical distance"?*

H.G. I say bullshit. I say, that if you don't live with it, if it isn't something that you carry with you at all times, if you don't want to get

closer and closer to it, to feel its heart's blood, and to feel its nerve endings, then you're really not involved with art. I believe that you're window shopping.

On a less gung ho note, there is a case to be made for the stance of distance. If your vocation is to be an objective viewer, and therefore, in my eyes, somewhat hostile to the needs of an audience that comes to the contemporary visual arts scene without knowledge or enthusiasm, I suppose it is possible to argue that keeping a conscientious distance from the artist and his viewpoint can seem a highly moral enterprise.

After all, formal criticism has taught us that it is through an analysis and understanding of what is actually present on the canvas that we can best evaluate a painting. Biographical and anecdotal details are merely diverting trivia. Of course almost no one sees things in such purist terms today; it is a mix of what we see and what we know that seems to serve us best, and if the option to know the artist is available to the critic, art historian, and curator it is important to record anecdotes and quotations that provide witness to the artist's methods and intentions.

As time goes on the work is, in any case, left to convince on its own terms and must remain as its own somewhat mute testimony. But in the shorter term personalities, incidents, and anecdotes serve to flesh out the legend and often can provide sympathetic access to work that might otherwise strike future viewers as distant and dull at first exposure. This is particularly true with regard to contemporary art, and just so Vasari's (not always firsthand) testimony helps the historian and the student in their appreciation of Renaissance painting.

In matters of ancient culture we value art's testimony exactly because of its immediacy. Archaeology presents us with the raw experience of ancient art. Except for wear and tear it is as it was when it was made. Whereas language, mores, and documents lose their context with great age. The work is shed of all that was incidental to its making. Here we are truly left with only the evidence of the work itself.

I.S. *Henry, why is it that it is often the critics who are basically and ultimately against art and who have made a kind of signature out of saying "there's nothing here," who get the attention in the non–art world? Often they don't have much respect in the art world or from artists, but the general audience tends to lap them up, these naysayers.*

H.G. There are many answers to that question. One is that there are very few people who are willing to do the hard work, going to the shows, going to the museums, getting their own impressions. If all one does is go in tangentially once in a while and then out again, perhaps one is delighted to have someone tell him or her that nothing is there. To be sensitive to contemporary art and to be open in those ways is hard work, and rare, and you have to have a kind of talent for it. For a long time I've had an idea for those negativos. Let's give them each two galleries to hang what they like, not what they don't like. Let's see. You know it isn't so much what a person is against in art that I'm interested in, but what they're for.

I.S. *I remember when you quit the Met in 1977 it was real news. Tell me some of the thinking that went into that decision.*

H.G. I quit for two reasons, one of them was to take the job as New York City Commissioner of Cultural Affairs. But the deep reason was that I felt that the curator of Contemporary Art at the Met should be somebody who was in tune with what was happening. Born in 1935, I would have been in the job until the year 2000, much too long to be responsible for contemporary art. The art of the seventies, conceptual art, didn't do the same for me that the earlier art had. It's the materiality of art, the lushness, the way it's made, that I like. The idea of art shorn of all materiality didn't enthrall me. I got it intellectually, but it didn't make me excited enough to sell it to the trustees, or to want to be an explicator of the art movement. It took until around 1982, when Clemente and Cucchi and Baselitz and Basquiat and Haring and Schnabel came along, that I said, "Whoa" again. What you realize after a while is that everything doesn't march in step. Movements don't succeed each other, they overlap. What you do is you tiptoe through the tu-

lips at your own rate. You find your own path. I go from tulip to tulip, which is what I love. And the stuff that's in between I tend not to notice, which I think makes me less than thorough but profoundly human. Now, not having any official capacity, other than writing and doing a couple of shows a year at DIA [the DIA Center for the Arts in Bridgehampton], and no responsibility other than to my nerve endings, I look for beautiful things. I'm the pleasure seeker in the world. I spend my time reading, looking at art, looking at birds, listening to opera. I'm the sensorial viewer, and that's what my book is about. There's a story from Harvard in which Sydney Freedberg said Svetlana Alpers is a mind and Henry Geldzahler is an eye. I'm happy with that.

I.S. *But clearly you also have a very sharp consciousness of issues that reach beyond art for art's sake. And that brings us to what's at the forefront of art discussions today. That old question: What some say is art, others feel is more social or political statement. What say you?*

H.G. To me that which is directed politically, whether it's for gender issues or racial issues or sexual issues, is making a conceptual point that is very important. For my own delectation what I always will look for is the marriage of the intellect with its material reification. I see that in Louise Bourgeois's work. Her work changed my idea of the female body, took away fears that I'd had all my life. I put her figure with multiple breasts in a show I did in Long Island at the DIA Center for the Arts in Bridgehampton. I went from not being able to focus on the work to carrying it around in my mind. Jean-Michel Basquiat's anger in his paintings is something that finds physical form beautifully. Often the ideas in so-called political or social art are terribly important but the results are more like broadsides, like Tom Paine pamphlets, a sort of didactic poetry. The question of whether or not something is art—I think—is linguistic cheeseparing. I am in search of the beautiful object, and Bourgeois and Basquiat sum up my sense of when it's there.

I.S. *It's interesting how certain moments in art are clearly turning points. Things are going on all the time, but there are those extra-*

*powerful moments when bam, something explodes or things turn.
You've watched a lot of those moments, and strongly identified with
some of them, and not been interested in others. A very famous
moment for both you and art was that show you did at the Met,
"New York Painting and Sculpture: 1940–1970." Apparently it
was quite an event.*

H.G. At the time, my father said that Hilton Kramer attacked my
show more than the *Times* covered the Vietnam War. I was hung in
effigy. It was the one-hundredth anniversary of the Met and it co-
incided with a watershed moment when painting and sculpture had
reached their apogee: art-for-art's sake. There was beginning to be a
sour feeling in the art world about money and art. Anger against our
growing presence in Vietnam. The Scull Auction was in the offing.
Artists were feeling that the value of painting was being skewed to-
ward money and away from quality. Minimal Art, Earth Art, Con-
ceptual Art were becoming more important. What I did is was to
collect 408 paintings and sculptures of the past three decades that I
wanted to see again. We made 420 requests! 408 yes's. That's some-
thing you couldn't do now.

I.S. *Who were the artists?*
H.G. Albers, Avery, Calder, Chamberlain, Cornell, Davis, de Koo-
ning, Diller, di Suvero, Flavin, Frankenthaler, Gorky, Gottlieb,
Guston, Hofmann, Hopper, Johns, Judd, Kelly, Kline, Kohn,
Lichtenstein, Louis, Morris, Motherwell, Newman, Noguchi,
Noland, Oldenburg, Olitski, Pollock, Poons, Rauschenberg, Rein-
hardt, Rosenquist, Rothko, Segal, David Smith, Tony Smith,
Stella, Still, Tomlin, Warhol.

I.S. *Quite a group. If you were doing this exact same subject,
"1940–1970" today, give me some examples of artists you would
put in who weren't included.*
H.G. Well, I missed Bourgeois, and she certainly should have been
there. I knew her, but I didn't know her work. Raoul Hague, the
sculptor.

I.S. *Were you conscious at the time that there were barely any
women in it?*

H.G. I was very conscious. I was also conscious that there were no black artists in it.

I.S. *Eva Hesse?*

H.G. Of course she should have been in, but I had no way to see what progeny her art would spawn. Now in 1993 I would like to do the two decades that came right afterward: 1970–1990, repeating artists from "New York Painting and Sculpture: 1940–1970" where their work continued to unfold, and adding Europeans.

I.S. *Great. Who?*

H.G. Twombly, Clemente, Mardin, Warhol, Guston, Bourgeois, Kelly, Stella, Hesse, di Suvero, de Kooning, Johns, Serra, Auerbach, Kirkeby, Baselitz, Polke, Tinguely, and Beuys. This is my idea of artists whose work was made between 1970 and 1990 that will look interesting years from now. A curator has to be able to do something which is almost impossible, and that is, look at the artist today from the point of view of twenty and fifty years from now, and try to pick out things that will still have physical importance and still carry the message, after the contemporaneity dies off.

I.S. *I note you say twenty, not the usual hundred.*

H.G. Alfred Barr said he would be very happy if ten percent of what he collected is still interesting in fifty to one hundred years. Flashing forward is a delusion anyway. So it doesn't matter what you tell yourself. But I think everything that I put in my "1940–1970" show, and everything I put in this new show that I have in my head, will be something that a museum in 2150 might bring up from that basement if it isn't already hanging. To keep accumulating with passion we must delude ourselves that it's possible to grab a handle on the future from today's perspective—history and calamity, of course, will inevitably alter circumstances and lead to new needs and visions. But for connoisseurs of American postwar art the show hit a nerve, summed up a high moment. There are collectors and dealers who tell me that they have the catalogue of the "1940–1970" Met show by their bedside, and when they can't sleep they make imaginary collections in the middle of the night. They wake up and they try to figure out which paintings they'd like.

I.S. *So back to the most important part of your concept for that 1970 show.*

H.G. I wanted to demonstrate that there was something these artists were building on, so I put in Stuart Davis, Milton Avery, Edward Hopper, and Joseph Cornell as artists who, in their independent ways, had created a ground floor that could support the rest of it. Also I put them in to provide the museum viewer, who couldn't accept any of the newer art, with a door that he or she could come through. Here's the book, what do you think?

I.S. *These dark blue Reinhardts are so beautiful they make my insides go into a grip. What is that pleasure about?*

H.G. The pleasure is the seeing and not seeing at the same time.

I.S. *You're right.*

H.G. That whole generation wanted to project the immanence of God, of divinity, in their work, without specificity. Rothko, Newman, Still, and Reinhardt—they were all about having an out-of-body experience, confected with the use of the physical pigment and of the eye, and without grounding you in anything specific that you could then dismiss. They wanted to lift you and keep you at that elevation. And they did it in different ways. So it's kind of a rabbinic tradition, a generation of rabbis. In Reinhardt's case what you get is that terrific charge of saying it, but not with words, with the eyes. That's what you have here.

I.S. *Tell me about the pleasure from de Kooning.*

H.G. De Kooning is an inside-out artist. He once said, "All the space I need in my paintings, is what I feel when I stand with my arms at my sides." And you get that feeling from de Kooning. What he's painting is what's from here to here. When he paints a woman, there is an aspect of it in which he is being the woman as well as seeing her. I think that's the authenticity of his work. It's all depiction of a consciousness, on a nerve-ending level.

I.S. *Flavin, what's the pleasure?*

H.G. That's the pleasure of Catholicism, of the Holy Ghost, of non-figured immanence.

I.S. *Help me with the pleasure of Frankenthaler. Is this a generational difference between you and me? I get no pleasure from her work. To me it's a bit like inflated tie-dyeing.*

H.G. You have to understand what Helen does, and what Morris Louis did, from the point of view of the history of American art. What they did was to move the watercolor onto canvas. They stained canvas instead of paper. You think of Winslow Homer. You think of Maurice Prendergast. And you think of Edward Hopper. And then you think of Frankenthaler, and Morris Louis. There's a continuity people don't see.

I.S. *I always love seeing these paintings by Johns.*

H.G. Johns has intelligence and wit, and a profound grasp of the historical continuity in American art. There's a painting here called *Triple Flag*, a flag, on top of a flag, on top of a flag. Once when the painting was still in his studio, I asked Jasper, "Did you bother to paint all the stripes all the way on the paintings, when we don't see them?" His answer to me was, "You'll never know." And that's sort of what I like.

This painting by Andy was Barnett Newman's favorite work in the show.

I.S. Orange Disaster—*it's one of my favorites. Why do you think Newman went for it?*

H.G. It was a little bit like Newman aesthetically, but nothing like him in content. He would never have said that Rothko or Still made his favorite paintings. Andy was the younger generation, different enough, and yet similar enough in sensibility.

I.S. *What was the opening like of this show?*

H.G. Pickets outside, rock bands inside.

I.S. *What was being picketed?*

H.G. We hadn't ended the Vietnam War. We were opening a show celebrating the museum's centennial. And there weren't enough women in it. All that and more. The opening was wildly crowded, I remember. The Chief of Protocol under Roosevelt and Truman, Ambassador Stanley Woodward, was standing behind me, and the

guards came running up and said, "There are people at the gate who don't have tickets." And this man whispered to me, "Everybody who bothered to come is invited." I repeated, "Everybody who bothered to come is invited." The door was opened and everybody came in.

I.S. *That's why one needs a Protocol Chief at all times.*

H.G. Yes, he understood what I wanted my show to be about. It was about generosity, not about exclusion.

I.S. *Henry, as time went on and you became an almost mythical figure in the art world, your own generosity to younger artists showed itself. You're known as someone who has time for them, who wants to look, to discover. I remember hearing through the grapevine, for instance, how you hung around with Jean-Michel Basquiat and Keith Haring. What made you so interested in Haring's work?*

H.G. Diego Cortez, God bless him, took me to see Haring, Schnabel, Clemente, and Basquiat. It was my second chance to be in at the start of something important in art, a chance to test myself and my ability to connect the public to new art. What was it for me with Haring? His clarity, his courage, his absolute authority. There wasn't a moment of doubting himself or of my doubting him, or of my doubting my respect for his work. He offered another way of dealing with the human figure, of dealing with public art. It was a great gift. And I'm happy I was able to make him feel that what he was doing was both new and within an identifiable tradition.

I.S. *Haring's gone because of AIDS. So many gone.*

H.G. I'm fifty-eight, which is not that old, but I keep mourning people who were younger than me. It's all a terrible loss. And it's a terrible anger. It's hard to articulate this, but you know, Ingrid, the extent to which they were important to us, and to the culture, is the extent to which they live on in their work. Charles Ludlam's plays are being done in all parts of the world. Robert Mapplethorpe is not even beginning to be appreciated the way he will be in years to come. And the things that Keith made are keeping him alive, car-

rying his nutty, caring vision forward. The Greeks used to say, "There is not a short life or a long life. There's only the life that you have. And the life that you have is the life that you're given, the life you work with. It has its own shape, describes its own arc, and is perfect."

1960s

The Art Audience and the Critic

[1965]

The history of Modern Art is also the history of the progressive loss of art's audience. Art has increasingly become the concern of the artist and the bafflement of the public. It is not a popular audience that was lost, not an audience made up of the great mass of the people, but an educated, enlightened, and enfranchised class of art connoisseurs, the aristocracy and church hierarchy of the pre-French revolutionary period. The artist of the Renaissance, Baroque, and eighteenth century knew for whom he was painting. His small audience was clearly defined, and there was a shared body of knowledge, literary and artistic, that patron and artist took for granted. Thus, if a myth were referred to in a work or if a work were commissioned to illustrate a personally and particularly meaningful myth or historical incident, no one for whom it was intended would find it a difficult picture; at times a complicated literary painting might be an elegant visual puzzle, but there was an answer and the problem could be solved. It was not until the false start toward the democratization of art in the nineteenth century that the professional critic became a necessary buffer between the painter and the public. A new profession, that of interpreter of art to a general public, became established.

As painting became less dependent upon a complicated and shared literary apparatus, and more involved, in the course of the

nineteenth century, with common and contemporary experience, it began to look in upon itself, upon its own inner necessities and mechanics. Surely the long and complex history of landscape painting which culminated in the nineteenth century is not about the history of landscape (geology) but rather about the formal problems suggested by the rigid format of earth, horizon line and sky, and the variations possible within this framework.

It must be with the Impressionists, the culmination in a sense of this landscape development, that we date the obvious split engendered by an art advanced for its day and a public led in its ridicule by hostile critics. Courbet and Daumier, in the years immediately preceding the Impressionists, were criticized too, but within the context of art; they were never dismissed as flingers of paint in the face of the public. It is undoubtedly true that the best audience, and in a sense the only audience, for Impressionist painting in its early years was the artist. Art had definitely begun to turn in on itself in a process that has continued for a hundred years.

The audience for art in our own time is still a specialized one. There has grown up in this generation a relatively small group as learned and knowing as the eighteenth-century connoisseurs. The ground, however, has shifted, and the specialist's knowledge today is not literary but formal. It is not the mythology and poetry, the Greek and Latin of the humanist, but the morphology of the art of the past century, the history of forms and movements in modern art, that is the necessary equipment for a full comprehension of the best in contemporary art.

The most important developments in the art of this century in their logical and inevitable sequence (inevitable, of course, only after the fact—and unpredictable before) are open and available, at first, only to the narrow but passionately interested audience for art made up largely of the painters and their immediate coterie. It has been the increasing concern with the basic elements of painting, the painter's vocabulary, with no concessions to a hypothetical audience out there that seemed unable or prepared to care anyway, that has slimmed and attenuated the public for art to an alert and interested few attuned to the closest scrutiny of formal variations

and adjustments that seem slight or nonexistent to the inexperienced, but are deeply meaningful and rich to those who have done the work of looking.

The critic speaks to the audience out front and points to the paintings behind him. He is an unfortunately necessary link in the communication between the artist and the public. The good critics of the past hundred years have been the audience for art, the artists themselves and their writer friends. This coterie aspect of art criticism smacks of cabal but has proved necessary. The Impressionists, Cubists, and Abstract Expressionists all had their critics, intimate with the artists from the early years of the movements. The public in most cases first heard sympathetically about the artists and paintings from the coterie, the artists' friends. The critics wrote and lectured, often persuasively, about art the public found difficult to accept. It was probably the early verbal formulation of much of the aesthetic theory, formal analysis, and conceptual programs of modern movements by critics who were so intimately acquainted with the work that gave the removed, private, and even esoteric air to the early years of each movement in the best art of our century.

The problem of audience is a crucial one to the critic: Whom exactly is he addressing? Is he an interpreter of difficult, recondite, or shocking art to an already interested audience or to a wider general audience? Or is he talking only to the most interested audience of all, the most deeply concerned and committed, the artists themselves? The critic who conceives of the artist as his audience is rare. But even here, his effectiveness is limited by the very fact of the medium in which he expresses himself, words. Paintings lead to paintings; words never do. For this reason exposure to the art of the past, both historical and recent, is essential to the intelligent comprehension of painting today. Words can point, direct the attention of the audience to certain paintings of the past or very recent past, but they can never be the substitutes for looking at works of art. Words, unaided pictorially, can summarize and organize visual information, and in this the critic is helpful. But painting is not verbal; it escapes words, and words cannot evoke with sufficient accuracy the effect or look or style which is the complexity of a successful painting or

sculpture. The creation of a work of art has required far too many complex and manifold decisions, has referred to far too many works already in existence, to be covered adequately by words. In short the critical task is an impossible one, but nonetheless worth doing for that.

In the past four decades the best artists have limited themselves in format so that an entire career, an entire productive life, consists in ringing changes on a single theme. In this, Mondrian, with the example of Monet's cathedrals and haystacks before him, was the pioneer. From 1920 to his death in 1944 Piet Mondrian stayed in his work with the right angle, the three primary colors and black and white. Within these strictures his work changed and became more complex; essentially it was a difficult art to viewers unprepared to look hard, comfortingly dismissable to those hostile or indifferent as nothing but the same picture painted over and over again.

There is something messianic in Mondrian's career and work. The implication is that he has got hold of the truth—not one truth among many, but the single eternal truth. It is necessary to the psychology of the obsessed artist, the artist who stays with a single theme over a great many years, to be exclusive and single-tracked in his thinking. This is in no way surprising, for it would be impossible to stay with an objective personal vision for more than a single painting if the stance from which the artist was working weren't held firmly and consistently.

What happens to the audience in this development? The artist who is tough on himself is that much tougher on his audience. But then there is no easy public art; there is only private, difficult art that is accessible to the public willing to make the effort. With Mondrian we have the first example of an artist who has stripped his work and who spends a major portion of his career working out and adjusting, arranging, and changing his basic simple image, and never feeling that it is quite right for the next picture, or that he wants to repeat it. That is the greatness of his art and of that of our most advanced recent painters: Clyfford Still, Barnett Newman, Mark Rothko, Morris Louis, Kenneth Noland, Frank Stella. They never feel they know how to make a Still, Newman, or Noland. Each re-

thinks his problem each time he starts a painting. And while they learn from their own experience, it must always be a renewed experience, never a remembered one. A painter who repeats himself meaninglessly, emptily, is remembering or trying to remember what it felt like to paint a picture last year. That doesn't work. The great men stay in touch with the wellsprings of their own creativity and are constantly recreating the impulse and energy that must inform their work. It is not surprising that this work is not instantly available to the public or easily absorbed. It is an artist's art; a critical examination of painting by painters, not necessarily for painters, but for experienced viewers. The problem of creative fecundity and excitement and a maintained level of inspiration and execution is much more acute in the stripped and repeated images of today's painting. For the painter limiting himself to a self-imposed and invested vocabulary, simple shapes and their relationships, there is literally no place to hide. This is the strength of the art and its emptiness when it goes bad. All is out in the open for everyone to see. That doesn't make it easier to see, but paradoxically, more difficult. There is no anecdote, no allusion except to other art, nothing outside art itself that might make the viewer more comfortable or give him something to talk about.

Actually, the effort toward making differences from picture to picture is not art; it is "artiness," exactly that which is extraneous to the picture making. The attempt to make it look different can have nothing to do with the generative processes that produce the painting. Such an attempt can only be socially ordained, as for instance, in the effort toward a more interesting or varied show. If the picture is painted in exactly the way it has to be, it will look different enough from the last picture, which had to be painted in the way it was, to satisfy anyone who is interested in looking long and hard at painting; and that finally is the only audience the pictures will have anyway.

In the past eighty years or so the artist has been influenced not only by the advanced art of his own day and that immediately preceding, but by a new critical awareness of the entire history of art. If pictures lead to pictures, then the new availability of a much

wider range of images and symbols from the art of all the world and all of history must have its effect. In past centuries artists were aware of the traditions of their own community; and, occasionally, owing to trade caravans or pilgrimage routes, or to the portability of small religious objects, the easy dissemination of prints, or travels by the artists themselves, an influence foreign to the home tradition would be felt and immediately absorbed. Now we no longer have trade routes; we have *Art News*, Harry Abrams, Phaidon, André Malraux, and jet travel—instant international communication. Between them nothing is unavailable. This in addition to widening enormously the possible influences on an artist multiplies incalculably the amount of visual material that can, and in many cases must, be brought to bear in the intelligent appreciation of contemporary art. The artist as art historian, as scholar of the history of art, makes the professional art historian his logical audience, and in the past decade it has been in this professional group that much of the early appreciation of new and difficult art has taken place.

The potentially interested viewer need not feel left out or hostile. The paintings exist and are in public collections; the very same paintings that influenced the artists and led to the important changes and breakthroughs in the style of the past decades can be seen; for instance, in the permanent exhibitions of the Museum of Modern Art and in the Guggenheim Collection. The Kandinskys, Kupkas, and Delaunays, the Picassos and Matisses, the Malevichs and Mondrians of the first two decades of this century have entered public collections, although not perhaps as rapidly or generally (that is, outside New York) as one might wish. Just as the painters have seen them, so can the public. The Museum of Modern Art and the college art history courses have helped create this new and aware audience for advanced painting. But all they can really do is to expose the audience to the art. The critic, curator, or historian of modern art can only point.

There is something unpleasant in the realization that the true audience for new art is so small and so specialized. The unpleasantness comes from an idea about an ideal audience or an ideal art, or rather an ideal relationship between the great democratic public

and the artist performing his social function; self-revelation made generally available. In truth, despite all the education available through our art museums, periodicals, and college art history departments, the process remains slow, the converts few, and true understanding rare. Whether this situation is ideal or necessary is a matter for speculation. It is and has been the situation for several decades, and is not likely soon to change.

Happenings

Theater by Painters

[1965–1966]

*H*appenings are theater by artists. The emphasis is therefore quite naturally visual rather than verbal. The strength and interest of a Happening when it is successful is in the force of its imagery, the carrying power of its props, situations, costumes, and sequences. In this they relate, perhaps nostalgically, rather more to silent movies with their forceful visual nonsense, than to anything in the highly verbal Theater of the Absurd. If the Happenings are seen as an attempt on the part of painters to reintroduce recognizable, human content into our artistic life, and if the matrix from which they sprang can be seen as an involvement in Abstract Expressionism and a reaction by young artists against its persuasiveness, we are well into the generative processes that made it necessary for several artists in the same year to work out parallel solutions.

The situation in American art in the late 1950s made a way back to painting or representing the human figure in any new, contemporary, meaningful way seem impossible. After the tremendous energy and inventiveness of abstract painting, centered in New York in the forties and fifties, the reintroduction of recognizable content (objects, landscape, or the figure) appeared *retardataire* and beside the point. The main issues that engaged the best and most mature artists were abstract manners and imagery personally arrived at and

26

subsequently staked out. These men left no room for the young art-
ist who was not satisfied to choose between the manner of de Koo-
ning and that of, let us say, Guston. There were, to be sure, still im-
plications to be worked out by younger men in directions suggested
by the relatively little-known paintings of Newman and Reinhardt;
these were to engage the sensibilities of the cool young nonroman-
tics (Stella, Poons, Judd, Irwin, and others). But where could a
richly romantic personality express itself in fresh terms after the li-
cense and extravagances of the most richly romantic artists in our
history, the Abstract Expressionists?

Robert Rauschenberg pointed a way out of this dilemma by
his inclusion of the real object in the work of art. Instead of repre-
senting a goat, that is, attempting to translate a goat into the
two-dimensional terms of painting, Rauschenberg, shockingly, in-
cluded the goat itself (stuffed but only slightly less a goat for that).
There was ample precedent in kind for Rauschenberg's decision, if
not in degree. His invention was to take a collage, a staid and almost
stately Cubist technique, and push it radically, logically, and con-
sciously to conclusions that were inherent some four decades earlier
in the first gluing of a real newspaper, or swatch of wallpaper, to an
oil painting. Thus one way out of the dilemma, how to represent
the recognizable, was clearly not to represent it but to incorpo-
rate it.

It was in this atmosphere in 1959 that the Happenings were born,
an atmosphere in which abstract art had been dominant for more
than a decade, and in which the shock and invention were not only
Rauschenberg's radical collage, but the younger artist Jasper Johns's
targets and American flags, frankly two-dimensional subjects
which did not so much have to be represented as presented. Thus,
Johns and Rauschenberg stand as the major figures, transitional in
retrospect, between Abstract Expressionism and Pop Art. Their
work of the mid-fifties helped point to a way out of abstraction that
had not been preempted by artists of the past. The crucial factor in
innovational art is never newness or novelty as an end in itself. But,
although repetition in modes already thoroughly occupied must be

stale, we still had critics crying for a revival of the art they had liked in their earlier years. A new humanism was what they wanted. When they got Happenings and Pop Art, a new art with human content, it did not look exactly as they had expected, and they were disapproving—once again indicating that art precedes criticism, an often strangely forgettable truism.

Here we have an indication as to why the early practitioners of the Happening—Red Grooms, Allan Kaprow, Jim Dine, Claes Oldenburg, and Bob Whitman—remain the interesting ones, and also why their more recent work in this medium has decreased in energy. The common solution to the apparently insoluble problem bound them together for several years. But once this shared interest in theater was explored and each created his several worlds of imagery, they turned to the more lasting and traditional media of their art: painting, collage, and sculpture. Only Allan Kaprow has remained exclusively with Happenings. The men who did the first Happenings have had no very convincing followers; just as there have been no very convincing Pop artists after the first wave broke in 1960 (Warhol, Lichtenstein, Rosenquist, Wesselmann, Oldenburg). The reasons are clear; both Happenings and Pop Art were vital solutions to the crisis of artists, all between their early twenties and thirties, who were searching for a way into suitable expression. Once they invented and staked out their ways, separate but related, those who came after were no longer faced with the same type of dilemma. A way had been worked out, a style invented, and the result was too comfortable, too clearly marked, for those that followed to feel the challenge. What resulted was what might lightly be called second-generation art (in less than half a decade); Pop Art and Happenings by minor talents who poured their content, sometimes quite individual, into forms that had been forged, ready-made for them, by the originators, the first and only solvers of the problem. Thus also, when in the spring of 1965 Dine, Whitman, and Oldenburg, themselves the originators of the Happenings, mounted new works, there was a staleness about their own continued efforts, which were still fresher than those of any of their imi-

tators, but not as necessary or compelling as their Happenings of 1960 and 1961.

Although John Cage's theoretical writings and ideas are often cited as the single source, the sources of the Happenings are complex. Cage writes in the foreword to his remarkable book *Silence* (Wesleyan University Press, 1961):

> At Black Mountain College in 1952, I organized an event that involved the paintings of Bob Rauschenberg, the dancing of Merce Cunningham, films, slides, phonograph records, radios, the poetries of Charles Also and M. C. Richards recited from the tops of ladders, and the pianism of David Tudor, together with my Juilliard lecture, which ends: "A piece of string, a sunset, each acts." The audience was seated in the center of all this activity. Later that summer vacationing in New England, I visited America's first synagogue, to discover that the congregation was there seated precisely the way I had arranged the audience at Black Mountain.

It is true that Allan Kaprow took a course in composition with Cage at the New School, an exposure which surely loosened and prepared him for his *Eighteen Happenings in Six Parts* (1959—the first use of the name Happening). However, the various theatrical forms and specific types of content that were the work of Oldenburg, Dine, Whitman, and even Kaprow had much less to do with the style and spirit of Cage than with German Expressionism, or our own Abstract Expressionism, which was an art of excess. What Cage stands for might be characterized as a neo-Dada flight from excess which resulted in compelling works that were only apparently simple-minded and absurd (Jasper Johns is in some measure their visual equivalent).

All the artists involved in Happenings from their inception were connected with the Reuben Gallery in downtown Manhattan. Much of the history of this movement and some valuable documents, statements by the artists and scripts of the Happenings, are brought together in the first book on the movement, *Happenings,*

by Michael Kirby (Dutton, 1965). He discusses possible anteced-
ents of Happenings, among them Kurt Schwitters and his Merz
poetry:

> In contrast to the drama or the opera, all parts of the Merz
> stage work are inseparably bound up together; it cannot be
> written, read, or listened to, it can only be produced in the
> theater. Up until now a distinction was made between stage-
> set, text, and score in theatrical performances. Each factor
> was separately enjoyed. The Merz stage knows only the fusing
> of all factors into a composite work. Materials for the stage-set
> are all solid, liquid, nongaseous bodies, such as white wall,
> man, barbed wire entanglement, blue distance.

This statement was first published (in German) in 1921. In its
breakdown of established categories and in its fusion of elements it
must be considered a theoretical forerunner of the Happenings.
Kirby also cites Tzara, Picabia, Satie, Cage, Schlemmer and the
Bauhaus, Moholy-Nagy, Gropius, and Antonin Artaud as possible
sources and forerunners, as well as certain of the more theatrical
Surrealist manifestations (for example Duchamp's creating a room
crossed by thousands of feet of string through which the spectator
had to climb to view the 1942 New York Surrealist Exhibition).
The distinction must be made between a Happening, in which
the audience is relatively fixed, and an Environment, in which the
audience moves at will through a predetermined, structured space
such as Duchamp's strings. The Environment is static in the tradi-
tion of the work of art; it is there and can be contemplated, experi-
enced, and walked away from like a work of art. A Happening, on
the other hand, exists in time as well as in space, and is therefore in
composition related rather more to music and to theater than to
painting and sculpture. Both Happenings and Environments are
logical extensions of the work of the painter-sculptor mentality, the
one in time and space, the other uniquely in space.
But the internal dilemma of painting was only one reason for the
invention of an improvisational visual theater; there was also an im-
patience with the live theater, and with film that was still tied to the

old forms. In 1961 (in an unpublished statement) Claes Oldenburg wrote:

> Test of film is what do you remember. Not the narrative but the images and in this sense the narrative is not important. I think it is so with theater too which I see not as a literary art primarily but a visual art . . . film has been dominated by theater and literature . . . it is a visual medium of course.

Film has fascinated and sometimes even preoccupied the recent generation of artists. The reason is surely, at least in part, the shifting forms on the large rectangle, which is the given shape of the movie screen as it is of the painting. It is also, conversely, for this reason that the traditional proscenium theater has seemed so tedious, so verbal and nonvisual. Here again we are faced with a rectangle, but with, even at best, relatively static sets. Whatever movement or eye-engagement there is in the movement of the actors; actors who in a normal proscenium situation occupy about the lower fifth of their rectangular box. To a generation brought up to look and look hard at paintings and movies (both growing into oversize, in the past fifteen years), there is simply not enough to look at in the proscenium theater or, for that matter, in the concert hall. This has been a major reason for the fascination of the Happening, theater that surrounds the viewers immediately with an absolute minimum of distance, both physical and, when it works, psychological. Having actors on the spot and occupying the same space as the audience was a refreshing and involving visual experience after the coolness and distance of the theater.

Oldenburg again (unpublished):

> When sitting in a certified theater I find myself always watching what I am not supposed to; the peeling walls, the frayed rugs, the crossing and uncrossing legs of girls in the audience, etc. etc. and I see no reason for eliminating the power which place has over the audience.

Here we have a basic tenet of the Happening; the audience and the performance are surrounded by what happens; the action is never

merely dead ahead but in several possible directions at once. The viewer must make choices, decide which action to follow if several are proceeding at once, or where the next event is likely to occur if nothing is going on for the moment. Thus each viewer or participant experiences a slightly different aspect of the multiplicity that occurs. This is particularly clear in the radically different photographs and film footage by different hands that are the only residue of each Happening. The viewer is not only in a position to make choices, he is forced to do so.

On the content of a Happening Oldenburg writes:

> It could be described as a short novel in which objects, rather than the description of objects, make up the language, a language which is necessarily more suggestive and on a more intuitive level. The composition as form is pre-arranged (that is, there are scripts) though rather freely—but the composition as meaning is not—that is a matter for the individual. . . . Needless to say the audience is also part of the event, which is not to be taken to mean that they are expected to contribute in any other way than has been determined by the arrangements made for their bodies.

A script exists, a series of impressions, possible working ideas, but the final determination is made by the cast reacting to Oldenburg's (or Dine's or Whitman's) formal vocabulary. Oldenburg, in his first working ideas, thinking on paper about a new Happening (*Washes*, 1965) notes:

> A cast will not be made up of actors or dancers, but of people I have come across or will come across in the remaining time, people whose use is suggested by some evident beauty or significant characteristics, for their suitability to the other parts and the themes as they develop; people whom I meet in the course of a day's events and who have the time to help me. They will not speak; they are my motors. My work with them will consist in finding out how to put them in natural motion by presenting them with a simple action or an object.

The description of a Happening can in no way replace the viewing of one. The types of props, characteristic space, extraordinary visual leaps from image to image do not lend themselves to verbal description. What do remain are films or photographs, memory cues to those who were present but rather formal and unrevealing of continuity to everyone else. The parallel may be made with Rubens's temporary triumphal arches in Antwerp, hung with hastily executed paintings, and with Bernini's plaster catafalque for a funeral, monumental efforts which were ephemeral by intent. From the Renaissance we have etchings and engravings which give us an idea of what these extravagances might have looked like. Today we have films and photographs, our contemporary print media and memorabilia, to record dead Happenings.

Some Notes on Sleep

[1964]

Andy Warhol's films conceal their art exactly as his paintings do. The apparently sloppy and unedited is fascinating. What holds his work together in both media is the absolute control Andy Warhol has over his own sensibility—a sensibility as sweet and tough, as childish and commercial, as innocent and chic as anything in our culture. Andy Warhol's eight-hour *Sleep* movie must be infuriating to the impatient or the nervous or to those so busy they cannot allow the eye and the mind to adjust to a quieter, flowing sense of time. What appears boring is the elimination of incident, accident, story, sound, and the moving camera. As in Erik Satie's *Vexations*, when the same twenty-second piece is repeated for eighteen hours we find that the more that is eliminated the greater concentration is possible on the spare remaining essentials. The slightest variation becomes an event, something on which we can focus our attention. As less and less happens on the screen, we become satisfied with almost nothing and find the slightest shift in the body of the sleeper or the least movement of the camera interesting enough. The movie is not so much about sleep as it is about our capacity to see possibilities of an aspect of film carried to its logical conclusion—*reductio ad absurdum* to some, indicating a new awareness to others. Andy Warhol wants to keep his editing to an absolute minimum and allow the camera and the subject to do the work. This, of course, cannot deny

the special qualities of his personality, for it is Andy Warhol that holds the camera, and it is through his eyes that we see the scene. Minimal editing accounts for the roughness, the opposite of Hollywood's technical proficiency, and insists constantly that we are looking at a film. There is no chance of losing ourselves in an artificial world. There is, strangely, no make-believe. In painting in the past fifty years, we have become increasingly aware of the limitations and special qualities of the medium: texture, two-dimensionality, brush stroke, and so on. Andy Warhol's film in which we are constantly aware of the filmic process, sometimes even seeing the frames that end the reels, frames that any sophisticated movie maker would edit out, makes us aware of exactly the limitations and qualities of film itself. A more incident-filled story would draw our attention from the fact that we are seeing a film. *Sleep*, one of Andy Warhol's first movies, is an indication of what he will soon be able to do: make contentless movies that are exactly filmed still lifes with the minimum of motion necessary to retain the interested attention of the unprejudiced viewer.

Twelve Stories

for John Cage

[February 1963]

I carried a piece of John Chamberlain's sculpture down the outside front steps of my house and hailed a cab. The cab pulled up, the driver got out, came around the front of the car and asked, What is that, a motorcycle? I said, If it were a motorcycle, would I be hailing a cab?

Andy Warhol went around the world. One night we were talking about Calcutta at Nicolson's. Frank Stella said he would like to see Calcutta. Oh, No, said Andy, of all the cities in Egypt, Calcutta is the last I'd want to go back to.

I was standing in a record store in Cambridge. A girl came rushing over to me and said, Aren't you the one who sang countertenor at Tanglewood last summer? No, I said, I'm the other one. What do you mean? she said.

The night before I left for Los Angeles, Frank Stella, his wife Barbara, and some other friends and I had dinner at Saito's. They didn't like his jacket, or didn't notice he was wearing one and they offered and he accepted one of their's, the usual gray laundered restaurant jacket. After dinner, we were halfway down the street toward Fifth Avenue when Frank realized he didn't have his teeth. We immedi-

ately thought of the pocket to the gray laundered jacket. We turned back to retrieve the teeth, but they were in Barbara's pocketbook.

Gerry Jonas and I were walking out the side door of our high school. We were about fifteen. Two twelve-year-old kids came out behind us, one of them saying, "Isn't it funny when a fat boy bleeds?"

Lovely Valerie Shaw came into Cronin's in Cambridge one night and sat beside me with a sigh. Now I've done everything once, she said.

I went into the Patrician Shop in Provincetown and ordered a cup of tea and a donut. A young colored boy sat two seats away from me without saying anything. After about ten minutes I asked for my check, turned to the colored boy and asked him what he wanted. A chocolate cone. I said to the woman behind the counter, he wants a chocolate cone. Are you paying for it? she asked. No, he's just been waiting a long time. She smiled, he hasn't begun to wait.

When my nephew Jonathan was four he called his father at work. My brother's office is very efficient and they told my nephew, Mr. Geldzahler is on the phone, hang on a minute. Hang on to yourself, he said, and hung up.

My mother was reading a novel. What do they mean by four-letter words? she asked. I said, what do you think they mean? Hell and damn? she asked. No, worse, I said. Shit, for instance. Shit, she said, isn't that merde? Yes. Merde isn't a dirty word, what else? Fuck, I said. But fuck is a three-letter word.

We took mescaline in Cambridge and suddenly had to have Syrian food. We telephoned for a taxi. Three of us got into the taxi. Do you have any special way of getting into Boston? the driver asked. I said, we thought we'd take a cab.

Another time in Cambridge I had peyote. I left the house sooner than I thought. I had given an exam the previous morning and a student stopped me on the street. What did I get? he asked. Eleven million, but I haven't worked out the curve.

One night, years ago, I dreamed of the song "Your Lips Tell Me No No, But There's Yes Yes in Your Eyes." In the dream I translated the song into French, "Tes Lèvres Me Disent Non Non, Mais Il y a Oui Oui dans Tes Yeux."

Andy Warhol

[1964]

The dead-pan, sweet, know-nothing quality of Andy Warhol's personality is continuous with his paintings. He plays dumb just as his paintings do, but neither deceives us. The paintings are of canned, commercial images, whether Campbell's Soup or Marilyn Monroe, or of scenes of destruction and death, an auto crash, an electric chair. The image always has a context and a history before Warhol uses it; he takes the second-hand or familiar and presents it freshly, with immediacy. We have seen photographs of the electric chair, and of Marilyn Monroe, we have seen Campbell's Soup ads, but never in the isolation and starkness of Warhol's presentation. The attitude implicit in his choice of images is much more complex than simple satire, grotesqueness, horror, or celebration. We are forced to the personal confrontation in his art with the most vivid representations of sex, food, and death but always through the intermediary of previous exposure through movies, the press, television, the entire black-and-white world of photo-reproduction. We have before us the essential symbols of our daily life drained of their force through repetition. In their isolation and repetition in Warhol's paintings the symbols regain their vigor though they must always be seen through the haze of second-hand familiarity so many find offensive in his work. The feelings Andy Warhol's paintings evoke in us are socially ordained, the forms of feeling and their

expression are what our popular society has evolved and superimposed; there is meant to be little ambiguity in our response. It is here that Warhol knows something he isn't telling. There is no image so simple that it means only one thing, no image so familiar that it has lost its meaning. The impact grows through repetition, the forms dissolve into pattern on the canvas, then regroup in fresh recognition. Through his apparent attempt to exhaust the images we already feel to be fatigued through overexposure, Warhol proves that the images of his choice are inexhaustible.

There is little casual in the apparently casual art of Andy Warhol. He searches through the magazines and newspapers for images that carry the directness and submerged ambiguity that are his subject matter. A silkscreen is ordered, of a certain size, never the size of the original photograph. The image is then repeated a certain number of times, on a canvas of determined size. The canvas is either left white or painted a uniform background color, or several canvases with backgrounds of different colors are mounted together. The same image is repeated, or several aspects of a subject, as in the portraits and the Tuna Fish Disaster, are juxtaposed. The image, which is always black, as in the cheap and ordinary reproductions that surround us, is laid down darkly or lightly, in images of equal or differing clarity, in a sequence from dark to light, or in more random, scattered darks and lights. Some local color is then sometimes added by hand, as in the Elizabeth Taylors and certain of the Marilyn Monroes. All these and many more are decisions which the artist makes, decisions that make the work his own, unique and unmistakable, despite the supposedly mechanical technique of silkscreen reproduction. No two artists using silkscreens, even the very same screens, will produce the same, or even similar pictures. The hand and the eye operate in subtle and conclusive ways to describe and characterize the personality and decisions of the artist.

Some of Warhol's ideas about composition come from advertising lay-outs, as do the repeated motifs and, often, the choice of subject and attitude. Perhaps only Léger and Gerald Murphy and Stuart Davis, before Andy Warhol, were interested in the possibilities of appropriating commercial devices, emblems, and tech-

niques, the look of the package or the advertisement, to what we consider fine art, traditional painting. But the barriers have been falling one by one. Children's art, art of the insane, primitive art, art executed under drugs have all entered fine arts through Klee, Dubuffet, Picasso, Pollock and many others. In this context, the assimilation of a style and content as oversophisticated and naive as commercial art into the painting of our time can neither surprise nor shock. No subject or influence can be proscribed in art in our time; nothing is inappropriate, undignified. The surprise is that so wide an area of our culture and experience has been ignored so completely.

Warhol's paintings sometimes strike us as not being art at all, as not being enough, as not being sufficiently different from life, from our ordinary experience. The artistry with which they are made is concealed and reveals itself slowly and the brash and brazen image, all we can see at first, becomes, in time, a painting, something we can assimilate into our lives and experience.

Andy Warhol

A Memoir

[undated]

Andy was shy and charming, his famous know-nothing personality already fully developed. He was painting on the floor, listening to rock records, occasionally glancing over at a television set that was permanently on. Some of the paintings were of comic strip characters; Dick Tracy and Nancy among others. A few weeks later when he saw his first Lichtensteins he abandoned the comic imagery because Roy had claimed that subject with greater authority. "Roy does it better," he said. Andy was also working on black-and-white, hand-painted pictures of Coke bottles, before and after nose job ads, and dance step schema.

The day after we met he came to the Metropolitan Museum to see Florine Stettheimer's Cathedral paintings. Along with Surrealism, he was particularly interested in certain aspects of *naïf* painting. Through the fifties, after his training as a painter at Carnegie Tech in Pittsburgh, he had been supporting himself and his mother handsomely as a commercial artist. In the world of advertising and graphics he was best known for his stylish shoe illustrations which appeared regularly in the *New York Times*. But he never lost sight of his original ambition, to be an artist, and, though he never said it, to be a star. He collected art, as he still does; of the artists whose work he owned, Tchelitchew and Jasper Johns are two that come to

mind. Visible in his studio were a super high-heeled shoe that he had bought at an auction of Carmen Miranda's effects and a gold painted Coca-Cola bottle that he had used in a Tiffany window display.

Andy had recently been around the world with a friend. He was curiously secretive about who had accompanied him. Had he been to Egypt? Yes, it had been his favorite country, especially the airport. What city in Egypt had he liked best? Calcutta, he answered and then in despair: "Oh, you know so much, teach me a new fact every day." He was kidding, but underneath, somewhere, he was serious. Actually, he didn't want to know things, but he had a need for people who did. Barbara Rose once speculated that Andy was an *idiot savant*; hearing about it he asked, "Why does Barbara say I am an *idiot souvent?*"

We were close for six years; through the switch in his art from commercial subjects to death and disaster; through his development of silkscreened paintings and through his early efforts to make films—my role was as a friend and advisor. One day when we met for lunch I brought him a copy of the *Daily Mirror* with the front-page headline 129 *Die in Jet* printed above a photograph of the wreckage. He made a large hand-painted canvas reproducing the page. Several years later, on our way to the New York World's Fair of 1965 I said, enough death Andy, it's time again for life. What do you mean, he said. I serendipitously picked a magazine off the floor and flipped it to a two-page advertisement with a color photograph of flowers. These were my best contributions.

Andy's first film was a hand-held, eight-millimeter, three-minute film of me brushing my teeth in the bathroom of a one-room apartment I had on Central Park West. He later did a much longer film in which I smoked a cigar. He had just rented some equipment that could be loaded for forty-five minutes without changing reels. We were alone in his studio on 47th Street. He set the camera, positioned me on a couch and then went about the studio, painting, making phone calls, occasionally calling across the room to me. After forty-five minutes he changed the reel and con-

tinued with his business. The result was a long portrait of a helpless creature smoking a cigar for an hour and a half with only the camera watching. It was a boring film but revealing of its subject.

It was Ivan Karp who introduced me to Andy in the late summer of 1960. I had just started work at the Metropolitan Museum, at the lowest end of the curatorial ladder. My main interest was new art. Given the conservative mentality in the Museum at that time, there was little work for me and I was left with a lot of free time to explore. Ivan Karp and Richard Bellamy were my guides. It was very exciting. Within that time I met Warhol, Lichtenstein, Rosenquist, Wesselman, and Oldenburg. All were reacting against Abstract Expressionism; all were aware of Rivers, Johns, and Rauschenberg, and it was not surprising that they soon joined forces to produce the new movement: Pop Art. I knew most of these artists well but it was Warhol with whom I was closest. We spoke every day on the phone, often for hours.

One night when I was reading late, I got a call from Andy urgently asking me to meet him at the Brasserie. I looked at my watch. It was two A.M.

"Andy, it's late," I said. "I'm in bed, can't it wait?"

"No, it's important," he insisted, "we've got to talk."

"O.K., give me half an hour, I'll be there." When I arrived at the restaurant, Andy was sitting in a booth, waiting for me. For a minute or two there was silence while I waited for him to broach the subject. Finally, I asked him why he had gotten me out of bed.

Andy said, "We've got to talk . . . say something."

Robert Rauschenberg

[1964]

The Robert Rauschenberg retrospective exhibition at the Jewish Museum in the spring of 1963 was the most impressive one-man show of the year in a New York gallery or museum. It is, in fact, impossible to conceive of a stronger, more consistently inventive and searching exhibition by any artist of his generation. The eighty-seven works in the show, paintings that surprise by the absolute rightness of apparently arbitrary elements, confirm both the historical position and the contemporary vitality of Rauschenberg, who, at thirty-eight, continues with each new work to meet the challenge he himself has set.

His use of disparate elements within a composition stuns us not because everything is unquestionably where it belongs, which is so, but because each element retains exactly its uniqueness and qualities as object and yet combines to form a painting; the goat remains a goat and the coke bottles are allowed to remain aggressively that, without diminishing the possibilities and complexities of their relationships within the painting (or combine). Whatever Rauschenberg uses brings to its new context the fullness of the context from which it has been ripped, enriching the associative value of his work without devitalizing it by an overly specific content.

The breadth of possibilities, subject matter, and materials within which Rauschenberg moves is the widest and freest ranging of any

45

artist now working. His latitude in working is restricted only by what he has already applied to the canvas. The question is never whether or not something is suitable; only whether it is usable. The separable elements in his work are direct quotations from his experience, which must be very like our experience, for they have a logic and inner consistency which we cannot quite grasp but which echo a sense of the organization of life and the relationship between things which we, too, feel. The shock is that of recognition but *what's* been said is embedded only in the work and cannot be translated out of it. A clock, large and solid and square, is fixed to a painting, just below it a shirt with its arms spread out; or four coke bottles stand side by side in an opening at the top right of a painting, below it an exultant bull. There is no doubt that little stories and meanings, connections, can be made between these objects, but they will serve only to deaden the work, to cut off its possibilities. It is vain to attempt a literary equivalence of any work by Rauschenberg because, far from exhausting its meaning, the story will not bear comparison with the painting. In a painting all the elements are visual and visible at once; in literature they necessarily follow one another in time. Thus the openness of painting is not the openness of literature. We can relate each object in a Rauschenberg in several combinations and directions *at the same time,* leaving room to breathe and to move in more than one direction. In Gorky the organization is fluid, each form exists in many possible combinations and relations and all is one unending continuum; the elements in a Rauschenberg suggest as many and more possible relations and combinations, but instead of merging into fluidity, they remain discrete and themselves. The difference is largely the difference between Surrealism (Gorky) and Cubism (Rauschenberg). Rauschenberg posits the plane of the canvas, most often breaking it down into subsidiary planes, all more or less rectangles and all lying on the surface, or forcefully projecting from it. The space is not the dream space of Surrealism, floating and endlessly continuous; it is the concrete space of the picture which is undeniably a two-dimensional painting and works its variations within those limitations.

Rauschenberg has said, and it has become famous, that "Painting relates to both art and life. Neither can be made. (I try to act in the gap between the two.)" Artists' statements are dangerous, for in our eagerness to simplify their work, to write away their complexities, we quote them and think we've said something. They are repeated ("I see in nature the cube, the cylinder, and the cone.") until they become equivalents to the work itself, and are easier to think and lecture about than the densities of the paintings in question. Rauschenberg's statement is particularly revealing; he does work in the gap between art and life. He appropriates rude blocks of life and uses them in his art. He presents us not with the interpretation of an experience (a ladder, umbrella, tire, glass, or chair), but with the experience itself. The tragedy, or rather the reality that so often looks like tragedy, is how rapidly we come to accept what Rauschenberg has given us; his best work is always fresh and mind-twisting on first confrontation; we turn it rapidly into art, into something we can deal with. We do not allow a work of art to throw us very often; we tame it and domesticate it. We do not allow it to put us at a permanent disadvantage. Rauschenberg's triumph is that his work continues to function as art even after we have drained its life as rapidly as we possibly can. The shock of life it first presents us pales, and we are left with a work that has lost its brutality but retains its challenge and gains, increasingly, elegance. Rauschenberg works in the gap between life and art, but his work, as the work of all artists, moves always toward art and away from life.

The problem of focus in Rauschenberg's work is a crucial one. We can take in an entire painting or combine at one glance, see the overall pattern, the composition and organization, but the richness of incident and detail demand a different kind of looking. Within one picture, *Rebus*, painted in 1955 and in the artist's collection, we find what is close to an anthology of the techniques of contemporary painting, dripped paint, hard rectangles of primary color, collage cloth, torn poster, comic strip, news photo, children's drawing, graffiti, mass reproduction of art (Botticelli); and this anthology is organized with an uncanny aptness and discretion into a harmonious composition that, in spite of its complexities, remains

somehow spare. In one year, Rauschenberg moved from the densities and happy excesses of *Charlene* to the spareness of *Rebus*; as if he had to put down everything in 1954 in order to know what he could safely leave out in 1955. Both are great pictures, but the elision of *Rebus* makes it the greater.

In order to take in the richness of these pictures, and this is true also of the latest black-and-white silkscreen paintings, we must be willing to examine them more carefully than the abstract aspect of their nature would make it seem necessary. The incidents and details that go to make up the whole differ greatly in size, in compositional prominence, in color and, in the earlier pictures, in medium; their choice is never a casual one; yet the juxtapositions are ever obvious. We must, as it were, stand different distances from the picture to focus clearly on its parts; or, rather than move forward and back, we must re-focus our vision, for the minutely detailed photograph three inches square affixed to a painting twelve feet long demands, certainly, another kind of attention than the entire painting. In Flemish art of the fifteenth century we see the foreground, the middle ground, and the background as separable but continuous planes, each viewed with remarkably sharp focus and clarity. The result is an enhanced vision, the ability to see details in the background with clarity and without changing focus. Rauschenberg fragments this across his work; that which is smallest lies directly next to the largest element in the work; color lies next to black and white; a loose, abstract handling of the paint is directly juxtaposed to an aggressively presented three-dimensional object—a wheel, or an electric fan, a chair or an umbrella. What we are presented with is not the ordered reality of Flemish art, with everything at a pre-arranged distance from everything else; that is the art of a society assured of its hierarchies and its values. Rather Rauschenberg produces all the confusions of focus and relation that Joyce and Pound have expressed and educated us to in literature, and like them through his art, he raises the apparent disorganization of his material to a level of intuitive comprehensibility.

The relationships of photography to the painting of the past hundred and twenty years are meaningful in the context of Rauschen-

berg's work. The early photographs, as we know, had compositional influence on the work of Ingres and Degas; we are also told, and it seems sensible, that the photograph took certain of art's functions away from art; especially the idea of art as a record of appearances, portrait, landscape, historical event. Thus much of the impetus to abstraction in art is laid to the move away from the function of photography. It is curious that with Schwitters and the Surrealists, and now with Rauschenberg and Warhol, the photograph has re-entered art; not as a compositional influence, or as something to be copied and altered (as in Cézanne) but as exactly itself. So much of our awareness and our information comes to us through newspapers and magazines, through movies and television, that the appropriation of the photograph into contemporary art does not surprise. In the Rauschenbergs of the mid-fifties photographs and reproductions act as shorthand indications of both their subjects and the context from which they have been drawn.

With the White Paintings of 1951 Rauschenberg apparently wiped out the history of painting; after that he was free to invent art all over again; that his work has continued to reflect a wide knowledge and use of the history of art does not negate the purity of the gesture. It merely makes it more ironic. With the black and red paintings of 1952 and 1953 he rediscovered texture, brushstroke, value, color, and collage. Then came the tremendously rich and varied period of *Charlene, Rebus, Hymnal, Obelisk, Curfew, Monogram, Trophy I, Winter Pool,* and *Pilgrim* (1954–1960); through these years the collage elements became bolder and more spare, the abstractly brushed areas larger and more beautiful. In 1961 and 1962 it seemed as if the combines were becoming increasingly aggressive toward the viewer and his space; the tension and balance of paint and collage on the surface of the painting was broken in piece after piece (*First Landing Jump, Coexistence, Third Time Painting, Pantomime*) by the physical presence of the three-dimensional object.

The Mona Lisa drawing (and others) of 1958 pointed the way to a break in style, although it was impossible to know it at the time. These rubbings with abstractly configured hatching are of course

based on familiar photographic material juxtaposed, as in all of Rauschenberg's work, according to his own nonliteral logic. They led to his ambitious and successful major work, the drawings illustrating Dante's *Inferno* (1959–1960). It is curious that at just the moment the combines were becoming so sculptural, Rauschenberg's greatest energy was directed toward these highly original two-dimensional works, works which combined through the frottage technique Rauschenberg's characteristic specificity of image with the abstractness of meaning, organization, and overall handling.

Rauschenberg had been talking and thinking about the possibility of translating photographic material directly onto canvas for some time. In 1961 Andy Warhol began using the silkscreen to reproduce the popular image exactly on canvas. This technical possibility, indicated by Warhol, made it clear to Rauschenberg that he could translate the specificities and ambiguities of the drawings onto canvas. He ordered many screens made, some from photographs he had taken himself. It is obvious that Rauschenberg's use of the silkscreen for his own purposes differs tremendously from Andy Warhol's. Warhol lays the screens down in repeated series, emphasizing the reiteration of our popular images. Rauschenberg uses the screens exactly as he used the rubbed newspaper photograph in his drawings of 1958, to produce his floating, yet anchored images.

The black-and-white character of the silkscreen paintings is a happy reduction of means. The effect of the very large (thirty-three-foot-long) *Barge* is very much like sitting in the first row of a black-and-white, large-screen movie. The images flash by and we make connections; we end up without a story, but with something much richer—the associative and imaginative leaps that Rauschenberg's works open up for us.

An Interview with Frank Stella

[1964]

HENRY GELDZAHLER *Do you conceive of an audience for your work?*

FRANK STELLA I don't conceive of an audience for my painting but if I did think of an audience I'd think first of other painters, and then a larger group, the art audience. I would separate the painters from the art audience because I think painters look at art differently. In general I take the position that painting is about painting and that there are no larger issues such as cultural or social history that appeal to the wider audience. The primary audience for my paintings is me. A friend has called them auto-didactic. That's how I work.

H.G. *Do you think of your work as being difficult for the viewer?*

F.S. No, basically I don't think it's difficult. I'm interested in simplicity rather than complexity and I think the simple thing is less difficult than the complex. The paintings can be made complex by describing them but basically they are reducible to a simple diagram that the mind and eye can hold once they see it. In other words they can hold it more easily than they can a de Kooning like *Easter Monday*, or Rauschenberg's *Rebus*. The basic problem seems to be in the attempt to evaluate the painting, whether it is any good or worth looking at. What I set out to do is to make something worth looking at, then I go on to quality; they can be good or bad. But

there is something worse than bad; they can not be worth looking at.
I sometimes feel I get it done to see what the diagram or scheme I
have in mind looks like but I already have confidence that it will
make a good painting if the execution is up to the level of the con-
ception. It's impossible to think of a good conception you are un-
able to execute. People who don't paint well don't have good ideas
about painting either. Nobody has good ideas about painting that
he can't carry out.

H.G. *You conceive of your exhibitions as unified rooms or series.*
Thus an exhibition may be all black pictures or all purple ones.
When they are sold they are sold individually and hang alone.
What do you think about the differences between the two
situations?
F.S. I like to have the series shown as a series once. I work on the
paintings as a series. After that I don't really care. I'd be particularly
uninterested to see them scattered and brought back together ten
years later. It would be pretentious and nonsensical.

H.G. *Do you have a perfectly clear idea of what your painting is*
going to look like when you conceive it? In what ways may the
finished painting differ?
F.S. First I make a very straight diagrammatic sketch. Then I might
make a sketch in which I color in the stripes. Then I have to find a
paint that has the right color and density for the pattern and the
shape. I don't try out different kinds of paint. I'll have found the way
a paint works by painting the bottom of a boat with copper paint,
let's say, and then later on I find the series and the shapes for it. It is
mysterious. I try to match up the qualities of paint and shape with a
random set of names. A group of towns in Florida—I had the
names for several years, and the pattern, chevron crosses—but no
color—I then came across zinc chromate and I had the three
things, the names, the shapes and the paint—I could then do the
paintings. I never have any idea what they are going to look like.
They either surprise me or disappoint me. If they disappoint I try to
figure out what went wrong. But I don't have a clear idea of what
they're going to look like from the beginning.

H.G. *To whose painting of the past do you relate your work?*
To whose painting of the present do you relate your work?
F.S. I don't relate my painting to anything in the past, in art history, but my preferences in past art reflect a basic taste. I liked Zurbaran and Manet while I was painting like Stefanelli and Gandy Brodie and disliked Rembrandt. Basically my paintings come out of New York School painting. If I had an ambition when I started out it was to be a New York painter, because there was no other way to paint. My black paintings were successful New York School paintings. After that I began to question New York School painting and examine painting. I went on my own and became a New York painter instead of a New York School painter. I'm painting in New York and it has that quality—Kline, Gottlieb, Newman, Kelly, painting that is accomplished and tough, of attractive strength and undeniable presence. But after that it's not enough. Then you get to the really hard part. The painting has to stand on its own. If you're icing New York School painting you're protected, but if you're out there alone you've to to make it through the paintings.

H.G. *How would you characterize the elements that all your work since the black paintings have in common?*
F.S. They don't have any atmosphere, anything romantic to hold them together. They're flatter and more brittle. They are more vul nerable to the accusation of non-painting.

H.G. *How do you feel about being included in group shows, annuals, cool art shows, the new geometry, etc.?*
F.S. It seems to me you have two choices—Still or Pollock. You either dictate your own terms or show anywhere. I lean toward being critical and not showing—that's what I'd like to do, but in practice I go the other way. I sometimes think it's better to show all the time, it's stupid and fussy to choose, but would still prefer to show under sympathetic circumstances. Finally it doesn't make much difference.

H.G. *Do you think of your work as being optical in William Seitz's sense of the word?*

F.S. I don't think my paintings are basically optical like Vasarely or Albers who are striving for a specific optical effect, but I have done paintings that relate to them, chromatic color, and fractured color, and day-glow paintings that are meant to deal with problems raised by Vasarely-type painting which I have always felt to be fussy and arbitrary.

H.G. *Do you think of your work as geometric?*
F.S. It's hard to say no but I don't think of my work as geometric in the popular sense of the word. Geometric painting has always been hard-edged. I don't think I'm more geometric than Ken Noland. The paint always bleeds into the canvas so that stripes don't touch. I use guidelines but no straight lines in my work. The stripes are really wavy, the painting is free-hand rather than ruled.

H.G. *Do you think of your work as being cool?*
F.S. It's not cool art. That's a term from before my time. Cool as opposed to what? That's a jazz term recently used in the popular press. I don't see how it applies to painting. All painting is detached, making it is a detached occupation. The fact that you sweat while you're doing it doesn't make it either hot or cool.

H.G. *Your work has been characterized as anti-feeling, emotionless, and nihilistic. Do these words correspond to your feelings about your work?*
F.S. I don't think about my work in these terms. Their use is the application of Abstract Expressionist prejudice; it is phony humanism that applies these criteria. People who are sympathetic to the romantic quality of Abstract Expressionism and who are looking for the New Humanism describe my paintings in that way.

H.G. *Have you seen any change in your work over the past five years? How has it changed?*
F.S. When I started I wanted directness. I thought that the way was to hit the canvas as hard as possible, to avoid fooling around with the brush and recording wrist and finger action; to make a real gesture and an expressive painting. Moving toward greater directness

has flattened the paintings, put more emphasis on the surface. The chromatic paintings take you optically from the surface but they are painted like the others. The point is the tension between the method and the optical effect. The method keeps them from being merely optical. The eye can't roam around and add up relationships; there is too much going on at too high a pitch. In Anuszkiewicz you can get around in the design because of the size of the elements and the scale. In my paintings you have to stay with the structure.

H.G. *How do you feel about teaching painting? What is it possible to teach?*
F.S. I had very good teachers so I feel I should teach; but basically the art schools seem discouraging. The moving of art schools into colleges might be better for the students but it is worse for teachers, because the college atmosphere is worse than being in New York. As a student you have to paint a lot where it doesn't count, the student painter can try everything out. He can actually paint in different styles. He's free. Later on you're free too, but you have to choose. Gorky is the classic example; he remained a student for years but finally he had to choose, too. Good criticism helps the student. But for the teacher teaching is a losing cause; there's nothing in it for the teacher. A working painter has no time for his students.

H.G. *What in your opinion is the value, if any, to the artist and the public of the daily and monthly criticism in the newspapers and magazines?*
F.S. I think the general level of newspaper criticism is very low and not really interesting to anybody except as news and publicity. Magazine criticism varies a lot in quality. *Art News* is consistently bad and out of it. Don Judd and Jabe Harrison and Michael Fried, the younger critics of magazines like *Arts* and *Art International*, are interesting. I don't agree that art criticism isn't useful because painters' criticism of paintings are finally limited. You can learn something from somebody like Clement Greenberg, somebody outside of painting. Artists are limited by their own work. Critics are freer in the sense that they don't have to go out and do it.

H.G. *How does the radical change of size of your paintings of a single motif affect the scale of your work?*

F.S. I don't ever think about scale. I use three different scales. One is the graph paper sketch scale. And then two blow-ups, one ¾-inch stripe small painting and then a larger stripe, 2¾ inches that I've used since 1958. These determine the scale of all my paintings. It started because the first brush I used was a 2-inch Sash Tool that spread to 2¾ inches. I liked that width brush and built my paintings around it. That is the module of my work.

H.G. *Is there a rationale to the shaped canvas, the invaded rectangle?*

F.S. I actually started cutting parts out of the aluminum paintings to make the paintings flatter; by cutting away corners I hoped to reduce the illusions of the paintings and keep the paint on top. Things were taken away to keep the perspective from building up. I think the shaped canvas has to come on because if you look at the painting today most of the trouble is around the perimeter, the leftover shapes at the edge. Painting is concentrated more on image than attack. Painters are better at making a strong image but they are left with edges. De Kooning makes accents and punctuations in the corner with his brush. Painters are becoming more concerned with spacial problems. It's academic but must be dealt with. I don't see why a shaped canvas is any more an object than a rectangle. They are both objects that have been painted on. One is illusionistic, the other has a decorative scheme painted on it. This doesn't make one more an object than the other. The only real problem is the spaces in between the paintings. A change in taste will be necessary before we can relax with the spaces between. After a while it will settle down. The danger at first is that the spaces between paintings will get interesting. This can be solved by hanging one painting per wall. It may also help indicate that paintings shouldn't be crowded together. The shaped canvas may liberate shapes in modern abstract painting. The shapes used by Mondrian and Max Bill are very dry and tight. With shaped canvases flat, angular shapes may give abstract painting new life.

H.G. *You don't think of decorative as a pejorative word in relation to painting?*

F.S. No. Because painting is decorative. It's never been anything else. It's supposed to mean that it lacks expressive quality. I think the burden of modern abstract painting is to give design life as in Celtic, primitive and Islamic art. There is no reason why abstraction can't be expressive again. People who level criticisms at design want something else; a humanistic, expressive, literary art fudged with a lot of linseed oil.

George Segal

[1964]

George Segal's work is realistic and natural in its bounds and its setting, and it is mysterious and removed at its center, in its meaning, in the figures. A white plaster (hydrostone) non-natural figure is set, sits, in a totally controlled natural (man-made) environment. The figure becomes the locus, the densest point from which the limits of the environment, the edges of the piece are to be measured. Where a piece ends, exactly, is problematical; its installation always a difficulty for the space of the piece must, necessarily, work differently in the very various given spaces of studio, gallery, and museum. The artist will not always be there to control and adjust the installation. Eventually instructions will have to be written into the piece, a kit assembled to accompany each Segal that will instruct exactly how it is to be placed, with photographs of previous installations and complex notes as to ideal distances between each element. The problems are those of choreographic notation; when the dancer's body goes, someone else must remember his motions. The figure itself is somewhat ethereal, unbounded, imprecise at its edges. It is the negative indication of the real-life figure that would be sitting, leaning, playing in the situation Segal has chosen to capture, a corporeal spirit figure walking through a familiar situation.

Segal's subjects are ordinary, daily experiences—sometimes pri-

vate (the woman shaving her leg in the bath, Ruth in her home), sometimes more general (the movie marquee, cleaning store, jazz trio). They relate to what Kaprow, Oldenburg, Grooms, Whitman, and Dine were all doing in 1960. Segal says in this connection, "Much talk preceded the first appearance of Happenings, talk about the urge to put contemporary experience into it—the litter of the streets—domesticity in your own household—the actual look of the landscape. None of these were accepted or legitimate concerns of art in the New York atmosphere. Once these concerns became clear the huge problem was how to give them form. Many solutions are possible—among them Happenings. I suppose the nature of the solution is dictated by the individual temperament of the artist, none really right or wrong but necessary to each one."

There is no specific social message in the work, no literary sense of anger or protest. Society is not being changed, it is being caught, frozen in a three-dimensional still at typical, yet beautifully composed moments. In his pastels and paintings Segal weaves the figure into a total skein of relationships with the air, space, environment, background; in the sculpture these relationships are implied in the exacting placement of object to object and object to figure. A problem is the extent to which the careful decisions Segal pours into the work, the fine adjustments, can be read by the interested viewer. We are led to take the pieces naturally, as continuous with our experience; the art is disguised, the total effect and intention of the artist's precise decisions is our casual acceptance of what he has done.

Segal is more humanist than Pop artist. He is in touch with contemporary culture and presents us with moments from it but with greater involvement and density, and consequently, less directness and immediacy, both of subject and technique, than we expect from a Warhol or a Lichtenstein. Segal's work is our first enduring truly environmental sculpture of interest. We can follow it detail by detail, inch by inch, in the all-over Abstract Expressionist mode, and also get it at once, in the single, startling image of the best work of the sixties. This accounts both for the complexity of detail and the final clarity of the piece considered as a totality.

HENRY GELDZAHLER *What caused you to move from painting into sculpture?*
GEORGE SEGAL My dissatisfaction with all the modes of painting that I had been taught that couldn't express the quality of my own experience.

H.G. *Had you done or thought of sculpture previously?*
G.S. In 1958 I had a combined sculpture and painting show. I had a history of painting life-size figures. I simply made three life-size figures out of wire, plaster, and burlap, one sitting, one standing, and one lying. They looked to me as if they had stepped out of my paintings.

H.G. *Is there much visual connection between those three pieces and your present work?*
G.S. Yes. One of the figures was sitting on a real broken chair, on a pedestal made from an old chicken crate. They were white. To me they seemed an important part of the show. The most important reaction was my own. I went on painting. I don't think I fully realized then the implications of the sculpture as formal solutions to what I wanted to express.

H.G. *Do you see any connection between Allan Kaprow's, Jim Dine's, Claes Oldenburg's, and Bob Whitman's Happenings and your ideas about sculpture?*
G.S. Yes, very much. Kaprow and I have a ten-year history of friendship and a history of great detailed, involved, analytical aesthetic discussion. They were passionate, we used to rant and rave.

H.G. *How about a visual connection?*
G.S. I left a path of my own dissatisfaction in my painting, alternately accepting and rejecting expressionism, geometric structure, figuration, transformation—and the decision to eternal literal space was determined by strong urges for total experience. I could never quite paint abstractly because I felt I was too young, too sensual to deal with what I thought was a splinter of the human experience, no matter how high the level of its metaphysics.

H.G. *Do you feel that there was a cohesiveness about the Hansa Gallery group and its relationship to the Hofmann School?*

G.S. For me the Hansa represented an embryo that hinted at most of the major directions in New York contemporary art. It's probably a great tribute to Hofmann that he spawned a group of individuals so willing to work passionately in so many different directions.

H.G. *Do you feel the environmental nature of your sculpture is misunderstood?*

G.S. Possibly. Yes. Many people seem so shocked by seeing a realistic white plaster figure that they tend psychologically to focus only on the figures. What interests me is a series of shocks and encounters that a person can have moving through space around several objects placed in careful relationship. I just finished working on a Gas Station piece. The man who posed really runs the Gulf Station on the highway near my house. He's taking one step forward with an oil can in his hand. My private irony is if I took away the oil can and turned his fingers up he could be St. John the Baptist in coveralls. He's behind a huge glass window and you see him through glass and a pyramid of red oil cans. As you move around the glass you encounter him from the rear and see a black rack of seven black tires suspended several inches above his head. This sudden catching off right doesn't happen until you move into the right position and then you know him differently.

H.G. *Therefore as with traditional sculpture your work is impossible to photograph adequately.*

G.S. Not impossible. I think it requires a different approach. Since there is not a definitive view, the photographer can enter the work and, more than usual, trust his emotional reactions to fragments or aspects of the work. If I set up a situation well enough there can be many emotional encounters on many levels. And this offers the choice to the traveller of extracting as much or as little as he wishes.

H.G. *You talk of realistic white plaster figures?*

G.S. The look of these figures is both accidental and planned. I usually know generally what emotional stance I'd like to have in the fin-

ished figure and I ask the model to stand or sit in a certain way. That model though is a human being with a great deal of mystery and totality locked up in the figure. In spite of my technique certain truths of bone structure are revealed and so are long-time basic attitudes of response on the part of the model. If you have to sit still for an hour you fall into yourself and it is impossible to hide, no matter the stance. I just finished casting three people seated calmly on bus seats with only slightly different poses and they came out three different, readable personalities.

H.G. *Does the whiteness of the plaster disturb or intrigue you? Have you considered color, painting the figure itself?*
G.S. The whiteness intrigues me; for all its special connotations of disembodied spirit, [it is] inseparable from the fleshy corporeal details of the figure. Color itself interests me a great deal. In the total compositions I use the built-in color of the real objects and increasingly I'm concerned with color as light rather than color as paint.

H.G. *Did your trip to Europe or seeing your work in Paris give you any insight or ideas?*
G.S. Yes. Mostly my experience as a tourist encountering a few staggeringly great things I knew about but had never been in before. I was working on my Gas Station before I went to Europe and had the piece saturated with dazzlingly colored advertising signs. After encountering the space in Chartres and being staggered by the austerity of the late Titian in Venice, I came home restless and ended by tearing all the signs from the Gas Station, replacing them with elements that are absolutely necessary and intensely expressive; there was a ruthless quality of pruning away the inessential.

H.G. *Did your European experience give you an idea about being an American artist?*
G.S. It was after my first trip to Europe this summer (1963) that I made a certain peace with myself about being an American artist. I made a sculpture in Paris and had incredible difficulties getting the simplest hand tools and materials that are cheap and common here. Parisian landscape is so different in the human sense that

American responses become almost impossible. I discovered that many of the emotional attitudes that provoke my work are encased in the ugly expanses of glass, chrome, brick of America.

H.G. *Are there compositional considerations that underlie your work?*

G.S. The rules of composition are pretty fluid and arbitrary until they're linked with a quality of how you understand the world. I read an article in *Life* magazine describing the DNA molecule. It seems you have to cut through a slimy, visceral mess, the kind that delighted Soutine, to get to a small bloody fragment that you put under an electron microscope. Amazingly a pure geometric helix is revealed. The ooze is undeniable—so is the geometry. Weaving together aspects organic and geometric keeps occurring to me because I suspect a natural truth that contains many seeming contradictions. Once you begin to deal with the ever-changing aspects of three-dimensional encounters the number of formal solutions is countless. The largest problem lies in the emotional choice of the most moving or the most revelatory series of experiences. The peculiar shape and qualities of the actual empty air surrounding the volumes becomes an important part of the expressiveness of the whole piece. The distance between two figures or between a figure and another object becomes crucial. My pieces often don't end at their physical boundaries.

An Interview with Larry Poons

[1963]

HENRY GELDZAHLER *When did you first get serious about painting?*

LARRY POONS I was exhibiting in a Washington Square art show; the guy exhibiting next to me said that my paintings were Neo-Plastic. And he told me about Mondrian, about a big book on his work. It was a summer I was home from music school in Boston. The paintings I liked when I saw the Mondrian book were the fox trot series—the black-and-white diagonal pictures. They were the first paintings that just hit me. That was the summer of 1956.

The last year in music school I didn't go to many classes—I was painting and writing poetry. My last year in high school I was taking art for seniors. I had made up my mind to be a composer, a great musician, but I found that I didn't have the ear to hear it right away myself and I didn't want to have to wait ten years to hear it. I wanted to hear it right away.

I read a book about van Gogh in high school—*Lust for Life*—and went out in the backyard and painted some trees. I had no doubts about the painting. In music I always had doubts when I sat down to write a piece. In painting I never had those immediate doubts about how I was painting. The last year in music school I knew I wasn't going to be a musician. I was still living off my father. I didn't want to give up the $40 a week. So I enrolled in the Boston Museum

64

Art School. It was a big change for me after four years of expecting to be a composer. I guess actually being in art school was a kind of security. I read Mondrian's books and did one very close Mondrian painting. At that time I also did a sketch called *Fugue* in which free forms changed in a procession, a circle into a horseshoe arch (form with three straight sides and an arc); the painting was figured out in three movements, there was a coda. I never did the painting. It kept me with the music and let me start somewhere and on something. One thing Mondrian wrote stuck with me. He had an art lover ask, if you just paint right angles what happens to the human element? Isn't it lost? His answer was, no matter what you do the human element will always be there, it's inescapable, that's the inescapable part.

Nobody in that art school thought I was a painter. I asked them all what they thought of Mondrian and they said that he was just a designer. I went to New York for a Stuart Davis show and brought back the catalogue and showed the design teacher a reproduction of the painting *Allé*. She just said he must have designed it looking at a TV screen. At that time I did a white, blue, black, and yellow picture. The teacher said it was just surface.

Jan Cox was a teacher at the school. I guess I looked pretty sloppy. I asked to see him to talk about my painting. The conversation was totally about the one meeting he had had with Mondrian on the Continent, and he emphasized the neatness of the man. Mondrian had kept arranging a box of matches on a table the whole time they were visiting. The feeling I got was that since I was such a slob I was barking up the wrong tree trying to have anything to do with Mondrian and his style.

In high school the art teacher showed slides and what stayed with me was a van Doesburg or Vantongerloo. The same response I had I guess to the fox trot paintings. It gave me the idea that I didn't have the limitation of having to wait eight years to learn to draw the figure. I have an abstract painting I did in the backyard during high school and it has right angles in it. In drawing class I did right-angle drawings instead of making the boats that had been assigned to the class. I wasn't interested in art. I was just taking a class.

H.G. *When did you see your first Barnett Newman?*
L.P. At French and Company. I had a coffee shop with the guy who had first told me about Neo-Plasticism. He brought Barney Newman's catalogue back to the shop and told me I should see the show. I walked through the first room and saw Eve. It hit me strongly like seeing the slide in high school. It was a more conscious experience than the Mondrian book because I was more involved in painting by that time. I guess I was more ready. It was the greatest experience I ever had. It's corny, I know. The blue painting on my left, the big red painting on the far wall. I felt like I had walked into a cathedral. I was that moved by the thing that happened to the architecture, to the room. I guess it had presence. I saw the show on its last day.

H.G. *How about Frank Stella?*
L.P. I saw the "Sixteen Americans" show and remember walking through a dark room, being reminded of Albers and then I didn't think about it anymore until I walked into Leo Castelli's and saw a silver painting with the center and the corners cut out. Those are the only three things that ever moved me as far as painting was concerned—Mondrian, Newman, Stella. I've appreciated other things but not been influenced by them.

H.G. *When did the change come in your painting?*
L.P. After I saw Frank Stella's painting, and after a friend said that the amount of effort and paint I was putting in my work was greater than the result that could be seen. I started thinking about simplifying it, getting it as simple as I could. I did a series of paintings that were based on a grid with eight squares, and the point went from center to corner, center to corner in a clockwise direction. I connected the points. The result was jagged—the painting was red and green, lightning-like. I didn't like it. That was one attempt to simplify the idea. In the next one I painted the points instead of connecting them. I left out the grid and just stayed with the spots. When I did that painting I learned a lot; I was still so moved by the Newman show and there was a breakthrough. I could make the painting bigger without just increasing the size of the squares from, say, six to eighteen inches. It wouldn't have to be a mechanical

blow-up. I had always used red and green, orange and blue. So when I did the first spot painting the red and green in the field and spot relationship produced an afterimage that wasn't at all intentional.

H.G. *Did you ever react with or against Abstract Expressionism?*
L.P. I really think I like Pollock only through my own experience as a painter, through my own work. It was never an immediate response as with Mondrian, Newman, or Stella. I liked some of the spare Klines, especially *Siegfried*.

When I was really young I had two things I liked doing; one was drawing a room I was in with paper, pencil, and ruler, the straight lines of the room. The other was astronomy. I liked drawing constellations. I would have been an astronomer but I was bad at math. There was no point in being an astronomer if math was so hard.

I remember walking down Pearl Street after seeing Frank Stella's pictures and making a joke to myself. They're going to look like star paintings.

An Interview with Ellsworth Kelly

[1963]

*E*llsworth Kelly's paintings are deceptively simple. What read at first as clear and simple forms rapidly become ambiguous and remain ambiguous. Two or three colors, one or two shapes the size of the painting are enough to engage our interested attention and hold it.

The canvas never quite contains the shape which is in the process of expanding, inhaling, nudging the limits of its rectangle.

We never see enough of the central form for a complete and final explanation. The image is cut off in such a way that we must finish it in our minds in any of many possible ways. This accounts for the ambiguity. The information given us is insufficient to lock the painting in. The painting is precise, yet possibilities are left open. Kelly's is an art of control; there is no stain or accident, no interest in freedom or the sensibility of the hand. The painting is flat, the handwriting of the artist painted out of the picture with impeccable technical skill. Adjustments are always away from symmetry; a curve begins to flatten, a shape to swell as in a detail of a Matisse line drawing.

Kelly's work has been spoken of as After Abstract Expressionism. This is inaccurate, an oversimplification. He has been working in this direction since 1949. His painting is continuous with the European biomorphic tradition, especially Arp's relief constructions,

and with the late, boldly simple Matisse cut-outs. But the scale of Kelly's work is the huge blown-up close-up and the impact is American and of this moment.

HENRY GELDZAHLER *What first gave you the idea, impulse to do sculpture?*

ELLSWORTH KELLY When I thought of the first piece, I happened to be having breakfast with Agnes Martin in her studio. I made a model for the piece called *Pony* from the top of a coffee container we used at breakfast. I folded it and cut it and it rocked. Agnes said you ought to do that. Another piece was a sketch from an envelope. It still has her name on it. It's called *Gate*. I folded it and cut it and it stood. I did it almost without thinking, almost as if I didn't decide; as if they just happened. Earlier, I had done relief work in wood, painted reliefs.

H.G. *Do you feel the sculpture is an extension of the painting?*
E.K. Yes and no. I really feel strongly that it's something else. The paintings are flat and are meant to be flat. The sculpture has its own space. The reliefs are frontal and flat but they're something I couldn't do with painting.

H.G. *Does the fact that you need technical help in making the sculpture embarrass you in any way?*
E.K. No. It doesn't make me feel that they're any less mine. I worked with Bernie Kirchenbaum at Edison Price, the lighting consultant and manufacturer of lighting equipment. They solved the problems I set. Mostly, I learned technique there, cutting, finishing, and using the tools. I probably will never do the welding myself. They can do it quicker. When the pieces are being made, I'm there at every stage.

H.G. *Why do you object to the designation hard-edge?*
E.K. Because I don't like most hard-edge painting. I'm not interested in edges. I'm interested in the mass and color, the black and white. The edges happen because the forms get as quiet as they can

be. I want the masses to perform. When I work with forms and colors, I get the edge. in a Chamberlain, the edges of the forms are hard but you don't think about the edges. In my work, it is impossible to separate the edges from the mass and color.

H.G. *When you first decided to paint, whose work did you admire?*
E.K. When I was younger, I spent a great deal of time looking at the Old Masters in museums. When I was in the army, I had a librarian get the Phaidon books on Rembrandt, Donatello, van Gogh. I liked Donatello very much at that time, in 1946. After that, it was artists like Max Beckmann, Picasso, Klee, and Matisse. But I didn't really feel close to American painting until I came back from Europe in 1955.

H.G. *Why did you choose to study and live in Paris?*
E.K. I went to Europe on the G. I. Bill of Rights. After the war I had been at the Boston Museum School. I guess I felt that Boston was a dead end. When I was in Europe in the war I felt I wanted to get back there. I was physically attracted to it. I liked being a stranger there.

H.G. *Why did you choose to come back to New York?*
E.K. I'd been working and earning a little, enough to paint. I was tired and was sick, and it was just time to change. I went in one time to Brentano's on the rue de Rivoli and saw an issue of *Art News*. There was an article on Ad Reinhardt who was having an exhibition at Betty Parsons's. That was the first Reinhardt I saw. Even though I exhibited in Paris and there was some interest, I felt as if I were waiting.

H.G. *To whose work do you feel close today?*
E.K. I like Frank Stella's and Jasper Johns's work. I feel good about their paintings as paintings, not because of what's in them. I like· what they're doing most, but I don't know if I feel close to it in my own work.

H.G. *Do you see your work as a continuation of Mondrian? Or of Arp? or of the late Matisse cut-outs?*

E.K. a) No. b) Not really. c) Not especially. When I saw the big Matisse collage show at the Museum of Modern Art, I liked it but I thought of Matisse. What I want to do is something else. It's been necessary for me to admire their work, all three of them. They helped as much as Beckmann and Picasso. All painting grows out of painting and tradition. It's almost as if I got to like their work through what I was doing. But I feel that Bonnard and Leger were just as helpful to me. It's all the same thing. The whole group of European painters excited me at the time I was forming. I saw the American painters alter and liked them but they didn't do the same thing. I saw them more objectively.

H.G. *To what extent is your work based on nature? Or natural forms? What is your subject matter?*
E.K. I like to work from things that I see whether they're man-made or natural or a combination of the two. Once in a while I work directly from something I've seen, but not very often now. A lot of earlier pictures were paintings of things I'd seen, like a window, or a fragment of a piece of architecture, or someone's legs; or sometimes the space between things, or just how the shadows of an object would look. The things I'm interested in have always been there. The idea of the shadow of a natural object has always existed, like the shadow of the pyramids and the pyramids, or a rock and the shadow; I'm not interested in the texture of the rock, or that it is a rock but in the mass of it, and its shadow.

H.G. *Do you think of yourself as an American painter? In what way is your work American?*
E.K. Yes. It's the result of what I've been looking at since I was a boy. It grows out of what I understand. I don't really understand anything but America and sometimes I feel it a limitation. I admire France, but I never felt like anything but a foreigner there, that's what I liked about it. I don't want my work involved with complications. I feel like I'm free, to do anything I want to do, that it's possible. The quality of living in New York is more open. When I did paintings in panel sections in the early fifties, a lot of Europeans

thought they looked American. Then I brought them here and Americans thought they looked European.

H.G. *Who do you paint for? Who do you see as your audience?*
E.K. I really don't think about it. I make things that I want to do. I paint really to please myself. I think the paintings are easy to like, but you have to want to like them.

H.G. *Do you feel that this is a time of multiplicity of styles and that there is room for your work and for Abstract Expressionism and for Pop Art? Do you feel these other styles are radically opposed to what you do? Are you interested in them?*
E.K. a) Yes, there are different individuals and they paint, it's always been like that. b) No. I don't think of it that way. c) Yes, very much.

H.G. *Has the intention of your painting changed over the years? Have you moved from one attitude to another in your work? Or are you still pursuing your original ideas and goals?*
E.K. I know that when I was in Europe I wanted to come back to America and paint huge paintings that covered the outsides of buildings. But now I feel I want to make things in my studio—and let anything bigger grow out of that. It wasn't really that I wanted to reach the public. I felt that painting with the Impressionists, Cézanne, the Cubists had become easel paintings for collectors, a luxury item. When I was in Europe, I liked Romanesque painting and Byzantine art and I thought why can't you see something that is a great spectacle.

H.G. *Do you see your work as simple or complex?*
E.K. Simple. I don't like the word simple. I like easy better. I want to forget about the technique. I sweat and worry but I don't want it to look like that; but you can't really separate the artist and his technique.

H.G. *Do you always know when a work is finished? Do you ever carry it beyond a point at which you wish you had been satisfied?*
E.K. If I do then I destroy it.

H.G. *Do you work from sketches? Do you adjust and change the idea of the sketch as you work the canvas?*

E.K. Yes. I work from drawings and sometimes collage: the drawing always comes first and then collage later because it's easier to think about color that way. I usually let them lie around for a long time. I have to really like it. And then when I do the painting I have to get to like that, too. Sometimes I stay with the sketch, sometimes I follow the original idea exactly if the idea is solved. But most of the time there have to be adjustments during the painting. Through the painting of it I find the color and I work the form and play with it and it adjusts itself.

Suite of Twenty-Seven Color
Lithographs, 1964–1965

[1992]

I. Prologue

My first visit to Ellsworth Kelly's studio, in tandem with Frank Stella, must have been in late 1961, or early in 1962. We both admired greatly the work we had seen at the Betty Parsons Gallery and in museum shows (both Frank and Ellsworth were in Dorothy Miller's 1959 exhibition "Sixteen Americans"), and to us Kelly was a crucially important "older" artist (by about twelve years) whose Paris period was a legend. The authority of his work was not in question.

Nevertheless, we were stunned by what we saw in the studio on Coenties Slip. Large, bold shapes, hallucinatory planes of color, and a somewhat self-deprecating wizard who instantly became both a cause and a friend for life.

I returned with my boss, Robert Beverly Hale, curator of American Painting and Sculpture at the Metropolitan Museum, and we purchased *Blue Red Green* (1963). Mr. Hale's baby of several months completed the party. I can't now remember if it was at the first or the second visit that I experienced what seemed like a lunatic instant in which I saw pure unembodied color moving in the studio. The explanation, that Kelly was walking a man-sized painting for a few feet, did little to lessen the impression of wonder I carry with me to this day.

74

Kelly and I became friends. I interviewed him for the catalogue of his 1963 exhibition at the Gallery of Modern Art in Washington, D.C. And he soon went off to Paris for a major show at Galerie Maeght and on to make the two sets of prints that make up the *Suite of Twenty-Seven Color Lithographs* and the *Suite of Plant Lithographs* (1964–1965). He gave me a set of each; the *Plants* I gave to the Metropolitan Museum in memory of John McKendry, my colleague who died at forty in 1972, and the other set are the color prints that form the basis of the current exhibition.

Nineteen sixty-four turned out to be the artist's *anno mirabilis*, the year in which he initiated his second and third great endeavors, his prints and his sculpture. I think in light of the precision and purposefulness of the work in 1964, rereading his remarks in 1963 has a special relevance.

II.

Ellsworth Kelly's *Suite of Twenty-Seven Color Lithographs*, printed in Paris between 1964 and 1965, can be likened to a set of variations in music. This is that rare situation in the visual arts in which the immediacy of art, its capacity to be revealed in the blink of an eye, can be seen to succumb to the demands and rhythms of music which can only be fully comprehended through time. Here, of course, the progression need not be limited only to the forward mode. The real pleasure to be found in this set is through the repeated reconfiguration of the images in which variations in color and/or in shape can be appreciated.

There is a recurring confusion in attempts to pin down Kelly's aesthetic in terms of the "abstract," "non-objective," "postpainterly," and "neo-geometry" which it touches at tangents. Even the term "hard-edged," which is sometimes used as shorthand to describe the work, misses the mark. Kelly's emphasis is more on the extent of the color than on the ways in which the shape "finishes" at the edge.

It is in terms of Kelly's interest in nature, in the shapes he derives from the keen observation of the natural and man-made world, that we can differentiate him from all of the above. In the formalist

terms that dominated the debate in the 1960s, Kelly's work didn't quite fit into post-painterly abstraction because its take-off point was the visible world, not pure invention. A pattern of windows or the shape under a bridge (doubled) or the angle of a shadow on concrete may suggest a shape; his inventions take over from there. Everything else: scale, color, texture, and format, Kelly invents. It is his unabashed allegiance to the poetry of the observed world that maintains the fragile connection to Nature, providing the shimmer that keeps the work so heartbreakingly touching and elegant. Paul Klee writes of modern art's goal to make "visible the invisible." Kelly plays with the vibrant edge involved in rendering the visible invisible.

III.

While Ellsworth Kelly made a lithograph in 1949 as a student at the Ecole des Beaux-Arts, he didn't concentrate his attention on the print medium until 1964 when he executed a series of twenty-seven abstract color prints. It is revealing perhaps to note that this was the first time that he conceived of making more than a casual pass at working in a medium whose end result was an edition. Kelly's aesthetic has always demanded individual works. In his painting he is almost fanatical about the evidence of the hand remaining visible in the work. There is nothing cool or removed about his involvement in the making of his art. People who misunderstand his intention and see geometry and hard-edged aesthetics at work miss the vibrant human touch that gives the work its ultimate power. (In the matter of his sculpture, which also came to fruition during this period, fabrication has been the rule, although here too he has scrupulously attended to every detail of its production, and, especially, its surface.)

In 1964 Kelly made a silkscreen for the portfolio *Ten Works x Ten Painters*, organized by Sam Wagstaff for the Wadsworth Atheneum in Hartford, Connecticut, where he was a curator. The artist returned to the silkscreen medium during the early 1970s.

In Mark Rosenthal's interview with the artist in his upcoming

book *Both Art and Life: Gemini G.E.L. at 25* (Abrams, 1993), he quotes the artist:

> In 1964 I traveled to Paris for an exhibition of my paintings and sculpture at the Galerie Maeght. At that time, Aimé Maeght suggested I make a print in Levallois, outside of Paris, where he had a printing establishment. When I presented the (same) set of drawings to Maeght's master printer, Marcel Durassier, he said that large areas of pure color are very difficult to print well; they are a real challenge. But I worked there for six weeks at the end of that year, and produced a suite of twenty-seven prints.

The various aesthetics and obduracies that seem common in every craft are no stranger to the print medium. Kelly had previously shown his work to Tatyana Grosman, the shaman-like publisher of lithographs at her Universal Limited Art Editions in West Islip, Long Island. Kelly told Mark Rosenthal, "All the artists who made prints with her worked in an Abstract Expressionist style, which was not my way of working. My idea for making prints developed from my painting, which presents large shapes of flat color. When I proposed making lithographs based on a series of drawings developed from previous painting ideas, Mrs. Grosman said she didn't like to work this way, that I shouldn't have preconceived ideas, and that any project with her had to be a collaboration." Kelly's observation that Rauschenberg and Johns (the artists most prominently associated with Tatyana Grosman) were working in an Abstract Expressionist style reads as a telling aside in his vigilant effort to distinguish his work from that of the geometers to one side and the "abstract" artists on the other. The relationship between Kelly's paintings and the *Suite of Twenty-Seven Color Lithographs* can be simply stated: they each derive from the drawings and studies of the Paris years, 1948–1954, which remained at the origin of his art in the 1960s.

Kelly now feels that since his "knowledge of printmaking was limited," he didn't realize at the time the full potential of lithography to restate his aesthetic aims as boldly as he would later. The

printer he was working with in Paris, Durassier, had worked with Georges Braque, Joan Miró, and Alberto Giacometti, all artists whose work had as its focus a kind of pictorial liveliness that hadn't prepared the printer for Kelly's large flats of color. "Later when I started to make prints at Gemini, I benefited very much from Ken Tyler's craft. Tyler realized that you had to roll the ink on the plate without overlapping, and that a very even layer of ink should be on the plate. I think obtaining a large area of unbroken color is one of the most difficult things I've had to do in making prints over the years." Kelly has always had a special fondness for these prints. Artists whose ambitions and working methods evolve over the years are often likely to point to their newest project as most worthy of the viewer's attentions, but Kelly has always had a keen sense of his own evolution and thus values greatly earlier studies and versions of his work.

In the early and middle sixties, Kelly, in New York since 1955, had evolved his work in an American manner that, far from denying his Parisian investigations, built on them. These vibrant paintings, big and bold, were constructed of large planes of color. These were the paintings for which he quickly gained international recognition. And it was the relationship of shape and color in these paintings that were the inspiration for the *Suite of Twenty-Seven Color Lithographs*. Of the prints, the studies for which he had shown Tatyana Grosman a few months earlier, he has said, in relation to the paintings, "I struggled over the same problem of painting a large area that doesn't look fabricated or industrial. I want a full, deep, solid shape of color, with the marks and gestures left out." And he has said that, "Oil colors are very different from printing inks. In working with oils, I repaint until I achieve the color I want. With inks I usually have a preconceived idea that the printer tries to match, and we pull trial proofs until the color satisfies." Until the color satisfies *who*? The printer and the artist? I doubt it. Until the color satisfies Ellsworth.

1970s

Creating a New Department

[1975]

Until 1967 the responsibility for twentieth-century art in the Metropolitan Museum was divided somewhat chaotically among several departments. This was the result not so much of indifference toward our own time as a disinclination to regard it systematically. Modern painting, sculpture, and drawing were cared for by three departments, each of whose responsibilities went so far back in time that the art of the twentieth century seemed incidental. Only twentieth-century American paintings and sculpture were husbanded together under one curator, and that only since 1949, when American artists demonstrated and wrote letters to the *New York Times* insisting that the Metropolitan fulfill its role in support of contemporary art through a judicious use of the George and Arthur Hearn Funds, established for just such a purpose in 1906 and 1911.

Among the incorporators of the Museum in 1870 were several well-known artists: the painters John F. Kensett, Frederic E. Church, and Eastman Johnson, the sculptor John Q. A. Ward, the architect Richard Morris Hunt, the landscape architect Frederick Law Olmsted, and a poet, William Cullen Bryant. The wording of the charter made it clear that the Museum was incorporated "for the purpose of . . . encouraging and developing the study of the fine arts, and the application of arts to manufacture and practical life, of advancing the general knowledge of kindred subjects, and to that

81

end, of furnishing popular instruction." Thus the art of our time was one of the founders' primary concerns.

Several urgencies led to the creation of the Department of American Paintings and Sculpture in 1949. Francis Henry Taylor, the Director, was under pressure from a New York art world beginning to sense that its contribution was no longer tentative and provincial: artists were conscious of the availability of the Hearn Funds for the purchase of paintings by living Americans, and the Museum had no adequate way of caring for the magnificent Alfred Stieglitz bequest, which included numerous works by such American artists as O'Keeffe, Dove, Marin, Hartley, and Demuth.

When Robert Beverly Hale was named first curator of the new department, the Metropolitan recognized its responsibility to living art and to its public. An artist himself and the most successful instructor in artistic anatomy in our time, Hale acquired magnificent paintings for the collection—Jackson Pollock's *Autumn Rhythm*, Willem de Kooning's *Easter Monday*, and Arshile Gorky's *Water of the Flowery Mill*. His success is the more admirable in light of the hostility he encountered from a Board of Trustees uninterested in contemporary art and outrightly offended by abstraction. Hale literally shed tears of emotion and frustration at the meeting of the Acquisitions Committee at which he presented *Autumn Rhythm*. This taciturn man's emotion convinced the Trustees, but in order to acquire the painting he had to turn back a smaller Pollock, purchased five years earlier. This Pollock is now in the collection of S. I. Newhouse, Jr.

American painting was well on its way to a handsome and persuasive representation at the Museum in the nineteen-fifties and early sixties. But what of American sculpture, for which there were no restricted funds? What of modern European paintings and sculpture? Thanks to the munificence of donors and the canniness of curators, none of these areas had been totally neglected. Gertrude Stein had willed her historic portrait by Picasso to the Metropolitan, and Joseph Breck had bought handsomely from the key 1925 Paris Exposition of Decorative Arts; the Stieglitz bequest included drawings by Picasso and Matisse and a Brancusi sculpture;

and Robert Hale had induced the Trustees to purchase, with unrestricted funds, Isamu Noguchi's handsome marble *Kouros*.

After Hale's retirement in 1966 and the advent of a new Director, Thomas Hoving, in 1967, it became apparent that a new department was needed to collect the art of the twentieth century more systematically. By this time the modernist movement was becoming a discrete entity and a necessary part of any encyclopedic museum.

Since New York during the war had surpassed Paris as a center of artistic ferment, and American and European modernists were influencing each other and competing as members of an international movement, it was no longer appropriate to divide responsibility for recent painting and sculpture among four departments. The inclusion of the decorative arts in the new department also made sense from the standpoint of the new postwar internationalism but had more to do with the need to act quickly if New York was ever to have an impressive collection of Art Deco furniture and objects. Interest in Art Deco and other neglected realms of collecting was still in the pioneer stage, but it was clear that once a market developed it would skyrocket.

Historical perspective is always at work in an art-historical museum that shows contemporary art. A Francis Bacon exhibition at the Guggenheim Museum is judged and felt differently than a Francis Bacon exhibition at the Metropolitan, because of the proximity of Velázquez, Rembrandt, Goya, and Manet at the Met. A painting by Willem de Kooning hanging fifty yards from a roomful of Rembrandts is judged according to the artist's highest ambition; the stakes are higher and the game more passionate.

The spirit of monopoly, borrowed from American business and sometimes encouraged by the art press, has no place in the community effort of New York museums; it is an advantage that more than one institution is busy collecting the best art that is being produced. In this way the definition of the best is not in limited hands; three or four teams are out there. Also, if the flight of Impressionist and twentieth-century paintings from France is any example, the more American museums that accumulate our heritage, the better we will be served in the future. That there are Hofmanns, Averys,

and David Smiths in five New York museums is not a failure of the system; it is its glory.

An argument frequently heard at Acquisitions Committee meetings is that an object proposed for purchase will fill a gap in the collection, as if we were aiming for a seamless web. The process of acquisition often involves the awareness of a serious gap, granted, but is inspired far more by the availability of a particular work of art—such as the appearance on the market of a David Smith sculpture that haunts the memory and that may never be available again. The need for excellence, not merely chronology, must be satisfied.

The purchase by exchange of David Smith's *Becco* in 1972 was the subject of a great deal of journalistic concern. The practice of museums selling and exchanging works of art, though much discussed, was not the central issue. After all, every major museum, in and out of New York, has quietly exchanged and improved its collections for many years without provoking scandal. To cite just one example, if the Museum of Modern Art had not disposed of a Cézanne watercolor to make the purchase possible, New York and America would not now have Picasso's *Demoiselles d'Avignon*.

It was not so much the Metropolitan's purchase by exchange that was questionable; rather, it was the Museum's failure to inform the public and the heirs of the donor whose gifts were being exchanged. Following a long-established tradition among museums of keeping such transactions quiet, the Metropolitan's first responses to inquiries were guarded. The critics of this secretiveness were correct. A change of policy was indeed overdue. One result of the press coverage of this and other exchanges and sales at the time is that the Attorney General's office has given the state's museums welcome guidelines to help protect the public interest.

Had the Museum announced that it was planning to exchange six specific paintings from the bequest of Adelaide Milton de Groot for *Becca* by David Smith and *Ocean Park #30* by Richard Diebenkorn, it is doubtful that there would have been much controversy. As it was journalistic critics without adequate knowledge of the paintings being deaccessioned suggested that since the Museum had traded works by such historical masters as Renoir, Bonnard, Pi-

casso, Gris, and Modigliani for a Smith and a Diebenkorn, future generations were losing the benefit of priceless treasures.

In fact, the six paintings exchanged were minor works of Renoir, Bonnard, Modigliani, and Picasso, each of whom is represented in the collection by far better examples, and neither of the two small paintings by Gris was significant enough to represent him adequately. The paintings had been at the Museum since 1952. Several curators had tried to hang them in the public galleries only to find again and again that they were simply not of prime quality.

I had to bring *Becca* before the Trustees more than once before we acquired it. In the interval of two years, pursuant to Smith's testamentary instructions, and to the aggressive style of the Marlborough Gallery, then agents for the Smith estate, the sculpture went up in price by fifty thousand dollars and then by an additional one hundred thousand dollars, reflecting the artist's increasing international stature, the importance of *Becca* as a late great work, and the acquisition of other major Smiths by public collections. Almost every member of the Acquisitions Committee was enthusiastic about *Becca* when it was presented the second time, displayed at an evening meeting in the Hall of Arms and Armor, steel against steel, a marvelously apt temporary setting. .

There was genuine admiration for *Becca*, but there was simply no money available to purchase it. We have never had money specifically marked for modern sculpture, no fund for sculpture equivalent to the Hearn Funds for American paintings. As a result, while the Metropolitan was building a persuasive collection of first-rate postwar American paintings, the sculpture of the period was collected only sporadically. When it became apparent that six paintings on a previously compiled list of works to be deaccessioned could be exchanged for *Becca*, I recommended this procedure and the Acquisitions Committee agreed.

Along with Isamu Noguchi and Alexander Calder, David Smith produced American sculpture of international quality. We have several Calders and a great Noguchi. We also have Smith's *Tank Totem II*, acquired in 1953, a pleasant example of an aspect of his work of that decade but one that does not adequately represent his

achievement. There were 408 works in our exhibition "New York Painting and Sculpture: 1940–1970"; 22 of them were by Smith. My conviction about the supreme quality of his *Becca* (named after one of his daughters, Rebecca) was such that it stood at the head of the grand staircase at the entrance to the exhibition. Executed in 1965, the last year of his life, *Becca* sums up both David Smith's lifelong debt to Cubism and the correspondence in his work to that of his contemporaries, the Abstract Expressionists and their immediate heirs, the color-field painters. It is a superb three-dimensional mate to Jackson Pollock's *Autumn Rhythm* and Morris Louis's *Alpha-Pi*.

In 1964 Barnett Newman's painting *Concord* was hanging in the back room at Betty Parsons's gallery. It had been part of her own collection since 1950 when she exhibited it in the artist's first one-man show. In 1950 the audience for Newman's work was restricted; we can almost count them—Tony Smith, Clement Greenberg, Jackson Pollock, Betty Parsons, and Annalee Newman. Though Newman had a reputation among artists, it was not until the late fifties and early sixties that he was seen more generally as a major contributor to the glory of postwar American art.

I asked Mrs. Parsons if she would consider selling *Concord* to us. She answered that it was not for sale, but that if it were to go to the Museum she would let us have it for $30,000. The price was reasonable, the picture excellent, and the provenance impeccable. Newman himself agreed with the choice. There being sufficient income in the Hearn Funds, I presented *Concord* to the Acquisitions Committee in 1964 and pleaded the case for Abstract Expressionism as a movement, Barnett Newman as an artist, and *Concord* as a prime example of his work. There was some discussion about the durability of the painting: the two vertical elements that divided the canvas in the middle were made of masking tape with some paint overlaid. The Curator of Prints, Hyatt Mayor, asked for his opinion, said that masking tape might conceivably not last forever. After curators have made their cases to the Acquisitions Committee they leave the room and the Trustees deliberate. It's a bit like school. The next day it was announced that the painting had been turned down.

Several years later, under a new administration, I went back to Betty Parsons and said, "Can we try again with your Newman?"

She said, "Yes, for the Museum."

I asked, "How much is it now?"

She said, a bit surprised, "Thirty thousand dollars."

I was grateful to her. She could legitimately have asked for more, but she was not out to make a killing; she was interested in the Met's acquiring an excellent painting.

The Trustees were presented with the same painting at the same price. Nobody mentioned the earlier effort, nobody questioned the longevity of masking tape. Indeed, the question of the masking tape never even came up. We bought the painting I consider to be one of the most beautiful in our collection.

But the masking tape continues to nag at my memory and conscience. We collect not only for the present but for the future. Hyatt Mayor was perfectly correct. Masking tape, unaided by scientific conservation, will not last forever. We keep a weather eye on *Concord's* condition, and twice have had to glue down tiny edges of tape. Our responsibility is clear. We will keep an accurate photographic record of the tape in its present state and be ready to reproduce it, when necessary, in a more stable material.

Artists have always experimented with new materials. Leonardo and Delacroix spring to mind. Leonardo's *The Battle of Anghiari* blistered off the wall almost before it was finished and, in the nineteenth century, bitumin turned out to be a fugitive material. Imaginative scientific conservation can go a long way toward arresting the effects of self-destructing innovation. If by its aesthetic quality a work insists on being preserved, a sympathetic scientific conservator can do wonders.

The parameters of the activity of the Department of Twentieth Century Art in decorative arts are indicated by the acquisition of a major set of windows by Frank Lloyd Wright, a collection of sixteen superb hand-turned bowls by the American craftsman James Prestini, a chair by the Spanish Art Nouveau architect Gaudi, four extraordinary pieces of furniture by his Italian contemporary Carlo Bugatti, and products of the Wiener Werkstatte.

Perhaps our most telling accomplishment has been in the collection of masterworks produced in Paris in the nineteen-twenties by artist-craftsmen such as the furniture designer Jacques-Emile Ruhlmann, the innovator in glass Maurice Marinot, and the silversmith Jean Puiforcat. At an auction in Paris in 1972 we made dramatic acquisitions in this field: an African-inspired stool by Pierre Legrain (already represented in the collection by several handsome leather-bound books) and a small table of ebony, ivory, and sharkskin by Clement Rousseau. Both had been commissioned by the French couturier, collector, and Maecenas, Jacques Doucet for his new apartment, which was barely completed at the time of his death in 1929. They represent the third phase of Doucet's collecting: he moved with grace from painting, sculpture, and furnishings of the eighteenth century to the works of Picasso and the Douanier Rousseau and then to the new design sense that was to triumph as Art Deco. Much of Doucet's furniture had been given to the Musée des Arts Décoratifs in Paris. The news that more pieces of comparable quality remained in private hands and through an inheritance dispute were to come up for auction at the Hôtel Drouot called for action. I requested twenty thousand dollars of the Trustees' funds to buy, I thought, a handsome sofa by Coard. We needed the unrestricted funds because we had spent the interest and capital of the Edward C. Moore Fund, the only long-standing money available for modern decorative arts, and we had plans for expending a handsome gift from Edgar Kaufmann on the purchase of a superb Ruhlmann desk.

It quickly became apparent, once I was in Paris, that my twenty thousand dollars were not going to buy the Coard couch. Everywhere I went I heard that Yves St. Laurent would be bidding, and Madame Helen Rochas, and a wealthy American from Richmond, Virginia, then unknown to me, as well as the clutch of Parisian Art Deco dealers. My sense of the competition was correct. The couch brought thirty thousand dollars and is now in the home of Sydney Lewis in Richmond.

When I saw the Clement Rousseau table, I felt simultaneously an extraordinary weakness and exaltation. In other words, I had to

have it. This feeling does not come over the curator often, but when it does he becomes wild, canny, daring, and, need I say, somewhat unreasonable. Tom Hoving describes these feelings in his pages on the Bury St. Edmunds cross. I was going to return to New York with the table and, if possible, with something else as well from among the Doucet masterpieces. I fixed on several stools by Pierre Legrain, who had been primarily a bookbinder until encouraged by Doucet to try his hand at furniture. The one I wanted most got away; it went to Madame Rochas and thus stayed in Paris. The Legrain stool I was able to acquire is a perfectly stylized French echo of its African progenitor.

This was my first auction in French. The bidding was in five-thousand-franc jumps. I was bidding against pros and collectors who could go much higher than I could. I had to figure in the auction house's commission, which varied as the price went up, and the shipping charges to New York. It was, of course, also a point of honor to return to general funds as little of the money voted for this auction as possible; my job was to buy the best, not to save pennies. On the other hand I had no authorization to exceed twenty thousand dollars. It was a close game. I had hired at a modest fee a French auction expert. He was to do the actual bidding. We sat in the first row. I didn't realize that all the collectors and dealers were buzzing that the infinitely wealthy Metropolitan Museum was there to walk away with what it wanted. I had discussed the pieces that interested me with my expert, and we had set the top bids on the few pieces I was after. When the Rousseau table came up, it quickly became clear that the price would exceed my limit. I whispered to the man to keep bidding. He refused. He believed in respecting the cool decision made previous to the heat and excitement of the auction. I poked him hard with my elbow. Nothing happened. My heart thumping with fear and excitement, I shot my hand up at several of the five-thousand-franc jumps that seemed as if they would wipe out my money and then some if the bidding continued for even one more round. At twelve thousand five hundred dollars the bidding stopped and the piece was ours. I had meant to stop at eight thousand. I had just enough money left to buy the Legrain stool.

Months later I learned that the underbidder on the table was Sydney Lewis. Lewis had thought he was bidding against all the wealth of a powerful museum. Gentleman that he is, he is happy to see the table at the Metropolitan. We have since become fast friends.

When the table arrived in the Museum, it was sent to Conservation for cleaning and minor restoration. There, a young conservator, Rudolph Colban, found a plug of wood on the underside securing a medal implanted by Clement Rousseau. The medal's inscription reads, "Je veux passer mon ciel à faire du bien sur la terre" (I want to spend my time in heaven secure in the knowledge that I have done well on earth). Could this hidden thought have drawn me to the table in the auction room? The table's delicacy, strength, exquisite proportions, and delectable combination of materials—not to mention the drama of its purchase—make this my favorite twentieth-century decorative arts acquisition.

My second meeting with Josef Albers was unexpected though not unannounced. He called to say that he was coming to the Museum the following day at eleven. He arrived early, with a package under his arm. In it was *Pillars*, a magnificent black, red, and white sandblasted, flashed glass work from his Bauhaus days. "Is it a gift, a loan, or an offer for purchase?" I inquired, apprehensive of giving offense but eager to set things straight. "Nine thousand dollars," he replied. I thanked him and presented *Pillars* at the next meeting of the Acquisitions Committee. It was purchased. Bob Hale had acquired three of Albers's *Homage to the Square* paintings in the 1950s, and Albers had given us two more paintings in 1969, but we still had nothing from his early period.

I soon realized that we were being tested by this serious man—serious, but with a twinkle. Several subsequent visits to his home in Orange, Connecticut ("Orange! That's good for Albers!" said his wife, Anni, on my first visit), and the gentle yet forceful intervention of Albers's lawyer, adviser, and friend, Lee Eastman, led to a retrospective exhibition of one hundred paintings by the artist, ninety-eight of them from his own collection. The Museum benefited magnificently from this effort when Albers invited me to ac-

cept twelve paintings of my choice for the Department of Twentieth Century Art. Furthermore, he gave a full set of his prints to the Department of Prints and Photographs.

My first meeting with Albers occurred in 1969, when I was preparing the exhibition "New York Painting and Sculpture: 1940–1970." It was a stormy one. Albers wanted assurances that his work would be treated seriously. As it turned out, he was pleased with his representation: thirteen works in a room devoted to him.

We passed our tests with Albers, and now we have the best representation of his work to be found in any public institution.

The outstanding promised gift made to the Department of Twentieth Century Art is that of Hans Hofmann's nine paintings of 1965, the *Renate Series*. In 1975 one of the nine, *Rhapsody*, was formally given to the Museum. In his last full working year Hofmann painted these pictures and dedicated them to his young wife, Renate, who in turn promised them to us. It was Hofmann's intention that the pictures be kept together and given to a museum, from which we can conclude that he regarded the series as an aesthetic testament. During his lifetime, Hofmann gave forty-seven paintings, spanning his work from 1935 to the mid-sixties, to the University of California at Berkeley. He made this gift in thankful recognition of the university's invitation to him to come to America in 1930 to teach a summer session. He ascribed his subsequent decision to live in America to this generous gesture and responded in kind. The Berkeley gift was a conscious effort on his part to represent the three decades of his American career.

The presence of the *Renate Series* at the Metropolitan, along with *Window* (1950) and *Veluti in Speculum* (1962), both acquired soon after their execution, made us, after Berkeley, the leading collector of this still underappreciated master.

After the collecting of twentieth-century art, there comes the problem of how to exhibit it adequately. The New York institutions that specialize in the art of their time are: the Whitney Museum of American Art, which grew out of the old Whitney Club of the early twenties; the Museum of Modern Art, founded by energetic enthusiasts in 1929; and the Guggenheim Museum, which began its ca-

reer in 1939 when Hilla Rebay interested Solomon Guggenheim in nonobjective art. Now, after fifty years of accomplishment in collecting and exhibiting, these institutions seem to be facing two alternatives: to continue to collect and exhibit, entailing costly expansion of both plant and staff to house and curate the art of the present and future in addition to all they have so far accumulated, or to limit themselves to some period, for instance 1870–1950, and assume less responsibility for the state of contemporary culture. The procedure of having special exhibitions practically prohibits the Whitney and the Guggenheim from showing the known collections. The Museum of Modern Art and the Metropolitan, while they have special exhibition galleries, still can hang only parts of their collections. At any given time there are numerous works of high quality in storage. This situation is not only wasteful of existing resources, it gives a false impression of an embarrassment of riches that discourages patronage at a time when New York should be energetically expanding its far from adequate public collections of postwar American and European art. Recognizing that, since the Whitney left its Eighth Street quarters in 1954, there has been no major museum in the neighborhood where artists live and work, the suggestion arises that the New York museums with public and private aid join forces to rent or buy a large building in Soho, which could be used to exhibit segments of their permanent collections.

An example of recent art that could be shown in the jointly operated exhibition space I propose is the *Renate Series*. I have been able to show these paintings as a group only twice since they came to the Museum. I always have as many of them hanging as possible, but the public would be better served if the series was on view more often while we wait for the Metropolitan's expansion program to be completed. Other examples of works not often enough on view are the Guggenheim's Kandinskys, the Modern's contemporary American paintings and sculpture, which must be rotated in the first floor gallery for reasons of space, and the Whitney's Gorky, *The Artist and His Mother*. The dialogue between the new museum and Soho's galleries could be resounding.

New York Painting and Sculpture:
1940–1970

[1969]

Almost thirty years have passed since Arshile Gorky and Jackson Pollock announced in their painting that a new era was breaking in American art. The augury was correct. By reason of its own achievement and the clear and indisputable effect it has had throughout the world, the art of the New York School stands as the most recent in the grand succession of modern movements from Impressionism through Cubism and Surrealism.

Much has been said about the achievement of the New York School in the past several decades. National pride and international acclaim recognize that something magnificent has happened. On the occasion of its centennial, The Metropolitan Museum of Art celebrates this achievement with the exhibition "New York Painting and Sculpture: 1940–1970." For the first time, admirers of modern art will be able to see paintings and sculptures in large numbers by the major figures who have produced the vital sequence of moments that make the New York School the historical successor to the School of Paris, the two generations of artists who have so successfully perpetuated the vitality and innovative energy that is the hallmark of any major movement.

The limitation to New York art in this exhibition is not parochial. The term "New York art," in fact, includes most of the significant

American art produced in the past three decades. The School of Paris was an umbrella that covered Russia as well as Spain. Regardless of where a work is made, unless it is primitive, anachronistic, or truly eccentric, it becomes associated with the center of its day, the city whose style it reflects. Thus we unblushingly include Morris Louis and Kenneth Noland, the acknowledged leaders of Washington's School of Color Painters, because their exhibiting history, the sources of their art, and their most cogent influence have all been located in New York.

The fact that New York has followed Paris as the dominant center of world art does not preclude the possibility of another, even several other cities, being the loci for important art. It seems clear at this writing, as it has been for a decade, that London and Los Angeles provide the two most fertile alternatives to New York.

The New York School includes Americans born in Armenia (Arshile Gorky), Holland (Willem de Kooning), Germany (Josef Albers and Hans Hofmann), Russia (Mark Rothko), and Sweden (Claes Oldenburg), as well as three men who grew up in California (Jackson Pollock, Philip Guston, and Robert Motherwell), a Texan (Robert Rauschenberg), and a Georgian (Jasper Johns). Except for Albers and Hofmann, who spent their formative years in Europe, all those named came as young men to paint or sculpt in New York.

Artists, both American and foreign, have looked to New York for much the same reasons that have always caused ambitious artists to gravitate toward contemporary cultural centers. The climate of discussion, theory, and technical advance at the center offers the opportunity for learning, testing, and growing. The teachers and schools are here, as are the accomplished artists whom they want to emulate and measure themselves against. Economic factors make New York (Paris, London, or Los Angeles) a center as well. The connoisseurs, collectors, critics, and commissioners are here, as are the art dealers, architects, and the private foundations that grant awards to artists. And perhaps most important of all, the museums and continuing gallery exhibitions that make possible the dialogue out of which significant art is produced are present in New York to an unprecedented degree.

New York stands for a style of life to the artist, a reference point, and a base of operations. Even if he is in no way associated with New York, except as one of the places he exhibits (one thinks of Mark Tobey, Sam Francis, Richard Diebenkorn, Larry Bell, and Robert Irwin, all West Coast artists), he makes the occasional talismanic visit to the city, most often simply to see what is happening. Artists of fully mature and personal styles, while their work remains largely untouched by the new, often are curious to see it just the same, for while they are passionately committed to their vision and expression, they are also disinterestedly committed to and fascinated by all art.

It is quite possible to produce great mainstream art at a distance from the center. But this is only possible (except in the rare case of the primitive) after the artist has first steeped himself in the continuous and evolving traditions which can only be absorbed in the sophisticated centers. Later, it is possible to move away, as did Georgia O'Keeffe to New Mexico and David Smith to Bolton's Landing, and continue to produce art in touch with the vital forces of the day. It is during the period of development, of formation of outlook and style, that the immediate contact with the source of energy is necessary. These, in time, came to be built into the fiber and character of the artist, and he can, when mature, move wherever he will and carry his interiorized contemporary world with him.

Thus the true school for the young artist, once he has gained the confidence and passionate certainty to know that he wants to be a painter or a sculptor, is the ferment and activity of the center, its multiplicity of styles and its complex traditions. Over and over again in repeated studio visits over the past ten years and in many days spent in viewing students' work in practical art schools, I have found that nothing can replace the firsthand knowledge of the great works on view in New York's museums and the turmoil that follows the exhibition of new work by contemporaries and older colleagues.

In 1929, when in the face of the Metropolitan Museum's conservatism the founders of The Museum of Modern Art had the excellent idea of making advanced European art available to an Ameri-

can public that had been tantalized and scandalized sixteen years earlier by the Armory show, they moved with courage and energy into an educational project of great importance. History records that the job was done superbly. In fact, the Modern's educational program helped make it possible for a generation of New York–based painters and sculptors to inherit the European Modernist tradition.

In his article "Arshile Gorky, Surrealism, and the New American Painting," William Rubin provides a specific example of the American painter's dependence on firsthand knowledge of works of art in New York's public collections. Professor Rubin posits Gorky's knowledge of a specific Miró, the *Dutch Interior* of 1928, "a picture that was constantly on view in the permanent collection of The Museum of Modern Art, and was probably a major influence on Gorky's *Garden in Sochi*," and then goes on to say that it was in the 1941 Miró retrospective held at the museum that "Gorky could observe in detail Miró's conversion from Cubism to Surrealism."

In the forties and early fifties The Museum of Modern Art and The Solomon R. Guggenheim Museum, with its excellent collection of nonobjective art, were among the daily meeting places and discussion centers for the serious artist and student who had to come to grips with Cubism and its aftermath if they were to paint in the Modernist tradition. Two factors, in addition to The Museum of Modern Art's persuasive permanent collection of modern European art, are generally recognized as having helped make New York a major international center for painting and sculpture after 1940. One was the Works Progress Administration; the other was the presence of European artists in New York during the years of World War II. W.P.A., with its various programs, was designed by the Roosevelt Administration during the years of the Depression to assist artists in surviving an economic catastrophe that had cut to virtually nothing private support of the arts. The W.P.A. programs gave artists a sense of community, shared problems, and styles of life. Out of this grew friendships and alliances, discussion groups, and several short-lived schools. W.P.A., with its resemblance to an artists' union, provided a common ground for the largely isolated Ameri-

can painter and sculptor. Discussions became fruitful and engaging; they developed from the artists' position in society to artists' rights, to questioning Marxism as the answer, to consideration of style, to admiration of and resistance to Picasso's overwhelming presence. Eventually, a key institution in the development of an artistic community in New York, The Club, was to be the issue and heir of the sense of shared involvement engendered during the difficult years of the Depression, alleviated in some measure by the W.P.A. Among the artists who participated in the program were Jackson Pollock, Willem de Kooning, Burgoyne Diller, Arshile Gorky, Stuart Davis, and David Smith. Something of the mood of the period is revealed in David Smith's memoir:

> Our hangouts were Stewart's Cafeteria 7th Ave. near 14th St. close to [Stuart] Davis' studio and school and 5¢ coffee was much closer to our standards but on occasion we went to the Dutchman's, McSorley's and Romany Marie's. We followed Romany Marie from 8 St. where Gorky once gave a chalk talk on Cubism, to several locations. Her place came closer to being a continental cafe with its varied types of professionals than any other place I knew. It was in Marie's where we once formed a group, [John] Graham, Edgar Levy, Resnikoff, de Kooning, Gorky and myself with Davis being asked to join. This was short lived. We never exhibited and we lasted in union about 30 days. Our only action was to notify the Whitney Museum that we were a group and would only exhibit in the 1935 abstract show if we were all asked. Some of us were, some exhibited, some didn't and that ended our group. But we were all what was then termed abstractionists.[1]

Another factor that liberated the American artist was the transfer of much of the School of Paris's energy to New York through the emigration of several of Europe's most advanced and admired artists. Léger and Mondrian and a sizable contingent of Surrealists—

[1]David Smith, *David Smith by David Smith: Sculpture and Writings*, ed. Cleve Gray (New York: Holt, Rinehart & Winston, 1968), p. 35.

Marcel Duchamp, Matta, Max Ernst, Marc Chagall, Yves Tanguy, Salvador Dalí, André Breton—spent the war years in New York and continued to produce important work here. There was something sacrosanct about the presence of these figures in New York, for they made flesh of legend and of recent art history. Mondrian and Léger, especially, continued to develop along lines that were consistent and continuous with their European work but which yet took cognizance of New York as their environment; Mondrian's *Broadway Boogie Woogie* and *Victory Boogie Woogie* are great American works by a European. The American artist, looking at the new and radical art by the European executed in New York, no longer felt it was necessary to go abroad to become an artist, an American prejudice since the days of John Singleton Copley and Benjamin West. Jackson Pollock put the matter succinctly in his answer to a question put to him by an interviewer in 1944:

> I accept the fact that the important painting of the last hundred years was done in France. American painters have generally missed the point of modern painting from beginning to end. (The only American master who interests me is Ryder.) Thus the fact that good European moderns are now here is very important, for they bring with them an understanding of the problems of modern painting. I am particularly impressed with their idea of the source of art being the unconscious. The idea interests me more than these specific painters do, for the two artists I admire most, Picasso and Miró, are still abroad.[2]

It became clear that great international painting could be executed in New York, that there was nothing talismanic about Paris. American painters understood that artists make art wherever they are, once they have absorbed those elements of tradition they find personally useful.

[2]Jackson Pollock, Interview, *Arts and Architecture* 61 (February 1944): 14. Francis V. O'Connor, *Jackson Pollock* (New York: Museum of Modern Art, 1967), p. 32.

The familiarity of the young American abstractionists with each other's work in the thirties and forties, fostered in part by the W.P.A.'s role as an artists' union, and gained through studio visits, informal discussions, and group shows in both galleries and museums, created a new resonance and a new level of ambition. Dependence on European models, illustrated by Miró's influence on Gorky and Pollock's frank avowal, constituted invaluable apprenticeships without which they would never have attained the independent mastery that made them the forerunners of the new American painting. These historical examples indicate that future practitioners and supporters of new art must have an opportunity to see what has been so far achieved so that they may come to terms with it and find unique ways to contribute to its perpetuation. One of the reasons French art weakened so considerably after World War II was that the key paintings and sculptures of the first half of the century were not on view in Paris. Thus, in showing the work of the New York School, we do more than honor the artists and do justice to history. That their work is on view, even relatively briefly, helps to ensure the continuation of the tradition.

New York's museums have served our artists and public well by collecting and exhibiting the key works of the Modernist tradition as it evolved in Europe between 1870 and 1940. The Metropolitan Museum's collection of Impressionist and Post-Impressionist pictures, the Modern's unparalleled history of the modern period (illustrated by originals), and the Guggenheim Museum's largely non-Parisian (Russian, Dutch, German) range of nonobjective art, form a more significant collection that that of any city in Europe. Each of these museums and The Whitney Museum of American Art have shown an awareness of the new American art as it has developed, but now, with three decades of clear historical achievement by the New York School, we must meet our responsibility to the continuing process out of which new art develops by showing the best recent art and by presenting it in conjunction with the older and more established work.

At the Metropolitan Museum there have been funds allocated specifically for the purchase of European modern art. With the limited money available, the European Paintings Department has concentrated its energies in fields less well covered in New York than the modern. The most continuous and coherent modern collection at the Metropolitan is of American painting. The reasons for this are twofold and equally important in the history of the collection. The first was the establishments of the George A. Hearn Fund (1906) and the Arthur H. Hearn Fund (1911) that were specifically earmarked for the purchase of American painting (not sculpture). The second was the magnificent Alfred Stieglitz Bequest, made in 1949, coincidentally the year that pressure by New York artists led to the founding of the Department of American Painting and Sculpture. The Stieglitz Bequest gave us an impressive collection of works by American artists who were first exhibited in Stieglitz's galleries, such as Marsden Hartley, Arthur Dove, John Marin, and Georgia O'Keeffe, together with fascinating minor works by Matisse, Picasso, Brancusi, Severini, and other European artists Stieglitz introduced into America.

With the aid of the Hearn Funds, Robert Beverly Hale, the curator of the new department, was able to make such major purchases as Pollock's *Autumn Rhythm* and Gorky's *Water of the Flowery Mill*, both in the current exhibition. The pressure on the part of the artists that caused the creation of the department coincided quite naturally with the growth in importance of our native art. It is thus ironic but understandable that as pressure mounted to expend the Hearn Funds, the rise in prices made these funds inadequate for their purpose. Rumor persisted into the sixties that the fabulous Hearn Funds lay idle. If they did, it was so that the money could accumulate long enough to make an important purchase. When major American paintings cost eight hundred or a thousand dollars, it was possible to make many significant acquisitions with the funds' income each year. Today the income cannot purchase the tenth part of a major Pollock. Recently, accumulated income has made it possible to purchase three major paintings in the exhibition, Morris Louis's *Alpha-Pi*, Ad Reinhardt's *Red Painting*, and

Barnett Newman's *Concord*, which he exhibited at his first one-man show at the Betty Parsons Gallery in 1950.

While the Metropolitan Museum has not had an extensive collection of contemporary New York art to draw upon, it was often, through the fifties and sixties, the one place in New York where several galleries were consistently devoted to the permanent exhibition of the new American painting. With the founding of the Department of Contemporary Arts in 1967 the Museum, under its new director, Thomas P. F. Hoving, further committed itself to collecting and exhibiting American and international painting, sculpture, and the decorative arts of the twentieth century. In three exhibitions mounted in the past two years—James Rosenquist's mammoth *F-111*, a small show of large works by Morris Louis, Kenneth Noland, and the English sculptor Anthony Caro, and five new sculptures by Jules Olitski—the Museum discovered that its size and flexibility, particularly during the current period of renovation, provide a unique opportunity to exhibit new work that has often in recent years grown in size and originality of concept beyond the normal confines of the commercial gallery.

New York's specialized museums have been so locked into complex and far-reaching exhibition schedules, which commit their time and space as much as three years into the future, that they have often been unable to serve the needs of the present. In spite of its concentration of artistic activity, New York does not provide an adequate exhibition hall, spacious, flexible, and available at fairly short notice to survey developments as they occur.

The Jewish Museum performed this essential function when it presented valuable mid-career retrospectives of the work of Helen Frankenthaler (1960), Robert Rauschenberg (1963), Jasper Johns (1964), and Kenneth Noland (1965), as well as the important sculpture exhibition called "Primary Structures" (1966), which revealed the strengths and some of the emptiness of the new Minimal sculpture. But it is clear that The Jewish Museum, with several roles to play in the community and with space that is not really adequate to the task, cannot fulfill the need for timely exhibitions all by itself.

The Metropolitan Museum's Centennial celebration has created the opportunity to see the shape of our recent tradition.

We point with optimism to increased museum attendance figures as an indication of a more interested public, and while this may be true, we should remember that statistics do not make a cultural renaissance. In the past century the increasing privacy of the artist's vocabulary and the decreasing regard for public reaction has attenuated the public for contemporary art to an alert and interested few attuned to the closest scrutiny of formal and philosophical developments that escape the inexperienced. At first, advanced art has meaning only to a small but passionate audience made up of artists and their immediate coterie. But no matter how many or how few people come through each year, the museum must continue to make the best works in the collection available to the public. It must continue to acquire and borrow the finest works of art and to present them intelligently to the real audience, to those of the newly immense public who linger and look.

Nonetheless, as a result of the heroic program of art education which began with the founding of The Museum of Modern Art and has been extended to the art departments of our schools and colleges, newspapers, periodicals, and television, advanced art is gradually being made accessible and comprehensible to the general public. But even though much of the public is unaware of the presuppositions that make modern art fully comprehensible, this does not exclude the possibility of response or enthusiasm. It is only a matter of time before important changes and breakthroughs become clearer, especially as key paintings and sculptures continue to make their way into public collections. We must remember that the Impressionist paintings, which are perhaps the most universally appreciated works of art in the Metropolitan's collection, originally outraged a public goaded by hostile critics.

The second-floor galleries of the Museum, usually devoted to the permanent collection of European paintings, are ideal for showing American art of the past three decades (it is in these galleries that

"New York Painting and Sculpture: 1940–1970" is being housed). The juxtaposition of grand and intimate spaces provides a setting for works of art of every scale. Contrary to prevalent opinion, paintings by such artists as Jackson Pollock and Morris Louis demand the same natural light in which we are accustomed to seeing Rembrandt and Monet. The original Museum of Modern Art building of 1939 (by Edward Durell Stone and Philip L. Goodwin) and Frank Lloyd Wright's Guggenheim Museum were conceived in the thirties for easel pictures. In both buildings the natural lighting in the architects' original plans has been eliminated for reasons of expansion and taste. At the Modern, the window wall facing 53rd Street has been covered by false interior walls to increase hanging space. At the Guggenheim, Wright's combination clerestory and skylighting was eliminated when James Johnson Sweeney cantilevered paintings off the wall rather than hanging them close to the wall as was intended, necessitating a supplementary artificial lighting system.

In 1947, in his application to the John Simon Guggenheim Foundation, Jackson Pollock heralded an end to the historical situation for which these museums were designed in a prophetic statement:

I intend to paint large movable pictures which will function
between the easel and mural. . . . I believe the easel picture
to be a dying form, and the tendency of modern feeling is
toward the wall picture or mural. I believe the time is not
yet ripe for a full transition from easel to mural. The pictures
I contemplate painting would constitute a halfway state,
and an attempt to point out the direction of the future without
arriving there completely.[3]

(By 1949 and 1950 Pollock and Barnett Newman were painting their huge, mural-sized pictures.) Philip Johnson's addition to the Modern (1962–1964) and Marcel Breuer's new Whitney Museum

[3]Francis V. O'Connor, *Jackson Pollock* (New York: Museum of Modern Art, 1967), pp. 39–40.

(1966) accommodate the new large paintings and sculptures. Because of the insistence on artificial lighting in both buildings and the lack of truly generous space at the Modern, it is the Metropolitan that will serve best (until a modern museum is built with a grand, rhythmic procession of skylight galleries) as the place in New York in which to see our own monumentally scaled art.

There are other than physical advantages to exhibiting contemporary art at the Metropolitan. The extent to which even the most radical Modern Art is continuous with and dependent upon tradition can be revealed as never before when that new art is exhibited alongside the art of the past. The isolation of Modern Art at the other museums creates an essentially artificial separation between contemporary art and the art of the past. Specialists in Modern Art too easily fall into the trap of measuring contemporary art only against itself, rather than the art of the past, the ultimate test of quality. De Kooning has said it gives him particular joy to see his work (*Easter Monday*, in the Metropolitan's permanent collection) hanging forty feet from the Rembrandts against which he must finally measure himself.

Robert Rosenblum, in his cogent article "The Abstract Sublime," has suggested revealing and enriching analogies between painting of the Romantic movement and the work of Jackson Pollock, Mark Rothko, Clyfford Still, and Barnett Newman. Clyfford Still is seen as an analogue to the British Romantic painter James Ward; Mark Rothko is compared to Caspar David Friedrich and Joseph Turner; and Jackson Pollock is also viewed in terms of Turner. Barnett Newman may be understood as well to participate in the Sublime, but without a specific predecessor. Such comparisons with the past are not intended to sanction or justify the achievement of those contemporaries; they enlarge our vision and enrich our experience of their work. Rosenblum's thesis demonstrates that these works breathe naturally in the history of art. The way is open to other telling analogies linking our artists with other ideas and epochs, links across history that Henri Focillon saw as families of ideas.

As curator, my guiding principles in deciding which artists to include in the exhibition "New York Painting and Sculpture: 1940–1970" have been the extent to which their work has commanded critical attention or significantly deflected the course of recent art. These "deflectors," as they may be called, are those artists who have been crucial in redirecting the history of painting and sculpture in the past three decades. My aim has been to choose works of quality and stature by those artists who have posited the major problems and solutions of our immediate tradition.

George Kubler in his stunning essay *The Shape of Time*, a work that makes Kubler a natural heir to his teacher, Henri Focillon, writes:

> Every important work of art can be regarded both as a historical event and as a hard-won solution to some problem. . . . The important clue is that any solution points to the existence of some problem to which there have been other solutions, and that other solutions to this same problem will most likely be invented to follow the one now in view. As the solutions accumulate, the problem alters. The chain of solutions nevertheless discloses the problem.[4]

The innovative artist in his grasp of a new possibility inevitably alters the problem and therefore deflects the tradition through his solution. The current exhibition was conceived as an accumulation of thirty years of solutions to a constantly changing set of problems—problems and solutions that make up a vital tradition.

Forty-three artists are represented in this giant exhibition. Not even at the height of the High Renaissance, Impressionism, or Cubism has anything like this number of artists finally seemed crucial to the development of the art of their time. Arshile Gorky, Jackson Pollock, and David Smith today look like the giants of their epoch, and a safer and more classical show could have been mounted devoted to their work alone. But we are celebrating a fortunate era

[4]George Kubler, *The Shape of Time* (New Haven: Yale University Press, 1962), p. 33.

of plentitude, and it is this sense of plentitude I hope to re-create in the current exhibition.

At a later time, one might well look back to reconsider and re-evaluate, to see different clusters and configurations of artists and movements. Many artists of quality have not been included in the exhibition. One thinks of the American Surrealism of William Baziotes and Theodoros Stamos; the Abstract Expressionism of Richard Poussette-Dart, James Brooks, Jack Tworkov, Conrad Marca-Relli, Joan Mitchell, and Al Leslie; the abstractions of Rollin Crampton, Robert Goodnough, Jack Youngerman, Cy Twombly, Ray Parker, Al Held, and Friedel Dzubas; the Abstract-Expressionist sculpture of Herbert Ferber, Seymour Lipton, Theodore Roszak, Raoul Hague, and Reuben Nakian; the figuration of Larry Rivers and Alex Katz; and the full Pop Art of Tom Wesselmann, Jim Dine, Marisol, and Robert Indiana. All these artists will be remembered and collected and, like the art in the exhibition, will be reevaluated, by each successive generation of artists, critics, museum men, collectors, and the general public in that process in which the history of taste merges indistinctly with the history of art.

"New York Painting and Sculpture: 1940–1970" has been limited to artists whose distinctive styles emerged and were viewed before 1965 in galleries, group shows, and museums. This by no means indicates a lack of interest in subsequent developments. But the making of reputations and the discovery of new talent is not the role of the Metropolitan. Three young artists, Edward Avedisian, Walter Darby Bannard, and the Californian Ron Davis, for example, have each grown rapidly in accomplishment and stature, but the record of their achievement is not yet clear and they are not included in the current exhibition.

It has been the Whitney Museum's function, especially during the fifties and sixties when so much varied work was on view every year in New York's many galleries, to recapitulate the season, impartially, in the mammoth Annuals devoted in alternate years to sculpture and painting. While the Whitney emphasized perhaps too much the provincial and regional aspects of American art, it

provided a forum in the thirties and forties for our internationally minded abstract artists before they had an audience to support them. (The Whitney Museum held a show of American abstract art in 1935). It was at the Whitney Museum, when it was on Eighth Street, that I saw the Arshile Gorky Retrospective in 1951, which convinced me of the emotional power in contemporary abstract art.

From its founding, the Whitney has had a sense of responsibility and fairness to all the styles that at any moment make up the totality of contemporary art. This sense of fairness has always made the annual exhibitions of painting and sculpture at the Whitney anthologies rather than attempts to define styles and emphasize quality. For many of us growing up in New York, the Whitney Annual was always a much-anticipated event, for it allowed us to see in one large exhibition much of the best that was being produced along with the most stagnant, least provocative art imaginable. Thus the viewer was thrown into the healthful turmoil of doing what some consider the museum's job—of deciding, comparing, rejecting, and accepting until he felt, often after several visits to the same Annual, that he was able to find his own way to what constituted quality in contemporary American art.

"New York Painting and Sculpture: 1940–1970" is not a general inventory of the past three decades but an evaluation, a sorting out of major themes and figures. This exhibition represents my view of the historic impulse that produced such continued excitement and high achievement in the past three decades.

The Museum of Modern Art's program is to illustrate art history, applying historical methodoloy into and through the twentieth century up to the most recent movement which can be dealt with historically, Abstract Expressionism. The Museum of Modern Art was founded in the nineteen twenties to take up the slack left by the Metropolitan Museum, whose coverage of the history of art ended with the Impressionists. Alfred Barr and his staff put together the world's finest collection of painting and sculpture of the period from 1870 to 1940, which from one point of view may be seen as a discrete his-

torical entity entitled "The Modern Period." In two exhibitions in 1936, "Cubism and Abstract Art" and "Fantastic Art, Dada and Surrealism," and in the accompanying catalogues, Alfred Barr formulated the sequence of movements and pin-pointed the great works of the twentieth century up to that time, setting the standard for subsequent scholars. With "The New American Painting and Sculpture: The First Generation," held in the summer of 1969, William Rubin assembled an exhibition consistent with the policy established by Alfred Barr.

The Museum of Modern Art deals with history as a continually closing system up to the point where there is sufficient data and perspective to tell the story convincingly. Collecting paintings at the Metropolitan in the past century has been geared to the values of the connoisseur-collector rather than to those of the systematic historian. Thus, while the result of what might be termed a century of the leisurely accumulation of works of art has led to a persuasive survey of the history of art, the collection was not formed systematically. This informality makes it possible to bring together works of art from the standpoint of both the historian and the connoisseur.

The current exhibition has been planned in a similarly open spirit. There is a danger that in acceding to the demands of historical processing, we may fail to do justice to the present. Far from closing the books on the Abstract Expressionists, we celebrate the continuing vitality of the New York School. Several of the artists in the exhibition, well known for successful work in an earlier manner, are currently extending their visions and reputations into the present with some of their best work; Robert Motherwell's new "Open" series of 1968 and 1969 will be seen in retrospect as essential to a clear understanding of his achievement as are the well-known Spanish Elegies (three works from his new series are in the current exhibition); Adolph Gottlieb has turned to sculpture for the first time (the two pieces shown here are his first sculptures to be seen publicly in New York); and Barnett Newman has opened new vistas with his recent paintings in triangular format, which relate to his sculptures, *Here I* and *Here III*. Among the younger men, Kenneth Noland's new horizontal stripe paintings and Jules Olitski's

low-lying sprayed aluminum sculptures are as subtle and as full of implications for the future as anything in the art of the past decade. Invariably, artists want to feature their most recent work. It is understandable that as they change and develop they naturally feel closest to their most recent styles.

New work by established artists is judged, praised, or faulted with even greater rigor than that of the fledgling. There are no safe reputations in Modern Art. The same dialogue that leads so productively to the constant renewal of tradition makes of each new departure an adventure and a dare. The art of the past seems more orderly; critics and historians have marshaled the facts for us, and our sense of quality is aided by perspective. It is possible to clarify the art of a past, closed historical period. New work is judged qualitatively almost as if it were discontinuous with everything done before. While the critical process in which the new art is dissected, in which rules change as fast as new problems and solutions are set, is exhilarating and rigorous it is also seemingly chaotic and shapeless except to the few who are continually in touch and in sympathy with it.

The art historian and critic Michael Fried extends the historical approach beyond Abstract Expressionism to an analysis of the achievements of Morris Louis, Kenneth Noland, Jules Olitski, the English sculptor Anthony Caro, and Frank Stella, and deals convincingly with the sources and achievements of these artists, who continue the Modernist tradition in abstract art (see his essay, "Shape as Form: Frank Stella's New Paintings"). Pollock and Newman are seen not only as great artists in their own time but as problem setters whose new ideas enriched the possibilities in abstraction. Louis, Noland, Olitski, Caro, and Stella can then be seen as taking the hint, providing solutions to some of the questions raised by the older generation.

Clement Greenberg, whose writings both Rubin and Fried acknowledge, and whose essay is also included in this book, has been the most acutely perceptive observer of and commentator on American painting and sculpture during the years covered by the current exhibition. His greatness has been not only in recognizing the

achievement of Pollock and Gorky in the early forties, Newman, Rothko, and Still in the fifties, and Louis, Noland, and Olitski in the late fifties and sixties, but also in locating them in terms both of their uniqueness and their place in a tradition that Greenberg, more than anyone else, has revealed as a continually vital one.

While the process by which journalists come to terms with the art of the past decade has accelerated, many continue to be hostile to most recent art on first consideration. Time and again they lament the choice of artists representing the United States at Venice, São Paulo, or the international world's fairs, never suggesting alternate artists, who would, in their opinion, better represent our culture abroad. We miss the fierce and positive dialogue of the European journalists. In this country one must turn to the art magazines, which presuppose a greater degree of sophistication and commitment than do the dailies and Sunday supplements.

During the period covered by the current exhibition, four art magazines have served as forums in the presentation and interpretation of the new art, thus making it available to a much wider audience than could frequent the studios, galleries, and clubs whose exclusive concern was the new art. *Art News*, under Thomas B. Hess since the mid-forties, has consistently covered the art world, often with relish (Abstract Expressionism), sometimes with disdain (Pop Art), but always fully and with copious illustrations. *Arts Magazine*, under Hilton Kramer in the fifties and early sixties, devoted extensive coverage to the new art with Donald Judd as a regular contributor. James Fitzsimmons's Swiss-based *Art International* has covered both European and American art since 1958. The latest entry into the field, *Artforum*, was founded in California in the early sixties and moved to New York in June 1967 to observe the scene better in the person of its editor Philip Leider. No clearer record of these decades exists or is likely to exist than the issues of these magazines. Not only are the major figures treated often and in depth, but there is also much to learn about the context in which their art was produced, about fellow artists who struck off in other

directions, often personal and eccentric, but fruitful nonetheless. Critical positions are stated with passion and vigor, artists' statements abound, and the rise and fall of minor reputations alongside the constant rise of the major ones make fascinating reading.

Making one's way intelligently through the maze of art produced in our time has been complicated unnecessarily by journalistic simplifications, attempts on the part of the various media to make sense of the new on a popular level. An example of a phrase coined by a journalist in the effort to encapsulate the art of the mid-sixties in New York as the nonsensical and unhistorical impression fostered by *Time* magazine that Op Art followed Pop Art. This is cute, memorable, and untrue. Duchamp, Albers, Max Bill, and Vasarely, among many others, were producing art in the twenties, thirties, and forties, one element of which was a concern with optical effects, as everyone conversant with these developments knows, and as anyone can learn from a casual perusal of the art periodicals of the period.

The mass media with their concern for immediacy and emphasis on the current moment make it imperative that we recall the simple historical truth that it is the total career, not merely the novel moments, that matters. Bonnard developed the elements of his style in the 1890s and went on to paint beautiful pictures until his death in 1947. His style changed somewhat over the years, but the changes were gradual and internal, and they had nothing to do with fashion or with contemporary movements (Cubism, then Surrealism) which seemed at the time to be the only styles in which a vital artist could work. When we organize a Bonnard show today, it is not only that first innovative decade of the 1890s we consider, but also the total evolution of a style that encompassed fifty years.

I well remember in the late 1950s being shocked to hear painters, who believed in the primacy of de Kooning's position and who admired him, wondering aloud whether next year's show would repeat his success, whether he could consolidate his lead not by painting a beautiful show but by changing in an unexpected and unpredictable way. Pollock and Kline were also under this kind of pressure,

which is cruel and destructive even for the strongest character. Fortunately, the younger generation has had the example of the successful Abstract Expressionists before them and are much less vulnerable than were the artists in the fifties, the first to sit on this particular griddle.

It was not until the nineteenth century that a regular, professional art critic became necessary to interpret current painting to the public. The artist of the Renaissance, the Baroque, and the eighteenth century painted for an educated, enlightened, and enfranchised class of art connoisseurs, the aristocracy and the church hierarchy of the period before the French Revolution. His audience was clearly defined and there was a shared body of knowledge, literary and artistic, that patron and artist took for granted. Thus if a myth were referred to in a painting, or more likely, if a painting were commissioned to illustrate a favorite, personally meaningful myth, no educated viewer found it incomprehensible; at times a complicated literary painting might be an elegant visual puzzle, but there was a correct answer and it could be worked out. With the loss of a literary apparatus we have the beginnings of Modernism which Clement Greenberg defines as "the use of the characteristic methods of a discipline to criticize the discipline itself, not in order to subvert it, but in order to entrench it more firmly in its area of competence."[5] Artistic problems become the subject of art. It is then not surprising that the media and the journalists jumped at the chance to write about Pop Art and Minimal Sculpture, for both these styles are theatrical. The cooler art of Newman, Rothko, Louis, and Noland is undeniably more difficult for the critic who, by his very nature, is reduced to words. An art that is antiexpressionistic and nongeometric, that makes no references to nature or literature and is comprehensible only in the context of Modernist art, is tremendously difficult to write about. This very difficulty may well have contributed to its greater staying power. It has been allowed to remain visual; the impact is still in the works themselves, whereas art

[5]Clement Greenberg, "Modernist Painting," *Arts Yearbook 4* (1961): 103.

that has news value must necessarily run the risk of becoming, in time, stale news.

It seemed for a while that the gallery system, with its biennial exhibitions of each artist's work, was implicated with the media in applying the false urgency of Hollywood to the fine arts. Certain galleries were open to criticism for playing to an audience overeager to spot trends, rising reputations, and falls from favor. It appeared to many that new shows by even the most established artists were conceived more in response to the demands of fashion than art. Before the galleries were discovered by the media, several major artists—David Smith, Barnett Newman, and Clyfford Still, among others—had broken ties with their dealers and started to sell their work privately to individuals and to museums. By breaking away from galleries, these artists freed themselves of confining relationships and commissions often as high as fifty percent. During the sixties the gallery system in itself came to be pictured as sordid and commercial, at best a necessary evil. The idea has grown among a group of radical younger men that the system is parasitic and overcommitted to established styles in painting and sculpture. In addition, contemporary art has continued to grow in scale and conception defying the physical limits of the conventional gallery, which, in a sense, reproduces the intimacy of the home. Some new art, such as Frank Stella's forty-foot paintings and Mark di Suvero's huge constructed sculptures, too big for galleries, looks better and can be better viewed in the studio, warehouse, museum, or exhibition hall than in the commercial gallery.

However, looking back over the exhibiting history of the postwar period, it is clear that the art dealers performed an invaluable service in supporting artists and in making art available. In the last twenty years younger artists in search of the inspiration and challenge necessary to their development have had to shift their attention away from the museums to the only place where new and advanced art has been systematically exhibited, the commercial art galleries. The galleries play more than an amusing social role in the

history of the period; they have served as school, forum, and news transmitter to the community interested in the complex course art has taken. The dealer who is alert to quality, who has committed himself early and clearly to the new art, has risked ego, prestige, and money, and must finally be considered a minor cultural hero.

In 1942 the gallery became the focal point for the artists and their immediate coterie, which comprised their total audience at the time, when Peggy Guggenheim, encouraged by the presence of the Surrealists in New York, among them her husband Max Ernst, opened her gallery called Art of This Century. She gave one-man shows to Jackson Pollock (1943, 1945, 1947), Hans Hofmann (1944), Robert Motherwell (1944), and Mark Rothko (1945), as well as to such Europeans as Jean Helion, Hans Arp, Max Ernst, Alberto Giacometti, and Theo Van Doesburg, exhibiting the work of these Americans in the more sophisticated context of European art. After the war Art of This Century was closed and Peggy Guggenheim moved to Venice.

The postwar New York market for European Modernist art and the growing challenge of New York's own artists led to the opening of two more galleries in the forties, those of Samuel Kootz in 1945 and Sidney Janis in 1948. Kootz's first triumph was in bringing back recent Picassos from liberated France to an American audience that had been deprived during the war years of the work of an artist they regarded as a hero. By the late forties Kootz was also exhibiting William Baziotes, Robert Motherwell, Hans Hofmann, David Hare, and Adolph Gottlieb. Janis opened with a stable dominated by European Cubists and Surrealists including Léger, Kandinsky, Delaunay, Mondrian, and Henri Rousseau, all of whom were given one-man shows. Collectors whose eyes had been trained by The Museum of Modern Art bought works that later ended up there as gifts or on loan, as did Mr. Janis's own collection. Janis's original list of Europeans was gradually complemented by the addition of a number of American artists who had proved themselves in previous gallery exhibitions; first Josef Albers in 1949, followed by Pollock in 1952, de Kooning and Arshile Gorky in 1956, and Motherwell in 1957. Janis has continued to change with the times. In the sixties,

after putting together the first show of Pop Art, which he called, in the French manner, The New Realism, he has shown the work of Claes Oldenburg, George Segal, Jim Dine, and Marisol, as well as such abstractionists as Ellsworth Kelly and Richard Anuszkiewicz. Two other dealers who also contributed to the density and richness of exhibition life in New York in the 1950s were Charles Egan, who showed Jack Tworkov, Reuben Nakian, Kline, Guston, Joseph Cornell, and Robert Rauschenberg, all between 1952 and 1955, and Eleanor Ward, whose Stable Gallery exhibited Conrad Marca-Relli, Joan Mitchell, Cy Twombly, Larry Rivers, John Graham, Myron Stout, Isamu Noguchi, Joseph Cornell, and James Brooks in the fifties, and Richard Stankiewicz, Andy Warhol, and Robert Indiana in the sixties.

Betty Parsons's first gallery, the Wakefield, was in a bookstore. She opened in 1940 and showed Walter Murch (1941), Alfonso Ossorio (1941, 1943), Joseph Cornell (1942), Saul Steinberg (1943), Constantine Nivola (1943), Theodoros Stamos (1943), and Adolph Gottleib (1944). Between 1944 and 1946, as director of the Mortimer Brandt Gallery, she gave one-man shows to John Graham, Theodoros Stamos, Hedda Sterne, Alfonso Ossorio, Hans Hofmann, Mark Rothko, and Ad Reinhardt. In her continuing capacity as director of the Betty Parsons Gallery she has been responsible for presenting the committed art public with some of its most memorable moments, among them Pollock's 1948 exhibition in which he showed pictures such as *Cathedral*, a painting that announced his most radically innovative period (Pollock had shows at Parsons in 1948, 1949, 1950, and 1951). She was also responsible for Barnett Newman's two one-man shows of 1950 (which included *Concord* and *Covenant*) and 1951, which introduced a powerful new voice into contemporary art. (He was not to show again in New York until his French and Company exhibit in 1958.) With Rothko, Still, and Reinhardt, Newman offered a viable alternative to the full-blown painterly abstraction that seemed to typify the style of the fifties. The austerity of Newman's work, his refusal to employ tired devices in even their most elemental form, gave him an extremely limited audience through the fifties (Clement Greenberg, Betty

Parsons, Tony Smith, and some fellow artists), until another generation of painters, Louis, Noland, and Stella among them, referred to him in their work. His vertical stripe, or "zip" as he prefers to call it, denies both Cubism and geometry, two of the staple props of abstract art before him. Betty Parsons also showed Clyfford Still (1947, 1950, 1951), Ad Reinhardt (twelve times between 1946 and 1965), Bradley Walker Tomlin (1950, 1953), Robert Rauschenberg (1951), and Ellsworth Kelly (five times between 1956 and 1963). The Betty Parsons Gallery continues to provide a forum for both older and younger artists.

Leo Castelli opened his gallery in 1957 with a group show made up largely of European masters, but which included de Kooning, Pollock, and David Smith, thus indicating the possibility of a drift toward the Americans in whom Castelli had been interested since the forties. In 1957–1958 Castelli showed Marisol, Jasper Johns, Robert Rauschenberg, and Friedel Dzubas, in 1958–1959 Esteban Vicente and Gabriel Kohn, and in 1959–1960 he represented Frank Stella, Cy Twombly, John Chamberlain, Lee Bontecou, and Jack Tworkov in group and one-man shows. Since then he has added James Rosenquist, Andy Warhol, Roy Lichtenstein, Larry Poons, Donald Judd, and, most recently, Dan Flavin. Like Janis, Castelli runs a gallery that reflects the growth and change of the American scene.

André Emmerich through the sixties showed the work of Morris Louis, Kenneth Noland, Helen Frankenthaler, and Jules Olitski. (Olitski's history demonstrates the complexity of many artists' gallery associations. Before showing with Emmerich he had been with Iolas, French and Company, and Poindexter. He is now represented by the Lawrence Rubin Gallery.) Two "blue chip" galleries currently represent many of the original generation of the New York School. The Pollock Estate, the David Smith Estate, the Kline Estate, Rothko, Guston, Motherwell, and Gottlieb exhibit at Marlborough-Gerson, while M. Knoedler and Company handles Newman, de Kooning, and the Gorky Estate.

One of the most fascinating galleries of the sixties was Richard

Bellamy's Green Gallery. Its greatest strength was in Bellamy's constant search for new talent, a search not enough dealers are willing to undertake. Bellamy made countless tours of studios and subsequently exhibited for the first time James Rosenquist, Larry Poons, Lucas Samaras, Robert Morris, and Donald Judd and gave the first uptown shows to Tom Wesselmann, Claes Oldenburg, and Dan Flavin, the first sculpture show to George Segal, and the first American show to the British painter Richard Smith. He accomplished all this in about five years. The Green Gallery worked, in effect, as a talent scout for the larger and more established dealers. Today, former Green Gallery artists show at Sidney Janis, Leo Castelli, The Pace Gallery, and Richard Feigen. Bellamy has become a private dealer.

The 1964 and 1966 Venice Biennales and the 1965 São Paulo Bienal were the occasions for attacks on the art dealers because nearly all the artists chosen to represent the United States came from four galleries: Leo Castelli, André Emmerich, Sidney Janis, and The Pace Gallery. (Alan Solomon was United States Commissioner in 1964 at Venice; he showed Louis, Noland, Rauschenberg, Johns, Stella, Chamberlain, Oldenburg, and Dine. Walter Hopps chose the artists for the 1965 São Paulo Bienal: Barnett Newman, Larry Poons, Donald Judd, Frank Stella, Larry Bell, Billy Al Bengston, and Robert Irwin. In 1966 I chose Helen Frankenthaler, Jules Olitski, Ellsworth Kelly, and Roy Lichtenstein to represent the United States at the Venice Biennale.) This should have been in no way surprising. In the past hundred years in which advanced art and the gallery system have coexisted there has never been more than a handful of galleries at any one time prepared to show the best, most innovative work of the moment. With the Impressionists and the Post-Impressionists the galleries were Durand Ruel, Bernheim Jeune, and Wildenstein; Kahnweiler was, at first, almost the exclusive dealer for the Cubists; the Abstract Expressionists, as we have seen, were launched by Peggy Guggenheim, then by Charles Egan, Betty Parsons, Samuel Kootz, and Sidney Janis. It is clearly more important to represent the United States at these international ex-

hibitions and world's fairs by the best being done than to be concerned with an equitable distribution among dealers.

While the total self-interest of New York's real-estate industry, for example, is contributing to the destruction of the city, this same self-interest in the economics of the art world may finally benefit the public. A work of art often makes its way from the privacy of the artist's studio, through the gallery, to the collector, and finally to the museum. The general public is excluded from purchasing and living with much of the best art being produced in our society, for it is in short supply in relation to the number of potential owners, and because it is expensive. Ironically enough, these very factors, scarcity and price, inevitably help speed paintings and sculptures into museums and other public situations where they become available to the widest possible audience. Our tax laws make it sensible for the wealthy to give works of art to museums, and our social structure makes it attractive to be associated with a museum. These tax laws are a major factor in the rapidly increasing number of museums in the United States and in the continuing expansion of existing institutions. While works of art are sometimes bought cheap and sold dear, or are accumulated in the drive toward upward social mobility, there are also many collectors who love art, and are willing to share it with others.

We need not turn to ancient times to find knotty problems of precedence, dating, and sequence in art. The years 1948–1950 in New York provide them in abundance. Future historians will inherit the task of unraveling the intricacies of these years. What is clear is that Gorky and Pollock opened the way for a generation of abstract artists. Gorky pushed the European biomorphic tradition beyond the influence of Picasso, Miró, and Matta. Pollock's mastery of the controlled accident, his ability to project his style with both gesture and exactitude on a broad, all-over surface created a new level of expectation that served as an inspiration to the artists who followed. These steps in large part made it possible to shed the Surrealist pre-

conceptions of small format and multiple elements that were, before 1948, the hallmarks of American abstraction.

David Smith's career spanned three decades, from the Picasso-Gonzalez inspired thirties to the close relationship with the new American abstraction in the sixties, specifically with the work of Kenneth Noland. Smith subsumed and surpassed his sources, as did Gorky, to create a body of work that stands indisputably with the best sculpture of the modern period. The late and glorious "Cubi" and planar pieces in stainless steel, such as *Becca* and "Untitled," have buffered surfaces reminiscent of the activated plane of Pollock's all-over painting. The painted pieces of his last years (with endless changes of color in the attempt to get it "right") comment upon and learn from the color painting of the sixties.

His love of materials, the joy with which he contemplated and then extended their possibilities, shines through in his writing:

> Steel . . . can be stainless, painted, lacquered, waxed, processed and electroplated with molybdenum. It can be cast.
> Steel has mural possibilities which have never been used.
> It has high tensile strength, pinions can support masses, soft steel can bend cold, both with and across its grain, yet have a tensile stength of 30,000 lbs. to one square inch. It can be drawn, oupped, spun and forged. It can be cut and patterned by acetylene gas and oxygen and welded both electrically and by the acetylene oxygen process. It can be chiseled, ground, filed and polished. It can be welded, the seams ground down leaving no evidence. The welds can possess greater strength than the parent metal. It can be formed with various metals by welding, brazing and soldering. Metals fall naturally to my use and [are] useful to my concept.[6]

Language for Smith was another joyous material.

In the mid and late fifties it looked to many as if de Kooning would dominate painting for a significant time to come. A group of

[6]David Smith, *David Smith by David Smith: Sculpture and Writings*, ed. Cleve Gray (New York: Holt, Rinehart & Winston, 1968), p. 53.

small galleries sprang up on East Tenth Street devoted to artists later called Second Generation Abstract Expressionists; much of their work derived its impulse and borrowed some of its energy from de Kooning's manner in the mid-fifties, the wide, slashing abstractions that look tame and lovely now, but seemed raw and angry then. It was to artists such as Alfred Leslie, Michael Goldberg, Grace Hartigan, and Norman Bluhm that Sam Hunter referred when he wrote in 1958:

> There is no single figure who has exerted greater influence on
> American painting over the past decade [than de Kooning];
> he is directly responsible for the general physiognomy of
> much of the painting of the rising generation.[7]

While de Kooning's personal contribution has been great, the line he fathered, as it turns out, was not the fertile one. De Kooning himself retired from the scene to East Hampton to work almost exclusively on the "Women," a unifying theme in his work since the late thirties.

There was a richer vein to be explored in the implications suggested by the works of Newman, Rothko, Reinhardt, and Diller, which were to engage the cooler sensibilities of the younger abstractionists such as Stella, Judd, Morris, Poons, and Flavin. And in the late fifties another alternative to Abstract Expressionism emerged—first around the Reuben Gallery on the Lower East Side, then uptown at the Green Gallery, Castelli, and the Stable—the Happenings and the new painting and sculpture with recognizable subject matter derived from contemporary mass culture, which came to be known as Pop Art.

The imagery of Pop Art can be seen as the new American landscape. Landscape painting has always selected, idealized, and described man's environment. The subject of landscape has shifted from nature to urban life in the twentieth century, and Pop Art, in

[7]Sam Hunter, *The United States, Art Since 1945* (New York: Harry N. Abrams, 1958), p. 284.

its development since 1960, has used the close-up technique of film on the artifacts and data of contemporary communication, making billboards, comic strips, packaging, picture magazines, and advertising the legitimate subjects of an art that is peculiarly American and of our decade.

No movement in the history of American art was named and received more quickly. A year after it hit the galleries and magazines, I had an air conditioner installed in my apartment. An Andy Warhol painting of six Marilyn Monroes was leaning against a wall. "What's that, Pop Art?" the air-conditioner man asked. Can you imagine someone in a similar situation in 1950, asking of a Jackson Pollock, "What's that, Abstract Expressionism?" For one thing, Pop Art was literally named before it began (Lawrence Alloway coined the phrase for certain English painters in the late 1950s), while the art of Pollock, Kline, and de Kooning was called Action Painting, New York School Painting, and still other names before it settled down as Abstract Expressionism.

Pop Art was radical and came as a surprise, yet somehow the American public was responsive to it. This, of course, became clear only after the fact. Nobody could have predicted it. There were critics in the fifties crying for a return to the figure, for a "new humanism." What they were hoping for was something comfortable and recognizable, a resuscitation of the art of the past veiled in the flaying brushstrokes of Abstract Expressionism. When they got their new figuration, it was not the tortured humanism of the postnuclear world for which they were longing but an art based on billboards, comic strips, and advertising. These critics cried "foul," and they cried it hard and long. Adolph Gottlieb has written, "Certain people always say we should go back to nature. I notice they never say we should go forward to nature. It seems to me they are more concerned that we should go back, than about nature."

The situation in painting in New York in the late fifties offered the possibility of a return to representational art that would be both contemporary and meaningful. After two decades of tremendous energy and inventiveness in abstract painting, the reintroduction of

recognizable content (objects, landscape, and figure) appeared at first *retardataire* and beside the point. The best and most mature artists at the time had created personal and distinct abstract manners and images. These men left little room for the younger artist dissatisfied with the choice between the manner of a de Kooning and, let us say, Philip Guston.

Robert Rauschenberg pointed a way out of this dilemma by the mid-fifties by incorporating real objects in his work. Instead of representing a goat—that is, attempting to translate a goat into a two-dimensional painted image—Rauschenberg included the goat itself (stuffed, but only slightly less a goat for that). There was ample precedent for Rauschenberg's gesture, in kind if not in degree. His point of departure was collage, by then an eminently respectable Cubist technique, incorporating bits and pieces of reality such as newspaper and rope in works of art, a technique that Rauschenberg logically extended. Kurt Schwitters set the most specific precedent for Rauschenberg, as did Marcel Duchamp for Jasper Johns.

Younger than Rauschenberg, Jasper Johns forms with him the bridge between Abstract Expressionism and Pop Art. Rauschenberg incorporated real objects and photographs in his work, imbedded in a matrix of brushed and spilled paint that was clearly Abstract Expressionist. Johns created images of objects we know to be two-dimensional, flags, maps, numbers, and targets. The integrity of these objects in his work made it possible for the Pop artists to separate them from Johns's painterly style that was characteristic of the fifties. The Pop artists of the sixties (Warhol, Rosenquist, Oldenburg, Lichtenstein) seized upon the recognizable image and dropped the painterly style of the previous decade.

Just as Surrealism retreated from the almost frightening formal innovations and implications of Cubism (and its aftermath) to new subject matter (Freudianism and the interpretation of dreams), so Pop Art coming some fifteen years after another formal explosion, Abstract Expressionism, stepped back to legitimize another subject, the imagery of advertising and the mass media. Of course, there had been precursors in the history of art for both Surrealism

and Pop Art. In the case of Pop, Duchamp, Schwitters, Gerald Murphy, Léger, and Stuart Davis may be cited. But the exclusive concern with comic strips, billboards, television commercials, and newspaper advertising in the fine arts of painting and sculpture was new in American art in 1959 and 1960. Both Surrealism and Pop Art were, to some extent, respites from problems of form; both returned to representation, distorted and dreamlike in the case of Surrealism, outsized and commercial in Pop Art.

Pop Art is seen by some to be radically different from the post–Abstract Expressionist painting of the sixties by Noland, Stella, Kelly, and Frankenthaler. But art of any given period shares certain stylistic presuppositions no matter how varied it may seem in its time. The abstract painting of Olitski, Noland, and Frankenthaler and the Pop paintings of Lichtenstein, Warhol, and Rosenquist will come in time to look typical of the 1960s in New York. All have been concerned with the large canvas, the simple, flat, close-up image of the movie screen, all have used the new brilliant plastic colors. The aesthetic permission to project immense Pop images derives in part from these artists' awareness of the most advanced abstract art.

The tradition of American abstract painting and sculpture of the past three decades is still very much alive, both in the continuing work of the established masters and in the younger men who emerge every few years, making clear the ongoing vitality of abstract art. It seems today that Pop Art was an episode, an interesting one that has left its mark on the decade, and will continue to affect the future, but not a major modern movement which continues to spawn new artists. In fact, just about everything new and original in Pop Art was stated by a few artists in the first years of its existence. Since then no artists of first importance have been recruited and no second generation has come along. There is a strong possibility that the second generation of potential Pop artists has been fed directly into television and advertising, thus repaying art's debt to the media. Just as Surrealism continues to haunt Modernist art, cropping up as an influence in unexpected places, for example, New York

painting of the 1940s, so Pop Art may well find its converts and adherents in unexpected future corners and pockets of major art.

Donald Judd, Robert Morris, and Dan Flavin are both the leading theoreticians of Minimal Sculpture and its most accomplished practitioners. Tony Smith, an architect whose involvement with the New American Painting dates from the late forties (he was among the first to realize the implications in the work of both Pollock and Newman), brings a richer and longer experience to his sculpture, making it more resonant, and, conversely, less purely Minimal. This new sculpture of the sixties shares several of its presuppositions with the paintings of Burgoyne Diller, Ad Reinhardt, and Frank Stella; all chose to eliminate from their work the roughness of surface and eccentric evidences of personality they associated with previous art. The Minimal sculptors strive for anonymity of craftsmanship, a clear projection of simple formal relationships, and a suppression of "signature."

The Minimal sculptors prefer to use common industrial material and processes, much as the Pop artists use common images and commercial techniques. Aluminum, fiberglass, and sheets of colored transparent plastic are their typical materials, materials which are familiar enough, but not in the context of sculpture. Dan Flavin uses light, first incandescent, now fluorescent, to create memorable icons with a minimum of construction and a minimum of compositional effects characteristic of the movement. Minimal Sculpture relies, for the most part, on three-dimensional geometric forms such as the cube; it avoids figurative references—it never stands on two legs—it hangs from the wall, leans in a corner, or sits foursquare on the floor. While the Pop artists still most often do their own work, these new sculptors are not sentimental about the artist's hand or touch. In fact, many of their pieces are fabricated industrially. Minimal Sculpture is the most recent movement in American art with a coherent body of work and a sizable critical literature.

This has been a brief recapitulation of what I consider to be the importance of the New York School as seen both in this book and in

the exhibition it accompanies. We hope that by emphasizing aspects of the exhibiting history of the new American painting and sculpture in the past three decades we may call attention to New York's continuing responsibility to the arts that so enrich it. New York must provide an opportunity to see recent art in much the same way that Cubism and Surrealism are visible at The Museum of Modern Art. The achievement of the New York School merits such a permanent base. Rather than devoting an inordinate amount of time to an accelerated schedule of theme shows and retrospectives, museum directors and their staffs, when concentrating on modern art, might do better to expend their greatest efforts on providing gallery after gallery of important recent works by major artists so that our students, foreign and out-of-town visitors, New York's own passionate audience for art and, most importantly, practicing artists can always have before them a collection of challenging contemporary art of the highest quality and relevance. In this way we may hope to avoid the unfortunate situation of the past three decades in which the new art has not been consistently visible. This goal might be achieved through the cooperation of four museums, the Modern, Guggenheim, Whitney, and Metropolitan, or it might be the additive result of four separate but dovetailing programs. It is a goal eminently worth the best efforts of all concerned with New York art.

David Hockney

[1977]

David Hockney's art has been lively from the first because he has conducted his education in public with a charming and endearing innocence. The pictures are often distinctly autobiographical, confirming Hockney's place in the grand tradition of English eccentricity. He has at each stage given us touchingly curious indications of how he felt, what he knew, and whom he admired. The humor both disguises feeling and insists that it is too strong to reveal without being disguised.

Hockney has never been interested in the commissioned portrait. As he has become increasingly fascinated by exactly how things look and in finding ways to paint what he sees with greater veracity, he has turned quite naturally to drawing and painting his close friends again and again. They are his guitar, absinthe bottle, and journal, the objects of his affection.

Ivy Compton-Burnett in her novels minutely examines family relationships. She describes the wit, courage, and anguish of people who live under the same roof whether through choice or through force of circumstance. The surface crackles with brittle inconsequential conversation, but at the same time it heaves and swells with volcanic rumblings, the real, almost unmanageable feelings of need and rejection that characterize the intimacy she depicts. The work of David Hockney projects similar complexities.

Although in recent years the work has become more illusionistic, Hockney himself now has fewer illusions. The world and its people are still lovable and good; but the romantic haze has blown away. Hockney today sees the world more as it is, clearly and memorably. Earlier he saw what it might be. The tougher, less romantic attitude signifies maturity. The levity of the early work remains undaunted—as in the past, Hockney is uncanny in his ability to choose just the right moment for celebration—but there is an underlying acuteness of vision that is the product of a newly athleticized capacity for deliberation. As a result, the more recent paintings give the viewer as much as Hockney's work has always given, but they are greater in their demands.

David Hockney has been painting seriously, as a student and in the world, since 1960. Distinct caesuras can be pinpointed and a development can be described most easily in his striving toward clarity, which he has achieved largely through a deliberate limiting of means. Over the years this has amounted to a relinquishing of skills and devices which may always be called on again to solve a particular problem or create a special effect. Thus, each time he paints, by making a limited number of choices from an ever-increasing repertoire of means, Hockney produces art of great physical interest and variety. He might be described as an inspired, literate, and sophisticated primitive in that he borrows and experiments with techniques and styles whenever it suits him. He is not afraid of straying down a curious bypath if his interest so leads him. It is for this reason that the picturesque story-telling in Hockney's work is never undermined by exhausted technique, so often a limitation in the work of artists, both figurative and abstract, who are illustrators and little more.

Technical prowess has heightened the power and concentration of his paintings. At the same time he is able to delight in the discovery and use of techniques in a way that has rarely been seen since the generation of Picasso, Klee, Miró, and Hofmann.

Since 1964, and consistently since 1966, David Hockney has proclaimed a higher ambition in his work: to compete with the history of art rather than with members of his own generation. As a

younger man he borrowed or mimicked contemporary taste. Now
there are no more empty spaces, no fudging; the intervals must be
dealt with as convincingly as is the subject matter.

Increasingly in his work he is concerned with specificity, finding
the exact essence and how to clothe it. Samuel Johnson would have
approved: "I had rather see the portrait of a dog I know than all
the allegories you can show me." This was not always so with
David Hockney. A painting like *Flight into Italy—Swiss Landscape*
(1962) suggests that he was interested at the time in juxtaposing
many kinds of information on a flat surface: a mountain range in
rainbow-like stripes quoted from contemporary abstraction; the
clearly lettered sign "Paris" contrasted with the speedy blurring of
"thats Switzerland that was" (a reference to a Shell advertisement
then current) and the streaked figures in the van. The sky is un-
painted, while the mountains are brightly colored. At the bottom,
a passage of thick paint is mixed with sand.

Much, even most of Hockney's pre-1965 work can be character-
ized positively as charged with energy, or negatively as overloaded
with information and inconsistent stylistic devices. Therein, given
either characterization, lies its immaturity and its charm. It is fruit-
less to accuse the early work of not being later. What surprises is
how much the early work bears scrutiny, how well it stands up in its
inconsistencies. A presence, a sureness, a wit keep these paintings
from going too far toward private and obscure reference, keep the
excesses of stylistic diversity in hand, just in hand in some cases.

Some of the excitement we still feel in this early work can be
traced to the variety of influences Hockney was open to. In *Sam
Who Walked Alone by Night* (1961), which was suggested by a story
about a boy who occasionally wore dresses, we find references to
Dubuffet: in the flattening of the head and upper body and in their
simplification; in the same painting the articulation of the head, its
necklessness, reminds us of the then much praised English sculp-
tors Reg Butler, Kenneth Armitage, and Lynn Chadwick. (As with
so much overpraised art, English sculpture of the 1950s is now
somewhat maligned—the truth lies somewhere in between.) The
canvas is shaped, in two parts, the body wider than the head. It is

one of several paintings of these years in which Hockney played with the rectangle, altering its shape for reasons of economy, humor, and expressiveness.

Francis Bacon too is present here. He was very much on Hockney's mind as a figurative artist who in an age dominated by abstraction continued to invent fresh and powerful personages with vigorous brushwork and varied paint quality. Bacon was in London, his habits and life-style topics of conversation and, most importantly, his paintings were often on view at the Hanover Gallery and at the Tate. As David Hockney was early committed to maintaining the human figure as the fittest subject for a painter, his admiration of England's best figurative artist was natural. He took what he wanted from Bacon when he needed it in certain passages of certain paintings; the body of the figure in *The Cha-Cha that was Danced in the Early Hours of 24th March* (1961), or the way the paint is laid down in his interpretation of Ford Maddox Brown's famous Victorian standby, *The Last of England*, which became *The Last of England?* (1961). In the Hockney version the man and woman of Brown's painting have become two boys. The composition is close enough to the Pre-Raphaelite picture to be easily associated with it. The great difference lies in the contrast between the millimetric literalness of Brown's painting and the slipped, fudged expressiveness of David Hockney's. Francis Bacon has stepped between. Bacon was so important, so was Larry Rivers, so was Dubuffet, so were the Abstract Expressionists. As with all brilliant students everything was new, potentially delicious, and had to be tasted.

Willem de Kooning, a Dutchman who came to America in his mid-twenties in 1926, brought a lively intelligence to the New York School in his portraits during the early 1940s and, famously and definitely, in *The Women*, his great series of paintings begun in 1949–1950 that advanced Cubist techniques of representing the human figure. By the time Hockney entered the Royal College of Art in London in 1960, de Kooning's brand of abstraction was what fascinated most of his more adventurous fellow students.

But abstraction aped from art magazine illustrations and half-digested influences of New York painting did not hold Hockney

long. He had a very traditional training at the Bradford School of Art from 1953 to 1957. Then, during a two-year break, working in hospitals in Bradford and Hastings to discharge his military service obligation as a conscientious objector, the empty routine had driven him deep into reading. Traces of Abstract Expressionism appeared in his work in the early sixties, but Hockney's attention was more devoted to finding a way to meld his literary loves with his need to depict figures and their relationships. It was at this point that he began to become himself, to discover his subject and to grope toward his technique.

At the Royal College he soon discovered another, older student with similar interests, the American R. B. Kitaj, who was studying at the College under the United States Government's G. I. Bill of Rights which paid tuition for the higher education of former servicemen. Like Hockney, Ron Kitaj was interested in painting the figure and in literature. They soon discovered another mutual passion, political idealism. It was Ron Kitaj, a bit older and more experienced, who first suggested to Hockney that he paint what most interested him, literature, politics, and people and their relationships.

What Hockney needed at the time was a way in which to introduce his subjects into art, a device that had been legitimized but not used up. It was several months before he dared to swim so forcibly against the stream as to use recognizable human elements. Instead he introduced lettering and words into his abstract compositions. A witty indication of Hockney's dilemma is a small painting of 1960 called *Little Head* in which the figure is the usual circular form topping a vertical rectangle with rounded corners. There is a reference here to the sculpture of William Turnbull, sculpture which is to turn up again on the lawns of Hockney's California-collector paintings half a decade later. The clearest indication that we are confronted with a figure, beyond the juxtaposition of these head-like and body-like forms, is in the quite literal semi-colon that sets the features in the face. Hockney was playing with the necessity to make his message literal by using typography figuratively, a literary playfulness he shares with another Yorkshireman, Laurence Sterne,

whose *Tristram Shandy* with its black and missing pages so amused him when he came across them a decade later.

In *Witch Riding on a Cloud* (1960), a bit earlier, several devices are introduced or rather overlaid on what was at first an abstraction: a large letter E, a graffiti-inspired outline figure that recalls both cave painting and Egypt, and the lower-case word *witches*. To Hockney the painting seemed lacking in content without these additions. Blues, mauves, reds, and grays billowing about the canvas simply did not suffice.

Words in paintings have a long history. One can go almost as far back as one wants; hieroglyphics in Egyptian wall paintings, names on Greek vases, holy and botanical words in medieval manuscript illuminations, scriptural quotations in countless Renaissance paintings, and in our century, more prominently, the lettering used to such great effect in Cubism to identify objects and to locate the picture plane. All this Hockney knew, some specifically, some vaguely. The most recent example of an imaginative use of lettering in figurative painting was in the work of the American Larry Rivers.

The Third Love Painting (1960) would be a rather standard Abstract-Expressionist painting were it not for the form looming toward figuration at the bottom right of the canvas and were it not for the placing and the content of the writing, a combination of quotations from Walt Whitman and from graffiti on the walls of the men's room in the Earls Court Underground station, a contrast between the dignified and sublimated love of the male with its lowest and most urgent counterpart. The Whitman lines quoted most extensively in this painting are the lovely closing ones from "When I Heard at the Close of the Day." The poem begins:

> When I heard at the close of the day how my name had been
> receiv'd with plaudits in the capitol, still it was not a happy
> night for me that follow'd.

The poet then finds his joy and ease not in national praise but in private companionship. The lines printed on the lower left of the canvas are the last of the poem:

For the one I love most lay sleeping by me under the same
 cover in the cool night,
In the stillness in the autumn moonbeams his face was
 inclined toward me,
And his arm lay lightly round my breast—and that night
 I was happy.

This on a canvas "ring me anytime at home" and "come on david admit it" and ruder matter as well.

At the same time Hockney was doing his first etching, *Myself and My Heroes*, Walt Whitman, Mahatma Gandhi, and a self-portrait. Whitman's attraction was as a vernacular poet of wide sympathies and lovely music; Gandhi's was as a pacifist and anti-imperialist. Hockney also admired Gandhi's vegetarianism; his mother had brought him up not to eat meat and his father not to smoke. (He now does both.) The self-portrait in this etching, a rather rare subject in Hockney's work, is the familiar figure of those years, the stone-like head sitting on a cut-off rectangle with rounded shoulders, this time wearing a little cap. His self-portrait in words is as modest, in the face of his heroes, as is his little cap: "I am 23 years old and wear glasses." He used a related image of himself in his first popular and critical success, the sequence of sixteen etchings, A *Rake's Progress* (1961–1963). These are the only self-portraits in his mature work until the recent etching, *The Student: Homage to Picasso*, myself and another hero, as it were, and more recently his image in the mirror at the center of his *My Parents and Myself* (1975).

Portraiture has been a concern of Hockney's from the beginning. The most complex of the early paintings and perhaps also the most successful is *Play within a Play* 1963, a playful portrait of Hockney's first dealer, John Kasmin, that takes several of its devices from a recently acquired and vastly admired painting by Domenichino in London's National Gallery. Kasmin's features are distorted because his face and hands are pressed against a piece of clear plastic, a "modern" touch that wittily emphasized the primacy of the picture plane.

Portraits of two people occur more frequently than single figures; more than two are never dealt with except in A *Grand Procession of Dignitaries in the Semi-Egyptian Style* (1961). This may well represent a revulsion on Hockney's part against his Bradford Art School training which insisted that an "interesting" composition must deal with at least three figures. It is in the drawings that the simple portrait of the single figure predominates. Despite the careful rendering of Hockney's drawings of the past five years, drawing for him is still to a large extent a form of note-taking. It represents time spent vis-à-vis someone he doesn't know but finds attractive, is getting to know, or knows so well that the likeness is no challenge. It is in these latter drawings, when he is observing close friends yet again after years of studying them, that the work is most masterful, relaxed, and ambitious. Limning the likeness can be a strain. When the likeness is available through familiarity he can concentrate on the *mise en page*, focusing our attention on a shirt or a chair, and eliminating what he feels to be nonessential: a wall, the floor, everything in the room that isn't the sitter or a minimal compositional element.

There is a moment, which can be pinpointed, when Hockney's drawings became consistently more concise and informative, more concerned with giving precise information. In September 1963, the London *Sunday Times* sent him to Egypt to do a series of drawings which in the end they did not use. They are among his best drawings up to that time. *Shell Garage—Egypt* is the most elaborate of the series; *Yoghurt Salesman Walking Home, Luxor*, the most charming, with its easy contrast of the flowing Arab robe and the determined set of the carefully rendered head, the boy's yoghurt box balanced firmly in place. Before this time most of the drawings were preparatory to specific paintings, or quick notes to himself. In this Egyptian sequence each drawing was an end in itself, the artist as a sharply observant tourist collecting information for the benefit of the Home Counties—the Englishman abroad. Like Edward Lear or Graham Greene, he displays an affectionate yet wryly ironic view of the exotic.

David Hockney does two kinds of drawings, line drawings in

black ink, usually with a rapidograph pen, and colored pencil drawings. In the line drawings he has always observed supremely well; lately he has set himself more difficult problems in them, placing the sitter in more complicated poses, giving more information and detail in the faces, hands, and clothing. He also does superb drawings using colored pencils in which he masses and blocks color; the line is there, of course, to bound a form, to set a perimeter, but the outlook is basically painterly. Indeed one might say, somewhat simplistically, that while the line drawings relate primarily to the prints, the colored drawings reveal his painter's mind. The colored drawings are most often done as ends in themselves, friends, landscapes, compositional ideas. They amount to a substantial body of work.

The movement in Hockney's art toward greater precision and closer observation can now be seen as an ineluctable process. We have already seen how he threw up a smoke screen of expressionist devices in the earliest work, 1960–1963. In 1964 and 1965 he composed many fanciful still lifes, interiors, and landscapes in which the use of chiaroscuro and local color began to give the work a modeled look. The forms might be painted simply and flatly with emphatic shadows (as in *English Garden* [1965]) or they might be conscientiously rounded, from dark above to light below, as in the waves of *Atlantic Crossing* (1965), and in the fully rounded biomorphic clouds that could have been lifted whole from Jean Arp by transposing two sculptures into paint and exaggerating their highlights. There are many more paintings of the period that share this mood and employ these devices; the mood can be characterized as theatrical and the devices, illustrative. The earliest painting worked fully in this manner is *Iowa* (1964), painted there when Hockney was teaching at the University. A clutter in the clouds indicates that he has not yet mastered the style; but the painting has the charm of its deliberate simplification, as do all these paintings, the charm of paring down to essentials before leaping into terra incognita. Looking back one can now see this new manner adumbrated as a peep at stage scenery through the curtains of *Closing Scene* (1963). Many of these paintings were "staged," deliberate problems; *Blue Interior*

and Two Still Lifes (1965) is a typical abstract invention of this moment. A fully rendered couch and a wide chair surround two sides of a legless table with three cylinders set on its surface; three vertical forms of unexplained purpose echo the cylinders in a space beyond the grouping; the furniture sits on a simple-minded rug, and the whole painting is surrounded by continuous finger-flames of pink and blue that form a frame within the rectangle of the painting—the whole an invention—a scene that never was on sea or land.

In the early months of 1966, before he left in June for Los Angeles where he was to stay a year, Hockney was busy with projects unrelated to painting. He designed a witty production of Alfred Jarry's *Ubu Roi* for the Royal Court Theatre, the drawings for which survive. In one of these, "Ubu Collecting Taxes from Peasants," he invents architecture for the stage that harks back to his first California paintings, *Wilshire Boulevard, Los Angeles* (1964), and *Building, Pershing Square, Los Angeles* (1964), and points forward to the *French Shop* (1971). In another he represents the "Polish Army" as two soldiers, one with a cockaded paper pyramid for a hat, the other with a cockaded paper rock, bound together with a paper bandage tied behind the second soldier. During these same months he illustrated the book of Nehemiah for a modern illustrated Bible commissioned by the Oxford University Press, with eight line drawings, which hint at Assyria and which picture elliptically the rebuilding of Jerusalem. The third project of early 1966 was the illustration of some of Hockney's favorite poems by the earlier twentieth-century Greek Alexandrian C. P. Cavafy, introduced to the English-speaking public by E. M. Forster. Hockney's interest was long-standing. Two of his first etchings, both of 1961, *Kaisarion with all his Beauty* and *Mirror, Mirror, on the Wall*, were inspired by Cavafy poems. Nine of the thirteen Cavafy etchings in the book, *Illustrations for Fourteen Poems from C. P. Cavafy*, picture two boys. They are seen in bed, in a living room, in front of a shop. The figures are drawn with great simplicity and tenderness, never explicitly erotic but with the shy awkwardness of casual contact. Sometimes they illustrate specific poems, as in "He Enquired After the Quality"; more often they picture a relationship, most touchingly in "Accord-

ing to the Prescriptions of Ancient Magicians." The sources of these illustrations were drawings and photographs of Beirut, visited in January 1966, photos from physique magazines, and drawings of friends.

Through all these years, 1960–1966, one senses that Hockney was competing with recent art and with his own generation, that he felt his pictures must somehow look "modern," experimental, and fanciful. The paintings of these years don't strain toward these effects; they were arrived at intuitively by an artist of limited ambition who thought allegorically and with verve; an artist who took his cues from what he had observed and embroidered fancifully on his sources: magazine illustrations, the life of the studio, and often earlier art, an Egyptian head, a Muybridge photograph. Whatever fed his imagination became a fit and sufficient trigger. During these years he traveled extensively in Europe, Egypt, and America, always with the devouring hunger and curiosity which mark his intellect and shape his taste. He visited museums, saw new kinds of architecture bathed in a flatter and less shadowed light, and realized increasingly the wonder and appeal of a world beyond Bradford, beyond London, beyond England, and finally beyond Europe. He also began slowly to realize, with increasing rigor of thought, that it was not only the art of the 1960s that fascinated him, but the art of the past, the best art of the Western tradition. At this point he stopped striving for originality; if one painted in the 1960s one was necessarily an artist of one's moment—one did not have to put that part in, so to speak.

Hockney's work since the middle sixties has been increasingly concerned with frontality, facing the subject and viewing it closely and stereoscopically, with the stillness of Byzantine Art, and the Surrealist sense of time out of time; simultaneously the pictures are an accretion of time, layer on layer, from conception to completion, often the result of months of thought and effort; painting and repainting, correcting perspective and adjusting color. One of the accomplishments of these paintings is the impacted time we apprehend. The image is available at first sight and retains a timeless quality. But the picture continues to unfold as it becomes apparent

that the craftsmanship is one of the vehicles through which the story is told.

In the past several years much attention has been concentrated on a group of American realist painters who depend on photography to a large extent for their finely detailed and accurately rendered representations of storefronts, cars, gas stations, modern entrance lobbies, etc. Richard Estes is the best known and most accomplished of these super-realists. Exhibitions and catalogues have been devoted to them in Germany and Italy and, by now, probably in Japan as well. There are many differences between the style they have adopted and what David Hockney is after; the most apparent is their lack of an ironic sense. The super-realists often confront us with a tense stillness, a frozen moment suggestive of the horror of paranoia or a waking dream. Once they have a photograph or transparency to work from their attitude seems to be that to describe is all. Hockney still judges and loves like an old humanist. One also realizes, looking at their work after some familiarity with Hockney's, that with the exception of Estes they have left accreted time out of their world. The time in most super-realist painting is the time of the still photograph that is its source, rather than the considerable time that it took to paint it. And yet it is the latter time, many hours of exhausting mental concentration, that forces itself upon the viewer—to the detriment of what one enjoys of the split-second imagery. Just as Hockney was not a Pop artist in the early sixties, though he shared some of their presuppositions, he is not a super-realist in the seventies.

There are as many kinds of "realism" as there are realist artists, or as there are individual styles within abstraction. If there weren't this natural variety, there might be a correct way to represent reality in paintings, an academic realism to meet every occasion. This cannot be. There is no such thing as a universally realistic painting; all attempts at recreating reality on canvas depend on decisions of inclusion and exclusion. It is these decisions that separate artists and the "realistic" painting of different eras.

Hockney's later manner was developed away from London and New York, during his several trips across America. He first visited

America in 1961; on that trip he saw only New York. It was on subsequent visits, when he was invited to teach in the Midwest and California, that an affection for the deadpan coolness of America clutched his heart. It was an America he was predisposed to like through his familiarity with American physique magazines, mostly produced in Los Angeles and San Francisco. Nikolaus Pevsner, in his *Englishness of English Art*, speaks of the detachment, reticence, and taciturnity of English portraiture, and goes on to say, "The English portrait conceals more than it reveals, and what it reveals it reveals with studied understatement." He then quotes Jane Austen, who in *Emma* says of "the English style" that it is achieved "by burying under a calmness that seems all but indifference, the real attachment." These are descriptions that capture the arm's-distance involvement of Hockney's love affair with America, particularly California, its swimming pools, swimmers, and architecture, its art collectors, sprinkled lawns, and blank allure.

In 1964 Hockney taught at the University of Iowa, in 1965 at the University of Colorado, in 1966 at the University of California in Los Angeles and the University of California at Irvine (in Orange County, south of Los Angeles), and finally, in 1967, at the University of California at Berkeley. Then, as he says, "I retire." He retired from teaching, but not from visiting America, most particularly California, a continuing if lessening fascination. While at the University of Colorado he did a number of paintings, one of which, *Man Taking Shower* (1965), points forward and back in his work, forward in the treatment of the nude man outlined against the tiles of the shower stall, with falling water, whose depiction forms a new and persistent interest; back, in the multiple focus of the composition, the bed and chairs rendered small in the distance, while in the foreground a rather abstracted plant with four dark green leaves lies flat to establish the picture plane. The man's body is painted more carefully, built up more convincingly, than in the earlier, expressionist *Domestic Scene, Los Angeles* (1963), painted before he went to California with the aid of imagination, a physique magazine, and mother wit. The composition of *Man Taking Shower* (1965) is flatter, more frontal, than an earlier representation of a similar

scene, *Man Taking Shower in Beverly Hills* (1964), in which the figure is still somewhat generalized, and the compositional device of the carpet cutting the bottom of the painting diagonally is still more involved with picture-making than with picturing. On the other hand *Man Taking Shower* (1965) retains expressionist elements and is itself *retardataire* in Hockney's development when compared to the painting of the following year, *Peter Getting Out of Nick's Pool* (1966), with which he hits his California manner in full stride.

The California manner is at its height, clearest, cleanest, and least complex in the two years 1966 and 1967. It is characterized by a coolness of vision and execution, a flattened, virtually shadowless transcription of architecture, pools, lawns, boys, and collectors. It is a catalogue of the Los Angeles art world in which Hockney spent his California years that will stand for the period much as Evelyn Waugh's *Loved One* stands for the earlier Los Angeles of Forest Lawn and other excesses. There are sensual intellectual Englishmen for whom Southern California has been a more sympathetic Riviera, a warm and modern escape from the vagaries of English class and weather: Aldous Huxley, Christopher Isherwood, and David Hockney. The paintings of these years were his best to date and there is one good one after another: *Beverly Hills Housewife, Portrait of Nick Wilder, Savings and Loan Building, A Lawn Sprinkler, A Neat Lawn* and, perhaps best of all, *A Bigger Splash*. All are detached and crystalline, all breathe a clarity of light, perception, and realized intention that mark Hockney's new and greater ambition to paint the world of today dead-on, as he saw it, with no concessions to modernism except those that were the built-in presuppositions shared by most of the painters at work in the 1960s.

The intellectual preoccupations of these paintings are simple to state: how to apply academic training in perspective, foreshortening, rendering, and composition to a new subject matter in such a way as to capture it on a surface that continues to look absolutely flat. There is nothing random about the choice of subjects or about his angle of vision. Hockney chooses to stand at the center of the picture, to plant himself firmly, and to look through both eyes, stereoscopically, rather than through the cyclopean viewpoint of the

camera and its photograph. The camera can help to fix the subject in his mind, to cue for color and for formal relationships; it cannot substitute for feeling or for thought. Its decisions are too mechanical. An earlier English painter, Walter Sickert, wrote in *The English Review* in January 1912: "The camera, like alcohol . . . may be an occasional servant to a draughtsman, which only he may use who can do without it. And further, the healthier the man is as a draughtsman, the more inclined will he be to do without it altogether." Hockney usually uses his camera in the way Sickert describes as a form of note-taking, most often when he is traveling. Some fifty leatherbound books of photographs in his library testify to an abiding interest. They cover the past ten years with increasing persistence and detail. Occasionally a photograph leads to a painting, for example *Three Chairs with a Section of a Picasso Mural* (1970) and *Beach Umbrella* (1971); but almost invariably the painting was already taking shape in his mind before and as he took the photograph. And, as comparisons between specific photographs and their subsequent related painting indicate, an artist has intervened. But this, the standard apology for painting based largely on photographs, is hardly necessary when one considers that just as photography may be used in the service of painting, the reverse is also possible. For example, Charles Sheeler, the American precisionist whom David Hockney greatly admires, might well be described in his middle years as a photographer who turned to oil and canvas in order to overcome the limitations of print-making by which all photography is bound, and in particular the severe limitations of color photographic printing in the current state of the art. Although Hockney is only occasionally a painter in the service of his photography, like Sheeler's his interests are aesthetically coherent. His best photographs and the several paintings he has based on them are as precisely and crisply personal as are his prints, drawings, and paintings observed directly from life.

Hockney's photo albums reveal his romanticism and sentimentality about people and places. His friends are photographed again and again, in new settings, in new clothes, with new partners. If art and life can be separated for a moment to allow for the making of a

point, they refer more to Hockney's life than to his art. As he says, he takes holiday snaps all the year round.

There is a technical fascination that runs through these California paintings of 1966–1967: how to render water and reflections on glass. While these are not absolutely new concerns in his art (water falls and splashes rather unconvincingly in *Man Taking Shower in Beverly Hills* [1964] and still water is somewhat crudely depicted in *Picture of a Hollywood Swimming Pool* [1964], and in *Two Boys in a Pool, Hollywood* [1965]), they typify the work of these two years as much as do the constant blue sky and the simple rectilinear architecture. In *Peter Getting Out of Nick's Pool*, the play of light on the water, suggested by curving, interweaving lines, is abstract but understandable, the bright orthogonals indicating light falling harshly on the glass. In *Portrait of Nick Wilder* the window glass is transparent, revealing curtains behind, and the water is less continuously interwoven. We see rather the shapes of jigsaw and camouflage.

One thing is abundantly clear from even a cursory look at these paintings. When there is a figure in them, no matter what the relation of its size may be to the total canvas, it is the figure that controls the content of the painting. *Peter Getting Out of Nick's Pool* is conceived in a series of horizontal bands: the roof, the wall with sliding glass doors, and the pool itself—only Peter emerges as a vertical element and thus very much the subject of the painting. In *Portrait of Nick Wilder*, the Los Angeles art dealer is shown in the same pool with the same building behind him but this time the horizontals are suppressed. We find him demurely emerging, cut off and stylized like a Roman bust at the far end of a flatly curving pool, cooly green and blue, reminiscent of a Mediterranean grotto. In both pictures the setting may dominate visually, but the fact that Hockney has chosen to depict a figure in a setting, and he only depicts his friends, spices these paintings with a second personality.

In *A Bigger Splash* (1967) the figure has submerged and, as Charles Harrison wrote in *Studio International* (January 1968), "will never surface in this world." Looking at this painting we are somehow not concerned with the absence of the figure, obviously present an instant ago. The subject of the painting is the explosive

wetness of the splash in contrast to the warm and fragrant stillness of the setting, no longer depicted with the expressionism of the earlier paintings, but frozen in place between the thrust of the diving board and the inevitable Southern California building in the background. The water is painted from a photograph Hockney found in a technical book on swimming pools, the building from a drawing he had recently made. The result has the charm of a nineteenth-century French academic painting in which the figure (the water in *A Bigger Splash*) is painted in the studio and integrated into a landscape that has been observed on the artist's travels, perhaps in North Africa. It is this staginess that accounts for the painting's success. It is obviously contrived. Yet it works perfectly, a moment of stilled excitement in an over-manicured world.

Hockney's most ambitious California paintings are two that combine so many problems it is difficult to think of them otherwise than as deliberately complex, the hurdle set high by the artist to prove what he can do, first to himself, then to his audience. In the heyday of the Salon, in Paris in the latter half of the nineteenth century, paintings like *Beverly Hills Housewife* (1966–1967) and *American Collectors (Fred and Marcia Weisman)* (1968) might have been considered "machines," impressively large paintings grandly conceived to show the artist's strength. In both, leading Los Angeles collectors are shown in the setting of their glass-walled, flash and angle houses; what one notices and remembers are the unending light-struck sheets of glass and the relentlessly rectangular architecture. These impressions are somewhat softened and yet perversely reinforced by the contrasting of animal skins, vegetation, and recognizable art by recognized artists. The *Beverly Hills Housewife* has a zebra-covered Corbusier lounge chair and a moosehead on the wall; these represent the presence and interests of her absent husband; the little palm tree at stage front right sets the scene and hits off nicely the William Turnbull sculpture. Diagonals of light on the glass wall are treated as they were in an earlier California painting of the same year, *Peter Getting Out of Nick's Pool*. The painting is all of a piece, cool and distant and amused. The housewife's head is recognizably her own and yet its individuality is deliberately

downplayed; like her house and her objects she exists in a windless clarity emphasized by her frozen stance, wooden dress and three-quarters profile, Egyptian and expressionless. The painting is so stabilized that it is only with the work of the next few years in mind that we look back on it as a moment of stasis, that could have led to emptiness if repeated.

David Hockney seems to have sensed the dangers of depending in his portraits on an endless blankness of attitude. In *American Collectors* (1968), *Christopher Isherwood and Don Bachardy* (1968), and *Henry Geldzahler and Christopher Scott* (1969), a greater ambition is realized and a new series of qualities appears in the portraits: a heightening sense of individual character, an increased concern with modeling and rendering the features, and a more subtle feeling for the interreactions that mark domestic life. The stance of the woman in *American Collectors* echoes the distorted mouth of the Northwest Coast totem at the right. The feeling of aridity in the picture is heightened by the segregation of the grass and tree to the extreme left and right of the painting. She looks at us, he stands stiffly sideways seeing something outside of our field of vision. Although this double portrait was not commissioned, the Weismans owned the painting for several years, but it was soon stored away, on loan to the Pasadena Museum of Art, and is now in Germany. The Weismann were not flattered by it.

The only commissioned painting David Hockney has done is of Sir David Webster, then retiring as General Administrator at Covent Garden. Hockney loves opera. He takes every opportunity of seeing familiar and unfamiliar ones in London and while traveling. He often plays opera on the phonograph in his studio, and in his car he plays opera tapes on any long or short journey. During the opening scene of a *Tosca* at Covent Garden he once turned to a friend and said of Cavaradossi, the neo-classic painter-hero, who in the first act steps down from his mural to sing an aria, "He's just like me, he paints for a while, then he listens to opera." Fortunately, Hockney came to know and like Sir David and the portrait is sympathetic in tone if a bit cool in color: lavenders, blues, and greens for the floor, wall, and table, red the tulips and reddish the face, face and

tulips rendered with equal care. Sir David sits on a Marcel Breuer chair borrowed from Hockney's studio, placed several feet from the glass table that dominates the living room; the flowers are Hockney's favorites.

Soon after painting *Portrait of Sir David Webster* in 1971 Hockney included the whole glass table in the elaborate and somewhat ominous *Still Life on a Glass Table*. The right side of the *Still Life* is the left half of Sir David Webster's portrait. When we see them together Sir David looks lucky to have gotten into his portrait. *Still Life on a Glass Table* has the emotional energy of a portrait. All the objects on it are things the artist lives with, vases, lamp, and ashtray, charged with familiarity and associations; yet there is a poignancy in their separateness. They do not so much interweave as declare their identities. A bit of thunder in the shadow under the table belies the decorum of the objects. *Still Life on a Glass Table* is as autobiographical as the late paintings are permitted to get.

The greater richness of the paintings since 1968 reflects the care and time that have gone into them. Hockney's work was never casually worked out or negligently arrived at. But in recent years he has moved away from the flattened, modernist space and composition of the California pool and splash paintings of the mid-sixties to a deeper, more traditional manner of rendering space, furniture, and people; he has set himself more ambitious problems. He is still a modern artist; he is working today; but many of the modernisms have dropped from his art. In the portrait of *Christopher Isherwood and Don Bachardy* (1968), begun in California and finished in London, clearly defined zones are set, one behind the other, emphasizing depth. The change at this point in Hockney's conception of painting is made apparent by comparing this double portrait with *Peter Getting Out of Nick's Pool* (1966), in which the various compositional bands read one above rather than behind the other. In *Christopher Isherwood and Don Bachardy* the table, heavy with books and weighted with fruit and their attendant accentuated shadows, is radically foreshortened to lead the eye between and beyond the figures which themselves sit comfortably ensconced and established in their own zone, the middle one, seen both from top

to bottom and from front to back. Don Bachardy looks at us, while Christopher Isherwood, respecting the new spatial development in Hockney's work, keeps his eyes and his glance in their proper zone. The solid three-dimensionality of their wicker armchairs reinforces the spatial complexity of the painting. The figures sit deeply and comfortably in their chairs, with shadowed shirts and trousers, and are themselves shadowed on the cubes in which they sit. The greatest detail in the painting is, naturally enough, in the faces. The books, the fruit, Christopher's trousers are still rendered somewhat tubistically. The perspective is exaggerated slightly to make a point. The wall behind them lies flat, but we are allowed an escape from the rigorous composition into the window seat at the right, a shallow escape but a subtle one for it helps move the eye to the right, as Christopher's glance at Don moves it to the left.

It is in the portrait of *Henry Geldzahler and Christopher Scott* (1969) that Hockney concentrates for the first time with great care on the accuracy of one-point perspective. He came to New York in late 1968 to make drawings and take photographs for the painting. He didn't paint exactly what he saw. The view out of the window in the painting is the view from another room in the apartment. The couch at the time was in sad condition (it hadn't been recovered since it was made in the mid-thirties). Hockney replaced its spots and tears with an imagined pale mauve satin; he also improved and regularized the parquet floor in the service of perspective. The lamp was there; the table with its diagonal reflections and the vase with tulips were London afterthoughts. They establish a foreground as the view out the window establishes the distance. Thus the couch and its person sit firmly in the weighted and positioned center of the composition. Kynaston McShine has called the painting an Annunciation. The figure of Henry Geldzahler is painted with greater verisimilitude than that of Christopher Scott; Hockney knows him better. He sees Chris as coming and going, at attention in a quasi-military raincoat, wooden and enigmatic. The parquet floor and the glass table lead inexorably to the vanishing point above the central figure's head. The triangularity is further emphasized by the overall diamond shape of Henry Geldzahler, which is dropped

from the vanishing point in such a way as to flatten the picture and return the viewer to the surface. For all its clarity of composition and detail this painting remains somewhat inscrutable. A story is being told, but once again, true to English tradition, it is beneath the surface. Hockney's painting has developed greater resonance. The poetry is less explicit and we are therefore slower to grasp it. This accounts for the greater staying power of these paintings. We see them, remember them, and see more on subsequent viewings.

Hockney's attitude toward abstract art has always been one of the reluctant admirer. He sees it as a bit empty and argues that most abstractionists repeat themselves unthinkingly. He believes that poetry and the recognizable are inextricably linked; and yet abstraction exerts a continuing fascination for him. It stands as one pole in his thinking, an attitude of mind alien to his own with which he refreshes himself periodically. As we have seen, the paintings of this first year at the Royal College of Art, 1960–1961, were increasingly successful attempts at climbing out of the molasses of art school Abstract Expressionism. He soon found his way to the keen observation of the world, the lovingly amused attitude that sits so naturally with him. It took some years for all traces of the early expressionism to fall from his work. As early as 1961 he was using shaped canvases for reasons of expression and wit. A few of these are *Tea Painting in an Illusionistic Style, Figure in a Flat Style,* and *Hotel* (all 1961); and *The Second Marriage* (1963). By 1965–1966 he was painting clean and fresh pictures that had little to do with abstraction but everything to do with the modernist principles enunciated by abstract artists and theorists; a painting is two-dimensional and its flatness must be respected or honesty and virtue are lost. It is only in the years since 1968 that Hockney has moved forward in his own thinking and back into tradition by introducing accurate perspective, trompe l'oeil, and illusionistic space into much of his work. At the same time he has been playing with increasing fluency and contrast with the manipulation of paint and its varied textures within single paintings, for example *Beach Umbrella* (1971).

Hockney's continuing interest in aspects of abstraction can be seen in isolation in certain paintings: *Two Stains on a Room on a*

Canvas (1967), in which both American stain painting (Morris Louis, Helen Frankenthaler, Friedel Dzubas) and reductionist sculpture are cited, mocked, and incorporated; and *Rubber Ring Floating in a Swimming Pool* (1971), in which the arrangement on the canvas reads two ways, as the depiction of the scene proclaimed in the title, and as a compositional comment on the work of such contemporary abstract painters as Kenneth Noland, Jules Olitski, and Edward Avedisian.

In two other paintings, *Cubistic Sculpture with Shadow* (1971) and *Mount Fuji* (1972), the borrowed or quoted stain is used in the service of heightened illusion. The shadow in the painting of the Gonzalez sculpture is strong in contrast and thin in application, hitting off the distinction between the carefully invented arbitrariness of the sculpture and the more casual, accidental arbitrariness of the shadow. In *Mount Fuji*, an amalgam of a postcard of Mount Fuji and a photograph in a Japanese manual on flower arrangement, the flowers and the bamboo vase are painted with a hard and snappy verisimilitude. They seem graspable, in relief, even from several feet away. This tactile quality is reinforced by the blue stained canvas that areas so convincingly as a mountain in the distance in the context of this painting. Seen alone, without the flowers or the title, in progress in the studio, there was nothing to differentiate the blue stain from the work of any of a dozen contemporaries; it lay flatly on the canvas with only the shallow space lent by the subtle veils of density that characterize acrylic paint used as a stain on unprimed canvas. The completed painting, one of Hockney's best, always hits one forcefully as a single unified image, the flowers and mountain comprehended in a glance. No amount of intellectualization, no separation of its components into hard and soft, near and far, "real" and misty, destroys the unity for long. The painting willfully snaps back into its own focus.

There is a strain in Hockney's work which runs counter to and complements his love of the Mediterranean and Southern California. He refers to it as his fondness for "Gothic gloom." Hockney's personality and his art are wide and varied enough to comprehend the two propensities and even to fuse them. We see the "Gothic

gloom" at its purest in certain of the etchings illustrating *Grimm's Fairy Tales*, a project that absorbed him during 1969. He produced a superb sequence of thirty-nine etchings illustrating six tales he chose from among three hundred in the canon. While one can hardly characterize the bulk of these illustrations as either Gothic or gloomy—there are many references to sunny climes and happy days—a Wagnerian mood of dark tones and thumpings below the surface can be described in "the haunted castle" and in the ominous "Cold water about to hit the Prince." Wagnerian also, in this most sustained of Hockney's print projects, is the magisterial sense of pace and shifting moods—the juxtaposition of a carefully rendered tower with a rose, the transformation of straw into gold. This northern, romantic vein is tapped also in *L'Arbois, Sainte-Maxime* (1968–1969), *Parking privé* (1968), and in *Still Life with TV*, the first painting of 1969. In the first two landscapes, there is a dense and clotted arboreal massing at the center of the paintings that stops the eye from penetrating in a most uncharacteristic way. The sun-struck buildings are there, behind the trees, but we can't quite get to them. (Another painting, *Schloss* [1968], derives almost explicitly from the atmosphere and research for the Grimm illustrations.) *Still Life with TV* is a straightforward rendering of objects on a table, chosen by the artist and arranged by him; an unopened dictionary, a blank TV screen, a sharpened pencil, a blank sheet of paper, and a sealed sausage, all resting on a wooden table. The table is brown, the wall behind the objects yellow (a rare color in Hockney's work). The blank TV is made relatively lively and eerily interesting through the subtly modulated ochre-gray of the screen. Shadows are emphasized, perspective is accurate and the result is a feeling of slight uneasiness, not quite the uneasiness of Magritte (so often reducible to a visual joke) but rather the haunting loneliness of Edward Hopper, or the romantic evocativeness of Caspar David Friedrich, an artist Hockney was coming to prize highly.

Looking for Friedrichs became something between a hobby and an obsession on his increasingly frequent short trips to Germany. What appeals in Friedrich is compositional clarity, a sensitivity to the extremes of atmospheric conditions and times of day—moon-

light, dawn, glaciers, fogs, and, most arresting, shafts of light beaming down from the sky—and the sense that a story is being unfolded within the confines of a rectangle. Hockney most admires artists who have confronted their subject matter, wrested it from the complexities of "reality." They do not dislocate reality as do the surrealists; they claim a subject and a way of seeing it. To Hopper with his small-town streets and single figures in rented rooms, to Caspar David Friedrich's bare trees in the snow and setting suns, we can add two seemingly unrelated enthusiasms, Georges de la Tour and Charles Sheeler. All these artists insist successfully on limited types of subject matter (in de la Tour, religious stillness by candlelight; in Sheeler, awe at the power and purity of machinery); and they know how to effect a perfect marriage between a peculiar subject matter and an obsessive need to view it in an invented "realistic" style, perfectly suiting the subject to the manner of its portrayal. In each case, what they rendered was unthinkable before they saw for us. The way they saw is the way we now see.

In recent years Hockney has borrowed from his early expressionism, he has quoted from his California sunniness, and he has introduced a new tension, a veiled uneasiness the more subtly felt because it lies beneath what seems to be straightforward both in handling and in subject. Perhaps the first time we feel this new aura is in *The Room, Manchester Street* (1967), a portrait of Hockney's friend and contemporary, the painter Patrick Procktor. The double portrait has allowed Hockney a close, almost voyeuristic scrutiny of relationships, a subject that fascinates him more than any other. How do couples work? How do two people assert and adjust themselves? How can one be alone and not alone at the same time? These are questions he returns to again and again, always with greater understanding, but always with some last question unanswered. As early as *The First Marriage* (1962) and many paintings of 1963, *The Second Marriage, The Hypnotist, Domestic Scene, Los Angeles*, and *Seated Woman Drinking Tea, Being Served by Standing Companion*, the subject is double. In the next five years there is an occasional use of two figures (*Two Boys in a Pool, Hollywood* [1965] and *Rocky Mountains and Tired Indians* [1965]). And then

in 1968 there is a full return to the double portrait. Since then, Hockney's interest has amounted to a continuing investigation of a difficult human problem, novelistic in intensity, unique in the painting of our time.

A painting still unfinished at this writing is Hockney's portrait of his parents,[1] which includes a self-portrait looking back at us from the center of the picture. After letting the idea for this painting percolate for several years Hockney finally resolved his dilemma by having his mother sit facing us while his father sits sideways looking both at the mother and into the distance. The artist, looking surprisingly boyish, stands between them, his face reflected in a mirror. He is both a painter viewing his subject and a son looking at his parents. This painting is David Hockney's most blunt and inelegant double portrait. It is painted with a Yorkshire accent appropriate to its subject—honest, unflattering, but, finally, accepting and loving.

For the past several years, from 1973 to 1975, Hockney has spent most of his time in Paris, painting and drawing in a large room facing a quiet courtyard not far from the Boulevard St. Germain. He moved to Paris in part because his life in London had become too public. Between press coverage of his every move and his own generous social impulses there was insufficient privacy for work. The delicate balance between social life and isolation was held for a time in Paris, but an immensely popular retrospective exhibition at the Musée des Arts Décoratifs, and the many commercial showings of Jack Hazzan's semi-documentary, semi-fictional film, A Bigger Splash, brought Hockney's art and his charismatic personality to the attention of a wider public.

Ideally, Hockney would like to draw and paint all day after a short walk in the morning to buy the papers and fresh milk for his tea. In the evening he enjoys having drinks and dinner with a few friends, usually beginning and ending in the studio to review the day's work. In order to regain a measure of privacy when this schedule comes

[1]David Hockney in fact altered this painting slightly before finishing it in February 1976.

undone, Hockney now moves back and forth between Los Angeles, London, and Paris. He plans soon to add New York to his repertory of alternative homes.

In the Paris years Hockney produced a series of drawings that became the subject of an exhibition at the Galerie Claude Bernard. Between 1960 and 1972 painting and printmaking alternated as his main interests, while drawing served as the underpinning common to both activities. In Paris, for the first time drawing became an end in itself. The drawings of Celia Birtwell in colored pencil are among the best of the Paris period. In depicting the moods of a lovely young woman, they demonstrate a growing sensitivity on Hockney's part to feminity itself. In these drawings we see the influence of a century of French art—Ingres, Degas, Toulouse-Lautrec, Hélion, Pascin, Matisse, and Balthus. At a time when School of Paris painters have joined American abstractionists in abandoning women as a subject, a provincial painter from the north of England was able to surprise and delight Parisians by continuing a tradition that seemed to be passing away with Picasso.

In the early 1970s Hockney's technical facility grew to such a degree that it frightened him into pulling back. The Tate Gallery's *Mr. and Mrs. Clark and Percy* and the double portrait *George Lawson and Wayne Sleep*, abandoned in 1973 and resumed in late 1975, achieved such heights of naturalism and finish that a sentimental and anecdotal quality in the subject matter threatened to undermine the paintings' formal strengths. While Hockney sought to grapple with the problem of these double portraits, drawing allowed him to continue working from day to day without fear of slipping into a helpless academicism. His drawing style still gave him license to be as precise as he needed to be in representing the face, or dress, or hands, by allowing him the freedom to leave large areas of the paper blank or covered with the merest indications.

Baldly stated, it is David Hockney's ambition to be more than an eccentric and popular figure in the history of English art. Hockney's popularity is due in part to his skill as a portraitist and illustrator, in defining character, in telling stories, in capturing and monumentalizing fleeting moments, and in transforming the familiar

into the exotic. He has faithfully husbanded these talents by avoiding technical refinement uninspired by exploration and experiment. The fact that there are amazingly few swimming pool paintings testifies to his unwillingness to repeat his successes. But in celebrating his imagery, Hockney's audience has at times disappointed him in failing to judge his work according to the formal standards he sets for himself.

Among the few paintings of the Paris period is the masterpiece, *Contre-jour in the French Style—Against the Day dans le style français* (1974), which, despite its dazzling subject matter, never lets us forget that we are looking at superb painting. *Contre-jour* shows a view through a window at the Louvre, more than half of which is hidden by a miraculously glowing window shade. For all his explicitness, Hockney doesn't hesitate to employ such abstract mannerisms as the pointillist rendering of the marbled window embrasure, a rectangle within the picture that yet frames it and the almost square, Albers-like format of the yellow-green window shade, the most arresting element in the painting. The embrasure is flatly rendered, as is the shade, and the floor is drawn with less regard to perspective than to the four sides of the painting. (The parquet at the Louvre behaves in more orthodox fashion.) All this flatness is given the lie by the illusionistic reflections in the floor's polish and by the vista seen through the bottom third of the window. Feather trees and a light-struck building stand on the opposite side of the courtyard. A gravel path shooting out in perspective makes our apprehension of distance acute. But then the circle at the end of the path finds its echo in the iron grille-work outside the window, which again brings us up short at one of the picture's planes.

Considering Hockney's doctrinaire objection both to abstraction and to the paraphernalia of organized religion, one is surprised by the symbolism of the cross formed by the side rails and mounting of the window, symbolism perhaps influenced by the example of the much admired Caspar David Friedrich. On one level it is the cross, at first barely perceived, that seems to illuminate the glowing rectangle that is the window shade.

Conflicting and contrasting elements reveal themselves in a

close analysis of *Contre-jour in the French Style*; the painting is a masterpiece because both before and after its complexities are noted its imagery and its life as an object unite to produce a new and memorable vision. Solutions such as this indicate that David Hockney's ambition is not beyond his reach.

A Commencement Address

[June 5, 1976]

Earlier this week I ran into Robert Beverly Hale, my first boss at the Metropolitan Museum sixteen years ago, and a wonderfully alert seventy-five-year-old gentleman, who is perhaps best known for his courses in artistic anatomy at the Arts Students' League. As we were chatting he told me that he had come to the conclusion that every generation is a secret society, that the possibilities of communication between generations were by nature limited, even minimal. At forty-seven, I stand somewhat less than midway between you and my old boss. What I will talk to you about today may therefore be impossible for you to hear—I am talking from my own experience, and experience is a personal battle and, at times, a victory. Here are some of the lessons I have gleaned from a close observation of art, artists, and the art world. I do not for a minute think that it is all the Truth with a capital T; but I hope some of it is useful and sensible to some of you. I do not doubt that like every generation since time began, you will stubbornly insist on marching into the world to make your own mistakes and to win your own victories.

Until recently painting and sculpture were so highly regarded that the prestige accorded other visual arts paled in comparison. Now filmmaking and photography have comparable status. While these professions may be recognized as the font of originality from

which many visual ideas spring, greater prestige should be given countless ancillary activities that are still the domains of anonymous and under-appreciated craftsmen. We need our painters and sculptors, our filmmakers and photographers, we need them as much as we need poets, choreographers, and composers. But life-enhancing as high art is, our lives need enhancing in other ways as well.

All we need do is examine the collections of the Metropolitan Museum of Art to appreciate that great intelligence, sensibility, and craftmanship in decades, centuries, and millennia past were dedicated to what have sometimes been considered the humbler pursuits of the applied arts. The historical creators of tables and chairs, plates and drinking vessels, clothing and wall coverings continue to live through their work side by side with the painters and sculptors whom we have romantically exalted above them.

On any busy day at the Metropolitan, and the busy days are fast outnumbering the slow ones, the painting galleries are always crowded. But much of what is finest, rarest, and most original in the Museum is to be found in astonishing variety in the galleries devoted to the decorative arts: the rooms dedicated to French, English, Italian, and, as one must piously emphasize in this bicentennial year (will it ever end?), American furniture; and, even less familiar to our public, the galleries on the ground floor devoted to porcelain, silver, and glass—galleries that are always empty, no matter how crowded the museum, but whose visitors often strike one as more dedicated and original in their search for quality.

You are familiar with the phrase, the shock of quality, that instantaneous weakness, that breathlessness we feel when in the presence of something that is absolutely *right*, in harmony, in rhythm, in material, and function. If we want to test our connoisseurship, if we want to enlarge the sphere of our knowledge, there are always new galleries to explore or old ones to rediscover in the great encyclopedia that is a museum like the Metropolitan. I spent many years at three universities studying the history of art—painting, sculpture, a bit of architecture. But almost no prints, drawings or photographs, furniture or the other decorative arts were offered to us. I

understand things have improved minimally in a few schools, but just.

Paradoxically, the most curious thing that has happened as a result of our overcelebrating the fine arts is that much work that would once have been considered applied arts—crafts, architectural drawing, audiovisual display, even window decoration has slipped into the fine arts and weakened them by masquerading as the more prestigious activity. You need only go to Soho or to any survey of recent work by younger artists to see countless products of such activities as woodworking, wall covering, needlework, even literature and mathematics exhibited on gallery walls.

Of course, some of this art is legitimate and a few examples glorious. The principle of borrowing from other fields has successfully enlivened modernism since the turn of the century. Georges Braque learned imitation marbleizing and woodgrain as a house painter before he began painting on canvas. It was these techniques that he later used in his Cubist paintings and that Picasso instantly understood and adopted.

But we have also, again in France, the example of Maurice Marinot, the greatest glassmaker of the past sixty years; although Marinot's glass was highly regarded at the time it was made and is today increasingly cherished by collectors and museum audiences, Marinot's greatest ambition was that his rather ordinary and uninspired paintings be taken seriously. As if this were not tragic enough, imagine if Marinot had decided in the name of fine art to abandon glassmaking in order to concentrate on his painting. And yet we see things like this happening every day; in my generation it is the brilliant art director who gives it all up to be a mediocre painter; in your generation it may be the potentially brilliant clothes or fabric designer who becomes a painter for the same reasons and who ends up doing paintings that are in fact enlarged fabric designs or the products of a "plugged in" sewing machine. We are robbed of his talent in its most intuitive and pure state and are given weaker works of art than those of which he was capable in a field that needs him. We wear less imaginative clothes, he is disappointed in his reception as an artist, and we are all somewhat the poorer.

There are several reasons younger people want to be painters or sculptors, filmmakers or photographers, even when their special talents should lead them to be craftsmen, designers, or illustrators. We have talked of the prestige attached to success in the fine arts. The legend of big money is another one. In fact, statistically very few artists in the twentieth century have been rich men. I will never forget Thomas Hess in a debate with John Canaday in the Museum of Modern Art garden making the point when in 1960 the Abstract Expressionists were already either dead or in their fifties that no American painter was making as much money as the vice-president of a bank in New Rochelle (he may have said Scarsdale). Since then American and international collectors have recognized the achievement of postwar American art and the prices and stakes have risen dramatically. There is an irresistible American urge to gamble—whether in the stock market or at Las Vegas—and in art the most popular professions are the ones that offer the highest stakes. But if prestige and financial success are your ultimate goal, art is still a risky endeavor; it might even be fair to say that, given today's return to philistinism and provincialism on the American art and political scene, art in its highest sense is as risky as it was in the forties and fifties. I know too many younger artists of quality who are having great trouble supporting themselves.

There is another attraction to the fine arts that dates back to nineteenth-century Paris: it is defined in the novel *The Bohemian Life*, written by the Frenchman Henri Murger in the 1840s and made world famous by Puccini in one of the most popular operas of all time, *La Bohème*. I am speaking, of course, of that attractiveness of the life of the artist who does what he wants when he wants to do it, sacrificing material comforts, but living in conditions of great conviviality in a community of kindred spirits all of whom are dedicated both to a fine time and to the fine arts, perhaps in that order. Myths die hard. On the other hand, myths come about because there is a nub of truth to them. There are many aspects of the life of the artist which are attractive, but my experience tells me that making works of art should be thought of as an occupation rather than as a way of life. F. R. Leavis tells us of a moment in Stephen Spen-

der's autobiography *World Within Worlds* when T. S. Eliot asks the younger Spender what he wants to do. Spender answers, "I want to be a poet." Eliot said, "I understand your wanting to write poems but I don't know what you mean by 'being a poet.' " Today there are numbers of stockbrokers whose way of life more closely resembles that of the traditional artists on the Riviera than it does the old-style stockbroker. Similarly, there are successful artists who live and look like stockbrokers. The molds are breaking and it is better so.

Another illusionary attraction of being an artist is that one works in isolation away from the red-tape committee work and heavy socializing we associate with the rat race. While this is obviously an advantage, it takes a very particular kind of person to be able to thrive on the loneliness and self-discipline of the studio and, at the same time, create an audience for his own work. It is perfectly possible to be a misanthropic artist of great quality whose work is not recognized in his own lifetime. But the truth of success, here and now, is more complicated. In fact almost every artist we admire, both in the very recent past and in earlier times has had to be a propagandist for his point of view; he has had to be socially adept in the sense that he could interest a writer, a few other artists, some collectors, and often an even wider audience in what he was doing. We need only point to the roles of Baudelaire, Apollinaire, and, in our day, the American Clement Greenberg, to realize that the news of great new art does not move mysteriously or automatically from the studio to the avant garde to the public at large. There are intermediate stages which demand social intercourse between artists and interpreters, artists and audience.

Unless you are going to be a caveman, a hermit, or primitive, some degree of social facility is essential whether your career is in the fine arts or in the commercial arts. It is obvious that the designer who works as a member of a team has to be able to communicate with his fellow artists and get along with them; and a filmmaker, whether he is the producer, director, writer, actor, or cameraman can never for a moment fool himself that he is making irrevocable and autonomous aesthetic decisions. The individual designer has to take his portfolio around or has to convince someone to represent

him. Strangely enough, the same is true of the painter or sculptor, the poet or composer. He too must convince others of his worth, must be able to talk persuasively, entertainingly, and memorably about his work.

He may say then that prestige, riches, and the virtues of isolation are insufficient reasons to become an artist. And I have said that there are aesthetic positions to be filled at every level and in every field in the arts. My best advice is to follow your instincts about your own best strengths and to do what makes you feel both most comfortable and most fulfilled. Beware of faddish fields which dominate the arts from time to time. Today it is perhaps photography that is the most popular career to choose; because there is a growing interest in the history of photography, because there has been a wave of exhibitions and books on the subject and because the work of good photographers of the past and present is rising rapidly in price. But we know by now that within our lifetimes there will be times of boom and times of slump. The committed artist is able to survive these changes in the material world because his sights are set elsewhere; he is stubborn, independent, knows he is right and he can out-wait the world. A realist painter in the 1950s, for instance, was bucking the abstract tide; but a man like Fairfield Porter followed his own path and we respect his career and achievement all the more. Any committed artist can sing "my time will come" and probably be right.

Many of you will go out and teach; many will enter commercial fields; some will survive as filmmakers and photographers or as painters, sculptors, or printmakers, but all of you have been trained and primed through your experience in school and in life to recognize quality when you encounter it. That is the success of your education. That is the preparation you bring to a life dedicated in one way or another to the visual arts, the heightened sensibility which is your real diploma.

Those of you who go into areas seemingly unrelated to the visual arts will always carry with you that invaluable training. Some of you may find yourselves in positions to influence your neighbors, your acquaintances, and yes, even that most obdurate of all elements in

our society, your relatives. They will imitate what they instinctively know you do better than they; your example will show that it is more satisfying, more exciting to live in a visually harmonious and stimulating environment.

The situation in the visual arts today is very much like that in the 1920s and 1930s—various styles are being practiced and much good art is being produced by eccentrics working in relative isolation.

André Malraux and others pointed out a generation ago that we are the first internationally visual culture and the first people to whom all the art of all ages is available through archaeology, museums, the camera, and travel. The same is true of the art of our own time—in the middle ages there were a few wandering artists and craftsmen; and crusaders and merchants carried art from one part of the world to another—but for the most part an artist spent his whole life aware only of what was being done in his immediate locality—and locality in those days meant a radius of fifty miles. Today art is available in such an avalanche that it takes a great deal of training and good instincts to pick one's way through it all. Alfred North Whitehead, the great British mathematician and philosopher who taught for many years at Harvard, wrote in *The Adventure of Ideas* that intelligence consists in the ability to choose the signals upon which to act from all the information available to our senses. In today's terms artistic intelligence has to deal with so much more information that it is not surprising there is so much confusion. This needn't be a negative perception—it does make it possible for the well-educated person who manages to remain in touch with his or her own instincts to come up with a more sophisticated vision based on a wider field of reference. This applies to the audience for art as well as to its creators.

We can draw a valuable lesson from this new complexity of available information. Rather than look for the simple and the narrow, would it not be healthier and more challenging to admit the complexity both in art and life and to make it our life's purpose to find form and purpose within multiplicity? Shortcuts to equanimity, religious and psychological, are becoming increasingly popular and

one reason is that the richness and overload of information is making us uncomfortable. We may well need the discipline of meditation or the expert aid of a group therapist, not to avoid the manifold riches available to us, but to teach us the equanimity to live with them.

Avoid automatically accepting the values of your peer group; try to find what it is you yourself want—a career in the arts — in photography, advertising, life in a commune, dedication to a meditation cult, weekends in singles bars with summers in the Hamptons—or even something entirely different, a combination of skills, ambitions, and joys which you have forged for yourself, through trial and error, through pain and ecstasy. And then again, some of us are so weird that to be normal is our greatest ambition and most difficult task.

What I am suggesting is that you take your training, your early homelife, your schooling, your inclinations and find your own goals and desires, your own ambitions.

Every night when I can manage to find a star in the sky of Manhattan, or wherever I may be, I make the same little wish, with the familiar star-light star-bright formula. It is considered unlucky to tell tonight's wish, but, as I make the same wish every night, I think it is probably okay to tell you last night's or tomorrow's wish—that should avoid the evil eye. What I wish for every night is equilibrium, not ecstasy, not mad success, but the tranquility to know my own strengths and needs, and to be satisfied, even quietly aglow, with the way things are. And that is what I wish for you: tranquility, equilibrium, finding your own values, and joy in modest success.

1980s

Approaching Clemente

[1983]

As New York City Commissioner of Cultural Affairs one of my favorite institutions was the Institute for Art and Urban Resources in Queens (better known for the former school it inhabits, P.S. 1). Thus it was a matter of course that I came to view an exhibition there in 1981, called "New York/New Wave," curated by a young fellow named Diego Cortez. It was in viewing that show that I first began to understand that something new was afoot. I saw work that had been on view at the "clubs" but which had passed me by. For the first time I saw work by Jean-Michel Basquiat and Keith Haring, and I felt an excitement that I thought had been missing from the art world. I immediately arranged to meet Diego Cortez and to ask his guidance through the new thickets. I asked him to introduce me to a few younger artists and to lend me his collection of art gallery catalogues to familiarize myself with this new work. It was a bit like a baseball fanatic changing cities, thereby having to root for a new bunch of heroes. The first thing to do was to learn the territory. In the course of a month Diego took me to see Julian Schnabel and Francesco Clemente. I spent an hour with Schnabel and at the end of the hour I said, "Thank you very much" and literally fell down the stairs. The mind-wrenching change that a new sensibility brings into play is totally disorienting. And I realized that some-

thing important was happening for me—not to be thrown down the stairs, but to be physically affected.

Within the week Diego took me to meet Francesco Clemente for the first time, in April 1982. We looked at everything in the studio. After an hour or so, we finished the circuit. I was thrilled at the quality of what I was looking at, his mastery of each technique and at the same time instantly horrified—no, I was never really horrified by his imagery as much as amazed, fascinated, and slightly shocked by his endless permutations of human gestures, emotions, orifices. I soon realized that what shocked me was the fact that I *could be shocked* by anything an artist might put down on paper or canvas. Much of this was swirling about in my head, not ready for articulation. What I was certain of, however, was that I was in the presence of a master. Both the work and his persona convinced me instantaneously.

Infatuated and still hungry for more, I gently asked Clemente, Again? And we looked at everything in the studio for a second time. That, coming along in tandem with Schnabel's work, which succeeded so quickly what I had seen of Basquiat and Haring, convinced me that I had to get out from under the administrative horrors of working for the government of New York City.

Part of the reason that I was so struck by what was going on in European painting was that few American curators had had the humility to check it out—to go to Rome and Milan and Berlin and Hamburg and see and report back. But it wasn't until the early eighties, when many of the new generation of Europeans were actually spending time in New York, that the information was forced through our surrounding thickness. For the first time since the onset of the Second World War there was a European way of seeing and thinking and feeling that was influencing young American artists. We had become so chauvinistic, so mired in the idea that Paris gave way to New York that we were spending all our time marching up and down Madison Avenue and making the well-traveled circuit of studios we knew well.

There were now European painters, several of whom had come

to New York as long ago as the sixties and early seventies, renting studios and working in their own vein without attracting interest, without there being a sensible or available route into the consciousness of the New York art world. As in psychiatry, it is true in contemporary culture, you cannot hear the new, or see it, or understand it until you and your equipment can tune it in. Georg Baselitz, Sigmar Polke, and Blinky Palermo had all painted in New York in the nineteen sixties and/or seventies. They spoke little or no English. Nobody knew who they were, and it took another decade before we were ready for the news from young Europe.

Baselitz was making paintings in the late sixties in Berlin which I can now see as important documents, as *facts* that must be taken into account when we survey the field of contemporary art history, but of which we were long ignorant. I do not say it is a crime for us not to know what is going on, but I think the slowness with which that information percolated to us must make us sit up and wonder. In mitigation, one can declare with some confidence that our country has yet to do anything so cruel as was done by omission to van Gogh. Nowhere is it written, "Thou Shalt Recognize the New." But it was really the courage of a few European curators who organized several significant international exhibitions around 1980 that attracted our attention. It was the inclusion of such key Americans as Cy Twombly, Andy Warhol, and Philip Guston that put the new European work in a context that clued us in, that took us by the hand, that defogged our glasses. It was then that the system—the "system" as it is also known—took over and convinced a few collectors and a few American art galleries and museums of contemporary art that there were new players in the game, and that it was high time we learned the rules.

Ezra Pound coined a useful phrase in the twenties that can serve as a prescription for how to make modern art, how to write, or recognize modern poetry; his three little words seem to me as pithy as the first "know thyself." Pound said, "MAKE IT NEW." "Make" is the artist creating, "it" is tradition, and "New" is what enters into it contemporaneously, that which is special to your own generation

and was not available previously. "MAKE IT NEW" then is an adjuration to recycle tradition and render it compatible with today's sensibilities.

Francesco Clemente is a serious student of Ezra Pound. He has an enormous amount of respect for the written word, and an unerring instinct as to where to look for it, whether in holy texts of a dozen religions, or in the most secular ephemera. Francesco had a classical Italian training in Naples in Greek and Latin and more; at eighteen he finished with his degree work and moved to Rome with the idea of investigating architecture as a career. In the same year, 1971, he made his first visit to India. In his traveling about the world, he found himself. He has been returning to India for varying times every year since.

Francesco talks about his work in ways that are reminiscent of Pound's method—the habit of quoting classical sources, referring to obscure tags in sometimes obscure texts, or in unknowable languages, Tibetan, Etruscan, that thicken the context while eluding specific pinpointing. So far Clemente has resisted weighing down his work with the scholarly apparatus of Eliot and Pound, but one expects that the academicians will be along soon enough with their "skeleton key" to Francesco Clemente.

Perhaps it is best now to talk about Clemente in terms of his working methods. *Perseverance* was executed in New York at the time of his *Fourteen Stations* of 1982. It is based on a dream Francesco had on his first night in New York. He dreamed it was raining excrement—his fear perhaps of what New York might bring. There is the figure of Francesco who without arms (classical antiquity) is bravely carrying a temple that is the Graeco-Roman tradition. In his posture he walks with anxiety of being sullied himself and with the feeling of responsibility for a culture he carries within himself, his classical training. And that is exactly what this work is about—carrying the Great Tradition through these perilous times, exposing himself necessarily. The fact that he is working *now* means that he is willing to step down from the safety of history to be sullied by New York and to be brought up sharply by the crude energies of contemporary life.

For Clemente self-portraiture, and his own body, is in large mea-

sure his subject. He uses himself as a sort of visual *lingua franca* that stands in for us all. It places us as unindicted co-conspirators. He is telling us so much about himself that we know through our nerve-endings that we are, in countless preverbal ways, the same as him, continuous with him.

What Clemente is doing in *Self-Portrait: (Crucifixion)* has some of the dreamtime quality of Freudian-inspired Surrealism, but he is involved here with something more complex. Clemente presents us with a close-up of his head blown-up movie screen–wise to fill the canvas. He paints a traditional crucifixion neither in front of nor behind his face but *interlayered*, displacing such handy old crutches as foreground and background.

It isn't only the shifts in foreground-background that Clemente plays with in his work; there is also the confusion of the up and the down and the feeling of floating. He implies a freedom from such mundane forces as gravity, a freedom that feels remarkably like fear as in swimming, the terror-release of being submerged then bursting through to the oxygen and the deep gulping breaths that restore us. Francesco Clemente's imagery is the most fascinating aspect of his work in all media—its variety, depth, and perversity. Anyone who has ever taken a course in iconography knows the amplitude of saints and graces, the hours, invented animals, the sins and the seas and so on. Clemente draws on three traditions in the main for his vocabulary of icon-ideograms, with which he is conversant in the Classical tradition, which he absorbed in school as a Neapolitan child of good family. This must have been colored by the exchange of naughty rumors about nearby Pompeii and Herculaneum and other such erotica which are the daily fare of all eleven-year-old school boys. The second tradition was also the Judeo-Christian tradition, instilled in him early and heavily. His father is a lawyer and a judge and so he is sensitive to all those saints, the pain, and yes, even the grace.

The third tradition into which he burrows is the Eastern. To put it more elegantly, he wears this tradition so naturally that it takes an effort to imagine Clemente *without* India and its literature and art. For over a decade now Clemente and his family have lived part of

every year in Madras. Much about Clemente can be surmised by an examination of the publications by and about him that have been printed under his supervision. The paper, the inks, the fuzzed registrations and the unconventional bindings all attest to his immersion in the Indian tradition in which all our standard values are stood on their heads (and forced to walk on live coals). The very notion of perfection and imperfection in the two cultures is enough to keep us off balance. In India he has also studied Sanskrit and made himself familiar with the classic texts, the Upanishads and the Bhagavad Gita. In 1972, when he was twenty, he began a series of drawings and notes that were his main preoccupation for the next six years. There are several thousand of these works, which he has been dipping into and putting in order ever since. This "dictionary" is at the basis of his astonishing ability to range far and deep, to make massive amounts of work without ever suggesting that his imagery is repetitive, or that his invention is flagging.

Clemente has said, "The way I think is in ideograms. I believe the language of images is [a] logical, rational, correct way of thinking. I know I can think that way. So the paintings relate to the language of the body, and to verbal language." I call this piece "Approaching Clemente" because he is elusive by nature and rather impatient with "solutions" to the puzzle of his work meaning. It would be a grave error indeed to get too close. If Isaiah Berlin's Fox knows many things in contrast to his Hedgehog who knows one thing well, Clemente must be counted a Fox with Hedgehog inclinations. If forced to come up with a motto for Clemente it would be André Gide's, "Don't understand me too quickly." It is not that he is hiding anything, just the reverse; he is attempting to deliver a much more complex message. As he spreads his ideograms about in differing bodies of work, in one continent or another, it will be a very long time before it will be possible to understand, to translate into words and sentences what exactly his work is "all about."

In much of modern art we have become accustomed to a mentality that likes the strictness of format within which to render complexity of feeling and meaning. What Clemente does is to turn this serialism on its head. The point in his investigations is often the *dif-*

ferences that can be accommodated by the series. Recently at Sperone Westwater Gallery in New York Francesco showed eighty monotypes, out of a hundred and eight, that he produced in Maurice Payne's print workshop. All were identically printed with a self-portrait head at the bottom center of the paper, and each painted and drawn on to create the widest possible field of references—to quote from himself and others in wonderful punning ways—hand-worked monotypes in no way diminished through their basic similarities.

Clemente sets himself hurdles, probably for his own psychic needs. For instance he will paint pictures in New York for a specific exhibition in England; or, as with the recent self-portrait monotypes, he will box himself into a form whose boundaries he then will stretch with his prolific imaginings. Clemente has created extensive bodies of work through his need to set himself tasks—months, often, of nothing but watercolor portraits, or of pastels. With *The Fourteen Stations*, his exercise was to start with darkness, a non-doctrinaire tenebrousness, the challenge being to create light and color suffused with night.

Francesco is interested, in ways few artists have ever been, in his own body—what he sees of himself without the aid of a camera. A self-portrait, then, might show his body from the neck down disappearing, diminishing through the perspective as he sees it. He can imagine his head, as in one of the *Stations*, as filling the canvas from one perspective, and repeated in several sizes and perspectives in the same picture. A composition may be based in large part on his feeling his way into a situation. Empathizing, "trying it on" with a foreign bit of psychology, perhaps, within the confines of a limited, self-limiting exercise, he ranges from delicate painting to raw earth marks, from, for example, Watteau to Soutine. Some are scratched and pitted, some include Hindu references, others are inevitably of Italian provenance.

When asked to characterize Clemente's sensibility and approach to work, we find analogies to writers more apt than to artists. There is a hint of his influences in the fact that Francesco collects, on a modest scale, work by Fuseli, Blake, Michaux, and Cy Twombly.

We should look, however, to the Argentine polymath, Jorge Borges, who loved the insightful game of cross-translation, and who bent time and space in post-Newtonian torques and turns. Blind as he was in his last decade, Borges kept the history of language and literature present in his memory and imagination. Clemente and Borges also share a love of the oddities in the history of culture, the bestiaries and walled gardens of medieval imagination. One aspect of being privy to artists' studios I particularly enjoy is the postcard or tearings from magazines that are placed haphazardly on a wall near a table (often where the colors are mixed). These give intriguing clues to some angles of an artist's view. There is an exhibition and a book to be organized around this theme—artists' artists.

Clemente's skill with and love of fresco painting is a rare gift to his American audience for whom the technique is admired by many and practiced by very few. For Clemente, fresco has a legitimate place in his technical armory. Fresco is a tradition dating back to the Etruscans, and especially familiar in Naples through its proximity to Pompeii's painted walls. Enormous interest was piqued in New York by his wholly appropriate decision to paint frescos in place at the Palladium, the nightclub that was a favorite in 1985. He has also painted frescos at the Sperone Westwater Gallery in New York. Francesco is *not* an expert on or in fresco painting. He *is* a painter of frescos. The continuity in this technique is with a living tradition.

For an American, watching him and his two assistants brought over from Rome to help with the preparation of the walls is a blink behind the veil that separates us from the Renaissance. When the Metropolitan Museum has need of impeccable craftsmanship in its re-installation of historic rooms, to recreate a plaster ceiling, to gild eighteenth-century furniture anew, the artisan-specialists are imported from Paris or Rome where the craft traditions have never fallen entirely into disuse (although we hear rumors that these crafts are in danger of dying in Europe as well).

To an American sensibility fresco has at first look a pallid, washed-down surface that is quite tamed and faded-seeming to eyes accustomed to the drama of Abstract Expressionism and to the

POW of Pop Art. Like so many things, it is probably only a differ-
ence in geography and climate that separates us. Walking indoors
anywhere in the countries that surround the Mediterranean basin
one feels the special air and light of fresco painting; their look is nat-
ural and organic, of its kind and place. As a New Worlder I must
slow down my expectation of fireworks and relax into the subtle em-
anation of drawing and color. The sense of drawing in fresco is
never overwhelming. The point rarely seems to be that figures are
bounded by lines—as they are in so many classical *revivals* (an odd
word to use when we are trying to describe something quite other
and new. Think of Poussin, Mengs, David, Ingres, the Nazarenes
or the Pre-Raphaelites!). Clemente in his frescoes is emphatically
not reviving anything—he is part of the continuum of fresco.

The whole question of color and its relativity to such culturally
important factors as latitude and longitude is in its infancy. Another
inquiry might study the nature of hues and pigments along trade
routes that supplied the color and the "taste" in fabric and design
favored by the ruling classes. (Indeed Clemente never returns from
Rome or Madras without a small parcel of powdered pigment indig-
enous to that locale.) Just as Italian fresco and surviving Roman
paintings on plaster walls seem pale and washed out to Northern
eyes until we re-climatize ourselves, that is, alter our expectations,
some of the more fiery color-field paintings out of New York in the
late fifties may on first view shout and intimidate our Mediterra-
nean brothers. Montaigne wrote about the influence of climate on
political systems more than three hundred years ago—the same
must be true of color.

What in my eyes reads as a compliment to Clemente is some-
times heard as criticism, especially during his remarkable three gal-
lery exhibitions in 1985 (Mary Boone, Leo Castelli, and Sperone
Westwater), that he is "too prolific," and other assorted envious lo-
cutions. It does take a leap of faith to trust one's "eye" in judging
masses of work by a thirty-three-year-old artist who casually fills
three galleries with new work. The work continues to bubble up like
some kind of volcanic eruption. It is not a question, as some write,
that he is brazen with his "facility." It is as if a composer wrote a

theme and variations, in which the theme, untraditionally, is his as well. Clemente's facility can be made to work for him in so many ways. He can cap it and turn clumsy, or he can redirect it in the manner of Watteau in one piece, and Egon Schiele in another. It was Francesco's work that led me back to the visual tradition of Vienna at the turn of the century, to re-see Egon Schiele as an avatar of the "punk," the anorexic spike-hair freak of so many portraits as in Clemente's art—a cry of youthful anxiety at the frustrations and nullities of an inherited world freighted with history and hypocrisies.

There is a cosmology of Clemente's ideas and images and feelings. There is a system to it all, but on so grand a scale as to defy classification. What he means to do, I am convinced, is to build a corpus of work that can be seen to run parallel with such achievements as Pound's *Cantos* and James Joyce's *Finnegans Wake*. Clues as to the shape and details of his cosmology are sprinkled about in his work in all media. I think that what whistles through his imagination, the whirlwind within his head, is of such velocity and complexity that it takes the amount of work he turns out in a year to house the ideograms, references, and self-references. It is also true of him that, although he complains quite often that he is not working, he is *always* at work. He only feels fully alive when he loses self-awareness in the act of making his art.

To place Clemente's ambitious work in what seems to me its correct perspective it is necessary to turn to such typically Modernist endeavors as the aforementioned *Cantos* of Pound and Eliot's *Wasteland*, twentieth-century works that are so wide and arcane in their sources and classical tags that a system of notes and quotes become necessary, a sort of impedimenta that freights the work with the respectable dignity of Academia and that can provide, for the alert and curious reader, a lifetime of fascination.

There is nothing new about the successful mining of an earlier art to lend propriety and panache to what must seem "difficult" art to uninitiated contemporaries. A bit closer to Clemente's Neapolitan tradition, we need only turn to the Roman use of Greek exemplars in art and drama; and to the Renaissance use of antiquity for

its own radically opposed purposes, to evoke some of history's great raids on the past. Where in literature a phrase or a reference may be borrowed, in architecture, actual fragments of Greek or Roman sculpture are often incorporated into a façade. This literal use and "reuse" has served Renaissance masters, whose vision of a new Christian Humanism demanded a "new" architecture with literal roots in the classical past. Its lesson is one of cultural continuity, a harmonious marriage of ancient and Christian elements in a new order, a new music of the spheres.

In Clemente's work we may catch scenes and glimpses of a whole that we have never seen entirely. They come from varied sources and, inevitably, as the work progresses, they comment on themselves as well, on Clemente's earlier work and images. We will never comprehend the whole corpus at once, we will never keep it in focus in memory. This grand vision is *not* a claim made by Clemente on his own behalf; rather it is made by a charmed onlooker and commentator, vastly admiring of his achievement to date. Clemente's refusal to provide the "notes and quotes" to his own work displaces the responsibility for understanding the work, to "solving" it, if it is indeed a puzzle, onto the viewer and the exegete. It is clever abdication on Clemente's part if he truly does not want to be understood too quickly. Let me hasten to emphasize here that it is the *method* of the Renaissance and Pound and Joyce to which I propose a similarity in approach between them and Francesco Clemente, and not yet to their achievement that I twin him.

Another twentieth-century literary figure whose method is relevant is an Alexandrian Greek of the first half of the century, Constantin Cavafy. With Cavafy it is not a process of *collage*, borrowing a line from Ovid, or a phrase from Homer, it is to set off an idea or an impression through its piquancy and contrast within contemporary diction. A Cavafy poem will often begin with a line from a poem or official document of the ancient world, or its Byzantine successor in the East. On this he builds simple narrative, a humble anecdote, most often in a gentle voice and from the point of view of a homosexual. I cite him in reference to Clemente because I find it necessary to enumerate more ways than one by which a painter can

be "influenced" by the antique, more ways than the "collage" quotation whose spice is in its contrast with adjacent material. The Cavafy method of entering into the past and attempting to comment from within is a technique that underlies the lives of drag queens who attempt to model their lives on that of the "other." So a painter can choose to portray a scene as the Romans did, or would have were they alive today.

Cy Twombly, an American painter who has been living and working in Rome since the mid-fifties, has been an influential figure to many European artists. It is his handwriting, his graffiti-like style with all the naturalness of American vernacular that has been the taking off point for several Italian painters. I cite him here because his "entry" into the life of the ancient world, an obsession with Twombly, his trance-like automatic attacks on canvas and paper also have a drag-like authenticity. Twombly never quotes the past: he becomes one with it. He extends the ancient sensibility by becoming himself. He was an example to the young Clemente of a natural artist working amid the Roman monuments and in some personal way, commenting on and extending the ancient with a sense of presentness. With Twombly, as with Clemente and Cavafy, it is almost never the collage-like quote of an earlier era that enters his work: it is instead through some necromancy that he enters the past bearing us along into the dialogue with antiquity.

Francesco Clemente is neither the first nor will be the last artist to use emblems of wounds and pestilence in his work. It is the intimacy with which the artist visits the plagues on his figures that both touches and repels us. In the ancient world the Flaying of Marsyas or Dante's Ugolino Eating his Children come readily to mind while in the Christian hagiography the curiously attractive Saint Sebastian has been pictured often and by many of the best painters. The almost confessional appeal of works such as these, the wounded hero, the wounded self, haunts our cultural consciousness. It is the grim fascination with nightmares that helps keep the Holocaust so present in our films and literature. Another distorting factor that is cited in every art history course is the fading color of the architec-

ture and sculpture of the ancient world as it lay in neglect under the debris of the dozen centuries it took to see them again, revived and revered by the Humanistic Renaissance. Concomitant with the bleaching out of color through the action of time was the incorporation within the new Renaissance aesthetic taste for the wounded and the broken, the armless Venus, the broken-nosed Emperor. It is often those bruises and traumas that affect us so deeply, a factor never dreamed of, one imagines, in the ancient workshops of their creation. Add St. Sebastian's impalements by arrows and the roughly deliberately unfinished later sculptures of Michelangelo, which rival and mate with the smashed fragments of antiquity. Thus when Francesco finds an untraditional orifice, or a new use for an old one, he is, let us admit, in the grand tradition. What shocks is the immediacy of his vision, the pains and ecstasies pictured by a young contemporary artist unafraid of the unlovely.

One reason we fasten on certain artists with such determination is that they address us and conspire with us in the creation of a new language, for our time. We need language and its renewal quite desperately to communicate attitudes and nuances of feeling all in the march of civilization, if not upward, then surely forward. We have an urgent spiritual need to define ourselves and re-define ourselves under that wisest of all oracular injunctions: "know thyself." The artist's role in all this comes about because in ordinary discourse we really don't know how or what anyone else sees, or feels, if they are reacting to the same stimuli, the same clues in the panoply unfolding without before the sensorium.

We need an artist like Francesco Clemente because he is willing to take his own body, his own being, and give it back to us in a way we can trust as truth, thus allowing us to measure responses within a constructed system. His work sets off an echo in us that I find liberating. It is just these thoughts that indicate why artistic censorship is so popular an attitude for certain conservatives—the Catholic Church or Plato's Republic—whose constant fear is the undermining of the carefully constructed system to which they cling by hangnails.

It is not verbal. It is beyond the verbal. It is not better than verbal. It is *other* than verbal. And I think that the fascination that new art of the past century has increasingly exerted with a larger public is due in some measure to the secrets in which a rare artist such as Francesco Clemente invites us to join him.

Sandro Chia

[1984]

It was only three years ago that we in New York were struck (almost violently) with the work of a dozen or so Italian and German artists. This was our first excited recognition that once again an International Style was alive. During the previous four decades we had been so concentrated on the new vitality and intelligence of American painting that, for the first time in our nation's history, Europe seemed distant, tired, and irrelevant.

The salutary nature of this slap to attention was felt most immediately by the generation of American artists who, in their mid-twenties, were aware that painting was due for a renewal of look and intent, who were conscious of the anomalous contours of art history and its wide terms of referral to new sources. Through the congruity of their needs and development with that of their German and Italian counterparts, we in America came to recognize, accept, and absorb a new wave of German and Italian art.

Sandro Chia "made his mark" on us from our first glimpse of his paintings. His large, lumbering figures, the peasant-proletarian hero, costumed vaguely as a character from a previous era, is inflated not so much with muscle as with presence. If we were to introduce this Chia figure into a crowded novel with only one sentence to spare, we might say, "He is surprisingly light on his feet given his weight." An elementary handbook on the psychology of

179

artists might tell us that Sandro's compulsively repeated figure must be a self-portrait, so unflaggingly does it hold his interest. And, of course, there is some truth even in a truism so tried; but the real Sandro Chia is a tall, handsome, well-proportioned man of thirty-five years. The self-portrait aspect of the figure is clearly not the way we see Sandro—not what we would see in a mirror, reflecting his image. It must then be what Sandro sees in the mirror, and in a touching and revealing insight, how he feels when he looks at himself—what he feels when he imagines himself in the world.

Willem de Kooning once said, "The only space I need in painting is that which I feel when I stand with my arms at my side." In his "figure," Sandro depicts the sense of space that he inhabits in his mind; the sensed boundary where the self's habitation ends and the world begins. Curiously, this is one of the very first lessons an infant of a few months can be observed learning in his crib: where do I end and where does the world begin?

If Chia's figure-style derives from his sense of himself in the world, it also derives from the artist's appreciation of and garnering from the history of art. Late de Chirico? Léger? Gromaire and Roger de la Fresnaye? Italian masters of the interwar period? The answer to all of these is Yes, but not entirely. Sandro has conflated himself and his heroes into a perfect crime; we have clues as to his influences and thought processes, but not enough to "solve" the mystery. The best artists transmute their loves and influences so completely through their own absorption and re-creation that we can only point and guess. In the end the evidence, the work achieved by a master, becomes so much himself, so entirely his own, that the question of influences becomes academic. It may be fascinating as gamesmanship or as an intellectual puzzle, but it is finally beside the point. We can *wonder* at Chia's figure, but we accept him so readily that we never *question* him or his place in our imaginary pantheon of artists' beings.

The richness of Sandro Chia's work (which might sound restricted if we only focus on his "figure") can be seen in the broad range of subjects it embraces: St. Christopher bearing the Christ

Child; a flasher in a raincoat in a public park; a man committing hara-kiri; a dancer tripping along with a child. The net Chia casts is wide; myths can be depicted as well as *fait divers*, and genre scenes—Sisyphus eternally rolling his painted stone up the painted hill; the ancient Mediterranean identification of heroic man with fisherman (*Water Bearer*, 1978); and, in a powerful, original invention, *Perpetual (E) Motion* (1978), a man simultaneously drinking and urinating, in the words of the old college joke, voiding the middle man.

Another curious aspect of Sandro Chia's paintings is their entirely non-specific place in historical time or recognizable venue. Sandro has dispensed with the superfluous specificities that weigh down so many paintings in the Renaissance tradition (saints' attributes, period costumes, Umbrian landscapes, etc.), yet maintains as his base the same familiarities with classical models and humanist ideals.

Sandro Chia's figures may exist in settings as particular as the *Blue Grotto*, or, as in *Personal (E) Motion*, on a farm; but for the most part the figure and its foreground and background are knitted seamlessly together in the interest of Chia's true subject, painting itself. There is no mistaking the love of materials in the way Sandro wields the brush; the densities and veilities, the ways in which color is interwoven, the satisfying richness of the surface in his most successful paintings, all evoke the great age of tapestry as it was practiced in Flanders and Northern France in the fifteenth to eighteenth centuries. The exchange of information between Italy and Northern Europe in that time assured the constant enrichment of the *tapisseur's* vocabulary of subjects and techniques. In just this way Sandro makes nonsense of our cherished game of categorizing art and artists as "Mediterranean" or "Northern," through his broad repertoire of images and compositional devices. Perhaps this ease with the "other" tradition can in part account for his successful year (1980–1981) in Mönchengladbach. His notebook, Mönchengladbach Journal, made up of drawings of that year, chronicles an especially fruitful period of contemplation of the problems inherent

in painting for a self-conscious contemporary, brought up in a time and place (Italy in the 1960s and 1970s) in which everything was put radically and violently into question. It is possible that Sandro Chia, in an only partly conscious rejection of all that was familiar and therefore tainted, found it necessary to conceive his scenes and settings as a neutral yet supportive vehicle in which his "figures" could lead their lives and undertake missions in a world unencumbered by memories, in an affirmation not of society but of himself. This in part accounts for the rhetorical nature of much of Chia's painting, as the same time as the *message* has so little specific context or content.

Typically, in Sandro Chia's pictures, we find a solitary hero without specific portfolio or attributes, performing simple tasks, or posed in classical contrapposto. In several paintings the Chia figure leads a miniature version of himself by the hand. The relationship, while possibly father and child, seems to have more to do with hero worship and role models—or are we seeing the same hero at distinct stages of his life?

As in operatic and cinematic costume dramas that are intended to take place in a time other than our own, Chia's men live in a world without wristwatches on their arms or vapor trails in the sky. Drinking from a manufactured bottle, smoking a cigarette, and standing next to a cannon are some of the ways in which we can locate these paintings as contemporary. The feeling we get is of a world of heroes and legends, of folktales handed down verbally, of a world that ignores the printed word and its more advanced sister forms of communication.

Sandro Chia's universe is one in which man's mettle is constantly being tested, an arena where play and battle are modes of action. The hero is cut off from society, either because he has rejected it, or because he lives in a world that exists before and after the self-destructive present. Chia offers up scenes in the life of *A Hero of Another Order* in paintings that have great presence, visual weight, and that delight in rich color and elegant inflections of the brush. He has added a Rabelaisian figure to our stock of Pantagruels, Paul

Bunyans, and Johnny Appleseeds, larger-than-life-size figures who live in the spirit of adventure and who, through their performance of humble yet Herculean tasks, give us hope of redemption, that in spite of all the traps that man has set for himself, he will survive, he will prevail.

An Interview with Georg Baselitz

[1984]

*F*or the first time in recent memory America's art audience has turned its admiring attention to European contemporary artists, for the most part Italian and German. Georg Baselitz was born Georg Kern in 1938, in the village of Deutschbaselitz, Saxony, in what was to become East Germany. The son of the village schoolteacher, Baselitz attended art school in East Berlin in 1956–1957 and in West Berlin, to which he moved, from 1957 to 1964. In 1963, at the time of his first exhibition at the Galerie Werner & Katz, two of his paintings were confiscated as "obscene." In 1969, he began his notorious practice of painting recognizable subject matter upside down, which continues to this day.

Georg Baselitz's personality strikes one as a remarkable amalgam, made up of an aloof, natural dignity, and a genuine eagerness to be liked. His castle residence in Derneburg (outside Hanover, near the East German border), while vast in proportions seems, after several hours spent in the company of the artist, his wife, and several studio assistants, securely domesticated. His two teenage sons are at school. Many of the rooms house Baselitz's collections—of African sculpture, Mannerist prints, antique musical instruments, his own paintings from the previous two decades, and those of his colleagues—Penck, Kiefer, Lüpertz, Polke, Immen-

dorff—as well as an abundant library on art and literature. More recently, the artist has begun to acquire impressive examples of Renaissance and Baroque furniture, pieces that were made on a scale suitable to this remarkable residence. Our interview was conducted in German over the course of two days, October 19–20, 1983, sitting in the lofty painting studio (a former chapel), and on a walk through a dozen adjoining rooms, with a West German TV crew in tow.

In New York, Xavier Fourcade Inc. showed Baselitz in 1981 and 1983, and Mary Boone has an exhibition April 7–28. Baselitz is featured in the St. Louis Art Museum's "Expressions. New Art from Germany." The traveling show, which also includes the works of A. R. Penck, Immendorff, Lüpertz, and Kiefer, will be at the Newport Harbor Art Museum, Newport Beach, Ca., April 19– June 10, and at the Corcoran Gallery in Washington, D.C., June 30–August 26.

HENRY GELDZAHLER *Over the years your sense of color has changed several times, and these new works are probably the most color-saturated pictures that you've made. Is there a psychology or a rationality to your palette of various periods?*
GEORG BASELITZ The choice of colors is a conscious decision. It does not come from deep within or from some secret source. There are no general precepts for whether I paint with green or yellow, or black or white. I have always varied, and I always keep the color-sense independent from what I am painting. Therefore, for instance, somber colors do not imply gloomy times or light colors gayer ones. Rather it is a decision I always make beforehand. And I may change it in a month. If, despite this, there should be some sort of psychological meaning to my use of color, then that is something that I don't know about. It's possible. One would have to ask someone who can interpret such things. But I don't maintain, for example, when I paint with yellow that yellow is the color of sadness or envy, or red the color of aggression, as concerns the paintings. It's another story with my sculpture. There the color is definitely used in the sense of aggression.

H.G. *So subverting accepted color-meanings in paintings is a good way to fight associations?*

G.B. I have always shunned associations in my painting. When I began the upside-down paintings, I actually put all associations aside. And if things happen to turn up in a painting, leading somebody to say that it implies this or that—of which I am unaware—I make a change.

H.G. *I was, like everybody else, I suppose, a little bit surprised when I first saw your upside-down pictures about three years ago. Now it seems perfectly normal. Not normal in the sense that everybody does it, but normal in the sense that one looks at it as a picture and so it works or it doesn't work, and being upside down has nothing to do with it. It's not even a good excuse to say it's upside down; one can't get away with it.*

G.B. It really is a very important matter because until 1968, I did all I felt I could do in traditional painting. But since I do not believe in traditional painting, cannot believe in it also on account of my training, I started in 1969 to use normal, standard motifs and paint them upside down.

H.G. *Could you define this tradition?*

G.B. Until 1968, there were problems in Germany that did not exist anywhere else. These problems have to do with tradition, a tradition that cannot be continued. Besides, there was a time when this tradition was set aside, and we lost the thread. I had no knowledge of this tradition. Up until 1968, there were always critical voices, negative voices, who said that I stood within this tradition, but I did not know anything of it. And I started to wonder, and I found out that the reason could only be that viewers always think that, if somebody paints a picture in which there is a cow or a dog or a person, that, in addition to what is to be seen in the pictures, something else must be there. I have always seen my paintings as independent from meanings with regard to contents—and also independent from associations that could result from them. If one pursues the logical conclusion of that thought, then it follows that if one needs a tree,

a person, or a cow in the picture, but without meaning, without contents, then one simply takes it and turns it upside down. Because that really separates the subject from its associations, that simply has to be believed; it defies an interpretation of the contents. If it stands on its head, it is delivered of all ballast, it is delivered from tradition.

H.G. *What is so brilliant about the upside-down device is not only does it free the subject, but it allows you to be a painter without the label "Expressionist." The painting can also be as abstract as you want, as far as the brush strokes go, yet it will never be fully abstract. So you don't have to fall into that trap either. It resists Expressionism and it fights Abstractionism.*

G.B. I am German, and German painting is called expressive, not only from the Expressionists' time but also from an earlier time; German art always presents itself as expressive. This starts with the primitive Gothic, then Romantic paintings, and ends with the present. But this modern concept of Expressionism is a word for a particular thing in the 'teens and twenties. It is incorrect to identify my work with that. For me that is out of the question. My problem was what you mentioned earlier: to fend off associations that might appear.

H.G. *On the part of the viewer?*

G.B. Yes, on the part of the viewer. And to make use of the whole abundance of forms in painting.

H.G. *You've made many etchings and, more recently, linocuts. Is that part of an effort to reach a wider audience than is possible with painting and sculpture?*

G.B. I have never let commercial considerations influence my work, and that would be such a consideration. The small editions contradict that idea. Concerning the linocuts, which are extremely large for graphic works, I wanted to try to schematize the pattern I use to make a picture. I wanted to show, in a very simple way, mostly in black and white, the model I use to make a painting. It is a demonstration of my method.

H.G. *So you carry what you learn from the linocuts to the painting.*
G.B. Exactly.

H.G. *When you were a student, even then, did you ever paint what was in front of you?*
G.B. Never. There are people who say they can do everything. One needs talent for that. And I have no talent. I don't know how to paint. I believe that one can invent: one has to invent what one does, and that requires no talent. It will come when you have done a lot of work, certain things will then just happen in the normal way.

H.G. *Talent is very dangerous; character is necessary.*
G.B. Yes, people usually think that talent is required to become a painter. That is accepted opinion because all academies assume it to be true. The idea is contradicted by a lot of painters who didn't possess talent—actually, those who most influenced art history. If you have talent, then you are able to quickly put on a piece of paper what you see out there, so that everybody else can recognize it. I don't have that kind of talent. And what's more, I find that that kind of talent is obstructive. I am more in the position of a layman-grandmother who is told "Paint uncle," and she begins with dots and lines or something like that. I have the same difficulties, the same problems in formulating, in transcribing.

H.G. *Cézanne is an earlier genius with the same problem.*
G.B. He made it seem that way, equally clumsy.

H.G. *When you see early Cézanne paintings, you can't believe that he was trying to represent anything.*
G.B. Oh yes, the lesson of early Cézanne is that when you paint a picture you need an important approach, an important reason, an essential motive. The motivation has to be very important to paint a picture. In the early Cézanne, a crucifixion, or a murder, or a rape was definitely required to fill the canvas. The motif or the representation could not be important enough. Cézanne failed miserably in this. Had Cézanne any talent, he would have been able to do it. Fortunately, he had none.

H.G. *He would not have found painting such a problem right up to the end.*

G.B. Well, I started as a student, as a young man in the G.D.R., also with those momentous things, as far as "contents" were concerned. I painted a Stalin portrait, a portrait of Beethoven, of Goethe: nothing could be important enough. I painted religious topics, but just during puberty.

H.G. *Then what?*

G.B. Then the influence of Picasso followed, because Picasso was a communist.

H.G. *Among American painters, you have mentioned Philip Guston as someone whose palette and way of brushing interested you when you first saw his work in 1957.*

G.B. Yes, I first saw the paintings of Philip Guston—the abstract ones, that is—in Berlin in 1957, in a big American exhibition that toured Europe. I was very excited by them. The Gustons that were done later, his "shoes and socks," are very difficult. Difficult for me, that is.

H.G. *They were difficult for Philip as well. Do you work on sculpture and painting at the same time?*

G.B. Yes. Sculpture work is physically very demanding; one has to conserve one's strength.

H.G. *So it's no good to do sculpture when you are angry?*

G.B. That's the best prerequisite, being angry.

H.G. *Do you find that the sculpture is a rest from the paintings and the paintings a way of resting from the sculpture?*

G.B. No. I believe these are two totally different things. I haven't made sculpture for very long, about four years, and I've made very few pieces. I looked around and there is a tradition in sculpting, a tradition that leads us to people like Carl Andre. And I saw that these people, these sculptors, were working in a fashion that is very far removed from my conception of sculpture. I thought that, as in painting, one has to start making sculptures without the academy, without this intellectual chain, that is.

H.G. *I find it fascinating that the same brush stroke occurs in the paintings of the last four or five years—not exactly the same but with a similar feeling of cutting away—as you have in sculpture.*
G.B. Yes, the impetus or the aggression is the same. My problem is never doing a thing in such a way that it would end up smooth-looking. Rather, I stop when I have achieved what I was trying to do, and then it usually looks quite rough.

H.G. *Do you ever make a drawing on the canvas when you start a picture?*
G.B. No, never.

H.G. *But you sometimes make a drawing if you think it makes a nice picture?*
G.B. No.

H.G. *Because there is a catalogue of yours where a drawing and a painting are always reproduced* en face.
G.B. Well, there are drawings, you could call them *plans*. When I think about a new painting or sculpture, then I draw a sketch. But these are really only schemata, and they are in the end very much removed from the painting in the making.

H.G. *But there are drawings afterward.*
G.B. There are many drawings afterward. After what is possible has been formally settled, then there are many drawings—parallels.

H.G. *Memories of paintings.*
G.B. Yes. You see, it is a technical problem. I never do preliminary drawings on the canvas. I paint in layers, and a preliminary drawing would hinder that process. I often do drawings on graphic works parallel to the paintings, sometimes also photographs to clarify the details on formal questions.

H.G. *What is the origin of the recent influence of Edvard Munch on your work?*
G.B. Influences such as this one are peculiar; I don't know where one takes them from. I don't know the origin. What I like is that

Munch's content is—apart from the illustrations he made—non-content; there isn't any.

H.G. *In the recent Whitechapel catalog, the two manifestos you wrote in the early sixties were reproduced. Maybe it's time for a third manifesto?*
G.B. Those times are gone. A year ago, Penck and Lüpertz and Immendorff and I sat together, and we discussed whether to do something collectively—one should definitely do *something*, we thought, an exhibition or a journal—and we could not even come up with a title for the whole thing! Everybody is simply too busy with work. The belly does not seethe any longer.

H.G. *What are these two paintings?*
G.B. Well, the left one is entitled "Reading Boy" and the one on the right is an eagle. The eagle is hardly recognizable; it is actually hidden in the painting.

H.G. *The "Reading Boy" is very hard to see, too.*
G.B. Oh no, it can be seen quite distinctly in the ground color; but the eagle is hidden in the methodical application of paint. And it has no contours; the other one has contours. These are two principles that come to merge and expand in later works.

H.G. *Do you find that the size of the studio gets into the picture in any way?*
G.B. I worked in the smallest studio that I ever had, in Berlin, for ten years, and painted some very big pictures in it—three by three-and-a-half meters. Now, of course, everything is much nicer, better and richer, but I can make do without it. I believe the size of my studio has no effect on the size of the paintings.

H.G. *You were eighteen years old when you started living in West Berlin in 1956. The first fifteen years of one's life are very formative. What aspects of your childhood do you think are still reflected in your work?*
G.B. I didn't leave East Berlin voluntarily. I had to leave the academy in East Berlin and so went to the academy in West Berlin.

There, the teaching method was abstract painting, and in the beginning it impressed me a great deal. I also painted that way. I proceeded on the assumption that what is visible, in the environment, cannot be utilized for a painting.

H.G. *But the question was about childhood memories.*

G.B. Yes, and in abstract painting—dependent as it is on its origins in Surrealism—one is supposed to utilize those things that derive from the unconscious mind; they should flow into the painting. The source of abstract painting is Surrealism: an automatism must necessarily exist to paint a picture, so that things that lie hidden can come to light. So, in this respect, I have tried to let elements from my childhood come alive in my pictures, although often one cannot see anything of it. But a painting needs an existence of its own. Other than this, I have never really been able to incorporate past experiences or events into my paintings.

H.G. *Were you ever seduced or attracted by abstraction?*

G.B. Yes, in the beginning. That was absolutely fantastic, that was the greatest conception of painting that I had when I came to West Berlin—to paint pictures on which nothing was to be seen!

H.G. *At that time the influences would have been Kandinsky, Ernst Nay and Willi Baumeister . . .*

G.B. Yes, and there were many more farfetched things. The first exhibition that I saw in West Berlin, funny enough, was an exhibition by Emilio Vedova. Then there was a book by Nay that I studied and whose formulas I used to make drawings and watercolors. I tried everything that was within my reach within a half a year.

H.G. *The visual culture around you as a young man included Russian artists like Vrubel and Repin, whereas a Western artist would have no idea of who these people are.*

G.B. Yes, I recognized that my position was a different one than those artists in the West, who were in touch with a tradition that did not completely satisfy me. I started looking for sources that were more in keeping with my personality, and inevitably I hit upon

other outsiders. A real outsider in his own time as well as in the sixties in Berlin was Vrubel. He was just about unknown. His paintings, (which, by the way, I couldn't even see except in reproduction) excited me tremendously. There were a number of other painters who perhaps didn't exactly influence me but whose situation interested me because I thought theirs was similar to mine. For instance, there was Gustave Moreau in Paris. There was one of his paintings at the museum in West Berlin. In the beginning I rejected Moreau's paintings on account of their subject matter—I didn't understand them. Ten years later I reversed my opinion entirely. It was simply that at first, my existence, my position in West Berlin was very problematical, difficult, very constrained, and I had to search for something with which I could identify, with which I could surround myself. I really had to search for that. Actually, it was not there.

H.G. *When you were a student in West Berlin, what cities would you travel to in order to look at the museum collections?*
G.B. The first trips away from Berlin I made in '59, almost three years after I arrived in Berlin. I went to Amsterdam first, to see the Stedelijk Museum. They had a picture there by [Chaim] Soutine that excited me very much and that I had never seen before—the *Side of Beef* of 1925. Afterward, I went to Paris and looked up the Moreau museum. I saw Fautrier there for the first time, and, most important, I saw the late [Francis] Picabia for the first time. And I saw Michaux. These were things unknown to me until then.

H.G. *Was a good art library available to you as a young man?*
G.B. At the academy we had a very good library. I myself had no books, except for literature.

H.G. *You referred earlier to the "New American Painting" show selected by Alfred Barr, which toured Europe in 1957–1958. It included Pollock, Guston, de Kooning; seventeen American painters in all. It must have been a shock.*
G.B. This exhibition took place in the building where we studied, in the academy, that is. The biggest shock was the huge crates in which

Pollock's paintings came. They were so huge that they did not fit into the hall. We had never seen anything like it. That was madness! Pollock had the most paintings in this exhibition and also a separate, very large room. Nothing like it had ever been seen before, and there were no doubts about Pollock or his paintings. Nevertheless, at the academy, Pollock had very little influence, particularly with the younger students. De Kooning had much greater influence because his painting was European, or of European origin, and its means of depiction were more easily comprehended. The most important aspect of the de Kooning pictures at that time was expression—the caricature of a woman which had been painted—her horrible expression. She was showing her teeth, and that was decisive.

H.G. *Did Pollock look wild or controlled when you first saw him?*
G.B. Not wild at all, because I thought the European paintings, especially those that had been painted in Paris, those of the European Tachistes, for instance Brienne—a man who had great influence— that while they were much smaller in size they were more sensitive, more exciting, and were more appropriate to the European framework and spiritual attitude.

H.G. *More timid, maybe?*
G.B. The European ones? No. The other way around. I considered a small painting by Wols or Fautrier more radical than a painting by Pollock. And if radicality is a criterion, then I am still of that opinion today.

H.G. *The development of your painting is very logical, "after the fact." It's not logical before you do it but, once you do something and an art historian looks at it, it has a sequence in your history. But only you can know what the next step will be.*
G.B. That's very interesting, but I don't have the answers either. That's a decisive question. One can provoke plans through additions. One can start with what one has already done, and then add to it formally and come to a sum. But this sum excludes all freedom,

and constricts one terribly. Ambition doesn't satisfy itself in hindsight. I have always tried to avoid this kind of thing. That is why my painting over the past twenty years is not a continual flow, but interrupted by definite breaks. I can prepare myself conditionally, but then tomorrow I have to invent the picture anew.

H.G. *In the course of our discussions you've used the word "position" in a way that I'm not used to. It clearly comes from an orderly mind with a political and philosophical orientation. The paintings are for you an expression of your position, but for those of us who don't know about that, they are paintings by a man who, with great difficulties, frees himself every few years.*

G.B. I mean "position" in the sense of attitude. An attitude that one assumes as a demonstrative act. This is not something that one thinks about beforehand, one is forced into it. A normal course of studies does not include such an attitude. It is outside of the usual teaching methods. This attitude came into being as a form of defense, as self-defense. When I started to paint figuratively in Germany in the late fifties and early sixties, the situation was completely different than it was in America or in France, because we had no hierarchy, no organized painting, no stars. There was just a lot of opposition. The hierarchy where one creates friction, where one accepts and learns, was missing. There was a general opinion that, for example, after the Bauhaus, after abstract painting and Surrealism and the accepted Tachisme, that figurative painting was no longer possible. But I was painting new, or self-invented figurative works. That caused constant fights. I simply was trying to find a position which could give me some breathing space as a painter.

H.G. *Defend yourself from what and opposition from whom?*
G.B. Well, first of all, the academic circles. I had an exhibition together with a friend, Eugen Schönebeck, in connection with the First Pandemonium Manifesto. Our pictures hung there, and a few people came, not many, but what did ensue was a tremendous amount of criticism. There were attacks which sought to take from me what I was trying to do, to take that which made my existence as

a painter meaningful. They said what I was doing was anachronistic. All the doors were opened by all that had been done before. It wasn't possible to start doing it again, they claimed.

H.G. *The fact is that your paintings look "nasty"—how do you translate that? As an art historian I can see that in the future these paintings will look more classical than they do now.*
G.B. I believe that that "nastiness" is probably more a handicap that I have and that many German painters share. It's something I didn't used to like but I couldn't help myself. In the meantime I've grown to love it, and I absolutely can't understand "pretty" painters, like Nolde, for example.

H.G. *How would you say "nasty" in German?*
G.B. Brutal, maybe.

H.G. *Brutal. Once you get a taste of it, it's hard as a public to be satisfied with less.*

Jean-Michel Basquiat

[1983]

In 1976, Jean-Michel Basquiat began "writing" his unique brand of graffiti throughout Manhattan under the name "SAMO." His work from the first consisted of conceptual, enigmatic combinations of words and symbols, executed with the curt simplicity of a late Roman inscription. Graduating from subway walls to canvas and from the streets of New York to the galleries of Soho, Basquiat took the art world by storm with his rampageous one-man show at Annina Nosei's gallery, early in 1982. His first one-man show, perhaps ironically, was not in New York, but in Italy, in Modena. Exhibitions since then have included Documenta 7 and the Fun Gallery, New York.

HENRY GELDZAHLER *Did you ever think of yourself as a graffiti artist, before the name became a middle-class luxury?*
JEAN-MICHEL BASQUIAT I guess I did.

H.G. *Did you work in the streets and subways because you didn't have materials or because you wanted to communicate?*
J.-M.B. I wanted to build up a name for myself.

H.G. *Territory? Did you have an area that was yours?*
J.-M.B. Mostly downtown. Then the "D" train.

H.G. *How did you pick the "D" train?*
J.-M.B. That was the one I went home on, from downtown to Brooklyn.

H.G. *But you knew Brooklyn wasn't going to be your canvas from the beginning. Manhattan was where the art goes on, so that was where you were going to work?*
J.-M.B. Well, SAMO wasn't supposed to be art, really.

H.G. *What were the materials?*
J.-M.B. Black magic marker.

H.G. *On anything? Or something was already prepared and formed?*
J.-M.B. The graffiti? No, that was right on the streets.

H.G. *Did you have any idea about breaking into the art world?*
J.-M.B. No.

H.G. *But when I saw you, you were about seventeen years old. You were showing me drawings, that was four or five years ago. . . . I was in the restaurant, WPA, in Soho.*
J.-M.B. Yeah, I remember.

H.G. *So you already had work to show.*
J.-M.B. No, I was selling these postcards, and somebody told me you had just gone into this restaurant. It took me about fifteen minutes to get up the nerve to go in there. I went in and you said, "Too young." And I left.

H.G. *Cruel, but true.*
J.-M.B. It was true at the time.

H.G. *Were you furious?*
J.-M.B. Sort of. I mean, too young for what, you know? But I could see, it was lunch time. "Who is this kid?"

H.G. *The next time I saw you was about two years later above a loan shop at the entrance to the Manhattan Bridge. I was very*

impressed; I was amazed, especially by the picture I got. Is that going to fall apart? Should I have it restuck, or put it behind glass?
J.-M.B. Anything is fine. A little gold frame.

H.G. *What was your idea of art as a kid? Did you go to the Brooklyn Museum?*
J.-M.B. Yeah, my mother took me around a lot.

H.G. *Did you have any idea what Haitian art was?*
J.-M.B. No. I wanted to be a cartoonist when I was young.

H.G. *When I first met you, you mentioned Franz Kline.*
J.-M.B. Yeah, he's one of my favorites.

H.G. *I heard you'd been spreading a rumor that you wanted to have a boxing match with Julian Schnabel.*
J.-M.B. This was before I'd ever met him. And one day he came into Annina's gallery. And I asked him if he wanted to spar.

H.G. *He's pretty strong.*
J.-M.B. Oh yeah, I thought so. But I figured even if I lost, I couldn't look bad.

H.G. *Whose paintings do you like?*
J.-M.B. The more I paint the more I like everything.

H.G. *Do you feel a hectic need to get a lot of work done?*
J.-M.B. No. I just don't know what else to do with myself.

H.G. *Painting is your activity, and that's what you do . . .*
J.-M.B. Pretty much. A little socializing.

H.G. *Do you still draw a lot?*
J.-M.B. Yesterday was the first time I'd drawn in a long time. I'd been sort of living off this pile of drawings from last year, sticking them on paintings.

H.G. *Are you drawing on good paper now or do you not care about that?*
J.-M.B. For a while I was drawing on good paper, but now I've gone

back to the bad stuff. I put matte medium on it. If you put matte medium on it, it seals it up, so it doesn't really matter.

H.G. *I've noticed in the recent work you've gone back to the idea of not caring how well stretched it is; part of the work seems to be casual . . .*

J.-M.B. Everything is well stretched even though it looks like it may not be.

H.G. *All artists, or all art movements, when they want to simplify and get down to basics, eliminate color for a while, then go back to color. Color is the rococo stage, and black and white is the constructed, bare bones. You swing back and forth very quickly in your work. Are you aware of that?*

J.-M.B. I don't know.

H.G. *If the color gets too beautiful, you retreat from it to something angrier and more basic . . .*

J.-M.B. I like the ones where I don't paint as much as others, where it's just a direct idea.

H.G. *Like the one I have upstairs.*

J.-M.B. Yeah. I don't think there's anything under that gold paint. Most of the pictures have one or two paintings under them. I'm worried that in the future, parts might fall off and some of the heads underneath might show through.

H.G. *They might not fall off, but paint changes in time. Many Renaissance paintings have what's called "pentimenti," changes where the "ghost" head underneath which was five degrees off will appear.*

J.-M.B. I have a painting where somebody's holding a chicken, and underneath the chicken is somebody's head.

H.G. *It won't fall off exactly like that. The whole chicken won't fall off.*

J.-M.B. [*laughs*] Oh.

H.G. *Do you do self-portraits?*

J.-M.B. Every once in a while, yeah.

H.G. *What did you think of James Vander Zee?*
J.-M.B. Oh, he was really great. He has a great sense of the "good" picture.

H.G. *What kind of a camera did he use?*
J.-M.B. Old box camera that had a little black lens cap on the front that he'd take off to make the exposure, then put back on.

H.G. *Do you find your personal life, your relationships with various women get into the work?*
J.-M.B. Occasionally, when I get mad at a woman, I'll do some great, awful painting about her . . .

H.G. *Which she knows is about her, or is it a private language?*
J.-M.B. Sometimes. Sometimes not.

H.G. *Do you point it out?*
J.-M.B. No, sometimes I don't even know it.

H.G. *Do friends point it out to you, or does it just become obvious as time goes on?*
J.-M.B. It's just those little mental icons of the time . . .

H.G. *Clues.*
J.-M.B. There was a woman I went out with . . . I didn't like her after a while of course, so I started painting her as Olympia. At the very end I cut the maid off.

H.G. *Who's harder to get along with, girlfriends or dealers?*
J.-M.B. They're about the same, actually.

H.G. *Did you have a good time when you went to Italy, for the first show, in Modena?*
J.-M.B. It was fun because it was the first time, but financially it was pretty stupid.

H.G. *It was a rip-off?*
J.-M.B. Yeah, he really got a bulk deal.

H.G. *Has he re-sold them? Are they out in the world?*
J.-M.B. I guess so.

H.G. *Do you ever see them? Would you recognize them?*
J.-M.B. I recognize them. I'm a little shocked when I see them.

H.G. *Are there Italian words in them?*
J.-M.B. Mostly skelly-courts and strike zones.

H.G. *What's a skelly-court?*
J.-M.B. It's a street game, with a grid.

H.G. *What about the alchemical works, like tin and lead . . .*
J.-M.B. I think that worked.

H.G. *I think so, too.*
J.-M.B. Because I was writing gold on all this stuff, and I made all this money right afterward.

H.G. *What about words like tin and asbestos?*
J.-M.B. That's alchemy, too.

H.G. *What about the list of pre-Socratic philosophers in the recent paintings, and the kinds of materials which get into your painting always, that derive not so much from Twombly, as from the same kind of synthetic thinking. Is that something you've done from your childhood, lists of things?*
J.-M.B. That was from going to Italy, and copying names out of tour books, and condensed histories.

H.G. *Is the impulse to know a lot, or is the impulse to copy out things that strike you?*
J.-M.B. Well, originally I wanted to copy the whole history down, but it was too tedious so I just stuck to the cast of characters.

H.G. *So they're kinds of indexes to encyclopedias that don't exist.*
J.-M.B. I just like the names.

H.G. *What is your subject matter?*
J.-M.B. [*pause*] Royalty, heroism, and the streets.

H.G. *But your picture of the streets is improved by the fact that you've improved the streets.*

J.-M.B. I think I have to give that crown to Keith Haring. I haven't worked in the streets in so long.

H.G. *How about the transition from SAMO back to Jean-Michel, was that growing up?*
J.-M.B. SAMO I did with a high school friend, I just didn't want to keep the name.

H.G. *But it became yours . . .*
J.-M.B. It was kind of like . . . I was sort of the architect of it. And there were technicians who worked with me.

H.G. *Do you like showing in Europe and the whole enterprise of having a dealer invite you, going over and looking at the show . . .*
J.-M.B. Usually, I just have to go myself and I have to pay my own ticket 'cause I don't know how to ask diplomatically.

H.G. *You are a bit abrupt.*
J.-M.B. And then I usually want to go with friends so I have to pay for them as well.

H.G. *So you end up not making very much money out of your show.*
J.-M.B. It's okay.

H.G. *Do you like the idea of being where the paintings are?*
J.-M.B. Usually I have to check up on these dealers and make sure they're showing the right work. Or just make sure that it's right.

H.G. *I like the drawings that are just lists of things.*
J.-M.B. I was making one in an airplane once. I was copying some stuff out of a Roman sculpture book. This lady said, "Oh, what are you studying." I said, "It's a drawing."

H.G. *I think "What are you studying" is a very good question to ask—because your work does reflect an interest in all kinds kinds of intellectual areas that go beyond the streets, and it's the combination of the two.*
J.-M.B. It's more of a name-dropping thing.

H.G. *It's better than that. You could say that about Twombly, and yet somehow he drops the name from within. With your work it isn't just a casual list. It has some internal cohesion with what you are.*

J.-M.B. My favorite Twombly is *Apollo and The Artist,* with the big "Apollo" written across it.

H.G. *When I first met you, you were part of the club scene . . . the Mudd Club.*

J.-M.B. Yeah, I went there every night for two years. At that time I had no apartment, so I just used to go there to see what my prospects were.

H.G. *You used it like a bulletin board.*

J.-M.B. More like an answering service.

H.G. *You got rid of your telephone a while ago. Was that satisfying?*

J.-M.B. Pretty much. Now I get all these telegrams. It's fun. You never know what it could be. "You're drafted," "I have $2,000 for you." It could be anything. And because people are spending more money with telegrams they get right to the point. But now my bell rings at all hours of the night. I pretend I'm not home . . .

H.G. *Do you want a house?*

J.-M.B. I haven't decided what part of the world isn't going to get blown up so I don't know where to put it.

H.G. *So you do want to live . . .*

J.-M.B. Oh yeah, of course I want to live.

H.G. *Do you want to live in the country or the city?*

J.-M.B. The country makes me more paranoid, you know? I think the crazy people out there are a little crazier.

H.G. *They are, but they also leave you alone more.*

J.-M.B. I thought they'd be looking for you more, in the country. Like hunting, or something.

H.G. *Have you ever slept in the country, overnight?*

J.-M.B. When I said I was never gonna go home again I headed to Harriman State Park with two valises full of canned food . . .

H.G. *In the summer?*
J.-M.B. It was fall.

H.G. *And you slept overnight?*
J.-M.B. Yeah, two or three days.

H.G. *Were you scared?*
J.-M.B. Not much. But yeah, in a way. You know, you see some guys with a big cooler full of beer. And it gets really dark in the woods, you don't know where you are.

H.G. *Do you like museums?*
J.-M.B. I think the Brooklyn is my favorite, but I never go much.

H.G. *What did you draw as a kid, the usual stuff?*
J.-M.B. I was a really lousy artist as a kid. Too abstract expressionist; or I'd draw a big ram's head, really messy. I'd never win painting contests. I remember losing to a guy who did a perfect Spiderman.

H.G. *But were you satisfied with your own work?*
J.-M.B. No, not at all. I really wanted to be the best artist in the class, but my work had a really ugly edge to it.

H.G. *Was it anger?*
J.-M.B. There was a lot of ugly stuff going on at the time in my family.

H.G. *Is there anger in your work now?*
J.-M.B. It's about 80 percent anger.

H.G. *But there's also humor.*
J.-M.B. People laugh when you fall on your ass. What's humor?

Good-bye, Dalí

Salvador Dalí's death, like so much of his publicized life, is taking on a grotesque, even a nightmarish quality. Now in his eightieth year, an *enfant terrible* for as long as he could get away with it, Dalí has lost his wife and mainstay, the redoubtable Gala, and with her his congenital optimism in the face of all that came his way. A depressed and justifiably paranoid old man, shaky with Parkinson's disease, he has retreated into virtual isolation in the beloved Catalonia of his youth, settled in an apartment adjacent to the Teatro Museo Dalí in Figueras.

For several years stories have been circulating, not about Dalí so much as about the Dalí industry; who has access, who's in control and, naturally, where do Dalí and *his* wishes come into the picture. This uncertainty, which has given rise to so much speculation, has its origin in three concomitant conditions, all of which have operated in gear: the phenomenal commercial value of the Dalí signature; the death of Gala, who was the chancellor of the exchequer; and the physically diminished, spiritually exhausted Salvador himself, for whom the *sabor* for life has ebbed away.

A brief shot on the early morning news of Salvador Dalí leaving the hospital in mid-October prepared me for what I would find in Figueras, Dalí's native town, and Port Lligat, his chosen haven twenty miles away. Dalí, the magician, still active and in high gear

in paintings made as recently as 1982 and 1983, was not in limbo. An inhabited shell with imploring eyes was all that remained. Dalí not yet dead, Dalí no longer fully alive—his ego felled, his curiosity wonderfully intact.

In 1926, at age twenty-two, Salvador Dalí was permanently expelled from the Instituto de San Fernando in Madrid by order of the King "for outrageous misconduct." He had gone to Madrid to study painting; in disgrace he deliberately left his luggage behind, signaling a total break with his youthful past. In 1928 Gala, married to the French poet Paul Eluard, visited Cadaqués and met Dalí, who was instantly captivated. "Without love, without Gala, I would no longer be Dalí. That is the truth I will never stop shouting or living. She is my blood, my oxygen." In 1929–1930 Dalí painted *Le Grand Masturbateur*, directly inspired by his love for Gala, who by now was living with him. The landmark Surrealist film *Un Chien Andalou* was written with Luis Bunuel during this time.

Dalí's acceptance in America was virtually immediate. In 1932, Dalí was twenty-eight years old. He had three paintings in an exhibition at the Julien Levy Gallery in New York. It is from this exhibition that The Museum of Modern Art, then three years old, purchased *The Persistence of Memory*, the famous melting watch that instantly became an icon symbolizing all that is bold, "psychological," and up to the minute. It is, in a phrase from its decade that has never been bettered, that Freudian will-o'-the-wisp, THE HAND-PAINTED DREAM PHOTOGRAPH. In 1941, on the brink of America's entry into war, The Museum of Modern Art gave Salvador Dalí a large retrospective exhibition, his first. The text mentions several times his scandalous reputation that has been talked about for a decade.

Dalí's writing and statement throw a screen around his art, obscuring and illuminating sometimes in the same paragraph. He is brilliantly amusing, deliberately obfuscating, and, finally, supremely worth the trouble it takes to shuck the corn to its delicious meat. He has always claimed that he doesn't know what his paintings mean; at the same time he has also hung the most extended, involuted literary-psychological meanings on them. "Be persuaded

that Salvador Dalí's famous limp watches are nothing else than the tender, extravagant and solitary paranoiac-critical camembert of time and space."

Like James McNeill Whistler and Oscar Wilde before him, Dalí makes verbal perverseness and a dandy's aestheticizing stance and garb his signature style. Everything he says is calculated to shock us into thought; he questions your assumptions with the humor of a true hysteric. "What I hear is worth nothing. There is only what I see with my eyes open and, even more, what I see with them closed." "One thing is certain, I hate simplicity in all its forms." "Each time someone dies, it is Jules Verne's fault. He is responsible for the desire for interplanetary voyages, good only for boy scouts or for amateur underwater fishermen. If the fabulous sums wasted on these conquests were spent on biological research, nobody on our planet would die anymore. Therefore, I repeat, each time somebody dies, it is Jules Verne's fault." It isn't only about his own work that Dalí can scintillate. He embroiders explanations of life with so much nonsense and true enigma that we are consistently caught off base. No wonder Harpo Marx is one of his heroes.

"But I myself am living, and I will live without ever liking jazz or Chinese sculpture. I have never been a pacifist. I have never liked little children, or animals, or universal suffrage, or modern art, or El Greco, or theosophy." Sometimes sounding like an auto-intoxicated, highfalutin W. C. Fields, Dalí, along with Picasso, stands apart from his generation of artists; dismissed as a charlatan by the popular press and, consequently, by the public. Charlatan is, of course, a left-handed tribute. What rarely is noted, however, is the unlikelihood of an intelligent and passionate adult acting the charlatan, much of the time alone in his studio, sixteen waking hours for as long as fifty years. If it were possible—what a hero of consistency the charlatan would be: how admirable!

The Gallery of Modern Art, in the underrated Edward Durrel Stone building in Columbus Circle that now houses the New York City Department of Cultural Affairs, was the unhappy dream of A&P heir Huntington Hartford. His *retardataire* and vehement hatred for all that was modern in art, especially abstract painting and

the Museum of Modern Art, so agitated him that he took a full-page ad denouncing both in the *New York Times*. In his Gallery of Modern Art he made his case by exhibiting work by artists that were anathema to doctrinaire modernists; the English Pre-Raphaelites, Burne-Jones in particular, the French academic painters, Bougereau and Meissonier, and, among contemporary masters, Salvador Dalí, the only artist he collected in depth to have a retrospective exhibition at the enemy bastion, the Museum of Modern Art. Dalí's espousal by the know-nothing Hartford polarized opinion about his work and he was cast for the first time since his excommunication from the Surrealist movement by André Breton in the role of the anti-contemporary, an extreme position that was belied by his continuing admiration for Picasso, Miró, and such Americans as abstractionists Barnett Newman and Willem de Kooning. A story is told about Dalí's visit to the great encyclopedic museum in Cleveland in the mid-sixties. Asked what he thought of the collection, Salvador Dalí is reputed to have said, "What kind of shit museum is this, with no Barnett Newman?" Both Dalí and Newman, at the time, were colleagues in the stable of Knoedler's art gallery.

I met Salvador Dalí and Gala in 1962 at a small dinner in Marcel Duchamp's townhouse apartment on West Tenth Street. Duchamp had seen me in a Claes Oldenburg Happening in the East Village several months earlier. The evening entertainment, two related Happenings entitled *Ironworks* and *Photodeath*, called on me to assume several roles. I alternated between sitting quite still and making extreme facial expressions at the public seated only a few feet from the area of the room designated the "stage"; and I wrote with a big pen on a scroll when suddenly a piece of black velvet dropped on me. As with all Happenings, nothing was explained or susceptible to explanation. For many years, Marcel Duchamp had been a chess-playing chum of my boss, Robert Beverly Hale, the first curator of American Painting and Sculpture at the Metropolitan Museum. Duchamp, always curious about art and the vanguard, invited me to dinner as a potential source of information. I had been at the Met for a few years and, of course, admired Marcel Duchamp enormously. I was a bit shaky but delighted to be at his table. The

Dalís' presence was an added fillip. French, with Salvador Dalí's exaggerated and charming Spanish accent, was the evening's language. Well over an hour into the dinner Duchamp asked me what was going on, in Happenings, Pop Art, underground film—the whole range of New York artistic activity. I gave as thorough an account as I could on the spur of the moment, waxing especially enthusiastically on the subject of Jack Smith's film, *Flaming Creatures*, in Dalí's mouth the almost undiscernible FlaaaahMeeng Cray-a-toooRrrresssss. It was at this point that Gala Dalí noticed me. She turned to Duchamp while I was speaking to ask him WHO I was. He explained and she announced in a loud voice, *Pour moi il n'est pas expert*, For me he's no expert. Inflated by Duchamp's attention, deflated by Gala's rudeness, I passed a memorable evening.

Another meal I had with Salvador Dalí took place on the top floor of the Gallery of Modern Art, the Gauguin Room (named for the two unauthorized tapestries after his South Sea paintings). Seated opposite Dalí, I found myself suddenly shy under his watchful glare. We chatted in French and English and, at the end of the meal, he asked me to visit him in his studio at the St. Regis Hotel. I was happy to comply; he continued to fascinate me as an artist and as an amazing contemporary presence, a wild man who had once jumped out of the window at Bonwit Teller in an event planned to publicize his art. A few days later I made an appointment through his long-time personal secretary, Captain Peter Moore. Dalí's startling revelation at this meeting was that he wanted to do a sculpture of my head in gold, with a moving tongue accurately modeled from life. I hesitantly asked him how we would come up with this unpleasant artifact? Dalí said casually, "You cast it from life. Bring it to me." After consulting with a dentist friend in Washington, Dr. Teddy Fields, I unreluctantly abandoned the project. What second and third levels of satiric meaning may have been concealed in Dalí's desire to portray me with *une langue qui bouge*, a moving tongue?

One evening a year later I gave a fund-raiser for Julian Bond, an old friend from Harvard Square (in the summer of 1958). Julian was running for reelection to the Georgia State Senate. After dinner

I took him with me to a party for Peter, Paul, and Mary at the St. Regis. I had known Peter Yarrow since high school and when we ran into each other in the lobby I introduced Julian Bond and Peter Yarrow. Suddenly the old Surrealist of the St. Regis, Salvador Dalí himself, advanced on us, a flush of excitement on his face; "Come up to my studio and I will show you the most *rrreeemarrquable objet* of the twentieth century." Sweeping my friends along with me he led us into the elevator, an oddly assorted crew taking off on a daring mission. I did what I could to introduce everybody, each with a tag line, for example, he sings, he writes laws, he's a Spanish painter. We got to the studio, the door slammed open, and there! under a white sheet! in the corner! stood the most remarkable object of the twentieth century, discovered that very day by the *zeitgeist* himself!! Dalí with panache and grace whisked the sheet away and there stood an eighteen-inch-high rubber incarnation of !!!!!! *LE BOOGS BOONEY*, splattered through his chest and tummy with paint freshly squeezed from the tube with utter prodigality. Yes, Bugs Bunny, the Woolworth version, stood in all his leering innocence, under an inch or so of rapidly applied color; Pop Art, I guess, had met with Action Painting; a new icon for our times was the result. Needless to say we were severally amazed and no one, to my knowledge, has ever heard of *Le Boogs* again.

Dalí adores Art Nouveau architecture and decoration. In Barcelona, one senses the influence of the city on his waking dream, especially in Antonio Gaudi's use of stone as a medium that can droop and melt, that can, as it does in his masterpiece the Cathedral of la Sagrada Familia, aspire to heaven in the fashion of gothic architecture, at the same time as it metaphorically dies and rots into the earth, dripping like the wax candles that are everywhere for sale in Barcelona's gothic quarter. Dalí takes Art Nouveau architecture so seriously that early on he wanted to pursue his identity with it to the point of eating it. One thing about Salvador Dalí, he always goes the extra mile.

Dalí himself first conceived of a museum for his home town, Figueras, as the first example of true Surrealist architecture, a building that would express his art, his humor, and his take on the world.

The art that would hang in the building was to be his collection, what he admired and wanted to share with his public. The town officials of Figueras were adamant that without Dalí's own art in preponderance, there would be no Dalí Museum in Figueras, and, surprisingly, given the track record of municipalities on questions of art, they had the right idea. The Dalí Museum, officially the Teatro Museo Dalí, a large building with four crowded floors and a huge courtyard, is a museum in the traditional sense, a former grand residence filled to brimming with Dalí's drawings, paintings, sculpture, and prints. It is, at the same time, Daliesque in the extreme; crowds of Catalans and a heavy sprinkling of foreign tourists swarm through it, amazed, impressed, and, at some exhibits, elbow-nudgingly giggly. At several points in the museum the public is urged to stop to look through the telescopes at what becomes, at a proper distance, a portrait of Abraham Lincoln, or in another, an arrangement of furniture in a large room that reads, through a framing device, as the face of Mae West. Works from every moment in Dalí's career are unsystematically arranged, with no information, no titles, and no date. Refreshingly Dalí-like, it rhymes with the old magician's nose-thumbing at the official art world and its self-importance. The people, his audience, need only Salvador Dalí—he communicates directly without apparatus. Dalí said it best in 1981; speaking of a catalogue of the collection at the Teatro Museo Dalí, Dalí pronounced that it must be "hypocritical, in a manner to trouble people's spirits." "It is necessary that all the people who come out have false information."

I had read some of Dalí's rhinocentric musings in the art magazines, and, needless to say, found them hard to fathom. One day in the mid-seventies I got an invitation to join the Dalís for lunch at a now defunct restaurant, The Baroque, very near the St. Regis. When I got there Tom Hess, the editor of *Art News*, and several other guests were already seated at a round table in the almost deserted dining room. Dalí instructed us, when Gala swept in about fifteen minutes later, that we were all to stand at our places and applaud her as she approached the table. Puzzled but game, we did as we were told. Lunch, after this off moment, progressed much as

usual. The only other untoward incident was impelled into action by my chatting with the lady to my right—Gala, wielding the weapon-like pasteboard menu, cracked me smartly on the head, with a *moi je suis là aussi*, I'm also here! Ignoring the blow as best I could, I took forceful advice and chatted with her. After the dessert and coffee, before anyone could leap to leave, Gala shushed us all and Salvador Dalí announced that this very morning he had written the most important art historical article of the . . . century . . . I think it was. He was going to read it to us in his amazing Spanish-French-English, and, the event that began the meal, our applauding Gala's entry to the restaurant was echoed perfectly by Gala insisting that, as Dalí read his piece, we all applaud politely until he finished. What little I can remember about the content of that day's lecture was concerned in some way with Vermeer and the rhinoceros horn, an ancient aphrodisiac in the civilizations of the Mediterranean.

The "Dalí question," how good an artist is he, how much of his work and words are to be taken seriously, has always preceded and hounded the enigmatic Catalan. Has he been the court jester of painting in our century? Has he used Surrealism as a theater of techniques, ideas, and images for his own aggrandizement? These "Dalí questions" have never been answered definitively; we are still too close to the phenomenon of his personality to know what is meat and how much is sauce. If he has been a jester (a noble role in the Renaissance hierarchy) has he, like Lear's fool, addressed his puns, visual and verbal, at higher truths?

I think the answer is yes, with the qualifier that the higher truth has always been profoundly autobiographical. This program, which ties all Salvador Dalí's art and explanations to a single logic and value system, has been so savagely adhered to, so openly the single subject of his life's musings, that, unable to take the *son et lumière* that has attended his morbid self-absorption, we have been tempted to shrug and smile at much of his infantilism. The great question that hounds all artists and their posterity, will the work survive the artist's absence, the death of his personality, is asked with particular urgency in Dalí's case and accounts, I believe, for the

constant sandstorm that roils the air when the man and art are considered seriously.

In his fascinating but infuriating spiritual autobiography, *The Unspeakable Confessions of Salvador Dalí*, the artist spends the greater part of the book making every effort he can to gross us out. As a very young boy, Dalí tells us, "My shitting habits, I must say, were not without charm, either. I always tried to think of some perfectly unexpected place: say, the living-room rug, a drawer, a shoe box, a step on the stairs, or a closet. Then I went about it discreetly. After that, I ran through the house proclaiming my exploit. Everybody immediately rushed to discover the object of my elation. I became the leading character in the family play. They grumbled, they yelled, they lost their tempers as time dragged on. I tried preferably to select a time when my father was around so he could see it happen, if not be involved himself. One day, just to make things better, I dropped my doody in the toilet. They looked everywhere for the longest time, but no threat would get me to reveal the place I had chosen. So, for days on end, no one dared open a drawer or set foot on a step without worrying about what they might come upon." All the essentials of the Daliesque drama and call for attention are present in the microcosm of this noisome vignette. Salvador the magician turns dross into gold by making its discovery the object of a "treasure" hunt; hiding it somewhere else each day gives an inconsequential story endless permutations, surprise endings and, at the same time, keeps the action close to home and in control. The fact that almost *all* the drama takes place in Dalí's own mind is yet another constant with his artistic strategies.

The adoration he accords Gala, his elder by a decade, almost from the moment he meets her in 1928, at age twenty-four, is the keystone of his bid for maturity, or rather for the "normalcy" always beyond his grasp. A masturbator until he meets her, his mother-twin, he finds in her his paradigm for heterosexuality; on first seeing her back, "Gala was there, sitting on the bench. And her sublime back, athletic and fragile, taut and tender, feminine and energetic, fascinated me as years before my baby-nurse's had. My most daring action was to graze her hand so I might feel the electric shock of our

mutual desires. I had no other intention than to remain eternally at her feet." Pre-verbal, touch the sense that turns him on, how like a little boy!

From the perspective of 1984 Dalí's achievement is mixed, but, on the whole, more positive than we might have thought a decade ago. In spite of Modernism's continued hegemony over the visual arts in this century, we see another vein that goes straight back to the nineteenth century and Dalí's much-admired French realists Meissonier and Bouguereau; their highly polished and technically breathtaking art had its parallel in every national style of the late nineteenth century. It now seems obvious that the public's slightly salacious adoration of this art, so despised by Modernism, has continued unabated and found popular expression in photography (the Marilyn Monroe calendar) and sharp focused film. Love of the recognizable, the enemy of total abstraction, is more tenacious than we thought. The human need to "see" the familiar, and to feel oneself at the center of the universe, remains amazingly seductive and perhaps even talismanically necessary.

Seen in this context Dalí's special brand of Surrealism, concocted as it was from di Chirico, Tanguy, Miró, Arp, and Ernst, as well as from the Spanish and Dutch seventeenth-century still-life painters, jolts us anew each time we return to it for the very reason that the disorienting visions he constructs so convincingly, the soft bones on crutches, the putrefying cadavers and the melting watch, speak at one and the same time to our secret dreams and fears *and* our guilty love for the precision and shiny glow, the fin de siècle rot, of sentimental realism. Dalí's most successful work introduces new subject matter, dream matter released by Freud, in a most comfortingly rendered vision, his canny crutch for the soft viewer to lean on, to make the unbidden supportable.

It is impossible to think of another painter in our century who has cast as much pepper in the face of his public as has Salvador Dalí. From the beginning he has refused to be judged on his merits; he has taken pride in his ability to continue into maturity and beyond the infantile behavior that so shocked his parents. His credo may well have been, if it worked then, I'll do it again.

Salvador Dalí, the naughty boy who shocked his parents and the King, is fading, but until his light goes out completely, let us not underrate his wit, tenacity, and flair. While alive, and even in his death no doubt, Dalí will always manage somehow to shock us one more time.

Isamu Noguchi
What Is Sculpture?

[1986]

The balance Isamu Noguchi strikes between his deep respect for nature and his always startling originality makes the study of his work constantly revealing. No one knows better than Noguchi when to leave things as he finds them: a few deep chisel marks or a dislocation of five stones from one environment (quarry or beach) to another (garden or art gallery) render the fulfillment of a gesture. Noguchi in his sculpture creates an impression of anonymity: his signature is difficult to remember, or even to imagine. He never opposes himself to nature; his work can be seen as the archaeological remnants of an ancient civilization, or as the harbinger of intelligence from beyond our solar system, fallen to earth with its formal integrity intact. Yet, in the presence of some of Noguchi's works the veil of appearances lifts momentarily to reveal a glimpse of the *numen*, the invisible essence that informs the universe and is as close to the apprehension of beauty as we can come.

Isamu Noguchi arrived at his aesthetic through a wide variety of apprenticeships and philosophical alliances. The stages of his enlightenment are disclosed in his autobiography, *Isamu Noguchi; A Sculptor's World* (1968). Here is the essence of his story—how he discovered and combined elements of diverse traditions to forge his own aesthetic; how he has carried on the direct carving of stone and the sense of proportions of Graeco-Roman statuary; his continua-

217

tion, in the wake of Constantin Brancusi, his first master, of the modernism that was wrested from Rodin's more strenuous humanism; and his alliance with the traditions of China and Japan, from the ceramic *haniwa* figures to his drawings in *sumi* ink. All are tributaries to a river of invention that flows through the artist and resides in his work.

The son of an American mother and a Japanese father, Isamu Noguchi conceived of multiple influences and points of view instinctively and pragmatically. It has been his genius and his gift to make order of a remarkable kind from such complexity.

When Noguchi went to Paris on one of the early John Simon Guggenheim Fellowships, he already knew Brancusi's work:

> . . . miraculous April of 1927 found me in Paris, at the heart of all that mattered. The day after my arrival I sat at the Café Flore and mentioned my admiration for Brancusi. Robert McAlmon, who overheard me, said he would be glad to introduce me. Great good fortune such as this has something of the divine and inevitable. I had not thought of studying with him, yet somehow the words came, and it was understood that I would work in the mornings with him, starting the very next day. He spoke no English, and I no French. Communication was through the eyes, through the gestures and through the materials and tools to be used. Brancusi would show me . . . precisely how a chisel should be held and how to true a plane of limestone.

In 1929, back in New York after his return from Paris, Noguchi rented the topmost studio at Carnegie Hall. There he made portrait heads of several artists who were to become lifelong friends and colleagues, among them Martha Graham and Buckminster Fuller.

In 1930–1931 Noguchi visited China and Japan, staying long enough to become familiar not only with the art but with certain specialized techniques, once again executing work in new materials and styles. Of his stay in Japan Noguchi comments:

> I moved into the cottage of a ditch digger in Higashiyama and applied myself to making terracottas and to discovering the

beauty of gardens and the Japanese countryside. I have since thought of my lonely self-incarceration then, and my close embrace of the earth, as a seeking after identity with some primal matter beyond personality and possessions. In my work I wanted something irreducible, and absence of the gimmicky and clever.

From the start, "something of the divine and inevitable" (as Noguchi characterized his meeting with Brancusi) has attended much of the artist's activities; so it was with his career-long interest in public parks which gained sustenance with his decision to leave New York in 1935.

After describing his stage set for Martha Graham's ballet *Frontier*, the first of such collaborations, Noguchi outlined the circumstances that prompted his departure:

> The WPA (Works Project Administration) was in full swing.
> I did a head of Mrs. Aubrey MacMann (not too flattering,
> I must admit), the New York Director of the Art section, upon
> her request. I only succeeded in gaining her hatred. I tried
> several times to get on the WPA but was refused as being too
> successful to qualify for it. This I considered further proof of
> discrimination against me. It was true that I could make some
> money doing heads even at the depth of the Depression, but
> it was not what I wanted to do. I told them I wanted to do a
> ground sculpture covering the entire triangle in front of Newark Airport, to be seen from the air. They laughed at me. In
> despair, I took off for Hollywood and there made some heads
> for money, with which to make an exploratory trip to Mexico.

In Mexico, a revolutionary social system was finding expression in the works of the muralists Diego Rivera, David Siqueiros, and José Clemente Orozco. While there, Noguchi created one of his most ambitious works, a sixty-foot-long, high-relief mural, *History of Mexico* (1935–1936), in colored cement on brick. Visiting Mexico several years ago, I happened on this mural, still standing in the public market of Abelardo Rodriguez in Mexico City. The sculpted

wall retains its extraordinary compacted energy. While other young American artists were assisting Mexican muralists with their murals in the United States, Noguchi was toiling at the source, in Mexico itself. He recalled:

> It was history as I saw it at the time, from Mexico. . . . It was no doubt biased by my bitter view. At one end was a fat "capitalist" being murdered by a skeleton (shades of Posada!). There were war, crimes of the church, and "labor" triumphant. Yet the future looked out brightly in the figure of an Indian boy, observing Einstein's equation for energy. . . . I sold my car to get back [to New York], but I never regretted having had the opportunity of executing what was for me a real attempt at direct communication through sculpture, with no ulterior or money-making motive.

Noguchi has had an intuitive sense of *where* to work over the decades—Paris in the twenties and Mexico in the thirties—while New York has served as a base of operations from which he continues to make his forays into the world. Through it all, the twin poles of America and Japan have alternated in demanding and rewarding his presence and his attention. This double font of inspiration, combining and recombining in unexpected ways, has consistently allowed him to find ways of making his sculpture yet more essential and irreducible. As we can now see, Noguchi's continuing evolution toward a reductive sculpture parallels that of his early mentor Brancusi.

A recurrent motif in Noguchi's autobiography is the extent to which his intellectual life has brought him in contact with philosophers and artists in the modernist world who, like him, are persistently reinventing the sacrosanct: Constantin Brancusi, Frank Lloyd Wright, Buckminster Fuller, Marcel Duchamp, Martha Graham, Louis Kahn, George Balanchine, Lincoln Kirstein, Alexander Calder, Jules Pascin, Willem de Kooning, Kenzo Tange, John Cage. Even Noguchi's enemies, those who would obstruct his path, like Robert Moses, are now legendary. The range of reference and the drama in Noguchi's career as he recounts it are

mandatory reading for anyone with more than a casual interest in his work.

Balancing the desire for direct, popular communication, Noguchi has maintained a spirit of innovation faithful to Ezra Pound's famous dictum MAKE IT NEW: tradition never slavishly followed, nor overthrown merely for the sake of destruction or innovation. In the context of Noguchi's private imaginings and his sculpture, what "makes it new" is the contemporaneity of the artist in control who cannot but assume the intellect and sensibility of his time.

Months of conversations with Isamu Noguchi have crystallized the sculptor's private concerns about his representation in the American Pavilion at the 1986 Venice Biennale. He refuses to be set on a pedestal as an artist whose work is largely accomplished. Now, as always, Noguchi's eye and heart are abidingly fixed on the work he has under way, and even more resolutely, on the next body of sculpture or the next garden he is eager to undertake.

Nevertheless, his relationship to his own past and its production is an integral one. The Isamu Noguchi Garden Museum, opened in New York in 1985, represents one of the most comprehensive accumulations by an artist of his own work: major sculpture from each period and in each medium are on view in the Museum, including models for realized and unrealized parks and monuments and extensive wall-sized photographs of projects such as the UNESCO Garden in Paris and the Billy Rose Sculpture Garden at the Israel Museum in Jerusalem. The Noguchi Museum is a model installation as well, serving to bring the vitality and variety of the pieces under the control of Noguchi's genius for harmoniously presenting his work.

In working with Noguchi one is not simply dealing with an artist who makes sculpture: the impulse that motivates decisions about what to wear or what food to eat proceeds from the same single unifying sensibility that animates his work. It should not, then, surprise us that he approaches working situations with more in mind than, "What should I send?" to a particular exhibition, but rather with, "What shall I make for this situation, this space, that is appropriate

to it?" His gardens and public sculptures in Detroit, California, and Japan, for instance, all share the double distinction of being *by* Noguchi, as well as *for* a unique set of circumstances.

Bringing all this to bear, Noguchi's approach to the question of what to propose for the American Pavilion has been thoroughly consistent. He has often visited Venice, most memorably, perhaps, with his friend and collaborator Buckminster Fuller; he knows the look and the mood of the city. In 1985, on one of his periodic visits to the marble quarries of Carrara, where in the past decade he has made splendid sculpture use of Italian marble, a counterpoint to his Japanese work in granite, Noguchi revisited Venice and undertook a study of the Pavilion building.

His first decision was to make the marble spiral slide. Taking measurements, Noguchi discovered that the piece as envisioned would fit; it has been crafted of eight pieces of marble fitted together to make up the form. He decided that the slide could not simply stand on the ground, nor would a platform or pedestal be appropriate. Solving this dilemma, he proposed to set the marble spiral on a ground cover, a bed of wood chips.

A major element in the Noguchi presentation at the American Pavilion is the *akari*, or light sculptures, familiar to several generations as something "natural." Learning that Noguchi first designed the *akari* over forty years ago creates a shock akin to the realization that a "folk" song was actually written by someone.

It was in the early forties in New York that Noguchi developed further his ideas about sculpture and its new and traditional roles.

> Everything was sculpture. Any material, any idea without hindrance born into space, I considered sculpture. I worked with driftwood, bones, paper, strings, cloth, shell, wire, wood, plastics, and magnetite which I learned to use at the [1939 New York] World's Fair. The way it works, thin with burlap reinforcing, permits shell-like hollow structures. One day I put an electric light bulb inside, marking the birth of light sculpture. . . . Now with the thinness I could achieve with magnetite, I thought of sculpture in which the light

source was integrally imbedded. More and more we live indoors; perhaps soon, in the atomic age, we will all live in caves. Already the outdoors is missing where much of the sculpture should be seen. They are indoors and artificially illuminated. Thus I felt it reasonable to conceive of self-illuminated sculptures. . . . I thought of a luminous object as a source of delight in itself; like fire it attracts and protects us from the beasts of the night. The self-contained luminous object was sculpture, so far as I was concerned.

Elements in the exhibition include one large *akari*, five feet in diameter, alone in a room, balanced by a sculpture in Swedish granite, a material that Noguchi has used increasingly since the early sixties. His studio in Japan is on the site of a great stone quarry, and he spends part of each year finding and working stone:

> My regard for stone as the basic element of sculpture is related to my involvement with gardens. My own work, I feel, is renewed each time I work in either—periodic activities that thread my life. With earth as with stone, it is the most physical involvement, to which I return with a zest.

This identifies the rationale underlying Noguchi's presentation: the logic of material synthesis and antithesis—illuminated rice paper in balance with granite; illuminated rice paper opposed to granite. In the present exhibition, there is also a cube of dark stone, six feet in every dimension. The bright and the dark, the fragile and the heavy, translucent on one side, opaque on the other, emanating light and absorbing it: these are the antitheses. The synthesis is the effect of the Pavilion experienced in its totality by visitors.

These polarities continue in the other rooms, one filled with a grouping of new *akari*, the other with granite stones Noguchi has brought from Japan and whose position in the gallery was determined in response to the space.

The final element of the Isamu Noguchi installation at Venice is a structure which Noguchi calls the tetrahelix, an inner structure found in biology and physics. For Noguchi, the choice of this kind

of form shapes a fundamental relationship to space: the indeterminacy of nature is exemplified by the tetrahelix, he explains: "It is the mysterious link of creation, its possible core." Another antithesis exists in the scientific and engineering complexities of the helix on the one hand, and the casualness of the found and positioned stones on the other.

Noguchi writes of the appearance in Japan several centuries ago of the spiral lanterns, explaining that *akari*, too, are a form of helix. "I believe *akari* to be a true development of an old tradition. The qualities that have been sought are those that were inherent to it, not as something oriental but as something we need." The statement "not as something oriental but as something we need" carries with it Noguchi's constant awareness of the two major traditions in which he works and his success at bringing them together in new conjunctions. It is one of the few rules that seem to work in matters of art and artists that there is an exact correlation between a man and his art—between a man's character and experience—and the content and appearance of his art. This idea was long unpopular in some modernist circles for whom an artist and his biography are almost incidental and the work is the sole unexplained and unexplainable datum. Noguchi has remarked on this: "Duchamp once said to me, 'Don't do anything that pleases you—only do that which you dislike and cannot help but do. This is the way to find yourself.' But it is also true that we cannot ever be more than we are."

The bilateral symmetry of the American Pavilion at Venice, the home every two years of work by one or more American artists, dictates to a certain extent what can be shown to good effect. The building houses five galleries, two left and two right, with an entry space that serves as the fifth gallery. Outside, there is room for a major sculptural statement. Noguchi has often spoken of the relationship between sculpted space and its architectural setting, "one as measure, the other as void." His collaboration with the Japanese architect Arata Isozaki for the Pavilion is an extension of this belief. In the past few years, Isozaki's reputation as a powerful presence in European and American architecture circles has grown rapidly. His

plans for the Los Angeles Museum of Contemporary Art and the Palladium nightclub in New York City, as well as the Barcelona sports stadium, have gained him a following in the West, where a 1985 exhibition of recent projects was held at the Japan Society in New York.

Noguchi and Isozaki first collaborated at the Seibu Museum in Tokyo in 1985, where Isozaki's tact and respect for the work of the older master provided a series of perfect frames—all of humble but somehow startling materials—through which their sensibilities powerfully and playfully created a third entity. The drama of the installation consisted in the felicity and unexpectedness of Isozaki's juxtapositions, vistas, and occasional isolations of Noguchi's stone and paper sculptures—appropriateness wrested from incongruity.

The success of this collaboration inspired us to call on Isozaki to provide once again the frame for Noguchi's work at the American Pavilion. New work by the sculptor elicited a new series of responses, paralleling but not repeating the spirit of the Tokyo installation.

Isamu Noguchi, at the age of eighty-two, continues testing the notion of sculpture, pushing its limits. His American Pavilion at the 1986 Venice Biennale succeeds in redefining the limits of sculpture in fresh formal terms. And, while the stones, light sculpture, and tetrahelix contribute to a coherent philosophy, the mystery still lingers.

Willem de Kooning

Abstract Landscapes, 1955–1963

[1987]

Willem de Kooning has been a leader of the movement known alternately as Abstract Expressionism and the New York School since its inception. If we mention Arshile Gorky, Jackson Pollock, and Willem de Kooning we name the germinating sensibilities of the "action" painting wing of the New York School. (The others, painters of "stillness" we might call them, Mark Rothko, Barnett Newman and Ad Reinhardt, were admired and admiring colleagues.) De Kooning came to this country from the Netherlands in 1926. He settled first in Hoboken, supporting himself painting houses by day in order to paint on canvas at night. He was forty-four years old before he had his first one-man show. His wry comment sums up those difficult years: "The trouble with being poor is that it takes up all your time." His academic training in art began in his twelfth year (he was born in 1904) and, though much of it was in night courses at the Academy in Rotterdam, he became as proficient at drawing, the basis of academic training, as any artist in this century. At the same time his skills in all the techniques of commercial art, especially his favorite, sign painting, were being mastered on the job.

From the time of his first inclusion in exhibitions, de Kooning has been recognized and, increasingly, his work has helped focus international attention on American art. It is rarely noted that on

his arrival in New York he was already thoroughly grounded in the
Dutch avant-garde movement of his own day, de Stijl, the reduc-
tionist painting and design of Mondrian, van Doesberg and the
others. He was also familiar at firsthand with Dutch Art Nouveau,
the dominant style of his own childhood. But, as de Kooning has
said, "Style is a fraud. I always felt that the Greeks were hiding be-
hind their columns."

It is possible, now that his great work is done, to look back at fifty
years of painting by Willem de Kooning, and to discern clearly the
shape of his achievement and the progress of his formal concerns.
As ever, much that seems perfectly logical and explicable after the
fact was invisible at the time of its creation.

In order to describe his painting and its shifts in style in the years
under consideration, 1955–1963, we must first consider his series,
Women, that so obsessed him after 1950, the year in which he in-
vented the radical format that expresses so well his amazement and
trepidation at the fact and the idea of Woman.

Up to the middle nineteen fifties virtually all of de Kooning's
work was figural. This bewitchment can be traced back to his aca-
demic training in Holland and to his natural fascination with the
human form as portrait and self-portrait, the classic concern of
Western art from the time of the Greeks. The human body as a rul-
ing passion would be hardly worth mentioning were it not so rare
among postwar artists of the avant-garde. Francis Bacon in the late
forties, his first paintings we know anything about, was poised on a
similar knife-edge between the figure and its deliquescence into
paint. But, grand as he is, Bacon never carried his search any fur-
ther than its first adumbration, whereas de Kooning would con-
stantly alter the balance between figure and ground, between his
concern for the female figure and his growing passion for land-
scape—on the same canvas.

On the subject of his Women, Clement Greenberg once told de
Kooning, "It's impossible today to paint a face," to which de Koo-
ning replied, "That's right and it's impossible not to."

His canvases have always had joy, playfulness, and ribaldry

among their attributes; packed with shapes, allusions, actions, and counteractions, they pile ambiguity on ambiguity; sometimes, it would seem, they are painted at lightning speed, at others in a more relaxed contour-loving gesture. De Kooning's work sustains a fusion of perceptions, feelings and ideas which—as his great friend Thomas Hess wrote—"succeed by banishing nothing."

"In art," de Kooning has said, "one idea is as good as another." The extent to which Willem de Kooning pulls his images and his energy from within is clear in what is perhaps his most famous statement:

> The argument often used that science is really abstract, and that painting could be like music and, for this reason, that you cannot paint a man leaning against a lamp-post, is utterly ridiculous. That space of science—the space of the physicists—I am truly bored with by now. Their lenses are so thick that seen through them, the space gets more and more melancholy. There seems to be no end to the misery of the scientist's space. All that it contains is billions and billions of hunks of matter, hot or cold, floating around in darkness according to a great design of aimlessness. The stars I think about, if I could fly, I could reach in a few old-fashioned days. But physicists' stars I use as buttons, buttoning up curtains of emptiness. If I stretch my arms next to the rest of myself and wonder where my fingers are—that is all the space I need as a painter.[1]

It was in the mid–nineteen fifties that I first started visiting New York art galleries with any consistency. At school in New Haven I found it easy and exciting to get down to Manhattan on a Saturday morning. Already aware of de Kooning's work, and of his primacy in the view of so many artists of the generation that followed him, the second-generation Abstract Expressionists, as they were called, I listened with the shock of youthful idealism to the discussions of

[1] Willem de Kooning, "What Abstract Art Means to Me," originally written for a Museum of Modern Art symposium, *Museum of Modern Art Bulletin* 18, no. 3 (Spring 1951).

de Kooning's new work in the bars and back rooms and studios of the day. Over and over one heard expressed such sentiments as: Sure, he's the best, but can he keep it up? O.K. sure he's great but what's new in his work, and more of the same.

Sadly it seems to be a peculiarly American obsession—is the best still the best? Prove it at the box office, prove it in every public opinion poll. Only an ego of obsidian can withstand this kind of pressure. And we do it in all fields; think only of Marilyn Monroe (a major heroine to de Kooning) and Henry Kissinger and Michael Jackson. It is almost as if we raise up in order to swat down.

Pressure from another direction was provided as well by the premature death in 1956 of his great colleague Jackson Pollock. Just as, in the same years, Picasso was to feel in his work the burden of being both Picasso and Matisse after the latter's death in 1954 as in *The Studio, Cannes* (1956) and *The Bay of Cannes*, de Kooning labored under the shift in weight to his shoulders of Pollock's presence occasioned by his death. De Kooning's intuitive decision to absent himself from all the nonsense of career pressure sent him out to Eastern Long Island (where Pollock had lived and was buried). It was because de Kooning was interested in everything about art except his own career that he first bought a small house in Springs in 1961. He had a wonderful studio built to his specifications ready for tenancy in 1963, the year of his definitive move from Manhattan. With his own ideas about light and his own considerations of space de Kooning served as his own "action" architect, building walls and tearing them down until he got it right. All this clearly was in aid of a rebirth, a second beginning.

De Kooning's paintings of 1984 and 1985 change once again in a manner unpredictable from what preceded them. The last paintings, the work of an eighty-year-old artist, reduce the anatomy of his previously fully fleshed abstract women and landscapes to their very bones. They slide and they slip and they have an unpleasant echo to them.

Since the sixties the movement in de Kooning's work has been toward greater simplicity and clarity of forms, and fewer of them; the color increasingly light and heightened toward yellow, which,

as Matisse noted in a lecture, is a particularly difficult color to use in large expanses.

The relief that de Kooning felt at the removal to the country was not unalloyed. It was impossible not to feel some anxiety and regret at committing himself to a life in the woods after five decades of life in cities. On first moving out he declared, "I'm no country dumpling." Several years later, relieved to find his inspiration waxing rather than ebbing in The Springs, he said, "I'm very glad to see that grass is green. At one time it was very daring to make a figure red or blue. I think now that it's just as daring to make it flesh-colored." For years de Kooning would not sit still for a retrospective exhibition. "They treat the artist like a sausage, tie him up at both ends, and stamp on the center Museum of Modern Art, as if you're dead and they own you."

In 1968 he relented. In the book that accompanied de Kooning's retrospective at the Modern, Tom Hess divided the artist's career into "stages" which, as with so much of his analysis of de Kooning's work, remains uncannily cogent. In the years that most concern us here, Hess noted the progression as follows:

Abstract Urban Landscape, 1955–1958
Abstract Parkway Landscape, 1957–1961
Abstract Pastoral Landscape, 1960–1963

The six paintings in the current exhibition can be cogently described by these categories. The loosening of de Kooning's tension, the ways in which he decisively moved away from the scratchy and conflicted work of the mid and late fifties are taken into account. Jackson Pollock's death, such a deeply felt wound, seems, after the passage of two or three years, to have relieved, and released, de Kooning's own spirit, allowing him to be only and purely himself. With an artist so spectacularly gifted in his writing as in his brushwork it is well to leave him with the last words.

"The pictures done since the Women, they're emotions, most of them. Most of them are landscapes and highways and sensations of that, outside the city—with the feeling of going to the city or coming from it. I'm not a pastoral character. I'm not a—how do you say

that?—a 'country dumpling.' I am here and I like New York City. But I love to go out in a car. I'm crazy about weekend drives, even if I drive in the middle of the week. I'm just crazy about going over the roads and highways . . . the big embankments and the shoulders of the roads and the curves are flawless—the lawning of it, the grass."[2]

[2]From "Content is a Glimpse," excerpts from an interview with David Sylvester for the BBC, reprinted from *Location* 1, no. 1 (Spring 1963).

Alice Neel

[1985]

At the time of this interview, July 1984, Alice Neel was recovering from surgery. We met in her New York studio and apartment on West 107th Street. Well into her eighties, Alice was both chipper and vague, excited to have a visitor but unable to concentrate for long. Flashes of the old Alice—funny and sharp, always a little mordant—lit up the rosy and dimpled face she showed the world. Between our two sessions, a week apart, Alice Neel flew to Los Angeles with her daughter-in-law Nancy to make her second appearance on "The Tonight Show." While clearly not at the top of her form, Alice was still enjoying herself.

Her life had never been easy. She started to paint as a young woman in the mid-1920s. Except for her close circle of friends, leftists and intellectuals, Alice Neel remained virtually unknown even in the art world until the early sixties. Her portraits of friends and family had a homemade, knitted quality that reminded us of primitive painting, but were always so trenchant, so well observed that one knew that a keen intelligence and a lot of psychological savvy were at work. It was with the publication of a monograph on her work by Harry N. Abrams, in 1983, that her full achievement could be assessed for the first time. There is to be an important retrospective of her art at the Pennsylvania Academy of Fine Arts in Phila-

delphia from January through March 17, 1985. Alice Neel died on October 13, 1984.

HENRY GELDZAHLER *I saw you last night on the Johnny Carson show.*

ALICE NEEL I knew a woman in California and her husband was the brother of a man I lived with for a number of years. She didn't like me, though. She came into the house and turned on the TV and she saw me on the Johnny Carson show, and she dropped dead on the floor. Isn't that strange?

H.G. *The perfect murder. No clues, no motive . . . Our first subject is going to be photography. Have you ever taken photographs? Are you interested at all in the ways some artists use photography?*

A.N. No. I never use photographs, but I lived with a man for many years who was a great photographer [Sam Brody] and through him I had an interest in photography. And I also was involved with *Aperture*, the magazine and book publisher. They published an August Sander book [*Photographs of an Epoch, 1904–1959*] that I think is remarkable.

H.G. *With the human figure "coming back," how do you feel about the big issue today, that artists ought to be taught how to draw from casts, taught anatomy? How important do you think it is to have that kind of old-fashioned, formal education?*

A.N. Well, I'll tell you what I didn't like: the New Realism. I couldn't stand that.

H.G. *It was cold.*

A.N. You'd have a table, a chair, and a person. And they thought the person is part of the composition, that it's no different from a table.

H.G. *They don't make choices. They think they're being fair, but by being fair they're not actually making art.*

A.N. They're just stupid.

H.G. *You studied at art school. Do you think that's important?*

A.N. Oh, yes. For me it was. I came from a little town. Before I went

to art school I used to copy covers of the *Saturday Evening Post*. You know, the gorgeous girl with her hand out and a drop of rain falling.

H.G. *Did you take any anatomy lessons?*
A.N. No, I didn't. I couldn't depersonalize people enough. I mean, I couldn't make a head an egg.

H.G. *That's what your art is all about, the "person" of the people you're sitting with.*
A.N. Yes, to personalize people.

H.G. *You're a translator.*
A.N. That's what I am really, yes. A sympathetic, or sometimes *not* so sympathetic translator.

H.G. *Do you paint the same way no matter where you are? Or, would you paint differently in the country or in the city, or in a big room or a small one?*
A.N. If I had enough money I'd experiment with that. I mean, I love this house, but it's definitely about a hundred years old. So I wouldn't mind trying for fun, living in a very modern place, you know, where nothing sticks out.

H.G. *Can you look at a painting and tell the politics of the artist from it?*
A.N. I think you can if you look at two or three paintings.

H.G. *How would you do that?*
A.N. Well, it's there. You might not know everything, but you'd know a lot.

H.G. *I think your work, for instance, is clearly the lifelong work of someone whose greatest interest is people.*
A.N. Yes.

H.G. *And the reason that I didn't know how good you were, when I first knew you, was that the Abrams book hadn't appeared. I didn't know your early work. I didn't realize how many choices you had made in order to get to where you are. I thought that you were painting the way you had to paint, not the way you wanted to*

paint. A sort of primitive painter. But there are pictures that you've made that are absolutely amazing, in the 1920s as well as recently.
A.N. Don't you like them?

H.G. *Sure, but you could have gone in the same direction as Odilon Redon.*
A.N. Oh yes, *Silence* [In the Museum of Modern Art collection]. I love that.

H.G. *Grandma Moses was clearly a primitive.*
A.N. She was an American vegetable.

H.G. *Does a good subject make a good painting?*
A.N. A good *artist* makes a good painting. Do you know when I painted *Fire Escape*? 1964. And do you know what that painting shows? That realism can be as good as abstraction.

H.G. *Well, that realism can be as abstract as abstraction.*
A.N. Yes, that's it. That's right.

H.G. *Other than Robert Lowell, is there anybody you didn't paint that you wanted to?*
A.N. Yes, let me think. Do you know who I wanted to paint and I had an idea of painting? That poet who went to England and died.

H.G. *W. H. Auden.*
A.N. Auden. Because you know why? The cracks in his face—you could have mapped him by inserting pieces—the wrinkles were so deep. It was like a collage. . . . I painted Allen Ginsberg.

H.G. *He's going to be sixty next year, and his collected poems are being published.*
A.N. He's sixty? I know him quite well. I liked "Howl."

H.G. *I also like the poem about his mother, "Kaddish."*
A.N. Yes, that was wonderful. We went to the play. I think he's very bright.

H.G. *He is and at the same time he's kept a sort of childlike naive quality.*
A.N. That's nice.

H.G. *It's charming. You can only write poetry from a kind of innocence, I think. You have to be able to hold onto that. During your lifetime as an artist the whole question of women as artists has come up and almost driven us around the bend. What's your feeling? Were you stopped by being a woman?*

A.N. I don't really think so. I also don't think there is woman's art and man's art. I think there's just art, don't you?

H.G. *Yes.*

A.N. And if you shut yourself up in a room to paint, you don't think of yourself as being a woman or a man. I never, for example, like Simone de Beauvoir when she said, "I couldn't accept the inheritance of the world because it was male-oriented," You can't make a new world. . . . You have to accept that influence because there is no other.

H.G. *Why do you think there were relatively few women artists and now there are more?*

A.N. Well, I do think encouragement means something.

H.G. *What did you think in the 1930s of the politics of the social realists: Ben Shahn, Philip Evergood, Robert Gwathmey?*

A.N. They weren't awfully far left. I knew people who were much farther left.

H.G. *This left-wing business fascinates me, because artists during certain periods are involved with politics as much as they are with art. The thirties were certainly such a time. Can you, for instance, teach through art? Can you teach kindness or concern? Anything humanistic from the way you paint? I'm trying to arrive at whether or not the politics of an artist gets into his work.*

A.N. Well, in politics and in life I always liked the losers, the underdog. There was a smell of success that I didn't like.

H.G. *Success smelled corrupt.*

A.N. Yes. And it always implied a certain kind of conformity.

H.G. *The world finally caught up with you.*

A.N. [*laughs*] Yes, that's quite true.

H.G. *It's nice to live that long.*

A.N. There's one thing about living that long—you can look back and remember that what they do now was despised thirty years ago. I used to think I knew a lot about food because I knew all these health fanatics, but now everybody eats good bread.

H.G. *In your book you say that you went to see a psychiatrist.*

A.N. Yes, he wasn't really deep, but a nice fellow.

H.G. *You didn't need a deep one—just someone to help you get on with your life.*

A.N. He used to tell me to be bold, to enter my work in competitions. He helped me in practical ways. I was timid. It was 1958, and I was pathologically timid. If I hadn't gone to him I would never have been known. I really enjoy putting a picture on the shelf. I wasn't ready for the world. He also encouraged me to invite Frank O'Hara, the poet and curator of the Museum of Modern Art, to see my work and pose for me. So, in 1959, I called him up and did his portrait.

H.G. *What sent you to a psychiatrist?*

A.N. Well, when I was younger I did have a frightful nervous breakdown. Did you read about it in my book? Some woman told me to "Take it out, it's not about art," she said. I said, "Sure it is, it's about my art."

H.G. *Of course. It helps explains the work before and after. The story you tell about the breakdown in your book is very touching and, at the same time, informative as to your mental state at the time.*

A.N. I think so.

H.G. *What do you like to read?*

A.N. I'm a big reader. Ford Madox Ford, Hemingway . . .

H.G. *It seems from looking at the book on your paintings the pictures were pretty much 25 inches by 36 or 30 by 40 for many, many years. And then in the middle sixties you began to paint bigger. Was that because you had more money to spend on materials, or because you were more confident?*

A.N. I think that if the figure hadn't been so damned in the art world I would have done much bigger ones sooner.

H.G. *Why did you do so little landscape? When you did do them they were wonderful. Is it that people interested you so much more?*
A.N. Yes, and I sold all the landscapes at very small prices.

H.G. *Would you be more likely to say yes to selling a landscape than a portrait?*
A.N. No, it's just they never wanted a portrait [*pointing to a figure in one of her paintings*]. He looks like an Albright [Ivan Le Lorraine Albright, Chicago-based American surrealist-realist painter].

H.G. *Albright just died this year. He was close to ninety. And in the last year and a half of his life he did a series of self-portraits, about fifteen of them, which I saw on view at the Chicago Art Institute recently. Beautiful!*
A.N. Good . . . Did he make himself horrible?

H.G. *Not as horrible as the painting of Dorian Gray he did for the 1940s Hollywood film of the Oscar Wilde story. No, he was quite honest and intimate. Like Rembrandt. The self-portrait at the end of an artist's life is a very interesting subject . . .*
A.N. Rembrandt at twenty-four made a self-portrait where he's laughing and you see his teeth. It's so wonderful.

H.G. *But a portrait of yourself laughing has to be done from memory because you see it and then you paint it, but you can't laugh and see it in the mirror and paint it all in the same moment. . . . Have you ever painted night scenes during the day?*
A.N. [*laughs*] That's a wonderful question to ask. You're trying to drive me mad.

H.G. [*laughs*] *Did you ever paint at night?*
A.N. Yes, I've painted at night; you have to use two normal bulbs and one daylight bulb. Then the painting is the right color, otherwise it's yellow.

H.G. *Did you ever do portrait sittings where you'd start in the day and the next session would be at night?*
A.N. No.

H.G. *It wouldn't work.*
A.N. No. Now look, Cézanne went even further than that. Cézanne insisted on the same kind of day, the same time, the same weather, and he had something like ninety sittings for a shirtfront. He wouldn't work on it just any day, it had to be a day like they'd had before. . . . He got the nuances of color so beautifully.

H.G. *What are some paintings that you've worked on longer than the others?*
A.N. Well, the one of Nancy [AN's daughter-in-law, Nancy Neel], and the rubber plant, which is eighty-six inches high.

H.G. *How long did it take you to paint it?*
A.N. Well, I'll tell you. I was so glad that I could keep on painting on it without losing interest. Because do you know what happens to me? At a certain point I just lose interest. And I never just paint for the sake of painting.

H.G. *In other words, when you say you lose interest, you've gotten down onto the canvas the part that interests you.*
A.N. Everything that I'm interested in.

H.G. *And you don't want to fill in the rest. We were talking earlier about the size of your pictures, and you said you would have painted bigger pictures if the figure had been treated with greater respect when you were younger. Do you mean if you had been supported better?*
A.N. No. It had nothing to do with money. It was just the attitude of the world. They tolerated the figure but they didn't really like it. And they didn't encourage. I could have done groups of people, not those hideous groups that women's libbers do, but real groups of people.

H.G. *Take your* Still Life, Black Bottles *(1977). Somebody who thinks they can describe a typical Alice Neel painting would never*

think that you would do something as strict and as abstract and as correct as this.

A.N. Don't you like it? Well, you know what that was? That was because I remembered doing still lifes in school and I thought, "Wouldn't it be interesting to do one now." I like that, don't you?

H.G. *It's beautiful. I read it as a morality lesson about strictness and the old WASP stiff upper lip. Always show your brave side. . . . What can be taught? Students ask me, should I go to art school, should I go to college? What would be your answer to a talented kid of eighteen or nineteen? The world, art school, or university?*

A.N. If they love art and they really want to be an artist I'd say art school. Just like with my son Hartley, when he decided to be a doctor they made him into one. You see, when you're a doctor you're in a hospital all the time, all you see is sick people. The world is bounded; the same with art. Even if your teacher is bad you're breathing the atmosphere, you're surrounded by oil and canvas and models and other students. The influence of the other students is always there. You're always concentrating on art. So wouldn't you say art school?

H.G. *I might say that the fact of asking the question probably means that you should go to a university, because if you're going to be an artist you're so nuts you'd do it no matter what. The artists I know who are very young become obsessed so early they just want to do art. Can anything be taught in art?*

A.N. Not much.

H.G. *What about technique? How paint moves, is thinned, et cetera.*

A.N. Well, I hate to separate technique from product. I never did, although I do change technically in certain ways.

H.G. *Did you learn anything in art school that was useful, or just the idea that art was an obsessive, all-engrossing occupation?*

A.N. Well, you see I was already twenty-one. I had already taken secretarial jobs because my family had no money and I felt I should

help them, I really overworked myself. I almost made it so that I couldn't paint because art is a kind of freedom.

H.G. *But freedom is painful when it has no . . .*
A.N. Basis.

H.G. *It's just wild.*
A.N. That's what they're trying to do now.

H.G. *That's why you had your nervous breakdown. It was freedom before you had the experience of life and the character to be able to stand up under it. Does that make sense?*
A.N. Some terrible things did happen.

H.G. *You've never made it easy for yourself.*
A.N. Oh no, just the opposite. There's a transvestite, her name is . . . What's her name?

H.G. *What's the point?*
A.N. Well, I'll tell you. She told me, "I've been a woman for twenty years." She's really a man, you know, and I said, "That's nothing. I've been a woman for eighty-four years."

Lichtenstein's Picassos: 1962–1964

[1988]

Analyzing the achievement of American Pop Art, one is amazed to find how many of the very best works were made between 1962 and 1964. Those were the classic years. Looking back, we can come up with a few reasons why this might be so. It was early enough in the movement that options were still open; individual artists were still claiming whole areas of subject matter as their fiefdom, and it was early enough for the enthusiasm of a common purpose to be unselfconsciously sustained. For Roy Lichtenstein, the *Picasso Women* series brings this classic period to a close, while at the same time signaling many of the new subjects and ideas that the artist would come to explore.

There are several aspects of Roy Lichtenstein's Picasso paintings that make them unique in his oeuvre. More than any of his painting before or after, they seem to insist on an uncomfortable presence. They are harsh and spiky interpretations, distant and unsentimentalized. Not only is there little wit or effort to please (as in so much of his work), these paintings are mercilessly stripped down to their armatures. In decoding Picasso, Lichtenstein removes any trace of the touch, or the manipulation of paint. It is just this skirmish between the painter and his canvas, the sense of "engagement" in Picasso's work (especially in the thousands of portrayals of women that make Picasso's work a moving diary of his emotional

life), that Lichtenstein chooses to eliminate. Devoid of this sense of psychological playfulness, Roy's *Picasso Women* have a feeling all their own, a demeanor of cool and imperturbable dignity, with more than a suggestion of "Keep your distance."

There is also, to my mind, a strong undercurrent of anger to these works—occurring at a time of great stress and anguish in the artist's life, when everything was suddenly in question: teaching, marriage, family life, and with all this a restless yearning to break out of the by now limiting strictures of his classic Pop style. These paintings contain the angst that Lichtenstein had to externalize before he felt free to guide us through the rest of the twentieth century with the parodic elegance of all that came after in his career.

On another level, Lichtenstein's engagement with Picasso was a way of getting back in touch with the "high art" that first inspired him, without relinquishing his new style. These paintings were a mediation between Pop and "high" art—a distinction that Lichtenstein would proceed to erase in the subsequent two decades. Roy's *Picasso Women* are his Emancipation Proclamation, the freeing of his own personal and professional (professorial) soul, to follow a relentlessly individual path in twentieth-century art.

With crisp black outlines, Ben Day dots, and undifferentiated areas of primary color, something elemental is at work: the need to strip the artwork of all artifice, to gnaw as close to the bone as possible. Lichtenstein is subverting the stodgy world of art history and art education almost as if his amused but critical stance was his revenge for all those years of Academia.

In his essay *The Glorious Company,* Leo Steinberg makes a crucial distinction between the working methods of Renaissance artists and those of the twentieth century:

The blame rests on the artists. It is they who traditionally—before the catastrophic unmasking performed by twentieth century art—covered up what they were doing. It was their thing to deliver quotations as if they were improvised, to incorporate borrowed goods with their own, to naturalize every immigrant presence as if it were native, making the most

studied rehearsal of previous art emerge like a novelty, a first glimpse. They were terribly good at it; and only occasionally, like classical actors addressing asides to the audience, would they let us in on the act, promoting us to the dignity of accomplices.[1]

By way of contrast the modern artist revels in his sources, to the point where the appropriation of earlier art is one of the dominant themes in the art of this century. A glance at the index of *Art About Art*,[2] a seminal text on the subject, shows Lichtenstein most often cited—thirty times; Picasso is second, with seventeen.

The modern artist makes no attempt to hide his sources; he affirms them. We are increasingly familiar with the widest possible range of art, old and new, through color plates in books, through travel, and through ever expanding and proliferating museums of art. Consequently the audience for art recognizes and enjoys the play of influence and counter-influence. In many ways the modern artwork exists as a frame for all the art that came before it. A further irony is that a work of art is almost never examined firsthand during the process of copying; it is always done from a reproduction.

Recently I spoke with the artist about his Picasso series.

HENRY GELDZAHLER *Why Picasso?*

ROY LICHTENSTEIN It was always an interest, back, I think, to some books I had as a kid.

H.G. *Did you select Picasso to counter all those arguments from the early days, that you weren't serious—all that comic stuff?*

R.L. No, it was that I was fascinated by the simplicity, the reductability of it all—black outlines and simple flat colors—like a comic strip, but still Picasso. And, I was reacting against the holiness of high art/low art. That seemed to be the way the Abstract Expressionists saw things. Also, I have always thought that Picasso was quite uncomplicatedly the best artist of the century.

[1]Jean Lipman and Richard Marshall, *Art About Art*, Introduction by Leo Steinberg (New York: E. P. Dutton in association with the Whitney Museum of American Art, 1978), p. 15.
[2]Ibid., p. 160.

H.G. *You frequently use sources or quotations outside of yourself.*

R.L. I often use quotes in the way folk songs are used in Tchaikovsky or Stravinsky, or the way jazz musicians take a familiar phrase, often from some popular song, and hide it or embellish it in their music.

In 1972 Diane Waldman asked Roy why he had limited himself to Cézanne, Picasso, and Mondrian in the early sixties: "I really didn't want to go through a whole roster of artists. I only did it when a specific painting or group seemed right. I chose images that had become public and clear and conceptualized. Generally, this is true of all the work I've done." Asked about his early Pop paintings, did he always paint them in series or did he work on them separately? "To begin with, I did as many different things as I could; products and objects and girls and war, all at the same time. Later I tended to focus more on single ideas."[3]

In further explaining his choice of Cézanne, Picasso, and Mondrian, Lichtenstein noted that "they just fit in. Mondrian used black and white and the primary colors. He was an obvious one to do and so was Picasso, in that Picasso is thought of as using simple colors and shapes surrounded by black lines." Here Roy is speaking of the Picasso of the thirties and forties, the Picasso of the years of Roy's initial passion for art. "I was interested in doing other artists' work not so much as they appear but as they may be understood— the idea of them, or as they may be described verbally."[4]

When asked about Mondrian—isn't he regarded as a rigid or dogmatic painter? "I think his work looks superficially rigid. But it couldn't have been done without an inner flexibility."[5]

As the critic Nicholas Calas wrote, "During the 1920's Surrealism was Cubism's anti-art, as Pop Art is the anti-art of Expressionism."[6]

As one of the most popular and articulate artists of his generation, Roy Lichtenstein has been asked every question and answered

[3]Diane Waldman, *Roy Lichtenstein* (New York: Harry N. Abrams, 1972), p. 27.
[4]Ibid., p. 27.
[5]Ibid.
[6]Lucy Lippard, *Pop Art* (New York: Praeger, 1966), p. 163.

them all thoughtfully and snappily. Questions abounded concerning his and Pop Art's sense of legitimate subject matter. How do you justify your attempt to elevate the processes of commercial art to the status of the fine arts? "We like to think of industrialization as being despicable. I don't really know what to make of it. There's something terribly brittle about it. I suppose I would still prefer to sit under a tree with a picnic basket than under a gas pump, but signs and comic strips are interesting as subject matter. There are certain things that are usable, forceful, and vital about commercial art. We're using those things—but we're not really advocating stupidity, international teenagerism, and terrorism."[7]

"I came to Pop Art by way of Expressionism, by abandoning my own taste in that direction. This was not easy for me."[8] "We think of the last generation as trying to reach their own subconscious while supposedly Pop artists are trying to get outside of the work. I want my work to look programmed or impersonal but I don't believe I'm being impersonal while I do it. Cézanne talked about losing himself. We tend to confuse the style of the finished work with the methods [by] which it was done. Every artist has disciplines of impersonality that enable him to become an artist in the first place."[9]

The complexity of Lichtenstein's position is evident in his adroit and reflective responses. His paintings remain as startling as they were at the moment we first saw them. After all the analysis they have undergone, like Picasso's Women, they continue to smile, and keep their secret.

[7]Interview with Gene Swenson, in Lippard, Pop Art, p. 86.
[8]Waldman, Roy Lichtenstein, p. 26.
[9]Interview with Gene Swenson, in Lippard, Pop Art, p. 86.

Andy Warhol Prints

Catalogue Raisonné

[1989]

Andy Warhol's career as a printmaker and as a painter are inextricably intertwined for the excellent reason that he employs the same silkscreen technique in both media. Warhol's technical contribution to the fine arts lies in his legitimization of the commercial silkscreen, a process which contributed an authentic "newness" to the history of picture making. Warhol's images (a combination of his silkscreen's photographic literalness and the oracular power of his subjects) helped put an end to the virtual dominance of American abstract painting and posited an entirely new set of possibilities. Every attempt made by critics, the media, or even other artists to define or domesticate this new vision was thwarted by Warhol's third contribution to art history: his personality. Through his "dumb blonde" persona, he quickly became associated in the public's mind with the new Pop movement.

More than any other artist in the movement, Andy set and then stretched the parameters of Pop within which all his subsequent images, ideas, written words, and media activities were generated. Andy Warhol, the blank recorder; one has to look to Hollywood or the world of rock music to find sources and parallels to his monumental impenetrability. He is unique in his ability to tell all and yet maintain his kernel of inviolable privacy. "Don't understand me

too quickly" might well be the motto of this most recorded and transcribed public personality.

As a classmate and friend of Philip Pearlstein, among many others at Carnegie Tech in Pittsburgh in the late forties, he moved with students whose ambitions were clearly in the fine arts. Andy came to New York upon graduating in 1949 and soon brought his mother to live with him. The practicalities of maintaining his mother and himself at barely twenty years of age, as well as the "he-man" aesthetic of Abstract Expressionism that ruled the day, forced a postponement but never an abandonment of his initial ambition.

It was in the commercial arts that Andy Warhol first earned his living and the attention and respect of his professional colleagues. As the 1950s wore on, he began to garner Art Directors' prizes for his shoe ads for I. Miller and his work for other clients. A group of hand-drawn, hand-colored books, made for himself and his friends (*Shoes Book* [1954], *Boy Book* [1956], *Cat Book* [1956]), shows the increasing refinements of his naïveté. Meanwhile, Andy's public personality was being memorably projected in his Tiffany windows for Gene Moore (who was also employing Johns and Rauschenberg at the same time). Two of Warhol's works from this period are particularly memorable: a delightful pastel-colored screen, light as air, with butterflies and angels in profusion and a real Coca-Cola bottle, gold-leafed, the latter a witty quotation from everyday life and a harbinger of his sixties oeuvre. And it was for a window display at Bonwit Teller's Fifth Avenue store that Warhol first exhibited the comic strip superhero images in the spirit and style that would soon catapult him to world attention.

When we examine Warhol's commercial work from the 1950s and his first forays into Pop in 1960, we find the artist's naive touch expressing itself through his tenuous, edgy draughtsmanship. His signature style of the period was a delicate broken line made by a simple transfer process—an early indication of the appeal the printmaking aesthetic would have for him with its qualities of displacement and "at one remove."

By Warhol's own admission (and my observation at the time), it was the jolt of the authoritative statement made by Roy Lichten-

stein's paintings that led Andy to abandon his nervous line and reticent coloring for the cool, clean, distant image. The result was the *Campbell's Soup Cans* of 1962—the *Nude Descending a Staircase* of Pop Art. Here was an image that became the overnight rallying point for the sympathetic and the bane of the hostile. Warhol captured the imagination of the media and public as had no other artist of his generation. Andy was Pop, and Pop was Andy.

Warhol's *Coca-Cola Bottles* (1962) and his equally celebrated and contentious sculptures of *Brillo Boxes* (1964) created worldwide recognition for this new American art, condemned as consumerist by many commentators, but enthusiastically accepted by the art public in Europe, Australia, and Japan. Here were quintessential postwar American icons, the Marshall Plan made manifest. America's dual exports, culture and low-cost consumer items (Campbell's Soup, Kellogg's Corn Flakes, Heinz Catsup), were monumentalized as part of the American dream that Hollywood has so successfully projected, inspiring an almost universal familiarity and fascination with all things American. One of the first salutary surprises to the American art community was the German phrase that so accurately described one aspect of Pop's message: Capitalist Realism. But at just the moment that Warhol seemed to be deifying the common commercial object, he turned the attention of the public away from Campbell's soup (although in fact he continued to create fugue-like variations on these themes into the middle sixties) toward a very different face of America—the *Birmingham Race Riot* (1964), *Car Crashes* (1963), *Electric Chairs* (1967), and, unforgettably, the images of Jacqueline Kennedy in mourning, the steadfast Roman matron of ancient times presented in all her tragic dignity.

In extending the range of feelings evoked by his art, Warhol joined George Segal in making it clear that Pop Art did more than mutely accept the values of America's commercial culture. It was both a celebration and a critique of those values. Thus, in the 1972 silkscreen *Vote McGovern*, the anger and horror Warhol feels for Richard Nixon is sharp and unrelenting. The image of Richard Nixon is as familiar through advertising as the soup can and bears

the same dead, frontal blankness. But here Nixon's face is divided into three color areas: yellow mouth, blue jowls, and green upper face—loathsome colors for human flesh. The smile, as Warhol tells us through these color divisions, never reaches the eyes; this is a latter-day *Disaster* painting, a category that looms darkly over all of Warhol's work where social criticism is expressed through the choice of images and the ways in which they are cropped, centered, isolated, or repeated.

In the silk-screen prints, there is, in general, a sunny, upbeat mood. (In fact, only the *Birmingham Race Riot* [1964], the *Electric Chair* [1971], and *Vote McGovern* [1972] can be construed as being negative about their subjects.) In the *Endangered Species* prints (1983), the impact is registered through the loving monumentality conferred on each of these mute heroes and by their brilliant coloring. By isolating and highlighting the *Pine Barrens Tree Frog*, the *Orangutan*, and the *Bald Eagle*, Warhol confers on them superstar status. Our horror is not at the image but at their potential absence.

The Mao portraits (1972) and the *Hammer and Sickle* (1977) can be said to escape easy categorization as positive or negative statements. The irony that is obvious and front-row center in these images is the fact that they are produced cheaply to be sold dearly by an artist in the heart of *the* capitalist capital of the world—this irony sits lightly on these superb icons. By their gnomic presence and noncommital presentation, we are forced, once again, to inquire as to the artist's intentions. Is he being cynical? Is he kidding? Is he simple? Does he think we're simple? Are we?

There is a quality to Andy Warhol's public persona that inspires endless discussion, quite unlike that of any other artist. Such discussions inevitably center on the question of his intentions and the artist's control over the meanings in his work which are often subtle and contradictory. He has cultivated to perfection a naïve blankness, a bottomless well of innocence when forced to declare himself on an issue. In a recent video interview, I asked him about the political implications lurking in the *Hammer and Sickle* and *Dollar Sign* series. "You know I don't know hard questions," he replied innocently. The truth is that those of us who have been among his

close friends for the past twenty years or more have exactly the same questions about Warhol's intent and control as does the informed public.

Andy Warhol's work consists of deeply intuitive choices by an uncannily shrewd commercial intelligence and, conversely, divinely accurate and semi-automatic dips into the dark of contemporary intellectual history. Andy has shown unfailingly his genius for finding and declaring the spirit of our times, the cherished *zeitgeist* that knows what it knows before it knows it. His work offers us a minefield of possibilities; when Italian, German, and French industrialists hang his *Hammer and Sickle* in their living rooms or offices, we know something is afoot. Much as hunters have always loved to hang trophies of their conquests, the instinct is to tame and render less threatening their deepest nightmares of the forest; thus, it is possible to purchase the opposition symbol and trivialize its potency by making it an element of decoration, handsomely colored, expensive, and, through repetition, less uniquely intense and formidable.

By the mid-seventies, Andy was sufficiently secure as a fine artist to quote from his own earlier drawing style—the one we associate with the aura of Jean Cocteau, butterflies, and the handmade books. In the *Flowers* (1974), the hesitant, nervous line is used to stunning advantage in a meditation that is at least as much about the vases that hold the flowers as about the blossoms themselves. To reinforce the allusion to the fifties and his own books, these silkscreens are left black-and-white in one edition, and the artist exercises the playful option of coloring them by hand in another. A delicate and casual hand hovers in the air and brushes with watercolor, now this leaf, now this petal. Andy Warhol the collector is also visible in these portfolios; by the mid-seventies, the Art Deco revival was in full swing. For half a dozen years previously, Andy collected the best of French art glass, and it is just this fascination with shapes and textures that provides the special charm of these silkscreens.

One fascinating aspect of Warhol's merging of the commercial world with that of the fine arts is his uncanny ability to work to "measure"—to meet the occasion with an unpredictable but, after

the fact, exact and apt image that suits the specific event yet lives beyond it. It is in this spirit that we can come to understand the best of his commissioned prints and portraits. Indeed, much of Warhol's work in recent years has been commissioned and tailored to specific locales and audiences; for example, *Beuys, Goethe, Ingrid Bergman, Kiku,* and *Love* for publishers in Germany, Sweden, and Japan; *Alexander the Great* to coincide with the Greek government loan show at the Metropolitan Museum; *Brooklyn Bridge* for the Centennial celebration. *Ten Portraits of Jews of the Twentieth Century, Myths, Endangered Species,* and *Details* are other kinds of print projects Andy has turned to in recent years with wonderful tact and vigor. It is almost as if Warhol works best under the pressure of an assignment—a holdover from the days of magazine layout deadlines.

As with all artists who produce large amounts of work, distinctions can be made only after a time as to what is major and unforgettable and, conversely, what is theatrical and ephemeral. Andy surprises; lightning strikes unexpectedly, and an image is permanently illuminated in our memory. These moments occur at every stage in his career.

Andy Warhol's importance lies in his ability to recognize the qualities of ordinariness and to focus attention on them until they are no longer ordinary. When a genius is riveted by the ordinary, it is filtered back to us through his eyes, becoming, by definition, extraordinary.

Hockney

Young and Older

[1988]

Basic to David Hockney's art from the first has been the need to communicate directly with the viewer. Hockney is not at all involved in the creation of beauty as an end in itself. It is exactly this didactic urgency, this need to be heard plainly and to be understood clearly, which is the basis of his phenomenal popularity. No other artist today has been the subject of so many books, most of them generated by the prodigious flow of his own art, work that he produces in abundance and with great care. As often as I have visited David over the years, I have never seen an empty studio, his cornucopia is always full to brimming.

Studying his earliest work, we may ask, How might he have painted if left to his own devices and those of his masters at Bradford School of Art? Judging from the very few paintings that survive from the mid-fifties—the painting of his father done in 1955, when Hockney was eighteen years old, being our chief evidence—we would be justified in thinking of Hockney as an Intimist, somewhat in the manner of Walter Sickert, whose work was sanctified in the English art schools of the day.

Intimist might be defined in this context as an affectionate record of homely truths; and Intimism, as an art that typically portrays a sweater as stretched through use and close to unraveling. It is this David Hockney who tells us twenty years later that the aged dress

best because, with all vanity and fashion consciousness out the window, they wear only the clothes that fit comfortably, trousers and dresses that read almost as a subclass of portraiture in their unexceptionable ordinariness.

Hockney's work is often so delightful that we are brought up short by the realization that a message always lurks in it, that a message must be implicitly present for him to undertake it.

The Hockney household was poor in material things with five children tumbling about in severely restricted spaces; but in rich compensation there was an abundance of fond familial attachment and—perhaps equally important to the child David—a riot of definitely held opinion. The causes that inspired various members of the family included his mother's religion and devotion to vegetarianism and his father's imaginatively waged campaign against war and smoking. That David ate meat and smoked when I first met him in 1963 (at Andy Warhol's Factory) could be construed as a tribute to this inherited cussedness, his lifelong penchant for swimming upstream.

It is almost as if a need for a cause more than a specific message attracts him. An early touching and telling work is the 1961 etching *Myself and My Heroes*. The heroes are Mahatma Gandhi, to whom is given the phrase "vegetarian as well/down with the Taj Mahal" and Walt Whitman, "for the dear love of comrades," while David's words are: "I am 23 years old and I wear glasses."

Gandhi is there by reason of his pacifism too. In 1957–1959, after David finished Bradford Art School, he did his stint in lieu of military service at a hospital in the south of England, where he spent what free time he had reading literature, with poetry a great and enduring interest.

Walt Whitman in *Myself and My Heroes* does triple duty: first, as a great poet; next, as a caring man whose nursing of soldiers in hospitals during the Civil War is the emotional basis of so much of his work; and finally, as a prophet of free sexual expression, a fresh voice from a new continent, which was to retain its appeal for David.

As for the third character in this key print, David was not to place himself in his work much again until the 1980s, when he discov-

ered that if he built a panoramic photograph with his own feet pic-
tured at the base, the viewer would identify with him and thus com-
prehend the scope of the subject more readily.

One reason there are so few self-portraits in Hockney's oeuvre of
this period, 1962–1975, was his great hunger for psychological in-
sight into his sitters' lives and, where there are more than one, into
their relationships. It is no accident that so many of the important
paintings of the late sixties depict couples. In getting it down on pa-
per or canvas, Hockney was affording himself an opportunity to ob-
serve the complexities within relationships, lessons of more than
routine interest to the artist, whose obsession with his work was
keeping his romantic life at bay.

It was impossible for Hockney to do commissioned portraits be-
cause of his consuming devotion to the "truth" of his experience.
At the same time, as his work became better known, the very glamor
of this rarity, the Hockney portrait, appealed more and more, espe-
cially for wealthy collectors on the fringe of contemporary art. In
the first drawings of a new sitter David found that he had to work
hard to "find" his subject, that double truth of likeness captured and
character evoked, the idiosyncrasies that made the drawing "like."
Every successful drawing was a victory; many were discarded.
When a subject was particularly resistant to his Rapidograph or col-
ored crayon (his preferred drawing materials in the sixties), he used
a phrase, wicked but apt: "I couldn't find him" or "I couldn't find
her."

It is only now, with the evidence of three decades, that certain
things become clear, such as the fact that David's work periodi-
cally undergoes great changes because he is interested in a tech-
nique only as long as it provides resistance. It is the struggle to
learn, to overcome "ham-fistedness" (a Yorkshire word that David
loves), which provides impetus—not, in fact, that he has ever been
clumsy.

We can now see that David turned away from the Rapidograph
portraits of the sixties for no discernible reason except that he knew
too well how to do them. There is a fear of and distaste in David for
the facile in art, especially his own, which closes off avenues he has

traveled successfully. He reacts against any hint of sentimentality as he does against doing versions of his pictures that have become twentieth-century classics, such as the Swimming Pool Paintings.

We see this too in his increasing fascination with a kind of Realism in his paintings of 1967–1974 and in his later retreat from it. This ambition in his work was probably the last vestige of old-fashioned thinking that he had to shuck off to become the increasingly complex artist he has become. His success in painting the world in the most conventional, Victorian way was making him more and more famous and more and more uneasy in his own skin. This move toward a popular Victorian style, which harks back to Ford Madox Brown and John Everett Millais, climaxes in the double portrait Mr. and Mrs. Clark and Percy (1970–1971), which the Tate Gallery tells us is the most popular work in their collection.

David was experiencing unscalable difficulties in attempting to continue innovatively in the direction of conventional ideals of verisimilitude: the unfinished double portrait of his great friends George Lawson and Wayne Sleep, book dealer and actor-dancer, for instance, or another of Gregory Masurovsky and Shirley Goldfarb, American artists in Paris. David was driving himself to the point of abandoning projects in his frustration. His work was demanding ever greater technical skill at the same time that his worldview was altering under the pressure of another reality: his loss of innocence, the realization of death's inevitability.

Picasso's death in 1973 hit him hard. For Hockney, Picasso was a heroic figure, whose later paintings, those made after the Second World War, were vastly underrated by the art world. In some way Picasso's demise became entangled with the decline and eventual death in 1978 of David's father. They shared a gritty defiance of death, a willful refusal to slow down in the face of the inevitable. The reassessment of Picasso's eight decades had begun in earnest three years before his death. It was the 1970 exhibition of Picasso's recent work in Avignon, organized by Yvonne Zervos, which forced attention to revaluation of paintings that had been dismissed previously as too quickly made and without coherence as a body of work.

It was Hockney's contention, along with a small number of art

historians—Gert Schiff and Robert Rosenblum prominent among them—that the later Picasso was unfairly dismissed with a pious word, while his Blue, Rose, Cubist, and Surrealist periods were counted as the sum of his achievement.

The shock of energy Hockney felt in contemplating the later Picasso was translated into a wonderfully rich "Picassoid" period. It is as symptomatic of the end of his innocence that I remark upon it. It was as if a torch had been handed to David to run with, a relay race as old as art. All we need to do is examine the memorable etching David made in homage to Picasso, *The Artist and Model* (1973–1974), to gauge the truth of these remarks. A youthful David sits naked at a table with the aged Picasso, wearing the maillot of a French sailor. We are witness to a meeting of apprentice and master, the innocent and uncorrupted showing his work to the great artist of the century. (For me the special joy of this etching has always been the intrusive palm tree that pridefully bursts forth on a line directly above the young man's genitalia, masked as they are by the table.)

Hockney returned to his parents as a subject in the early seventies, the time that he lived and worked in Paris, the period I call his "loss of innocence." Eventually he destroyed that painting and returned to London, where he built an elaborate studio in Powis Terrace, and there undertook and completed the second and final version of the painting. It was not the likenesses of his parents that proved difficult so much as his idea of their attitudes toward each other and even more crucially the way he saw himself with regard to each of them. He had to invent a composition that could bear the freight of all this unacknowledged feeling. It is of interest to note that he is the only child in the family portrait, *My Parents and Myself* (1975); none of the older or younger siblings, three boys and a girl, is portrayed. It is difficult, in fact, to remember more than a few drawings of his brothers and sister. Given my American predilection for Freudian psychology, it seemed important to me at the time that David come to terms with his deeply conflicted feelings toward his family.

What turned out to be the most arduous task was placing himself

in the portrait. If he was in focus (in a mirror placed on the artist's taboret in front of which his quite disparate parents sat), he lost the tension and clarity of his mother's and father's images. It was only when he dropped himself out of the equation that he was finally able to complete the painting in quite another version, *My Parents* (1977), executed on his final return to London from Paris.

The fame and riches that have been attendant on David Hockney's every endeavor may seem to have been his goal. Nothing could be less true. What has propelled him from the first—and still does to a remarkable degree—is not illusory fame and riches; if anything, they bother and distract. What does move David is the double entrancement of learning and teaching. The learning in recent years has ranged rather widely: to the theories of time and vision in Chinese art and to the new physics and mathematics, two fields that have dominated his thought and his conversation for much of the present decade. If we add the later Picasso and the aims and limitations of photography, we have catalogued all his interests in this decade. His eagerness to share his thoughts with close friends and newfound dinner companions is legendary. What he is doing is continuing his education in private and public, as has been his procedure from the beginning. Learning and teaching, not fame and riches, are the spurs, the excitement worth its weight in rubies.

We sense much in Hockney's polemic—and he does love a nice "jar" about painting and theory—which would place him firmly as a stubborn "pre-Modern" in a Modern world. He and the American painter R. B. Kitaj were at the Royal College of Art in overlapping years, 1959 and 1960. Through ideological sympathy they got themselves locked into an elaborate defense of figurative over abstract art. In their argument "humanism" in painting seems always to have been reduced to the presence of humans portrayed—figurative art. It got to the point in the late sixties, when their battle with the adherents of Clement Greenberg's strictures against facile humanism crested, that the names of certain English and American painters would be enough to cause their eyes to roll.

In this context it is fascinating to view David's early progress during the first decade of his career. From his point of departure, *The*

Most Beautiful Boy in the World (1961) and *The Cha-Cha That Was Danced in the Early Hours of 24th March* (1961), he moved to the carefully drawn and composed Victorian pictures of the early 1970s, complete with one-point perspective. The boisterous titles of the earlier paintings hint at the energy that was both contained and released by the young student. I am always astonished at how much vitality he managed to suggest in the barely articulated figures of those paintings.

A major influence in David's early days in London were the homosexual and nudist magazines available there, illustrated first with tawdry black-and-white photographs; and, a few years later, with amazingly hyped cinematic color. Through them he became aware of California, whence most of these publications emanated. It came to mean for the young, impecunious artist a freedom from the cant and dubious moral standards that were paid lip service in the England of the day. From this source too can be traced the paintings of males in showers, which predate by a year his move to Los Angeles, as can the flooding of many interiors in these pictures of the mid-sixties with "natural" light. David has commented that the scenes in these illustrations are often "obviously (like old movies) shot in made-up sets out of doors. Bathrooms had palm tree shadows across the carpets, or the walls suddenly ended and a swimming pool was visible."[1]

Other influences on his work at that time—Francis Bacon, Larry Rivers, and the English sculptor William Turnbull—have been described often. We can't help but feel that there was not that great a degree of choice available to David, who in his mid-twenties was frankly learning his craft. It wasn't as if he was shrugging off an uncanny ability at verisimilitude to which he later succumbed. It is exactly the ongoing fascination with learning (and then abandoning) techniques that describes his path through the sixties.

British art circles in 1960 were still reeling from the impact of "The New American Painting," the major exhibition of large

[1]Quoted in Christopher Finch, *David Hockney in America*, exh. cat. (New York: William Beadleston, 1983), unpaginated.

American paintings that was circulated throughout Europe under the aegis of the Museum of Modern Art in 1958. It was an exhibition that suddenly put all art theories and practices into question, on the table, so to speak. The size of the paintings by Pollock and Rothko and Still was something new in studio art, as was the boldness with which each abstractionist claimed his bit of the psychic landscape, his personal topography.

Undeniably art in Europe and America since the war had been made and seen against a background of the Holocaust and the atom bomb. The European reaction—and I speak here in generalizations—was to show the agony of the individual. The flayed, emaciated, and tortured figures of sculptors on the Continent and in England—Lynn Chadwick, Reg Butler, and Elisabeth Frink among them—can be seen in the crucial competition for a Monument to the Unknown Political Prisoner, which gave programmatic definition to the entire generation of figurative sculptors. In David's generation those who didn't become abstract artists were the friends and contemporaries who invented and sustained British Pop, led by their wise and witty teacher Richard Hamilton, an artist whose intellect Hockney respects greatly. Except for a few very early paintings incorporating brand names, such as Alka-Seltzer (1961) and Typhoo Tea (Tea Painting in an Illusionistic Style [1961]), and a certain openness to the spirit of his day, Hockney himself really can't be comfortably called Pop, a designation that is much too narrowly concerned with the contemporary to contain his questioning nature. Hockney's sources and exemplars are more likely to be the poets George Herbert and Andrew Marvell or Degas and Toulouse-Lautrec than this morning's headlines. Curious as he is intellectually, he has little room in his working aesthetic for the cascade of data that crackles about us like static.

In 1977 I began an essay on the artist: "David Hockney's art has been lively from the first because he has conducted his education in public with a charming and endearing innocence."[2] A decade later

[2]Henry Geldzahler, "Introduction," in David Hockney by David Hockney, ed. Nikos Stangos (New York: Harry N. Abrams, 1977), p.9. Reprinted in this volume.

this "innocence" has been dealt a series of rude shocks through deaths in his circle: first, that of his father, and then, the relentless clanging tocsin of AIDS, which seems every month to toll for still another great friend or colleague. One cannot help but wonder whether all loss of innocence, even that in the Garden of Eden, comes with the realization that death is inevitable and that no one lives happily ever after, not even Snow White and the Prince. Indeed in folk and fairy tales, a favorite source for David's work, the soothing convention of reanimation is maintained in defiance of tragedy: Sleeping Beauty (Death) is awakened by another Prince, cousin to Snow White's animator, death defying, death denying. Go to sleep, little boy, you're safe, you'll waken on the morrow.

. The extent of David Hockney's attraction to and puzzlement over the "happily ever after" bromide is evident in his most recent major project, the sets and costumes for a production in December 1987 of Wagner's *Tristan und Isolde,* directed by Jonathan Miller and conducted and performed by Zubin Mehta and the Los Angeles Music Center Opera. *Tristan* ends with the death on stage of the cheerless lovers, a death that in Hockney's description is followed by several chords of heavenly beauty, signaling a transfiguration that transports the lovers to an eternity in which their love endures. More elaborately than "happily ever after" this solution to the irrevocability of death carries the denial to a higher level of metaphysical contemplation. We might say that organized religion, with its circular arguments and self-sufficient systems, aspires to the same end, an end that somehow is not *the* end. We sense Mother Hockney's religion in the offing.

But as a proselytizer it has been through his brilliant stage sets, his thorough sense of how a production must look, that Hockney has found a new and enthusiastic audience. What is interesting about his opera work is the way in which it fertilizes everything else he does. I was frankly concerned that all this preoccupation with theater was distracting him from his real job, his painting. This turned out to be nothing but the endemic narrowness of the traditional art historian. I was quite mistaken.

The unforgettably witty sets and costumes for his first Glynde-

bourne endeavor, Stravinsky's *The Rake's Progress* (1975), based in large measure on Hogarth's prints, fed directly out of Hockney's work as a printmaker, with all it hatchings and crosshatchings, and then back into his painting *Kerby (after Hogarth) Useful Knowledge* (1975).

The French triple bill for New York's Metropolitan Opera, with music by Satie, Ravel, and Poulenc, was a perfect blend of music, text, and sets. In this case the excitement at the saturation with throbbing color, especially in the Ravel, *L'Enfant et les sortilèges*, inspired Hockney to rethink and repaint his house and studio in the Hollywood Hills with the very same reds and greens and blues that he had used in the sets. These new surroundings were then in large measure the colors and vibrant harmonies of his new paintings. Everything gets used and recycled: the work is a dialogue David Hockney holds with himself.

During the rehearsals for the French triple bill one ten-year-old chorister whispered aloud to another, "Did you see that tree and that sky? The tree is blue."

"That's nothing," said the second boy: "You should see the designer."

The child had observed wisely that David does nothing half-heartedly; he dresses the stage as he dresses himself. He changes his home, the frame in which he lives, to make it consonant with his current obsession. And in all this sits the teacher, eager to learn so he can impart.

Pop Art 1955–1970

[1985]

*P*op Art emerged with hilarity and élan from a matrix of Abstract Expressionism paint handling. It was a new style that took into account, for the first time in any systematic manner, the way our modern world looks and the ways we receive information from it. This view helps to explain in part both the deep hostility engendered by Pop Art in some, and its quick acceptance by others. The one group felt that there were things about our environment that were best left unnoticed, much less highlighted and memorialized; the other recognized the familiar as a charged subject and felt a thrill at seeing it elevated to fine art. Landscape painting has always made the familiar visible and helped us see more clearly and concretely the exterior phenomena of the world around us—formerly natural (although often man-shaped), now virtually man-made.

Pop Art, then, is a knowing response to our environment. It takes into account the facts of television, the daily newspapers, weekly magazines, and the billboards and movie screens—all providing us with both entertainment and unremitting information.

It is simpleminded to say that Pop Art came into being as a reaction against Abstract Expressionism. Cause and effect enter into the history of art, but never so neatly and with so clean an edge as we would like to think. The clear and forceful contours of Pop Art are also in part a return to the local or common subjects of provincial

America, as seen in the paintings of Stuart Davis or Gerald Murphy in the twenties and thirties. Pop Art's peculiarly American subject matter also harks back to the Regionalists and the Ash Can School of the same decades. It is only a short skip from Reginald Marsh's subway and Bowery scenes, to Claes Oldenburg's gritty evocations of the same subjects; in fact, they very nearly overlap.

What, exactly, then led to American Pop Art? If we backtrack to America's position in the visual arts in the nineteen forties and fifties, we can describe a sequence of movements and ideas that will help answer such questions. The circumstances that led to the new American hegemony in the postwar years have been elaborately argued. Briefly, the W. P. A. (Works Progress Administration) that President Roosevelt created in 1935 to help artists through the Depression had a stimulating effect on what was to become the New York School. Artists met to discuss mural projects, and for the first time there was a significant crossfertilization of artists of every conviction—social realists, Precisionists, abstract painters, Regionalists. This led to an unprecedented exchange of information, and had much to do with the new mutual respect and shared excitement that were necessary for American painting to make the leap to a new coherent style, broadly called Abstract Expressionism. Another factor was the sudden influx of many of Europe's greatest artists (Marcel Duchamp, Fernand Léger, André Breton, Piet Mondrian, Joan Miró, Marc Chagall, Jacques Lipchitz), who came to New York during the Second World War, working and mingling in the burgeoning artists' climate that the W. P. A. had helped foster. Many of these artists did some of the most ambitious work of their careers in New York. Indeed, several of the great masterpieces of this period (by Léger and Mondrian in particular) specifically took New York into account. For American artists there was the dawning realization that one didn't have to go to Paris to paint; there was nothing talismanic about the City of Lights. What mattered was not geography, but confidence and the knowledge that fine work can be created anywhere if the artist has the necessary experience and discipline.

Many of the European exiles returned home, leaving behind

them a thirst for greatness and taking with them the information that something of quality might well be afoot in art in New York. Abstract Expressionism in the 1950s changed the way in which American art was viewed in Europe. For the first time, American painters had international reputations.

Abstract Expressionism, specifically Dorothy Miller's "The New American Painting," had toured the major European art capitals in 1958–1959, and artists, critics, and museum professionals were now on the look-out for the good news that there was fresh and stimulating art being produced in New York. It was, of course, this new respect for American art that helped make Pop Art instantaneously newsworthy, and quickly collected by European museums.

There is one way, however, in which the rapid international acclaim of Pop Art can be seen to have done the American art establishment a disservice. While it was natural for the newly excited audience for American art to be ready for this stunning contemporary and topical explosion of visual energy, Pop Art in its American context can be seen as a retreat from the ambition of Abstract Expressionism, its deeply embedded internationalism, and its continuity with the School of Paris. Yet there was something brazen and joyful about Pop paintings that caused them to be read as enthusiastic (but sufficiently ironic) artifacts of the brave new world of the postwar era, and that attracted intellectuals, and quite soon a large audience. America had never been so visible in every corner of the world, exporting ideology and consumer goods with all the naïve self-confidence of Jimmy Stewart in Frank Capra's film *Mr. Smith Goes to Washington*.

It was the Vietnam war, of course, that pierced the bubble and forced us to look again at our values, and at these pictures suddenly revealed as complex, and to delve more urgently into the depths they now proclaimed. The Minimal artists and the Super-realists of the 1970s can be seen to have responded to the oversaturation of commercialism and ideology as subject matter, withdrawing into a serenity, a soundlessness that refused any dialogue with a corrupt society, or into an overly detailed obsessional activity. The latter is seen in the work of Duane Hanson and Richard Estes, focusing the

attention aggressively away from mood and feeling, to the tranquil-
izing concern with exact description of the shell of reality. Malcolm
Morley's *Racetrack (South Africa)* (1970), with its precision crudely
defied by the angry red X (Malcolm's X), is a violation of the Pop
attitude to received icons.

In the above scenario, Pop Art seems at times to play the role of
the villain, the ugly American, a role that doesn't sit comfortably,
not only because it is ideologically refuted by much of the work, but
also because that was emphatically not the way it felt at the time.
The question that was asked almost immediately in sophisticated
art circles was, does this art glorify America, and is it simply a paean
to consumerism? It should be remembered that in the face of this
question, Andy Warhol shifted his subject matter from *Soup Cans*
to the *Disaster Series*, the *Race Riots* and the *Electric Chair* paint-
ings of 1963–1966.

In retrospect, it almost seems as if Pop Art was cooked to order for
consumption abroad—an insight that was unavailable to the art au-
dience in the 1960s, no matter how sophisticated. The eyes of the
art world had been trained to expect new art from New York. We can
see now that there was a retreat implicit in the emergence of Pop Art
and its ready acceptance; it was a retreat in philosophical terms,
from the high-minded grappling with abstract concepts that lay at
the heart of the best Abstract Expressionist painting, and all abstract
painting in general. To attempt to find verbal equivalencies or ex-
plications of Jackson Pollock's or Barnett Newman's work is even to-
day no less of a struggle with difficult concepts than it was at the
time. By presenting such clear images, such apparent certainties in
their work, and such a thoroughly contemporary solution for the re-
introduction of the figure in art, the Pop artists (to some extent un-
wittingly) brought the ambition of American art back to a level of
ideation many were once again comfortable with. But this was not
the overriding concern of the artists.

Pop Art in fact signaled a continuity with prewar American paint-
ing, and a return to American subject matter. Echoing the title of
Nikolaus Pevsner's *The Englishness of English Art*, we must ask the

question, what is the Americanness of American art? This can in part be answered by pointing to a few characteristics: love of the handmade and the homely detail; the great energy spent on verisimilitude, as in William Harnett and John Frederick Peto; and, more difficult to characterize, the American light—called Luminism by today's scholars of nineteenth-century American painting—something we can see in our own time, from Paul Strand and Georgia O'Keeffe to Edward Hopper to James Rosenquist. All of these local qualities can be seen time and again throughout this exhibition without diminishing the international stature of the work.

Origins of Pop Art

When we look back on the art of this century, some valuable distinctions can be made in the telling of the story. There has been an avant-garde for most of the past eighty years; in defining the avant-garde audience, it is necessary to speak of an elite art. The litany is familiar: Fauvism, Cubism, Futurism, Vorticism, Synchronism, Suprematism and de Stijl. All this occurred prior to 1920, much of it with the anguish of war, the smoke of battle giving urgency and weight to the reinvention of the world and a new vision of it. In large part, the shattering experience of the First World War created the new sensibility that forced the public to abandon comforts that looked increasingly like decadence (Art Nouveau) and encouraged the desire for a new way of seeing the world, a way that sought to invent a better future, more idealistic and more cognizant of the changes in our environment, particularly those that science had made apparent. It was the very look and feel, the texture of the world that was being created anew.

From our perspective in 1985 we can glance back at this century and see another vein that can be traced farther back into the nineteenth century. It, too, is an insight we were unprepared for a dozen years ago. The highly polished and technically breathtaking painting of Adolphe Bouguereau had its parallel in every sophisticated national style of the late nineteenth century. We can now speculate that the public's slightly salacious adoration of this art, so despised

in Modernist orthodoxy, has continued to find popular expression in photography (pin-up calendars), and in the cinema. Love of the recognizable, especially in conjunction with ever more sleek, shining, and "super-real" forms and surfaces, is more tenacious than we allowed ourselves to think.

Thus when, in 1913, having followed Cubism to what seemed to him a cul-de-sac, Marcel Duchamp declared the first Readymade, making possible the introduction and incorporation of physical objects from our environment into works of art, something was transpiring at another level. The submission of a factory-made white porcelain urinal to an art exhibition was an audacious gesture. The other element in this gesture, and its progeny, Dada and Pop Art, may now be seen as culture's need, parallel to the popularity of film and photography, to see the familiar, to recognize in our environment objects that are, in one sense, the equivalent of fine craftsmanship, surface and shine to the despised academic realism of the Bouguereaus.

Pop Art itself was born of a set of circumstances, the preparation for which goes back as far as Marcel Duchamp and his urinal. A great many of the stylistic innovations in twentieth-century art have come about because a new area of subject matter has been made the province of the fine arts. The list is distinguished: the new physics and mathematics at the turn of the century with its correspondence in Cubism and its various offshoots; Freud's dream theory which lies behind Surrealism; the knowledge of and interest in ethnology and the arts of Oceania, Africa, and the Pre-Columbian Americas which freed so many artists from the tyranny of Western forms and perspective; the art of children and of the insane, which had a profound influence on Paul Klee and Dubuffet. In this genealogy Pop Art came about through the incorporation of mass media and consumerism into the fine arts. In a postwar world in which the entire globe, for a time, seemed to exist as a potential market for America's commercial products, what could be more apposite than an art movement that took its cue from the sleek modernist surfaces of the new technology? Duchamp's urinal became the precursor and

Mona Lisa of a movement that in France was identified by Pierre Restany as *Le Nouveau Réalisme*, and in Germany was referred to with wit as "Capitalist Realism."

Proto-Pop

To gauge the extent of Abstract Expressionism's hold on the younger generation one need only study a few works in the current exhibition: Larry Rivers's *Washington Crossing the Delaware* (1953), Robert Rauschenberg's *Red Import* (1954) and *Memorandum of Bids* (1957), and Jasper Johns's *Target* and *Flag on Orange Field* (both 1958), to see how, in matters of style, these young men were influenced by the preceding generation. It was Rivers, with his congenital irreverence for the niceties, who kept recognizable subject matter and *history* painting (of all things) very much in the forefront, in spite of the dominant abstraction and its determining influence on his own style. *Washington Crossing the Delaware*, by the German-American painter Emanuel Leutze, was displayed on thousands of classroom walls and seemed mandatory in history books for every American generation since it was painted in the mid-nineteenth century. A contemporary legend has it that Willem de Kooning dropped in on his younger colleague while the painting was in progress. There ensued a conversation in which Rivers wondered aloud as to how long it would take him to finish; de Kooning replied, "Don't ruin it! It's finished."

Robert Rauschenberg attended Black Mountain College in North Carolina, where he came in contact with some of the most advanced sensibilities of postwar America. Instructors there included Josef Albers, Robert Motherwell, Franz Kline, and poets Charles Olson and Robert Creeley; students included Cy Twombly, John Chamberlain, and Kenneth Noland.

It is the collage of Kurt Schwitters that lies most immediately behind the Rauschenberg "Combines" of the years 1953–1962. Schwitters, in the late teens and twenties, incorporated into his collages and assemblages paper and objects found in the streets. Schwitters's materials are always organized in flat rectangles, glued

to board or canvas, according to Cubist compositional principles. Thus too with Rauschenberg, but on a larger scale, and with the added dynamic of the Abstract Expressionists.

Following in the spirit of Duchamp, Rauschenberg excelled in the gesture or "event" as work of art, as in his erased de Kooning drawing, which is just that: de Kooning gave Rauschenberg a drawing when the young artist explained that he wished to erase it and exhibit the result as his artwork. Equally shocking to art audiences was his painting *Bed* (1955). The artist hung his bed on the wall, brushed and splattered with paint. The sheets, the pillow, the quilt are all in place, with paint dripping down from the top half; it is an arresting and brilliant image of our daily life, whose very ordinariness is transformed into an electrifying presence. Rauschenberg adapted the Cubist principles of pictorial space to action painting; his work from the 1960s forged ahead into a flatter, neater, and brighter aesthetic, all representative traits of the art of that decade.

Another artist working with images from our visual environment to brilliant effect was Jasper Johns. In his best-known paintings (as early as 1954), Johns selected as subject matter commonplace images that were by their nature two dimensional—the American flag, the target, and, slightly later, the map of the United States. In the late fifties, when Johns began to exhibit, his work was at first dismissed, then quickly characterized as Neo-Dada (the term was virtually invented for Rauschenberg and Johns), as if pigeon-holing it would relieve the viewer of his anxiety in the presence of something so new and and so irritatingly memorable. Johns's strategy in choosing subjects so ordinary, so taken for granted, was to make it clear that it was the painting—the way in which the paint was laid down, the way in which the brushstrokes gather and meet, that seduces the eye. And it is in just this fascination with the ways in which paint can be manipulated, the artist's handwriting, that Johns's paintings have their affinity with the dominant abstract mode. It is the care and mastery that he brings to these paintings, the sense of rightness, and the absolutely convincing placement of each stroke of the brush that make his work a crucial intermediary between Abstract Expressionism and Pop Art. As with any great artist, it is his work

that holds us in thrall; the art historian "uses" the work to make connections—the artist makes the work for its own sake.

Another aspect of Johns's personality and intelligence that gives his work a continuing and even increasing interest is his wit, his ability in his work as in his conversation, to pose elegant questions and provide answers that tease rather than satisfy, but that always challenge the viewer to look again, to think again. In *Flag on Orange Field II* (1958), he floats the American flag on a field of orange interlaced brushstrokes—surely the most difficult color, along with green—on which to see the Red, White, and Blue as occupying the same picture plane in harmonious continuity. We are familiar with Paul Cézanne's decades-long fascination with his *Bathers* and *Mont Ste. Victoire*. In a similarly obsessed fashion, Johns has altered, quoted, and inverted his Numbers, Flags, and Targets, varying size, medium, and every other separable aspect. In this continuing dialogue between Johns and his work there are elements that hark back to some of his preferred intellects, Duchamp, Ludwig Wittgenstein, and John Cage. Finally, the true subject of Johns's work is, What is the truth, or, better, What are the truths, and how do we communicate them without bruising and altering them?

Pop Art and the Single Image

American Pop Art was born, in part, out of a reaction against the glut of paint and its manipulation by the second-generation Abstract Expressionists. The fact that it was also moored firmly in its own decade, side by side with single-image abstraction, takes a somewhat different sighting of the Pop phenomenon and helps to situate it in recent history. Even at the time, while it was obvious that something new was afoot, Pop paintings could be visually related to the new group of abstract painters: Helen Frankenthaler, Kenneth Noland, Ellsworth Kelly, Morris Louis, and Frank Stella.

American Pop Art and sixties abstraction shared a new specificity of image after the shifting surfaces of Abstract Expressionism. There was a clarity of shape, and a radical downgrading of paint handling for its own sake. History has taught us that the violent disagreements within a generation—Rubens vs. Poussin, Ingres vs.

Delacroix—arguments about style in painting that seem dramatically at odds in one generation—take on the characteristic look of that generation. Pop and single-image painting were clearly both conceived by sensibilities reacting against the oversaturation of abstract gestural art. Like the painters of the abstract single image, the Pop painters projected easily identifiable signs and symbols. The difference lay in the meanings and references evoked by their subjects.

English Pop and Nouveau Réalisme

While there is a tendency to consider Pop Art an American phenomenon, in point of fact there were manifestations in Europe prior to 1960 that hinted broadly at the new popular subject matter and high-tech finish that were to characterize the Pop Art movement. In 1966 Lucy Lippard wrote of Pop Art, "It was born twice; first in England and then again, independently, in New York." When Lawrence Alloway coined the phrase Pop Art, he was referring to the English, the work in the first instance of Hamilton, Paolozzi and Blake.

English Pop, an umbrella appellation that covered many approaches, was, in contrast with the American brand, somewhat fussily hyperactive; far from single-image painting, it was characterized by accumulations of small elements. In Eduardo Paolozzi's work, the art clearly commented on and ran parallel to the machine aesthetic, modern industry's complexities and high-gloss finish, prototypically the anthropomorphic robotic machines of his 1967 serigraphs. Peter Blake's work concentrated its attention on popular culture, *Bo Didley* (1963), his well-known portrait of *The Beatles* (1968), and several self-portraits. They have, in their accumulation of detail, a Victorian obsessiveness that provokes an intentional awkwardness with their contemporary subjects, making them anachronistic, yet memorable.

It is of Richard Hamilton we think first when the subject of English Pop Art comes up. He stunned the London art world in the mid and late fifties with his carefully controlled collages, most often clipped from slick, popular magazines and newspapers. The con-

summate Pop work of Hamilton, executed in 1956, is only nine by ten inches; it was made to be enlarged to wall-size for an exhibition Hamilton assembled for the Whitechapel Gallery called "This Is Tomorrow." Titled *Just What Is It That Makes Today's Homes So Different, So Appealing?*, it consists of brilliantly juxtaposed collage elements in an order that suggests a room with a view out the window; it includes a turned-on TV, a comic strip panel, a canned ham, a bathing beauty, and a muscleman holding an enormous lollipop or a dumbbell, on which the word POP is written.

In the sixties English Pop, never a true movement, included the work of Richard Smith, who was happier with the beautifully brushed single-image abstractions he encountered on his visit to New York in 1959. Allen Jones, Peter Phillips, and Patrick Caulfield, in various personal combinations, paid homage to both abstraction and a popular high-tech figuration. R. B. Kitaj, an American who chose to live and work in England, and his slightly younger friend David Hockney, were concerned primarily with draughtsmanship as the basis of artistic intelligence and produced spellbinding work that was only incidentally Pop.

It is interesting to note the similarities in the breeding grounds of Pop and New Realism. In the School of Paris after the Second World War the dominant new generation of artists were abstractionists—Hans Hartung, Pierre Soulages, Georges Matthieu, Serge Poliakoff and the heterodox Nicolas de Staël. These artists, like the Abstract Expressionists, were concerned with personal anguish in a style that began to look less pained and more like a formula to the younger artists who made up the *Nouveau Réalistes*. Picasso, Matisse, Ernst, Miró, Magritte, Léger and their confrères were clearly masters of an earlier generation whose work seemed more relevant to history than to the concerns of the day for younger artists.

Le Nouveau Réalisme gained acceptance in the late fifties and early sixties, through the efforts of the critic Pierre Restany, a forceful and imaginative conceptualizer. *Le Nouveau Réalisme* described the return to the observed world that was the common chord struck in their work. It was actually Léger who had invented the

phrase thirty years earlier to describe the new machine aesthetic of his time; he wrote of "the seductive shop windows where isolated objects cause the purchaser to halt; the new realism." It was not as picture makers that these artists excelled. Their strength came from their ability to recognize the special qualities of the world about them, and, in highly varied work, to incorporate elements of this new world in their art.

American Pop

It was in the 1959–1960 season in New York, behind the scenes in artists' studios, that the phenomenon Pop Art was born. We know today that it was the pioneering work of Duchamp, Schwitters, and, more immediately, Rauschenberg and Johns that laid the groundwork; but no one at that time, no matter how well prepared to understand contemporary art, could have, or, indeed, did predict what half a dozen artists in virtual isolation from each other would come up with.

For a symposium on Pop Art at the Museum of Modern Art in 1963 I wrote: "Pop Art is a new two-dimensional landscape painting; the artist responding specifically to his environment. The artist is looking around again and painting what he sees. It is interesting that this art does not look like the new humanism some critics had been hoping for.

"We are living, after all, in an urban society exposed ceaselessly to the mass media. Our primary visual data is, for the most part, secondhand. Is it not then logical that we make art out of what we see? Hasn't it always been true, since the cave painters? Man's art has always taken its cue from the visible world, thus triggering the imagination to invent and fabulize.

"The subjects of Pop Art are often borrowed from the popular press, most often *Life* magazine, the movie close-up, black and white, or technicolor and wide screen, the extravagantly glamorous billboard (or hoarding as it's called in Britain), and, finally, some would say the last straw, the introduction of television through which this blatant overload of information has entered our homes.

There is no way of escaping the modern electronic world. It seems now that an imagery so pervasive, so insistent *had* to be noticed."

The ground having been prepared, Pop Art sprang on a public prepared to embrace its confident message and bold manner. A new game with new rules was underway.

Gertrude Stein, in an often quoted remark, called America the oldest culture in the world because it entered the twentieth century first. We need not wonder that so much Pop Art left America so quickly to find its home abroad. In the postwar years, the American Pop aesthetic seemed instantly glamorous, forward-looking, and somehow right, not only at home but to an international audience.

By any definition the paintings of Roy Lichtenstein, James Rosenquist, and Andy Warhol in the years 1961–1964 must be seen to be at the very center of the American Pop Art movement. It is no accident that seven of the nine Lichtensteins, the seven Rosenquist paintings, and ten Warhol canvases in this exhibition were painted in these three years. When first seen they were startlingly clear, and the passage of time has done little to diminish their thumping momentum and their penetrating clarity. What has evolved, and was not immediately apparent in the veritable storm of new images conceived of and executed by artists whose growing pains had occurred in the absolute privacy of their unvisited studios, was that already the seeds of their differences were in evidence, though not easily pinpointed.

Roy Lichtenstein's work, even at its inception, was clearly addressed to the history of art at the same time that it was undeniably making art history itself. The intellectual dialogue with the past that Lichtenstein was to engage in during the seventies and into the eighties was adumbrated in *Sussex* (1964), and most clearly enunciated in *Rouen Cathedral, Seen at Three Different Times of Day* (1969), in which he directly quotes Monet in Ben Day dots. While there is always something cool in the distancing device of quoting from masterpieces, Lichtenstein's emotional commitment is obvious in these classically balanced compositions.

From his first appearance at the Green Gallery in 1962, James

Rosenquist's painting was clearly a prime example of Pop imagery and technique. The well-known story of his apprenticeship to billboard painters in the late fifties explains his technique, especially when seen in the context of his previous education at art school in Minnesota. It did not take him long, however, to be uneasy with single imagery in his paintings. Rosenquist's personality is too disturbingly layered and resonant to be expressed for long in simple compositions, no matter how large in scale. As early as 1962, in *Marilyn Monroe, I*, Rosenquist's personal spin on the Pop Art billiard ball is abundantly apparent. Just as in his conversational style Rosenquist is incapable of making simple declarative sentences, so in his paintings fragmentation and inversion of several images lead him naturally to the complexities and contrasts that make up his poetic syntax. There always has been a Surrealist element in Rosenquist: patent leather shoes dancing on canned chop suey, spaghetti with tomato sauce in a shotgun wedding with grass. It is in the connections that Rosenquist's distinction lies.

Andy Warhol, when all is said and done, may well be the prototypical Pop artist, the blank façade at the heart of the matter, the magician of popular imagery. *Mona Lisa* (1963), and Elizabeth Taylor, (*Liz*, 1963), are treated as effectively packaged and marketed products. Warhol spent ten years as a successful commercial artist prior to his first Pop works in 1960. It was he who introduced the commercial silkscreen into the fine arts, leading the way for Rauschenberg and many others. He has continued to give us stereotyped images of already familiar likenesses. In his portraiture he has moved, in the seventies, part of the way to society portraiture with the impact and social sparkle that we associate with the Edwardians, John Singer Sargent and Giovanni Boldini. Of all the Pop artists he has carried his vision farthest afield, creating films and a flourishing monthly magazine, *Interview*.

Both Claes Oldenburg and Jim Dine came to New York from the Midwest, Oldenburg from Chicago, Dine from Ohio. They arrived in the late fifties to find the same hegemony in painting as did the other Pop artists; for them, however, the rebellion against Abstract Expressionism took a different route. In 1958 Allan Kaprow

and, independently, Red Grooms were theorizing about and performing a new form of artistic activity—Environments and Happenings—theater by artists who were primarily visual artists—the cross-disciplines that this implied were to be one of the salient aspects of art in the sixties; dancers, painters, composers, and poets working together in odd but inspired combinations, enlivening and startling their growing audiences and, not least, themselves. The dancer and choreographer Merce Cunningham and the composer John Cage, both of whom had taught at Black Mountain College (which closed in 1958) had pioneered these fields in the fifties as had the Dadaists, in Zurich, and Schwitters and Oskar Schlemmer in Germany in the twenties. Indeed there were not a few connections between the work of the German Expressionists and the Bauhaus with the new burst of activity in the early sixties that was centered in New York. An Environment, as its name implies, is static—a room or part of a room with fixed objects made by an artist to evoke a wide range of possible feelings in the viewer, bringing him up abruptly against his expectation, either through familiarity or incongruity. The most famous and successful of these environments were unquestionably made by George Segal, whose white plaster figures, cast from life, inhabit sculpturally constructed bits of our real environment; in this exhibition, *The Photobooth* (1966) and *The Parking Garage* (1968).

Claes Oldenburg's attachment to the "real" world, that is, the visible world, was so overwhelming as to force him to devise a new way to reintroduce it into art. His early environments, particularly *The Store* (1961), a rented storefront in a run-down neighborhood on the Lower East Side, for which he made several pieces in the current exhibition (including *7-Up with Cake*, and *White Shirt with Blue Tie*), was one of the great events in New York in its decade. The sculptures, made of fabric soaked in plaster molded over an armature of chicken wire and then colorfully painted with enamel, had all the animation of a private universe made accessible to the public by a new Walt Disney; of his own work Oldenburg has written: "I made it all up when I was six years old." In his earlier work, there are influences from Dubuffet, and from American Abstract Expres-

sionism, in paint handling and the generally eccentric outlines of the sculptures and drawings. Oldenburg, with his genius for the essence in common objects, found a way to revivify the somewhat exhausted painting style into something new and necessary.

When we speak of Happenings the two names that come first to mind are Oldenburg and Dine. Theater by artists also provided, we can now see, a way for painters and sculptors to re-introduce the human figure and form into an art they could be passionate about. With only sketchily written scripts, improvised in front of, or rather amidst, scenery and props designed or chosen by the artist, Happenings partook of the avant-garde theater tradition and can be seen to have led more or less directly to the new Performance activity, a veritable explosion of talent, and a vast new audience worldwide since the early sixties, one important characteristic of this has been cross-media participation.

Jim Dine includes the object itself—the shoe in *Shoes Walking on my Brain* (1960), and the tools in *Five Feet of Colorful Tools* (1962), in the current exhibition—in his work of the early sixties, whereas Oldenburg, the sculptor, fashioned a simulacrum of the object. In later years Dine would turn to careful renderings of the objects that fascinated him, while Oldenburg upped the scale and made more permanent the materials of his art.

Both Oldenburg and Dine were clearly obsessed, with much humor and eccentric charm, with the role objects play in our lives, the props and tools with which we work and amuse ourselves. It is specifically this elevation of the common object to a fit and natural subject for artistic contemplation that has associated these artists with the Pop Art movement. That they are important artists is not in doubt. What we might reconsider is the appositeness of calling them Pop artists. Let us agree that, for a time in the sixties, they made work arising out of similar circumstances as their Pop confrères.

In describing and characterizing the work of all those who can legitimately be called Pop artists, I have not been grading them by some abstruse, absolute Pop measure known only to a few cabalists and alchemists; my purpose has been to put the Pop house in some

sort of order. Another way of approaching the question What is Pop? is to point out how decidedly heterogeneous is the art that can be and has been sheltered by the Pop umbrella. In re-examining the literature on Pop since 1964, it has become increasingly clear that time, the ineluctable, plays a large and even decisive part in cleaning out the stable. Much of the art that critics and historians felt they had to consider has fallen by the wayside, taken itself out of consideration, making our task of pruning in 1985 cleaner and clearer.

In light of the quick fame and widespread interest in Pop Art in its early days, it is somewhat surprising that in the late sixties the "movement," as it were, seems to have become diffused, although its best works are emphatically still of aesthetic and historic importance. What happened, I am convinced, is that both the novelty of a new subject matter and new techniques borrowed from popular culture began to wear off, and the artists themselves continued to develop in their individual manners, with little sense of loyalty to a movement that was recognized, named, and publicized (largely by others), *after* most of them had arrived independently at their mature styles. Nevertheless, with a perspective of some twenty-five years it is now possible to say that the best works are emphatically still of aesthetic and historic importance; the classic works of 1961–1964 that are the core of this exhibition and catalogue retain their luster and glamor and will do so for the foreseeable future.

Nineteen seventy is not a cut-off debate in originality or interest in these artists' work. For most of them this terminal date for a Pop Art *movement* serves as a sensible moment to allow them to wander off on their own in pursuit of the Muse.

1990s

Louise Bourgeois

[1992]

*L*ouise Bourgeois and I have known each other professionally and socially since the mid-sixties. But it wasn't until her triumphant retrospective at the Museum of Modern Art in 1982 that I understood her accomplishment. Bourgeois's art is more about states of being than about how things look in the world. Few artists depend less on the work of their predecessors. Her link, nationally and generationally, to the Surrealists (she is eighty years old and emigrated from her native Paris to New York in 1938) is often overstated. It is in her work's freedom from cant and its driving biological urgency that a cousinship to the Surrealists can be discerned.

Bourgeois is a tribe of one. Her personal obsessions and the symbols they give rise to provide imagery powerful enough to maintain a tribe without words or texts. The work is knotted and knitted and, in its perilous existence, stands as its own justification. She is so busy in the mastery of her own demons that one senses her merely societal roles (of daughter, wife, and mother) can be maintained only by an act of will, an act of courage in an artist who has refused to deny her own childhood trauma of not belonging. Her life and her work affirm the searing and healing consolations of art.

Last October, within a period of six days, three shows opened that featured Bourgeois's work: the Carnegie International exhibition in Pittsburgh, and, in New York, a group show at the Museum of

Modern Art and a one-person show at the Robert Miller Gallery. This interview took place on a Saturday in late September. We began at the Chelsea Hotel, where Bourgeois came with her assistant, Jerry Gorovoy, to pick up Raymond Foye and me, and continued in her car to the studio in Brooklyn where she works. We concluded our conversation there, surrounded by old and new work.

HENRY GELDZAHLER *Three openings in one week! It's like war.*
LOUISE BOURGEOIS For me, the tension is before, getting ready for the show. The idea of being late makes me nervous. But what happens afterward, happens.

H.G. *You don't wait for the reviews?*
L.B. Oh, I am not going to answer this!

H.G. *Do you ever work with a show in mind?*
L.B. I work to work. The pressure is to work every day—to do all you can, every day. Right?

H.G. *You work at home as well as at the studio.*
L.B. Yes, but I do different things at home. At the studio it is the putting of the thing together, not the conception.

H.G. *Louise, you are so conversant with anthropology, Freud, and Jung. Have you ever studied them systematically?*
L.B. No, it is just an interest I have in psychoanalysis. I've read many books. But I am not interested in Jung.

H.G. *Have you ever been psychoanalyzed?*
L.B. No.

H.G. *That doesn't interest you?*
L.B. It is almost the subject of my entire work!

H.G. *You do it yourself—homemade psychoanalysis. Are you afraid the process might take away some of the tension in the work?*
L.B. The work is a form of exorcism, an acting out of very deep concerns. I don't want to say problems. They are not problems. What I have against Freud is that he allows us to act out our problems, but he doesn't erase them. They are still there.

H.G. *And they are infinitely repeated—which is the problem.*
L.B. Well, every time you repeat something it loses its sharpness. Yet it's still there. Now, the problem in making a work of art is, is it convincing? Either it is or it isn't.

H.G. *I had a strange experience with a piece of yours, a polished bronze called* Nature Study. *For many years I could hardly look at it, yet now I find it extremely beautiful. My experience of it went from something I couldn't contemplate to something that I get pleasure in contemplating. So I think you cured me of some little thing.*
L.B. That's a great compliment!

H.G. *You studied Cubism and worked for a while with Paul Colin, a Deco artist. We can see remnants of the Cubist grid in the structure of your work.*
L.B. I am closer to Art Deco than Cubism! In taste and education, in fact. Art Deco was a pejorative for a while, depending on where you were coming from. I am so close to it because I saw the Exposition des Arts Décoratifs in Paris in 1925. I was very young at the time and it made a deep impression on me. Those works were handcrafted and very beautifully made. Later I was taught by these artists. I have to say, I have a soft spot for all the people who taught me something. I liked all my teachers. The people I was revolting against were not my teachers.

H.G. *Can the influence of Art Deco be found in your work?*
L.B. Yes, certainly.

H.G. *Your family's business was the restoration of tapestries. Has that continued underground in your work in any way?*
L.B. In my motivation, yes. I always try to repair things that have gone wrong. There is a section of my show at the Robert Miller Gallery that has to do with lost causes. One of them was the state of health of my mother, whom I took care of for five years, in my late teens. That was a lost cause. The pessimism of it all. I was always repairing things as an acting out of my wish to make her well. Well,

she never got well. So there is that pessimism versus the motivation to get things right, well done, and on time.

H.G. *As if someone's life depends on it.*

L.B. Yes. Now, many of the collectors of tapestries were Americans, Puritan Americans, so no sex anywhere. But, my goodness, the tapestries of the Renaissance were very sexy—genitalia everywhere! So my mother would cut out the genitalia, very delicately, with little scissors, and collect them.

H.G. *There's a lot of genitalia somewhere.*

L.B. That's right.

H.G. *It sounds like your work.*

L.B. That would be the unconscious thing. But this is history.

H.G. *How do you feel about the graphic arts, making prints?*

L.B. Oh, that's a waste of time! I know that some people make a lot of money out of it. It is for artists who have a hard time making money, I suppose.

H.G. *I once read that in your early studies, when Euclidean geometry ceased to interest you, you turned to topology.*

L.B. Topology, I have a passion for that. Surfaces, height, width, depth—how you configure all that. Topology is sculpture itself.

H.G. *Topology is non-Euclidean in the sense that it is not about perfect surfaces. A topological surface can be changed, manipulated.*

L.B. It can change—it's the world. Topology is applied mathematics. I used to think mathematics was eternal, but it is not eternal! One of the greatest emotions I had was when I went to the attic of the Académie Militaire in Paris. They had topological maps of forts, battle sites, landscapes. For the purpose of planning strategy, physical strategy. That is the way I see the world: as a three-dimensional map.

H.G. *The sculptures you showed at the Carnegie are called "cells." In the sense of a prison cell?*

L.B. Communist cells. Prison cells. And, very specifically, the cells of our blood. That is to say, little entities that are next to each other, yet separate. Sometimes they repulse, of course; sometimes they merge. Construction, deconstruction, reconstruction. These pieces are about saving the world: making the world, inventing the world, remaking the world. And making it foolproof. Safe. It's a lost cause—we all know that.

H.G. *The cells you've produced create their own enclosures.*
L.B. Right. This is a reaction against the fashion in galleries. There were galleries in SoHo and TriBeCa that were architectural masterpieces, and they were dealing in shit! And everybody screamed about the beauty. I am not going to name names. But the beauty had absolutely nothing to do with what was put there; it had to do with the more fantastic beauty of the architecture. So I reacted strongly against that. As an artist I don't want to be subservient to the architecture. So I built my own. The piece is its own architecture.

H.G. *The cells represent confidentiality versus the right to know.*
L.B. Right. This is a big matter. This is partly the subject of my relationship to interviewers. Or let me say it from a different point of view: like a child who is omnipotent, I want to be both secretive and exhibitionist, in the same person.

H.G. *Isn't that double impulse in the nature of art?*
L.B. Maybe. But is it a right or a privilege? You can hear the professional say, "Look here, it is my business to know." So I say, "It is my right to be silent. I don't want to reveal this." So there is a conflict, a twisted relation of the two. I have also made a group of works I call "lairs." The lair represents the right to hide.

H.G. *So the lair is also about confidentiality, the way the cell is.*
L.B. Right.

H.G. *Does confidence mean trust as well?*
L.B. Confidence mean trust? No. Confidence means that you cannot shut up. Sometimes one talks out of fear, which is my impulse. To push the person away.

H.G. *You make a work, then you stop. Does that mean the impulse has been satisfied?*

L.B. Momentarily, yes. The impulse has been pushed away by another impulse.

H.G. *There is something very Duchampian about these cells—the way they incorporate doors, hinges. Was Duchamp an influence on your work?*

L.B. Not at all. But I knew him personally. He was coy in the sense that he pretended to do nothing. But in fact he was a workaholic. He was working and nobody knew it. He pretended to be indifferent—"la belle indifférence"—but he was very engaged. He looked very fine and debonair, but he suffered like a dog. He was not cynical; he was a romantic who could not admit to it.

H.G. *That was also about hiding and confidentiality.*

L.B. Yes, definitely.

H.G. *Don't you think some things are soiled or ruined by being revealed?*

L.B. I don't know what you mean by "things."

H.G. *Ideas, objects, feelings, expressions.*

L.B. Absolutely. One must hide things to protect or preserve them. That is why I didn't show for so many years.

H.G. *Duchamp said he didn't like artists.*

L.B. He didn't like women artists. He could not conceive that a woman could be an artist. Duchamp never bridged the gap between himself and someone else. He was emotionally arrested, and didn't connect with other people. He was too afraid to.

H.G. *Making art is connecting, in a way.*

L.B. It connects if you are convincing.

H.G. *And being convincing in art is based solely on the way the work looks.*

L.B. That's right. It's purely an aesthetic thing.

Myron Stout

Pathways and Epiphanies

[1990]

Solving enduring mysteries is one way to encapsulate Myron Stout's lifetime search for his own equilibrium.

Stout's post-Cubist, post-Mondrian paintings of 1947 to 1952 may be seen retrospectively to be conjectural pathways toward the light and dark of solid form of his mature black-and-white paintings, the guarded and silent epiphanies toward which he strove with all his intellectual and emotional energy for the rest of his life.

The power of his paintings lies in their hovering quality of irresolution (without exactly fixed boundaries) within resolution, their power first to disturb and then to soar and to remain aloft in our imagination. Their staying power, once grasped, is their most remarkable quality.

In Provincetown, where I knew him from the early sixties, we used to say about his graphite drawings and his paintings that he would "tickle them to death," working months and years (on and on and off and on) to achieve exactly the proper density, the exact ambiguity that was his ultimate resolution.

Myron's personality was that of an exquisite, his speech a refinement of utterance that expressed itself in hints and feints. His everyday reading was of British and American mystery novels, the solace of the mildly paranoid. He also had a particular passion for the western novels of Louis L'Amour, treasuring the whiff of North

Texas they evoked. Stout also, of course, kept his larger cultural sense intact by constant immersion in the great literature that formed his standards and much of the subject matter of his "abstract" work.

There is much to be said about those subjects; their density of reference and meaning movingly parallels their richness of touch. Myron Stout's paintings are elegies to the heroes and heroines of Greek tragedy at the same time as they are players in the great biomorphic game that enthralled so many major world artists in the mid-twentieth century. To see Arp and Gorky and Kelly in the same universe as Myron Stout is in no way a derogation of his talent or his originality. It is, rather, an accurate reflection of the Joycean wealth of reference he had available to his mind's eye and fancy.

From the sublime to the absurd, the forms in Stout's paintings can be, and have been likened to, teeth, maritime furniture (anchors and such), rocks, and much more. The point is that they are at once invented and multireferential, yet another vibrant paradox in Stout's procedure.

Never one to recontrive the well said, I quote from Sanford Schwartz's exemplary notes to his catalogue for the Whitney Museum's 1980 retrospective of Stout's work: "By 1947, Stout had settled on the small, easel-size painting format he would always be comfortable with. . . . Three years later, his first crop of mature paintings was in—handsome, well-tailored abstractions, made with a palpable confidence and pleasure. Some take the form of checker-board and woven, rug-like patterns; others are made up of rectangular color patches which, set side by side and tilting in toward the top, create the effect of an endless stream of blinking, alternatively bright and subdued, upward-moving particles. Each painting, in a different way from its neighbor, and in colors that one believes have specific meanings for him, seems to embody a separate mood or experience."

In trying to find an exact verbal equivalent of Myron Stout's aesthetic intention and effect, I think it fair to describe his *Epiphanies*, the post-1954 black-and-white paintings, as ecstatic contemplative, and even as ecstatic indefinite (in the sense of edge). There

seems to be a correlation between the time it took to paint them and the time it takes to "get" them, at least to get them for keeps, because it does take a while to realize how anchored, in spite of all their "hovering," they become in our conscious memory bank of art that is and remains relevant.

All questions of biography in the case of Myron Stout depend on two matters of geography: where he was born and where he chose to spend his life. Once we ground the artist with his family in the landscape of North Texas, we come to understand the revelation Provincetown must have been to him, the relief and succor of its watery expanses, the familiarity of its endless dunes and scrub brush, and, finally and most crucially, the delicious curve of its bay—the overwhelming roundedness of Provincetown's central datum, the bay, the bay, and once again the bay.

Is it too much to ascribe the *Pathways* of 1947 to 1952, the painting he invented in the years he spent summers at the Hans Hofmann School in Provincetown, to the climb out of his natal landscape, and the rounded *Epiphanies* to his mature choice to live by the water? Perhaps. And yet in the paintings Hofmann himself was producing in the early and mid-forties the specific landscape of Provincetown Bay was a strong presence, a central fact. Hofmann did not encourage his students to become intimate with his own work, but one might conjecture that they had some familiarity with it.

Let us turn to Stout's Journals, a stunning and as yet only partially published guide to his own perplexities and, at times, their resolution. (These excerpts are culled from two previous compilations by Tiffany Bell [*New Observations*, 1985] and by Sanford Schwartz [*Myron Stout*, 1980].)

October 17, 195?

There is one thing in particular that I learned through Hofmann that, again and again, proves its value: the necessity of keeping in direct touch with nature. For someone with the tendency towards abstraction that I have, this is very important. I see so often how my work becomes sterile through an over concern

with the abstraction and loses touch with the *thing*—the original visual impetus. When a painting "begins to die," it is doing exactly that—it is losing its connection with life, with reality. It has lost touch with its source in nature . . .

. . . A painting should fill the air between it and the viewer with its vibrations so that one has the sense of being both close to it and at a distance, as one stands at one's best point for seeing, of course, and is satisfied whether feeling close to or far away from it. It must bridge the gap of from near to far. The feeling of proper—of "just right"—spatial orientation that can make a masterpiece depends on the proper attunement of all sense of direction from out to in, from above down, from side to side, and reverse, from down up plus all possible intermediate directions. And this does not omit upside downness and top or bottom one-sidedness.

June 4, 1953

The life of a symbol is in its refusal to become fixed. It is through its metaphorical quality that it takes on a thousand meanings, meanings changing in time as you work, or afterward, as you contemplate, meanings changing in space, intraspatial meanings, meanings which take in new values as approached from varying standpoints, frames of mind—emotional and logical. The totality of the painting finally becomes a supreme metaphor.

April 26, 1954

It must never be forgotten that the artist doesn't have, never had, and never will have ready-made symbols, nor does he just incidentally pick them on his way, nor can any symbols be taught by one person to another, nor any sure-fire method be developed to teach just how to find them for himself. He must find out on his own, his purpose firm, his patience infinite, his faith boundless, his vision open to the ends of all the universes conceivable.

April 14, 1955

We are subject to error in following any conception in practical application to its logical, conceptional end. But to rest satisfied with what seems a well-rounded conclusion is the real error. We can only constantly inquire, remembering that, if there is any predetermination, how can we know that we have discovered what it is? . . . I have constantly to remind myself that nothing is final. Nothing is achieved in a conclusive sense. What I see and grasp as the truth, I have to remind myself, is in its substance and structure capable of being so complex that whatever core of truthfulness I have faith it contains and which is the anchor of my hope, faith and surety, it still must be discovered how and in what way there is the truth in it.

June 9, 1957

When I was first getting acquainted with Romantic poetry I was entranced by it all, but I wondered secretly (because shame-facedly) how I could ever come to the poetical meanings which must surely be those of a line like "When all at once I came upon a crowd—/ a host of daffodils." In Texas daffodils don't grow out where, wandering high, you can come upon them un-expectedly. Where I lived you couldn't wander high at all short of walking the eight or nine miles (as the buzzards fly) south and westerly to Pilot Knob, the one geographical eminence the whole 900 square miles of the country possesses. I never got there—walking or otherwise, though once when I was in college I did go to a party that was at the . . . bottom of the rise. But as I remember it was the sort of party where one wasn't much interested in finding daffodils.

April 1, 1964

Re: Bowra, *The Greek Experience*, p. 23 & ff. It's interesting what he has to say about the effect of the *light* in Greece on the artistic conception there, and even on their thought in general,

because, especially when I go back to Texas after some time
away, I am aware of how different and distinct the light there
is; and I often speculate about its effect on my color concepts,
and notice the wholly different color preferences that people
there have.

The long period each year of heat and drought, when the heat
sears; and so does the light, for the hot, clear—that is, largely
clear, but a little bit slatey—light can sear the eyeballs just as the
hot sun and wind sear the skin—and penetrate to the bones.
The outside is so uninviting that the tendency is to cut off the
outside from the inside . . .

April 15, 1964

The trouble I referred to that haunted me for so long began
when I quite consciously attempted to simplify the painting
process for myself. The constant and agonizing doings and
re-doings seemed quite enough to have to put up with, and my
inadequacies with technique to cope with on top of that seemed
too much. Many people think that with the simplicity of style
in my paintings and the stark purity, etc., that they require great
technical adequacy and facility for their execution. In my case,
anyway, the reverse is true. I do not have technical facility, and
every telling brush stroke is the result of great effort—often will-
ful effort. Similarly, they think of me as having great patience. I
do have—or rather I have developed a great measure of it, but it
is precisely because I have no patience, basically, that I have had
to develop it—my first and most persistent tendency is to go on
ahead with it, letting the chips fall where they may . . .

November 26, 1964

. . . thus, seeing a part of the "shape" out of kilter, I know that
the edge has not, say, the proper curvilinear quality to reveal the
shape—to define the substance that's *in* the shape (and it's *in* it,
not at the edges!) so my consciousness works with the *curve* at
that particular place, trying to see and develop its necessary de-

gree of curvedness, its continuousness, whether it is properly
swelling or contracting the shape . . .

The source of a curve—of "circularity"—is in one's body—
not in the idea, "circularity," or "curvedness," and in my painted
shapes every curve has its source in my body movements—or in
my sense of them, my feeling of them. Every curve painted, I
believe, is an analogue of some particular movement felt and
sensed.

July 1, 1965

I believe I don't really feel that (to put it interiorly) the painting
or drawing is *mine* until I've gotten muddled, then fiddled
and diddled over it for long in this state; and then when I can
approach the work again with the fresh, alert, comprehensive
vision that seems most productive to me it opens up, clears,
seems beautiful to me again, and I can go on to a conclusion.

October 13, 1965

I think it was only when I came fully alive, so to speak, as a
painter—when I had worked with Hans—that the effect on me
of the flatness of my native environment had affected my imagi-
nation so powerfully. The flatness—or rather the successively
endless, low-rolling character of North Texas and of all the areas
of Texas that I went to in my young years had the effect of giving
promise in every direction. "Things" and likewise "affairs"—
whatever I was aware of and that concerned me extended out
in, possibly, every direction—every direction of thought and
of possibility—but they extended predominantly in a single
plane—horizontally. Except for various structures such as
the county courthouse and the grain elevators and such (never
climbed more than to the second storey) my habitat—my
familiarly known plane of existence—was the ground. . . .

Stout's rational skepticism as a painter was such that he constitu-
tionally disbelieved in the evidence of just one sense—seeing was
not sufficient for believing. His work had to appeal to another sense

to be credible and thus the endless adjusting and readjusting that was his method. That method was viewed as idiosyncratic at the time, but we can perhaps now understand that it was to engage that rarely considered and more rarely discussed sense, the haptic, that he labored so to give his "flat" forms substantiality. Now, we all know the caveat against touching the surface of drawings or paintings. Haptic in this context is defined not as the sense of touch but as the sense the eye gives of how a flatly painted form would feel to the touch if the painter's volumetric evocation were to be palpable. It was in Berenson's writing from the turn of the century on the Italian painters of the Renaissance that I first (and probably last) came across this use of the word. I think it helps resolve the mystery of Stout's appeal to the senses.

And as into the 1980s Myron saw less and less well I like to think he took comfort in the weight and the touch of his work.

An Interview with John Chamberlain

[1992]

HENRY GELDZAHLER *What do you think of efforts to explain your work through illustrations of Renaissance drapery and pillows? I sometimes use the word "drapery" to get people going about your work.*

JOHN CHAMBERLAIN For the last three or four years, I've been much more interested in how the bed or the pile of dirty clothes looks in the morning, or how the towels hang in the bathroom than I am in car crashes.

H.G. *I see wings of angels and the* Nike of Samothrace *as much as I see that your material comes from cars.*

J.C. My vertical pieces always have that sense of Rodin's *Balzac* in them. You know, like someone who's proud . . . always standing up. All in all, the *Balzac* absolutely was his opinion of Balzac. You know, he had all that garbage on him, but he did make a nude version, too.

H.G. *That garbage is a cape. The problem of sculpture in the twentieth century was how to get it off two feet, and put it either directly on the floor or on the wall. Your standing pieces certainly get away from that. There are no implied feet.*

J.C. Actually, there are to me. The foot problem doesn't bother me

except that it sometimes has to do with balance and then it has to do with structure. But going back to the feet . . . you're right. The feet are important.

H.G. *In the earliest pieces, like* Calliope, *and the ones that . . .*
J.C. I see that. I see what you mean.

H.G. *It was necessary somehow to get the thing going. You couldn't just have a drawing hang in the air. It had to be attached to something that had a stance firmly on the ground.*
J.C. For instance, I made these two (*Calliope* and *Clide*) at the same time. [*Points to a page in his catalogue raisonné.*] They would be connected at several points. Now, to keep on the foot problem, this is really almost verbatim plagiarism from David Smith in terms of influence. It just got more expressive here. This was the first one I ever did.

H.G. *And you saw David Smith's work . . .*
J.C. When I saw David Smith's work, it didn't remind me of anything, and that was the key. It was like: America, we have arisen.

H.G. *Also, like you, he's from Indiana.*
J.C. Well, I don't know that territory has an awful lot to do with it. The decades will roll over a territory and produce somebody. Maybe in another fifteen years they'll all be coming out of Wyoming . . . or Nebraska. But the feet are important. The way it stands is important and I try to get it as light as I can so that it's not "clubfooted," as they say.

H.G. *You also have to make a structure for something to hang on a wall. You can't just throw metal together. You have to be the engineer who figures out how it's going to hang on the wall.*
J.C. What I meant about the foot . . . there could be lots of points touching the floor, but there's a daintiness I particularly like. If I don't get the daintiness, then I do something else. And, things can be thrown in a pile and kicked at until they don't move any longer, until they look as if they're meant to stay that way.

H.G. *You said something the last nine words of which I think you could wear on your T-shirt.* "*For twenty-five years, I've been using colored metal to make sculptures and all they can think of is, 'What the hell car did that come from?' Who gives a shit what car it came from.*" *I think that sums up the attitude.*

J.C. The addition is that somebody would come along, knock on your door and say, "Listen, I'm getting rid of my old Mustang. Do you want it?" Or somebody says, "Here's a panel from something. It's a real nice orange. I thought maybe you'd like it." The first one implies to me that they want immortality by their car being stuck in something...

H.G. *... a self-portrait ...*

J.C. ... And, the other guy is saying, "I was just thinking of you." I mean, it's changed. A hundred years ago there were statues. Now, there's sculpture. A difference I see is that statues are made by artisans who can carve out something that everybody wants—sort of commercial art—like an illustrator. In modern art, it's the artist's sanity that we're looking at and not somebody else's.

H.G. *Also, the nineteenth-century idea of the man on a horse or the man standing there is "Man in Nature." Whereas when you're inventing something, you're really contrasting it with nature. You're doing the equivalent of nature when it creates something. Can your car sculptures stay outside and deteriorate?*

J.C. Sure. They can stay outside.

H.G. *For how long?*

J.C. Well, that was the complaint when I squeezed rubber in the 1960s. Everybody said, "How long will it last?" Two, that it was very sexual, and three, that I just wanted to get away from metal.

H.G. *Was it rubber or latex?*

J.C. That's the same question that came up earlier. What car did it come from? Nobody wanted the latex pieces because they wouldn't last. I still have works from that time.

H.G. *They'll last longer than we will.*

J.C. Probably last longer than those guys complaining about it.

H.G. *Right. What about the idea of outdoor sculpture? Have you done anything specifically?*

J.C. First of all, I don't know what the catch is about outdoor. I mean, what does outdoor have to do with anything?

H.G. *Sometimes it has to do with public funding. I'm talking about the way the bureaucracy has built up.*

J.C. Well, I've taken the position that since I'm old enough to retire now, what I feel is that I'll say yes. Yes, it could go outdoors. And, when it starts to fall apart, I couldn't care less. You never think about it. It's only lately they've started to think about maintenance with regard to new art.

H.G. *I always think that if it's important enough aesthetically to the culture, they're going to preserve it, somehow or other.*

J.C. I've got some pieces outside. They don't last long. You can start to see rust show up. It's just the material I use.

H.G. *There is something stunning about seeing your work indoors. You're used to seeing that kind of material outdoors—that kind of metal, that kind of paint job, the way the light hits surfaces. Whereas inside it comes as a wonderful shock. It's an aesthetic displacement.*

J.C. That's a good thing to say.

H.G. *You often have talked about Franz Kline.*

J.C. I remember one of the best stories I ever heard I got from Franz. As far as his work went, I think it produces an ambiance of some sort.

H.G. *And, the compacted energy . . .*

J.C. I don't know how to analyze it. But when we were all getting drunk at the Cedar Tavern, I did have brains enough to keep my mouth shut and listen to him. The only thing I can remember him saying about sculpture is that if you drop it on your foot, it'll hurt.

H.G. *That it's real.*

J.C. Yeah. It's real. He always liked mine. I mean, what he saw of it.

At the time, what he saw were essentially the early welded metal pieces.

H.G. *Well, I'm rather familiar with* Calliope *because I lived with it for about seventeen years.*
J.C. Was it around that long?

H.G. *Oh, yes. It's a great, great piece. Joe Goto. Was he in Chicago or was he at Black Mountain?*
J.C. No, he was in Chicago. When I walked in the room and I saw his welding and his Japanese way of handling the metal, I got it. Well, he was influential for the same reason—attitude. Ambiance. Between seeing him welding and seeing the David Smith upstairs here, I think it was *Agricola IX.*

H.G. *Right. You got the idea of how it's done.*
J.C. And I think it was between the two, Smith and Goto, that I got started [Joseph Goto is an American sculptor of Japanese descent. His work in welded metal inspired Chamberlain in 1950 to master the techniques in use by David Smith—techniques he continues to use.] Also, the only thing that I remember about going to school is that you had to walk through the Art Institute in order to get to the art school. I always felt that I remembered more on that little trip four times a day than I did when I was in the school. But I do remember walking past the sculpture room. They had somebody named Mitzi. I can still remember her name. She was a model. And she was very, very plump and very black. I looked and said, "Shit, this is the room for me." [*Laughter*] Yeah, this is the room for me. I remember things like that. And I also remember why I quit.

H.G. *You quit because they criticized you, probably.*
J.C. As a matter of fact, I think you're right. But I learned something on those walks. When you make the trip again and again, something all of a sudden means a lot more than it had up to that point.

H.G. *Exactly.*
J.C. The first thing I can remember is the Chester Dale Collection.

H.G. *Those are paintings . . .*

J.C. Yeah. It was all Impressionist. And it was the first time I understood that van Gogh was intuitive. "I guess I am too," I said. I'm really drawn to those.

H.G. *That's a nice parallel, actually, because you're both color wizards and not exactly self-taught. You're artists because you got turned on by art. I'm very intrigued that your idea of being an artist was preceded by your fascination with a sense of scale. The specificity of being an artist came a little bit later. Maybe even after the Navy, but that idea . . .*

J.C. I remember when I was small I used to steal from the dime store, and what I would steal were very small sculptures of cats and deer . . . all that little china stuff that seemed to make sense to me.

H.G. *You thought they were beautiful or . . . ?*

J.C. Yeah, I thought they were very beautiful. I thought I liked the way they sort of sat. I liked the size of them. What one artist, Robert Graham, did in the sixties was fantastic to me because of the little tableaux. There's something about little tableaux and me being the giant (Dr. Cyclops?) looking down into a scaled-down perfect world . . . the miniaturization of life or something.

H.G. *But it's unusual for a little boy even to think of things as being beautiful.*

J.C. Oh, really?

H.G. *Most of them want an airplane or car. They're thinking about speed, about escape . . .*

J.C. Well, I thought about that, too. Up until I was twelve I wanted to be an aeronautical engineer.

H.G. *I have a theory that the reason kids get interested in trucks and planes and stuff so early is that they're trying to figure out how to leave home.*

J.C. Yeah. I think everything I did was about leaving home but, of course, where are you going?

H.G. *Right. The self-discovery of an artist came in stages. The sense of beauty and the sense of scale and the sense of playing with space, all of that was already in place.*

J.C. I would put model planes together, so I knew what the workings were. I used to make airliners move and something would retract, the wheels would retract, and I got interested up to the point where I probably wanted to leave home.

H.G. *I'm fascinated by the cigarette pack thing—the idea of sitting in bars and listening to people talk and nervously smoking and then finding a cigarette pack empty and crushing it and beginning to realize that that has a certain kind of elemental interest to you.*

J.C. Yeah, it did. Actually, what started it was squeezing the foam. After squeezing the foam, I did the brown-paper bags on the assumption that here was a big explosion of energy, if you blew air in it and popped it. But then, since I had done that and everybody else does that, or has done that one time in their life, suppose you just went slowly. So, put it in slow motion. Then it became articulate wadding. I thought of putting watercolor on it, but the feat of engineering that has never been brought up was the pouring of the resin in the creases. So it maintained its sense of paper, and increased in weight.

H.G. *How do those pieces look now?*

J.C. They look pretty dingy, but I still get it. I mean, I can still get it out of them.

H.G. *Have they picked up line and air . . . ?*

J.C. Oh, yes. The watercolors faded and I only have about five anyway.

H.G. *Are they out in the world? Did you manage to sell some?*

J.C. I didn't sell any.

H.G. *The cigarette pack has a relationship to the other sculpture as well as to the metal sculpture.*

J.C. Well, that's what I was gonna say.

H.G. *O.K.*

J.C. When I wanted to do the galvanized boxes, I went out and . . . this [*pointing to his cigarette pack on the table*] is the proportion of it . . . that's the proportion of the galvanized box when I had it made.

H.G. *Right.*

J.C. When I smashed them or changed their surfaces, I remember I had to borrow the baler at this guy's place on White Street. He let me bring the stuff in. I did it and I left. Then the elevator operator remarked, "They look better going out than when they came in."

H.G. *That's approval. But, you know, in art history, there's a phenomenon that happens: when things get very baroque and very rococo and very colored and everything, the artist or the society decides to get back to basic forms, black and white, eliminate color and start again. I always had a feeling that you were knocking the color out in order to start thinking about the whole problem again.*

J.C. That was the galvanized piece.

H.G. *Yes. I think the color comes again . . .*

J.C. I wanted to see what it looked like without color . . .

H.G. *That's it.*

J.C. . . . and that big. And, as nice as those pieces were, there were no takers then either.

H.G. *Those are beautiful pieces.*

J.C. And then, right after that, I made melted metal boxes.

H.G. *Which didn't work.*

J.C. They did. They did work.

H.G. *Are there pieces like that in here?* [Catalogue raisonné.]

J.C. Yeah, there are a couple of them. They didn't work by themselves, and what I wanted to do was run color inside of them. That never happened. So I had them shot in Larry Bell's machine.

H.G. *What do you call it? Vacuum box? What do you call Larry Bell's . . . ?*

J.C. A vacuum coater.

H.G. *Vacuum coater, right.*

J.C. But that stuff scratches off really easy. It was very expensive at the time. I was making them in the wrong size, so the next step was to reduce the size and I had no money. And they had to be perfectly clean to go into the machine.

H.G. *Well, there was a whole aesthetic in the fifties and sixties of the immaculate object. Ad Reinhardt, I guess, was the first—Donald Judd, Larry Bell, the least little breath of reality makes it no longer usable.*

J.C. You should learn about the word "perfection" from that. "Perfection" is good for an instant.

H.G. *Salvador Dalí said, "Don't worry about perfection. You'll never make it." [Laughter.]*

J.C. Well, that's not necessarily true, you can make it, in a sense, in a given parameter.

H.G. *But then you can't control it beyond our studio.*

J.C. Well, it declines from there. Perfection for an instant. Perfection will exist for an instant. And then it digresses. Things keep moving. You can't see the molecular structure when it's moving, but it is moving. Things are constantly in motion, so perfection is good for an instant.

H.G. *It's like "love at first sight."*

J.C. And then it becomes hindsight. *[Laughter.]*

H.G. *Is Judd the first person to write about you sympathetically on a really intellectual level?*

J.C. I think so.

H.G. *There's a piece he wrote in '64 that still reads as one of the best things anybody could ever say about you.*

J.C. I like the sentence where he says, "It has Rooseveltian colors." *[Laughter.]*

H.G. *Right. Right. That's an incredible piece and it really is the first time somebody sat down and didn't say, "He's throwing cars*

*together" or something. He tried to think about what it is that he's
actually looking at when he looks at your work. What about that
evil canard that the galvanized pieces were just leftover Judd boxes
anyway?*
J.C. No. No. Judd had some boxes that were *not* "perfect." I mean,
they had gotten a dent in them or something, and he couldn't use
them just for the reason you stated. And, so, they digressed to me.
And I tried scrunching them up but nothing worked. I didn't really
have a good setup for that. But I gave it a shot. Those boxes were
never used for anything. I scrunched them up at Mickey Ruskin's
farm.

H.G. *Which was where?*
J.C. In Massachusetts. Great Barrington.

H.G. *At some point, you didn't use the pieces as found and then
merely crushed them, but you added color and then crushed them.
When did that start to happen?*
J.C. Adding color? That was '61.

H.G. *Before they were crushed?*
J.C. Yeah. I used the color I found, up to about 1961, and then I
started messing around.

H.G. *And you've done that ever since. People don't realize that.*
J.C. Yeah. When you look at the formula for the paint they used on
automobiles, you find that there are five components to the for-
mula. You can look at a book, a paint catalogue . . .

H.G. *You can prepare the paint, choose your color.*
J.C. You can find 1,800 variations of white that are listed and there's
more, the Pepsi-Cola "white" or the postal service "white," there are
all different whites. It's amazing. So it goes from "hot white" to
"cold white."

H.G. *So how does it work? Do you look at the stuff and say, "I need a
yellow or green here?"*
J.C. The additions are subtle, much too delicate to even notice.
Hey, I got a commission just the other day. So the guy calls from

California and he wants a three-foot piece, or something that's bigger. And it's all white . . . white and chromes. Then he calls me back and says "the white I like . . ." [*Laughter.*]

H.G. *So why doesn't he just do it himself? That's funny. But, there is something magical about the white pieces? I don't know if you think this is too private or too technical, but you don't decide between 1,800 whites when you're looking at a piece.*
J.C. No. No. No.

H.G. *What do you do? Do you have white in the studio?*
J.C. Usually all I've got is white and ivory. So, there's that difference.

H.G. *People don't realize . . . they think that you assemble the material on the floor, you get it in various car lots and then put it together. They realize that you crush it. But they don't realize that the color—which makes such a fantastic difference—is your creation, not only choosing the elements but adding to the color.*
J.C. For the last two years, the only materials I've been using are van tops and chrome—chrome bumpers. The van tops are tops of vans that have been cut away when they've been replaced with bubbles.

H.G. *I see.*
J.C. So the van top—and it's the complete top, too, when they take it off—I buy at three bucks apiece.

H.G. *They're not too similar?*
J.C. They're all similar. What we do is make two cuts lengthwise, so we have three strips. And each of those strips is painted by the painter on both sides . . .

H.G. *I see. Right.*
J.C. . . . and I tell him what I want him to do for a while and he does that. We cut templates, and he uses the templates to paint. He makes up a sort of palette. For instance, this particular piece was sand-blasted. I got tired of the colors that were on things at the time. They were my paint jobs. I thought, I've seen enough of them. I wanted to get rid of the color and I thought: "Well, let's see what it

looks like if we just take all the color off." Well, it went matte, didn't shine. And so, what we did was, well, listen to this—we tried making roadways with the paint and things like that, and you could tell when he was in a hurry . . .

H.G. *Right. It's called "before lunch" and "after lunch."*
J.C. Something like that. I mean there were some days when the lines would be thin, he would be in a hurry. Some days they'd be thick, when he wasn't in a hurry. This stuff was painted—everything's painted. They were laying around, just parts in a pile. So, the paint would drip down and through.

H.G. *You piled them up and painted the lot?*
J.C. Yes. It's just like I take this pile and start painting . . . you know, dripping paint back and forth. Then it would go down through and mix up that way. The pouring is all right, but the weight of it coming out of the can hits things and goes this way, goes this way and it goes that way. It does things you wouldn't get unless you did it like this.

H.G. *Your work is often talked about with Flavin and Judd, and yet, it seems physically and sculpturally quite different. What's that about?*
J.C. I'm caught in the crack in the sidewalk between Abstract Expressionism and Pop, which came next.

H.G. *And Minimalism.*
J.C. Well, everything started having all these categories about 1963.

H.G. *Yes. We need you here or we need you there. Was your work used in Pop shows at some point? Did they drag you into those Pop books and so on?*
J.C. Not very often. I sort of started to get left off because I'm that side of the crack to whomever is doing this book and if I'm in it, then I'm on that side. Well, I'm the opposite of Judd . . .

H.G. *Right.*
J.C. . . . and Flavin lights it up.

H.G. *Yes. Flavin's the Holy Ghost.*

J.C. I thought I'd die the night I saw him do the sign of the cross on leftover food.

H.G. *Oh, my. Did he really? I'm glad you didn't die. What about di Suvero's work? Does it seem to be on your wavelength?*

J.C. Well, Mark is exuberant. There is an exuberance and a will involved with di Suvero. I don't know that his work expresses it.

H.G. *I think the scale of the big pieces outdoors in nature is a miracle.*

J.C. Really?

H.G. *A real miracle. The way the really big ones work. I saw them in Paris around the Tuileries and thought they were absolutely stunning.*

J.C. Every time I see one of these things turning and turning, I don't know, I think about the African thing.

H.G. *That's one place the balancing and turning comes from by way of Calder. Remember the time we went up to see David Smith, and your friend climbed the sculpture and I thought I was going to have a heart attack because I was so embarrassed? What was his name?*

J.C. John something.

H.G. *Oh my God. It was the middle of the night. They were all drunk and they were out climbing on David's sculptures. I just thought, as a curator, I wanted to fall on my sword. That was quite a weekend.*

J.C. What struck me about that trip was when he took us into the basement, and you couldn't get in because it was so full. And he said, "This is for my daughters . . ."

H.G. *Right. And they got it, too. He had 2,000 drawings he wanted to show me. After 1,200 I said, "David, I really can't see anymore." He was going to show me 800 more drawings! It was fantastic. One of the things Judd said about you in '64 is: "There's not space beyond the work. There's a lot in it." And that's a real revelation . . . just saying that. To look at your work and see that it's not a*

*construction, it's a drapery. We go back to that again. The air goes
in and out. Aesthetically, the most amazing thing about your work
is the same thing that is amazing about you. In order to do the
work, you have to be an engineer on the one hand, and a poet on the
other. You have to be a realist and a romantic at the same time. You
have to be masculine and not afraid of being feminine all at the
same time. Feminine in the sense that such an almost "nail polish–
lipstick" aestheticizing is going on, which could embarrass someone
who's embarrassed by things like that. I don't know, I just admire
the fact that the structure is perfect, and at the same time, the color
works. So tender. I know the idea of being feminine doesn't thrill
you, but I think it's there.*

J.C. Well it is. Everybody's both.

H.G. *That business about looking at miniature objects when you
were a kid and seeing that they were beautiful—Claes Oldenburg
once said, "Everything I do I made up when I was six years old."
And, I think that's very true, generally, about artists. The impulse is
very early.*

J.C. It certainly is true about the Ray Gun store . . .

H.G. *Absolutely. That was a great moment. We're having a show
here at DIA in Bridgehampton in August 1992 and, to me, the
point of this show is that pieces as small as ten inches and pieces as
tall as ninety inches are, in their separate ways, perfect in scale. It's
the best work that you've done recently. The sense of scale in this
work is so perfect that I would like the public to understand that you
can put eleven sculptures of three or four radically different scales in
the same room and understand what it is that the artist is doing in a
way that you can't from a book or from a show of works of one size.
When you work on the small ones, where do you get those small
elements from?*

J.C. Well, let's see.

H.G. *I mean the material for them.*

J.C. It's all the same material. It's all cut.

H.G. *Cut from what?*
J.C. It's the same material. I mean it's not a thinner material because it's small. It's the same material as the big stuff.

H.G. *Right.*
J.C. It's curled or it's flattened or it's stamped or whatever it is. A man came and said he waned some truffle boxes. You know about this . . .

H.G. *Right. The small pieces came out of that?*
J.C. Yes, after I did the four truffle boxes. [In September 1991, Chamberlain was faced with the problem of making a box to hold the chocolate truffles a friend in Paris was obsessed by. He bought a well-made cigar humidor and tried attaching a pre-existing rosette-like piece of scrap he had retrieved from his own work process because it had pleased him. It was in making this box and several more that he conceived the idea of making the small pieces of 1991 and 1992, the pieces he refers to as *Baby Tycoons*.]

H.G. *Right.*
J.C. I had a lot of material left over, and so I just put it together and it came out seven inches high. It was a real trick, you know. But it was one of those things that I love. It's like doing something on the wall, and then, after a while, doing them on the wall is tiring. The decisions you make are getting to be repetitive and, all of a sudden, the work slips down and hits the floor. And then, all of a sudden, it moves out from the wall. It only happens if you will it. I will this to be this way.

H.G. *But also, since you're the first expert and connoisseur of the work, if you're bored with a process, then it's time to change. Yours is the sensibility, in the first instance, which has to be gratified . . .*
J.C. Oh, of course. That's mandatory. Mandatory that the artist satisfies his sanity first, otherwise it's commercial art.

H.G. *Right. But yet, in our age we can respect fabrication, also.*
J.C. Regardless of how it gets done, or who helps do it, it's still the

initial sanity of the artist getting out a certain amount of insanity to everyone else without screwing himself up in society.

H.G. *I used to say about your work in the sixties, when you were still up in Rockland County, that it was like working with brush strokes lying around which you figured out how to put together. But I didn't really understand about the color then, and how you manipulated it.*
J.C. That's a good idea . . . that's a good shot.

H.G. *And that's the way in which you can sense de Kooning as being an admired and influential artist for you.*
J.C. My feeling of connection with de Kooning was that we both ended up using the same amount of whites in our paint. The Detroit formulas for car paint were similar to some of the paints he used, especially some of those greens with a lot of white in them—basically the Manhattan green that hallways in tenements are painted. Somehow, a lot of colors that de Kooning used were similar to what I was using. That's the connection.

H.G. *De Kooning's training was as an industrial or commercial artist as well as a fine artist, and he knew all that. I just thought of something. Frank Stella began doing . . .*
J.C. I've heard his name lately.

H.G. *Right. . . . his Black paintings and his Aluminum and Copper paintings after a period of two or three years when he totally admired Kline and de Kooning. Then he took an art history course in manuscript illumination at Princeton in 1957 or '58. He began to realize that there was something wrong with the corners in de Kooning's and Kline's paintings . . . they were kind of left over because of the rectangular format. So, he thought, knowing the Book of Kells and thinking of manuscript illumination, he would knock the corners out and start with the outside and work his way in. Your sculptures can be seen as wall pieces in relation to de Kooning. You take care of that problem because there are no corners. You end where you want to end. You jag where you want to jag and you jig where you want to jig. If you had to put each of your*

pieces in a rectangle in order for them to be moved safely and
everything, they would die 30 percent.
J.C. Yes.

H.G. *You can hide your rectangle, as it were.*
J.C. I hid my corners . . .

H.G. *But it's implied, because, you know, we tend to see the world as*
through a window. And you look at a piece and you somehow or
other intuitively rectangularize it anyway. I remember telling you
in the mid-sixties that your days of fame and success were just
around the corner. I want to apologize. I missed by a decade.
J.C. Or two.

Keith Haring

[1990]

Keith Haring's images remain inexhaustible. Their resonance and vitality survive endless encounters. Like Andy Warhol, his friend and mentor, he found ways in which to communicate with the widest audience in America without in any way diluting his seriousness, wit, or ironic sense of distance.

A product of Pop Art, he belongs to the succeeding generation, to whom TV was a fact of life. Born in 1958, he said: "I feel more that I'm a product of Pop, rather than a person who is calling attention to it," as was true of Warhol, Rosenquist, and Lichtenstein. In 1966 I asked in a lecture if one could imagine an art made by someone brought up with both television and the example of Andy Warhol's art. In 1980 when I first saw the work of Keith and Kenny Scharf, I realized that that conjunction had been made.

Pop Art describes the origin of Keith Haring's art and its destination. The immediacy of his recognition within a year of his first work, in the subways and on billboards in 1980, was astonishing. Equally startling was the breadth of his popularity and recognition; Keith painted on the Berlin Wall in 1986 and he opened his Pop Shop in Japan in 1988 where its daring and contemporaneity was vastly admired and imitated. A painting by Keith was in my apartment when it was photographed for the New York issue of the Japanese magazine *Brutus*. Much to our astonishment clothing began

to appear on the market in Japan that quoted directly from that specific painting. Keith sent me some photographs and we talked about it on the phone. He didn't know whether to be pleased or annoyed. I explained that it was merely the obverse of success. And he, of course, agreed. Copying Pop had to go with the territory.

Keith was always crystal clear in the distinction he made between his art for the collector and the private gallery, which was so amusing, and so daring, and what he did in subway stations, on urban walls and in schoolyards. "Kids like the drawings," he said, "and I don't want to endanger that." Among his most perfect works is a birthday book he made of a girl's fifth birthday. Without a trace of condescension he spoke directly to a child's intellect and fancy. I have seen kids turn over the pages of Art in Transit, his book without words that pictures much of his subway art, for hours at a time, engendering a love of the format of a book that in many cases pre-dates and short circuits the ability to read.

The last thing one expected from Pop Art was a moral dimension and yet, in the generosity of his life as in his uncomplaining death, Keith provides us with exactly that.

A large part of the staying power of his work has to do with its wordlessness and absence of specificity or topicality. He said of the barking "dog" in his work that it's not just a dog but a four-legged animal. It stands for Nature and even in its scale it is telling us something—small it's a pet, large it is menacing. His frame of reference includes the imagery of his Catholic boyhood immersion in the Bible, as for example in his vivid image of idolaters worshipping the Golden Calf. Ancient ruins and hieroglyphs are echoed in his work as are today's most advanced artifacts, e.g., spaceships and lasers.

Of his Mickey Mouse drawings, a tribute to the art of Walt Disney, he said that he'd been doing them since he was a kid. "partly because I could draw it so well, and partly because it's such a loaded image. . . . I did the [sumi ink] drawings just after I saw the Whitney Museum Disney show." It is unbearably sad that at the very end of his short life, Keith was approached by the Disney Organization to discuss collaboration.

Eternally fresh, Keith Haring's images are so universal that they remain apt in every newly relevant context, be it greed, patriotism, or excess.

Keith produced a tuneful art that keeps us humming.

Keith Haring died in February 1990.

Dale Chihuly as of 1993

[1993]

America has an art glass tradition best known through the work of one of the most admired artists of his day, Louis Comfort Tiffany. Tiffany and Frank Lloyd Wright were the first American artists whose styles and achievements had international influence, both in Europe and in the Orient. I think it is possible to compare what Dale Chihuly is doing with what Louis Comfort Tiffany did. Tiffany ran a studio, he worked in various styles, often concurrently, and he understood the history of glass, especially the effects that time lent to the metallic surfaces of ancient glass, and Tiffany was able to bring these recreated innovations into the mainstream. Chihuly, in his own way, working with a team to make one-of-a-kind pieces in series, is doing something similar. I believe his best glass rivals what Tiffany did one hundred years ago.

While the techniques that Chihuly uses are not all that different from the way glass has been made historically, bonding sand, human breath, and fire, there is a kind of abandon within strictures in his work, a refusal to be timid or to admit to "realistic" boundaries that makes us feel more buoyant and optimistic in its presence. . . . You walk into a gallery with twenty "Macchia" up on white columns and you see color as you've never seen it before, as if color itself were floating in the air. It is an elevating experience. It makes you walk a bit lighter for the rest of the day.

Chihuly has brought the medium of glass to a growing new audience through his exuberance, through the constantly developing morphology of his work. These works dare to look different from year to year and yet always emanate from a consistently, even insistently personal sensibility. He's brought glass out of the crafts department and into the realm of sculpture. Chihuly's work can be appreciated as sculpture made of glass. Chihuly's glass is purely about the creation of form, given the reality that glass is liquid when hot and that gravity is a fact of life; when liquid glass wants to fall, to sag, Chihuly takes all that and makes it work to his own ends, leaving out all the incidentals that, I think, make much contemporary glass too cute, too "twee," as the English say.

The greatest obstacle to a universal appreciation of his work is that he's inevitably ahead of his audience. Chihuly challenges taste by not being concerned with it. He never asks himself is this good taste. I don't think he knows the difference between good and bad taste. His sole concerns are color, drawing, and form. He does go over the top at times, with pieces about which people say, "This is really too much," but perhaps it's not. Five or ten years later it's no longer too much.

In 1989 and 1990, Chihuly chiefly concerned himself with his series the "Venetians," inspired in the first instance by his admiration of the venerable glass tradition of Venice, since the Renaissance an acknowledged center for the high art of glass. Working with a master glass blower from Murano, Lino Tagliapietra, Chihuly pays tribute as well to his own Fulbright year in Venice. Chihuly fully integrated Tagliapietra into his long-standing team of glassworkers, his acknowledged co-heroes, and through his inventive drawings and on-site direction, produced a large body of work, work which is an example of what I mean when I say "over the top," and ahead of today's taste. The "Venetians" are daring and they challenge us. I have found that over time visitors to my house lose their trepidation at the "shock" and come to find the "Venetians" an awesome delight.

You don't have to convince anyone who is comfortable with high art that much of Chihuly's work is beautiful. That's what I mean

when I say that taste doesn't interest him. What interests him are the possibilities inherent in the material.

We often look at an artist's work and imagine that we can read character into it. I used to think I could. In Chihuly's case, an interviewer asked recently if his work isn't obviously the art of a pretty happy guy. Exuberance shouldn't be confused with happiness. Chihuly has his moods. It often takes a lot of loneliness, moodiness, and quite a lot of depression to get yourself into a state to make art of this quality. Chihuly especially seems to need to go away and come back. He's constantly disappearing and reappearing, and I think it is then that he revitalizes himself. He finds the energy, the magisterial calm in combination with the almost frantic animation, that it takes to conceive and to direct this work.

Chihuly looks like a pirate and sometimes he acts like a pirate; perhaps it's partly a disguise, an attitude, a way of getting through life, a way of taking something negative and making it work for you.

Chihuly lost an eye in an automobile accident in England in 1976, which affected how he makes his work. With one eye you can't see properly in the third dimension. When he relinquished his position as gaffer, or head of the team, where he was completely physically involved with the making of the glass, he found he could see the process better and have more control over it. He has been inspired to run a larger operation; with full sight, he might have been satisfied with one or two assistants.

Dale works as an artist, the "onlie begetter"; but he also runs the team, choosing and often training the glassblowers who work with him as he creates a large body of work. It takes eight or ten people, some of whom have worked with him for almost twenty years, with Dale coming in and out; watching; directing; making drawings and paintings that suggest shapes and colors and surface treatments; saying this is good, let's move in that direction, this is the kind of color I'm looking for. Since the same team works together over a period of weeks, Dale can direct it to make another piece similar in color, form, or surface to another, or, alternatively, can bring in changes of color and form on a successful piece, altering it to his liking.

Chihuly's originality lies in his refusal to believe that there are

fixed rules that must be adhered to. Within the confines of his craft, he sees no boundaries. He is able with each new series to invent work that is conceived in formal terms with all the strictness of an aesthetic that deals uniquely with form, color, and surface, and yet, at the same time, to relate each series back to the real world, the world of nature and civilization, the world of the sea on the one hand and the glass of Venice on the other.

In the "Persians" the ancient Middle East is evoked, while his "Baskets" owe a clear debt to the woven crafts of the Native Americans of the Northwest.

I recently saw Chihuly's one-man show at the new Seattle Art Museum, curated by Patterson Sims. It was well thought out and planned, and it left one with a sense of his achievement to date. But there was one aspect to the show that I think was particularly original. Most large museum shows reassemble work that is out in the world, in private collections, galleries, and museums. It is a difficult task indeed to convince all these individuals to lend work they cherish for long periods to unfamiliar venues.

Chihuly sees it differently. He doesn't want to rest on his laurels and review the past. And, as there is no such thing as a previous style for him, everything he has done remaining fresh in his armory, he re-makes the work and lends the exhibition himself to the institutions. He and his team re-conceive the work, one series or another, and, I have noticed, almost invariably they grow larger and more colorful in repetition. There is something touching about seeing old "Macchia" and new together. There is a classical dignity and modesty to the earlier versions that give way to greater confidence and a pyrotechnical virtuosity, a kind of baroque exoticism in the later examples. Indeed, I think we may have discovered an art historical law: Work in revival always grows larger. Think of the ancient world and the Renaissance, or, more humbly, the way the decorative artists in the 1950s enlarged forms and details of the Art Deco they were so often inspired by.

Of course, glass can only be stretched so far without breaking. There are controls inherent in the medium. The "Floats" of 1991 and 1992 are probably as large and as heavy as glass will allow. That

doesn't mean that some technique or technology will never come along to refute this, but at this point I can't imagine it. Glass is so very much handmade. That's an aspect of it that we instinctively relate to.

Dale's formative years as a student and young teacher were the 1960s, a period in which color field painting was felt as a dominant sensibility. Clement Greenberg's hold on the imagination was most vivid, and it was the veils of Morris Louis, the chevrons and stripes of Kenneth Noland, and the large stained chromatic landscapes of Helen Frankenthaler that heralded a new aesthetic sensibility. And yet it was a sensibility whose roots could be traced back a hundred years in the masters of watercolor—Homer, Prendergast, Marin, Demuth. It was their way with light and air, their identification of the paper as the support that also existed as a source of light, that served the color field painters as example and inspiration.

Intuitively Chihuly seems to be working within these great American traditions of watercolor and color field painting. In his progression from "Indian blanket" to "basket" to "sea" forms, his freedom in working with brilliant and fresh color juxtapositions, and his play with the diaphanous clarities of the glass medium, show him updating art history through an unexplored medium. By skipping back to the generation of Winslow Homer and Louis Comfort Tiffany we can identify the concerns and abilities with color that they shared and bequeathed to subsequent generations of artists. It is this American tradition of color plenitude that Chihuly raids, updates, and continually expands.

Chihuly's work is American in its apparent vulgarity, its brightness, and its fearlessness to move farther out west even if there is not a further west to move to. There's a kind of pioneering spirit to it. And yet in 1986 the Musée des Art Décoratifs in Paris gave him a very rare one-man show. The exhibition was deemed superb. On an aesthetic level this work succeeds in Paris as in America, crossing national boundaries even as he transcends art/craft barriers.

What I Know about Photography

[1992]

When I was in college in 1956 (my senior year), we had a seminar in aesthetics and they asked us to discuss the question, Is photography a science or an art? I listened for about a half an hour and I raised my hand and said, "Science or art? No, it's a hobby." Which is a bit of a joke but not much. The question of whether photography is a science or an art is really a false question, because it's obviously both at the same time. The reason that I made the joke and why "it's a hobby" is that a camera is very much like a pencil: it's a tool. A genius uses a pencil; a Dürer, a Picasso, uses a pencil, and the result is amazing. He makes something that's never existed before; anybody else uses a pencil and it looks perfectly ordinary.

I think the camera is the same thing. The fact that we all take pictures and we all have a camera as part of our life should not cause us to lose respect for the practitioners that set the standards for quality. And I think that's the only interesting photography.

All that's interesting is the best; everything else is holiday snaps, personality pictures, memory trips, memory aids. The photographs that change the way we look at nature; change the way we look at art, the way we think about physical objects in the universe: those are the ones that matter. The billions and trillions of photographs that merely get taken are part of the sea of disappearing flotsam and jetsam, the detritus, of modern life.

By the time I got to the Metropolitan Museum in 1960, I was twenty-four years old, and in none of my schooling had we taken photography seriously as one of the elements in the history of art. We studied architecture, sculpture, painting, manuscript illumination. But photography in the fifties hadn't yet gotten the academic respectability that it now has. The only serious collectors of photography, previous to about 1960, were a few institutions: The Museum of Modern Art, Eastman House in Rochester, the Bibliothèque Nationale in Paris, the Victoria and Albert Museum in London. There were very few. And the history of photography, the very origin of photography, was still a question that was up in the air. The French claimed it, the English claimed it, the Russians claimed it. It was only when (and I hate to say this, because it sounds cynical, it was only when) photographs began to be expensive, when they began to change hands for serious amounts of money, that first academia and then the press began to pay attention to it. That happened during the course of the 1960s and was the result of the work of a few collectors and a few dealers in photographs.

It was the photographer Edward Steichen, who was eighteen years old and taking pictures in 1898 and lived into the 1960s, who founded the Museum of Modern Art photography department in the thirties. It was really his exhibition "The Family of Man" after the War that pulled photography together sociologically and aesthetically and made it clear that through the showing of a wide range of photographic styles from many cultures one could harmonize a world that had fallen apart and indicate that there is a "family of man." And that was really quite important.

There were few historians of photography. Beaumont Newhall, in America, did a survey of history of photography. But it wasn't much of a field. We knew about Daguerre in the 1840s, the Frenchman, who supposedly invented photography. Another, Fox Talbot, an Englishman, at the same time came up with something very similar. And interestingly enough, the reason that photography got invented had to do with the difficulties of exact draftsmanship from nature. An artist like an Ingres or a Delacroix didn't need photography. But in the early nineteenth century an artist who was more

of a scientist, somebody who wanted to record botanic specimens, who wanted to make exact renderings of a building, or somebody who wanted to ponder the geological aspects of a landscape, would use a device that was known in ancient times and was developed in the Renaissance, the camera obscura. With a tiny pinhole light, the sun would come through and an image in a darkroom would be projected upside-down on the far wall. In Vermeer's time they knew it, although I wonder whether Vermeer himself used it. Canaletto did use it. The great Venetian masters of the eighteenth century who made those very, very exact facsimiles of Venice and its canals used a camera obscura. By standing in the darkened room, and outlining the image exactly, they were able to get the drawing right according to the Albertian system of perspective.

Fox Talbot, an Englishman, went to Italy in the 1820s and thirties. He wanted to come back with something concrete that the Grand Tour had given him (they didn't have postcards, they didn't have photographs), not only to prove that he was there but as an active notebook of memories. He discovered through the camera obscura that it was possible to do this. The great change that made photography possible at that time was the discovery that you could project this onto paper that's chemically treated in such a way that the image can be fixed. The camera was only part of the invention. The crucial part that came later was the photosynthesized, chemically treated paper. In simplifying, I'm giving you the broad outline.

The way in which photography works in landscape and in tourism is it pulls and fixes our head a certain way to look at this exactly beautiful view. It's a way of preparing you when you get there to expect what you're going to see and to organize it in a way that makes aesthetic sense.

There's a history of that too. In the eighteenth century when aristocrat English tourists went to Switzerland on the Grand Tour they knew and admired the work of an earlier artist, Claude Lorrain, who was a contemporary of Nicolas Poussin. He painted wonderful landscapes; through the use of varnish they had a yellow cast to

them, a yellow glaze. In the 1750s tourists carried something called the Claude glass and you would go to Switzerland with your Claude glass which was a rectangle of glass, slightly yellow, and hold it up to the landscape until you had a perfect Claude Lorrain. The need for photography was there, before photography was invented, the idea of holding your head in the right place and at the right angle to get the "correct" view.

I remember in 1962 I went to Iran and there was a beautiful mosque in Isfahan and I had a little camera, a stupid camera, I'm a terrible photographer. I stood to take a picture of the mosque and a guard came running over and said, "No, no, no, you stand there." I stood there and I said why? He said Cartier-Bresson stood there. So there's a perfect place to take that picture too. That's what I mean by your head being held by tradition or by somebody else.

As art history students we knew few rudiments about photography; we knew about the prelude to it, the camera obscura, the Claude glasses, the art historical part of it. The next thing we knew about was that Nadar made photographs of the Impressionist painters, made photographs of Baudelaire. He was the official photographer of French intellectual life in the 1860s. A little bit later, there was Atget, who was the photographer of the popular Paris of the moment, and with Lartigue, he remains the photographer when we think of Paris at the turn of the century.

The first time that photography actually entered into the history of art in a way that made a difference was with the Impressionists. By 1850–1860, photography was common enough that it entered into the life of the artist in his studio. Degas knew about photography, for sure. Monet knew about photography, for sure. As a matter of fact, it is documented that Toulouse-Lautrec used photographs as the basis of some of his compositions. And as a result, painting changed. The idea of perspective changed the idea of flattening the surface; we have two eyes, the camera has one eye. And the monocular lens of the camera flattens things and we see in modern art that the space changes and comes closer to the surface as it does in photography. Also, the other salient aspect of photography for

painting is the cropping, the way a photograph is always cut in a very radical way and in a way that has to be arbitrary because there's no natural place to cut a view of nature.

John Szarkowski has pointed out that photography is the opposite of drawing, because in drawing you start with the empty space in the middle and fill it up; whereas with photography you start with the edge. The edge is the controlling aesthetic factor.

But as always in the history of art, probably any field that you know well, it isn't as simple as that. We say that Impressionism changed the history of art through the introduction of photography. But there is something called parallel causality, two things that happen at the same time, but do not necessarily touch; they run parallel to each other. Japan was opened up in the early 1860s and 1870s. The Japanese print entered into Monet and Degas and Toulouse-Lautrec's studios and consciousnesses at about the same time as the photograph. The Japanese print again had a different kind of perspective than the two-eyed perspective leading back to a single vanishing point. It had a radically different orthogonal perspective. Also in Japanese work the cropping is very different than in European art, the way the figure's cut off, the landscape's slashed. So you can't really unravel, with regard to the Impressionists, the Oriental influence from what it is photography brought to them. It's a fascinating field, and in sophisticated art history courses these days it is something that is talked about and is worth talking about.

In the United States, photography entered into the consciousness of the collecting public in around 1900 or so, with Alfred Stieglitz and his gallery where he showed paintings and photographs side by side. It was the first time that anybody did that. The photograph had the same aesthetic importance to Stieglitz, who was a photographer himself, as had the paintings of O'Keeffe, who was his wife, and Arthur Dove, John Marin, and the other painters that he showed. The New York art public began to see that this man who was the first to show Rodin and Brancusi and Picasso and Matisse in New York was also showing photographs by Steichen, by European photographers. That made a respectable connection in people's minds and even an important aesthetic connection.

At that time there seemed to be a division of opinion about what photography should do. And this raises the question that we're going to deal with for most of this lecture, which is the relation of photography and realism, or photography to reality. We know that it is possible to have a kind of landscape photography that you might call Impressionist, where there is a mist, and the trees are slightly lost in the distance, and there's a wonderfully still pond. That's the way things look sometimes. Paul Strand and Stieglitz himself, Edward Weston, and later Ansel Adams thought photography was something else; it was precise, it portrayed factories and locomotives and was very hard edged, and that it was "exact," that it was reality. So we have misty landscape reality and hard industrial reality. We begin to see that realism or reality is a very strange concept, and that there is no such thing as one objective reality. And yet we continue to think and act as if there is. We know that physics tells us, chemistry tells us, that there are empty spaces between everything; that reality is a kind of crutch that we use to get through the day, that it doesn't really answer the way in which the world is built or in which the world works. And yet we all believe in this funny way with the Englishman Bishop Berkeley, who, when he was told that the world was not real and there was space between all the particles, stamped his foot on the ground and said, "Thus I refute thee," in other words, look, my foot didn't go through the wood, therefore I prove my idea of reality. I think we still tend to feel that way.

When I was fourteen years old, I was given my first pair of glasses, and I remember going into Central Park and putting on the glasses and looking up at the trees, and saying, "Oh my God, Rembrandt is right, you can see the tops of trees." I thought that was some sort of fantasy. (That's a true story.) I knew from the Rembrandt etchings that according to him everything had the same focus, the near and far. You know in Flemish painting, in the painting of Memling and van Eyck, one of the reasons we find that painting so uplifting and so beautiful is that our ability to see is enhanced. We can see without changing focus very clearly, distant, middle and near. In life, you can't do that, your eye has to keep skimming back and forth.

The Flemish realists of the fifteenth century gave us an enhanced feeling of sight, a possibility of seeing beyond seeing. You always get a thrill when you look at those paintings. Given the idea that you see differently when you are old than when you are young, when you're nearsighted you see differently than when you're farsighted, when you have your glasses on you see differently than when you have them off, how can we ever posit a universal common way of seeing, which you must have in order to make sense of realism?

And our idea has come to be that the clearer, the more precise, the more focused, and the greater the contrast in the photograph, the better it is, somehow, the cleaner, the harder. A photograph like Charles Sheeler's 1920 photograph of a locomotive, presented with absolute clarity, is one idea of a great photograph. It isn't the only idea. If you look around this room, at Mapplethorpe's work, there are things that are focused. Then there are other emphases like the flowers that are seen from an unusual angle where it isn't simply a matter of realism. As a matter of fact, what photography is really about is editing, making choices. The photographer is not merely giving you back what you see as in a mirror. He's giving you back his choice, his selection of what it is that is available through him. At any given moment in our lives, our sensorium and our five senses take in so much more information, through the ear, through the eye, through the body, through tremblings of the building, so much more than the mind needs or can absorb, that one definition of intelligence, by Alfred North Whitehead, is the ability to select from those signals that are in any given instant. We have so much information, more than we need, that we must select the information that gets us from A to B, and the smarter you are the better you do that, the better you are at tracking through this vast amount of information that comes out of everywhere.

So, the artist edits and preselects what he's going to shoot; he does it through the eye of the camera. But that's only part of it: he does it in the editing room, he does it in the enlarging room. He does it again, and again in the printing, which can go one way or another. There is nothing random about a photograph, and there is nothing

exactly scientific about it. It's full of the aesthetic choices made by the camerawoman or man.

In real life we don't walk into a mirror very often, even though that's as real as anything can be. You can have a few drinks and walk into a mirror. But I don't think anybody's walked into a painting, although the painter sometimes tries very hard to be that realistic. There's a wonderful story that, when Velázquez wanted to get into the Academy of Fine Arts in Rome, he did the portrait of his student Juan de Pareja so exactly that, when Pareja knocked on the door and held up the painting they said, "Come in," thinking that the painting was the person. That's a story about a need to think that realism and reality are the same thing.

Think about something as simple as the differences between Northern European painting of the Renaissance and Mediterranean painting of the Renaissance. Rembrandt versus Caravaggio, for instance. Is it because northern reality is different than southern reality? Are they geographic realisms? That's nonsense. Somebody said that the reason the paintings were different was that in the north it's cold and you sleep under the blankets, you don't know the body as well, and in the south it's hotter, you sleep on top of the sheets, so you know what people look like.

There's a Spanish artist called Claudio Bravo, who actually did a painting of a couch with pillows on it, that I saw across a room in an apartment in New York one day and I thought, for a millisecond, that's a nice place to sit, walked toward it, and found it to be a painting. It can happen, but it's extremely unusual, and fooling you is rarely what the artist has in mind.

There's something new, though, called virtual reality, which I'm sure all the young people in the audience know of, which is a computer-derived three-dimensional reality. You can be an astronaut, sitting and going through space working with your dials and virtual reality projects a convincing simulation; or you can be in the desert in New Mexico. And there are things now that can be done with computers that give the lie to photography—Terminator II, that fantastic stuff with the melting figure. David Hockney and I,

two years ago, went to Alaska; we took a cruise of the Inner Passage and one of the aspects of the cruise was to get off and go on a white-water canoe trip. I'm not very athletic, I can't even drive, but David wanted to go on this white-water trip and he had paid for it, so I thought OK, just calm down, go on the white-water thing, what could happen? So I get on it, and I'm very brave, and freezing. We get back to Los Angeles and the daughter of the man who ran the white-water trip had taken pictures with a telephoto lens from up on a bus, following us along and there was this picture of David and me sitting in a canoe with waves crashing around us. I felt very proud, until somebody pointed out that they can do that now, with a computer, place you in a picture, and it doesn't prove that you're actually sitting there in the white water. It has never been true that photography portrays things exactly as they are. It is now undermined even further with virtual reality on the one hand, and the computer-derived changes in what a photograph tells you on the other.

The uses for photography in its first twenty or thirty years were, basically, portraiture, rural landscape, and urban architecture. Those were the traditional subjects of photography in the nineteenth century. It's interesting that they took them over from painting. Painting and photography ran parallel because photographers were not inventing something new with photography, they were imitating what they knew. There's one theory of art history, that the way things change is through the physical translation of one material to another. For instance, the Egyptians built a temple column with wood, the Greeks changed it to marble. The change from wood to marble suddenly brought an entire other order of change. It's a kind of technological view of the history of art. It took a while for photography to separate itself from painting and have its own ambitions, its own ways of seeing. And what fell out that had been popular was history painting, genre painting, battle painting. They reexamined the province of kitsch nineteenth-century painting up until the turn of the century, and what would replace that was cinema. It was the epic of deMille, the big battle scenes, the biblical costume scenes, of the early silent cinema which continue into our

own time, that replaced the need for battle paintings and that kind of grandeur.

Black-and-white photography on the one hand and color photography on the other are another aspect of the investigation of "realism." It's only in the past thirty or forty years that we've begun to take color photography as seriously as we do black and white. I think that we're so used to and we're so comfortable with the world of black-and-white photography that we take it for granted. There is something about color that is jarring, that makes us feel an artificiality about the scene. (I'm not sure the same is true to a generation under thirty.) Color has been coming up slowly, and has been made more familiar through color television, through magazines like *Life*, etc., from the forties on. Up to about 1960, color photography was something very unusual. First of all you had to be wealthy to be able to do it. The average photographer didn't have the money, you just couldn't print color, he had to dye transfer. An American photographer called Eliot Porter, who was a student of Ansel Adams, made some of the first great American landscape photographs in color in the forties and fifties. He was a wealthy man with a private income and thus able to do it.

The Bechers, Hilla and Bernd Becher, make black-and-white photographs of buildings, of types of industrial architecture. And part of the photographs' magic is in their being black and white. The Bechers pursue a kind of building in a particular area, designed to perform a restricted function at a certain time. This typological investigation has to do with being able to compare them and those comparisons, if color were introduced, would be less specific and thus more confusing.

It's curious, the academic mind. In the early 1960s, I owned a beautiful Roman head. It was a copy in marble of the head of Antinoüs, who was the lover of Hadrian and was considered the most beautiful man in the ancient world. He drowned in the Nile at the age of nineteen. I wanted to know where it was from; here was this Roman head in my collection which I knew was from a Greek model. So I took it to the Metropolitan Museum where I was working, to the Greek and Roman department. And here was this three-

dimensional object in marble, all in a wonderful color, the pale marble, peach, the discolorations of natural marble which had been aging underground for a thousand years, and I said, "What is it?" And they said (and I was horribly shocked, I was young myself), they said, "We'll let you know after we photograph it in black and white from the correct angle so we can compare it to the other Antinoüses in the literature." That's what I mean by typological. And that's what the Bechers do, making things similar enough that you can compare them one next to the other. And I was amazed by that.

Cindy Sherman took the color of Hammer films. I don't know if many of you know these films, Christopher Lee films of the 1950s, made in the very cheap studio in London in Hammersmith, called the Hammer studios. The movies make you scream and they used to play as the second feature. Christopher Lee is the most famous actor from those films. Cindy Sherman plays with color, she does color that looks like films, she creates color that feels like a parody of color. And in her art she plays with parody. She also tries to capture both the essence of a situation, and at the same time its alienation. You never look at one of her pictures, as, "Oh yes, this is the way it is." Her work is about stereotyping, which is in itself a form of abuse. It's never totally natural, never the way things are unadulteratedly. That's not what she's after. It's interesting that of the three artists in this exhibit she's the one who uses color regularly and yet she's the one who's the furthest from "reality." Here again we have a use of color that moves away from what we think of as natural.

Color always seems to have a second agenda. Color seems to have an underside that undermines its verisimilitude. There are kinds of color photography, there are choices within color photography. In a book, as you're turning the pages, if they're by the same photographer, made by the same system, and reproduced the same way, you can fall into that way of seeing in a rather nice way. But the minute you put the book down, and you look around and back at the pictures again you realize their arbitrariness. It's something about dye, about color, about the way ink sits on paper. You can accept it as a coherent system, but not as anything natural. With black and

white you don't have that feeling. Somehow black and white seems more natural.

Color can begin to seem natural, in the slides of our holiday with which we bore our friends or photographs of our grandchildren which we make everybody look at. And those are color, and you take it for granted that they're color, but again, you know very well that you're looking at an artificial moment; that is a recorded memory to be shared by others, more important to the person who is showing it than the person to whom it's being shown. It's an unreal experience.

Think of the Rodney King trial. Think of that videotape. And think about the extent to which any interpretation of photography has to do with the way in which your mind is prepared to view it. We know about racism in America. We know about police brutality. We see the videotape again and again of this man being beaten, and there's no question in our mind that excessive force was used. The defense of the officers in the Rodney King trial took the jurors, frame by frame, through the same eighty-one seconds in which he is hit fifty-six times, and they changed the focus from what the officer was doing to what Rodney King was doing. They said, "Look at how he's trying to get away. Look at how he's moving, look at how aggressive he is, look at how he's reaching for something. Look how scared they have to be." And the jury is turned around into, what looks to us, prejudiced jurors who have lost the point. The same photographic evidence has been used to prove two different things. So, let's not get too uppity about what photography is and what it means about truth to photography. We believe somehow that the lens is impartial; it's not. The photographer is not impartial and the person who looks at the picture is not impartial. We bring our structured intelligence and sensibility to everything we look at.

David Hockney is one of the artists today who paints and uses photography in very advanced ways. He has periods when he does photography; he has periods when he's painting and he doesn't think much about or of photography. When he's doing photography he's doing nothing else but photography. One of the reasons he took to photography in the early seventies is that he had gotten to a

point in his painting, a kind of pre-Raphaelite realism, where the style and technique didn't interest him anymore. He knew how to do that. Photography opened up another kind of vista for him. He always tells me that a painter or somebody instructing painting can look at a painting or a drawing, and tell you whether it's based on a photograph or if it's seen by the eye. One reason is the flattening, where everything looks the same because it's seen through the single lens of a camera as opposed to the two eyes of the artist who is observing. It's a slightly subtle point but the reason that we feel more enriched by a painting that's painted from observed reality is that the duration of looking is built into the painting. The painting is seen by two eyes and by a head that moves slightly while it's working. And in a very subtle way what you're seeing is not just a flat representation, you're seeing an intelligence and a sensibility working its way in a true situation and trying to replicate that true situation on a canvas. The time invested in making the picture is to a degree inherent in the painting.

There are several tests of quality in painting and in photography. One of them is, if it stays in your memory it's probably good. Another one is, if you keep learning from it on the second and third and tenth viewing it's probably good. Another one is, that if the photographer or painter has taken a corner of reality and made it his own, like Andrew Wyeth, or Edward Hopper, or Manuel-Bravo or Diane Arbus has taken over a slice of the world that we live in, I think that that's a pretty good sign that the work has quality. If we can say of reality, that's an Arbus, or a Hopper, it's probably good.

One change that photography has made is that it's altered the vantage point from which we seen things. The photographer can't move the object very often (other than a person or still life) so he moves himself, he shoots from below, from above, from behind, from the side, from a helicopter. He sees things that we would never see in order to bring us another kind of reality than what we see walking five and a half feet off the ground with our eyes on a level plane. I think that's a very important thing to remember about photography. It's the vantage point, the change in angles, the radical

change in angles from which a picture can be taken very close up or very far away, that characterizes much of modern photography.

There's a lovely book, with wonderful reproductions of 120–150 photographs, from which I learned a lot and which was published by the Museum of Modern Art in 1966, called *The Photographer's Eye*, by John Szarkowski, then director of photography at the Museum of Modern Art. Its text is short, to the point, and has been useful to me in preparing this talk.

In photography, again with regard to reality, each new lens, each new development in chemistry and printing changes the way that photographs look. It happens every five or ten years, and yet we always think each change makes photography more realistic. We always say, my goodness, isn't that real. And what's interesting to me is, we don't lose the old realisms, we add to them. The conventions of earlier times still are real to us. A photograph from 1910, 1950, 1990, just because it is made with a new camera or a new kind of chemistry or a new paper wasn't superseded by other realities. We add reality to reality, or realism to realism.

And the twentieth-century search for realism is sought in all the arts. Think of James Joyce, think of Gertrude Stein, think of the magical realists in postwar Latin American literature. All of them are trying to bring another kind of realism to paper, a historical realism or an interior monologue or the way we repeat things in our minds, or the way that we feel our family history is involved with the family history of our own generation and earlier generations. These are all different kinds of realisms. The French composer Olivier Messiaën just died. He was both a composer and an ornithologist. His contribution to realism was to bring bird sounds, real bird sounds, into his music, bringing the real world into the invented world of music.

Up to 1920 photography was a way in which we tried to imitate nature; then in 1920, after the First World War, with Man Ray and the Surrealists, with the Hungarian photographer László Moholy-Nagy, the photograph changed from being a simulacrum of reality to something invented. The artist was painting with a flashlight in

the dark, he was printing something with solarization, going back to the early history of photography, when the sun printed a leaf put onto a sheet of paper, because the paper was chemically coated the right way. In the 1920s and thirties artists began using photography to *create* images and not as a way of describing nature.

Moholy-Nagy used photography less to create a document of realism than to create a dramatic design of his own invention. Then about 1960 Robert Rauschenberg realized that painting and photography were of equal aesthetic value, and it wasn't a question of one or the other, they were the same thing, they had the same value, and he started making paintings using photographs in the same work with paint, without one of them dominating the other. About the same time Andy Warhol came along, and for Andy the breakthrough was that printing and painting were the same thing. He took a silkscreen, which is a reproduction of a photograph, and instead of screening it onto paper, he screened it on a canvas. With that simple act, he took the art of photography out of the suburbs into the main avenue of high art, of fine arts. Paper might age and disappear, but canvas has futurity; canvas, we feel, is there for the ages. It's a prejudice, it's a kind of trick of thinking. Andy and the other Pop artists moved the media—TV images, newspapers, billboards, cinema, everything that had been urban landscape—out of the environment onto the wall, and into the museum and into something permanent. That was their genius. That was one way in which they changed the world, in ways that we are still working out

The Sixties

As They Were

[1991]

I've been thinking about the sixties since 1960, which is thirty-one years. I'll try to speak for about fifty minutes, which amounts to a little less than two minutes a year. I won't say everything I have to say or everything there is to say. It's going to be a personal talk, seen from my own point of view. This won't, in fact, be a talk about the sixties "as they were"; that implies, to me, a statistical and scientific analysis; but rather, the sixties as seen in contemplation by a witness and, dare I say it, a survivor. I will speak from my own experience as honestly as I can.

I was never omniscient or ubiquitous but I'll try to be as honest as I can be from my own experience. For instance, I'll tell you that I grew this beard in 1966 and haven't shaved since. I've bathed but I haven't shaved. I'll tell you the reason I grew the beard. I worked at the Metropolitan Museum for a summer when I was nineteen years old in 1954. After graduate school, I returned to the Met as an assistant curator in the American Paintings Department. I had a little beard. Rather a disgusting little beard, I think. And James Rorimer told me to shave it. I was twenty-two or twenty-three years old, and I said, "Why?" He said, "You haven't earned it." That sounded to me like it made a lot of sense. So I shaved it. In 1966 I became Curator of Contemporary Art. I figured I'd earned it, and I grew the

beard back. So, that's a story of defiance. But I think "earning it" is a nice phrase.

In the final analysis, art isn't about decades and it's not about movements. It's about unique individuals who worked in their own moment, in the context of contemporaneity, and who raided the common tradition in various permutations to create unique works. The decade is a convenient slice of time but it's a convenience for art historians, it's a convenience for teachers; it sweeps up but it doesn't really clarify very much.

No decade one has lived through exists in some pure and objective state of consciousness. *When* in your life and when in your development you entered the decade and lived through it has major influence on your memory and evaluation of it. In a wonderful book called *The Shape of Time* (1959), George Kubler (one of my professors at Yale) talked about entrances. About the moment when an artist enters an art movement; when an artist comes "on stage" as it were. Raphael's talents, for instance, were perfect for the moment of the High Classic Renaissance. He made a very happy entrance. And I had a very happy entrance. On a much more humble level, my entrance came in 1960. I'd been brought up in New York but left in 1953 to start college. I came back in 1960. Within a couple of months I had met Frank Stella, Roy Lichtenstein, Andy Warhol, Dan Flavin, Donald Judd . . . I mean, it went on like that. For the first four or five years, my job at the Met was strictly to continue my education at their expense. That whole concept of fame as curator, by the way, is quite amusing in a way because I, famously, after eighteen years at the Met in 1978 was making $28,000 a year, when I became Commissioner of Cultural Affairs. There's a feeling in the higher cultural world of trustees that curators are church mice who dedicate their lives to research in the corner somewhere. And that is one aspect of it. But curators also have to move with the collectors, move with the artists, dress, go out to dinner. It's tough. This is not a plea for me, but it's a plea for the profession. I think we should think it through again. But anyway, enough of that.

My entrance coincided with a reshuffling of the cards, as it were,

or a reinvention of the game. Abstract Expressionism, of course, was dominant, but in 1960 the Color Field painters and a New Abstraction—Kelly, Reinhardt, Albers, Stella—were coming along. The Color Field painters were becoming a focus of attention, and of course the unpredictable media craze that erupted around Pop Art began the following year. It was possible, by going around to studios with Ivan Karp and Richard Bellamy in '59, '60, and '61, to meet these guys and introduce them to each other—Rosenquist, Lichtenstein, Warhol, Wesselmann, Dine, Oldenburg, Marisol, Segal. Many of them didn't know each other; some of them did. It was a very, very exciting moment.

But another way of thinking of the sixties is that perhaps the best work that was done in that decade in America was done by David Smith in the last five years of his life and by Hans Hofmann in the last five years of his life. They both lived into the mid-sixties. You don't think of Hofmann and Smith as sixties artists, but they are. If you think of their achievements, very much as if you think of European painting in the 1960s, you don't think of Picasso. Picasso was doing the best work in the sixties. I don't mean to denigrate anything that anybody else was doing, but I'm trying to work against the theory of decades. For the sixties, you can think of Hofmann and Smith just as well as you can think of the names that come to mind more easily.

For an artist who works on his own and especially an artist who has a programmatic mind, who works from a philosophical mindset, his work is made from a stance that is fixed. He sees what he does, he sees the world from his own point of view; think of it as one-point perspective invented by each artist on his own. For such an artist to choreograph his work into exhibitions and decades and movements can be seen as an insult of a sort. The "choreographer,"—curator, critic, teacher—comes along and says I'll take this and that and that and that and make a Julia Child cuisine of it for myself. That sounds arrogant when it's seen from the view of the individual artist. From the point of view of the curator or teacher or the art historian, it makes sense. It's a way of teaching, it's a way of

organizing, it's a way of presenting the work, because in our profession we're all middlemen. We all thrive in a field that wouldn't exist if it hadn't been for the French Revolution, the democratization of art. There was no general newspaper before 1820 or 1830. There was no art critic who had to mediate between the audience for art and the artist in his own world. The first audience for all art, really, has always been and remains a few other artists, his best friends.

Art history came as a result of the invention of the art museum in the early nineteenth century and the invention of the newspaper and universal education. It developed as a discipline in Germany, actually, in the second half of the nineteenth century. I'm saying that the curator, the educator, comes along and makes what the artist is doing, which is unique and individual, available by making it of greater general interest. More interesting, more digestible, more comestible. Alfred North Whitehead said somewhere in his book *The Adventure of Ideas* that in education it is more important that a proposition be interesting than true. You should think about it for a minute. It's probably wrong, but it's certainly interesting.

The artist does not want to be told where he belongs, what he belongs to. The artist wants to generate his work from the fullness of his own creativity. All the rest of it, the categorizing, strikes him as uncomfortable. There's a wonderful story Barnett Newman told me. In 1949, there was a meeting at the Museum of Modern Art organized by Alfred Barr, everybody's hero at that moment because he did such a great job with the organization of twentieth-century art in the Museum of Modern Art's collections and in his catalogues. Barney got up at a meeting in 1949 at the Modern and he said, "Don't tell me who my father is. My father is not Cézanne. Paul Cézanne is not the father of all modern art. I'm not a bastard. I know who my father is. My father is the late Monet and you don't have one in the Museum of Modern Art collection." And they didn't at the time. They had twenty or thirty Monets but the late Monet was not being collected. He was considered an astigmatic artist, an artist who had gone over the top. Everybody knows about those pictures anyway, they're not very good. His late paintings had to be re-evaluated, and that partly happened through what Rothko

and Still and Newman did. That's an instance of an artist's being categorized in a way that feels uncomfortable to him.

Looking at art intelligently and sympathetically in the role of the critic and the curator, it's possible, even desirable, to see it more inclusively. Eyes move when we look and contemplate. And they stay in place when we concentrate and create.

I think one reason I was asked to give this talk on the 1960s is that I did a show at the Metropolitan Museum in 1969 called "New York Painting and Sculpture: 1940–1970," which was a bit of a liberty because the show opened in October 1969. The show had 408 works. It extended over the entire second floor of the Metropolitan Museum. They took down the collection from Giotto through Rembrandt to the Impressionists and put up Larry Poons and Donald Judd and Roy Lichtenstein and Pollock and Joseph Cornell. It was quite amazing at the time. It was the opening shot of the one-hundredth anniversary of the Metropolitan Museum, the centenary, followed by four more exhibitions. Xerox paid for it. It cost $350,000. They gave me wall-to-wall carpeting and a new system of knee bangers to keep people away from the pictures. All kinds of innovative things happened. There was no way of knowing it at the time, but the Vietnam experience was crescendoing. Our disabuse of our cultural selves was beginning. And it turns out that, purely by happenstance, the one-hundredth anniversary of the Metropolitan Museum turned out to be a moment when it was possible to look back at New York art in a synoptic way to put it together and present it. That was my luck. A couple of years later, it wouldn't have worked. First of all, because New Art came along and made the whole concept of 1940 to 1970 kind of messy: the neatness of it all, which we felt in 1968 and 1969, when I was organizing this show, was really quite amazingly strong.

There were forty-two artists in the show. I'll quickly group them for you so we have an idea of what we're talking about. I'll talk about this show for only a bit, but I think contextually it makes a lot of sense because it was the way one thought about art of the Sixties in 1969 and 1970. I'm going to try to indicate the ways in which our thought about that art has evolved, changed, or been proven to be

wrong and the extent to which we still agree with it. I began the show historically with four artists whose work one could have known earlier but who were active in the period of 1940 to 1970.

Masters Whose Styles Were Formed Prior to 1940

Edward Hopper
Stuart Davis
Milton Avery
Joseph Cornell

Sculptors

Alexander Calder
David Smith
Isamu Noguchi
Tony Smith
Gabe Kohn
John Chamberlain
Mark di Suvero

Abstract Expressionists

Hans Hofmann
Arshile Gorky
Jackson Pollock
Willem de Kooning
Clyfford Still
Mark Rothko
Barnett Newman
Bradley Walker Tomlin
Robert Motherwell
Phillip Guston
Adolph Gottlieb

Hard-Edged Abstractionists

Josef Albers
Burgoyne Diller
Ad Reinhardt

Ellsworth Kelly
Frank Stella

Color Field Painters

Morris Louis
Kenneth Noland
Helen Frankenthaler
Jules Olitski
Larry Poons

Minimalists
(an admittedly fudged category)

Donald Judd
Robert Morris
Dan Flavin

Pop Artists

Robert Rauschenberg
Jasper Johns
Roy Lichtenstein
Andy Warhol
Claes Oldenburg
James Rosenquist
George Segal

Of course, any attempt at neatening up a period into categories has to have its messy edges; Rauschenberg and Johns are not Pop artists, they are immediate precursors of Pop. And George Segal is obviously more a sculptor than he is a Pop artist.

Now, the selection was criticized very heavily at the time for its omissions. I felt sort of badly used because I thought it was pretty inclusive, but I don't think you get grades for inclusiveness. You get grades for exclusion. The critics in California and Europe were very friendly. The New York critics, I think, were so tied up with it all and so much involved with friendships based on their taste that the omission of Larry Rivers, of Jim Dine, of Louise Nevelson, of

Richard Pousette-Dart rankled and they said, "Where is so-and-so, where is so-and-so?"

As evidenced in my introduction to the catalogue, I knew that I was heading for trouble. I listed artists whom I considered and who could have been in the show. I tried to indicate that I thought in no way was this show definitive. I didn't think that I was sealing up history in any way. But secretly what I was trying to do was something in line with Alfred Barr's two shows of 1936 and 1937. The 1936 show was Cubism and Abstract Art; the 1937 was Fantastic Art, Dada, and Surrealism. In 1969, I tried to do something similar for the New York School: set up a chronology of excellence, I guess you would call it. It was based on consensus, in a way, but my two most immediate mentors were Clement Greenberg and,. surprisingly, perhaps depending on how well you know me and the period, Frank Stella, who was a very dear friend and whom I saw every day in the decade of the Sixties, as I did Andy Warhol. Frank, who had been to Princeton, who was extremely articulate though shy, had had a solid art historical training. We could talk about New Art in a common language. I went to Yale, Harvard, and the Sorbonne and had had many years of art history. I think that's the real reason that I was able to walk into the Met job and go to studios like Stella's, Lichtenstein's, and Warhol's and not say, "Hey, wait a minute. This isn't art," or "Where's this coming from?" These guys were, as I said, traditionalists; they were working on permutations of the tradition of art; they were doing something new and contemporary, which I could feel, and there never was a moment when I thought, "This stuff is falling out of the sky from nowhere." It always seemed to be possible to put it in some kind of contextual relationship with recent art and with older art. I did say also in the catalogue's introduction that I was going to limit myself to artists whose exhibition history was clear before 1965, so that Flavin and Morris and Judd were, in a way, the newest art that was in the show. I felt that I already knew that this was a very messy decade, as are all decades, and that you couldn't say 1940 to 1970 and feel as if you'd cleaned everything up to the moment when the show opens. There's just no way of doing that. So artists who began showing in '64, '65, '66 and some who

ended up being, in many cases, the interesting artists of the seventies and eighties, were eliminated from the show. So, already the show had a kind of "cleaned up" look to it.

Another reason for that was that I had to defend myself constantly at the Met for being involved in twentieth-century art in a city that had the Modern and Jewish Museum, the Guggenheim, the Whitney—what's the Met doing here? My argument always went back to my first pugnacious remark to Mr. Rorimer, before he hired me: "You've written an encyclopedia with the last volume missing. You won't be able to buy the paintings that we're talking about in thirty or forty years!" I wrote a memo to this effect to Tom Hoving when he became director in 1966 or 1967. He found the memo and gave me my department in twentieth-century art, whose role it was to continue the encyclopedia. But I think the argument was a good one. De Kooning once said to me, "It's one thing to see de Kooning at the Whitney. It's something else to see de Kooning fifty yards from the Rembrandts." We judge things differently. Our level of expectation, the ways in which we honor things have to be different in the context of an encyclopedic museum than in what I call a specialist museum, as great as those other museums are.

For some of the critics, like Harold Rosenberg and Tom Hess, what I did was a very sixties version of the forties, fifties, and sixties. And they were critical of that. I now understand that much better than I did. It's amazing how much smarter you grow as you grow less young. Now I understand their point of view. They were in their fifties. I was in my late twenties, early thirties. I was seeing what Pollock and Gorky and Hofmann had done from the point of view of the sixties, which was when I came on the scene. They were seeing it and feeling it from the inside in a very different way. And there had to be a clash of temperaments, a clash of decades, a clash of sensibilities there. Among other critics, Michael Fried wrote some valuable articles in that period; a little Talmudic, a bit of a gloss on what Greenberg was doing, but of interest in themselves. Donald Judd, in his criticism, I have to say now, was ahead of me. It took me a while to understand the underpinnings of Minimalism that Judd articulated in his critical writing.

I've read you this list of the forty-three artists who were in my pantheon, as it were. Here we are twenty years later—do I have any regrets? Do I revise my idea of what was going on? Well, let me give you some examples. There are half a dozen artists I want to talk to you about one at a time. By the way, I didn't illustrate this lecture with slides, first of all because I don't like talking in the dark and then because somebody once said if you want to prove a point, don't illustrate it. I think that's true enough. So you're going to have to use your memory and imagination as I mention these artists.

Leon Golub was an artist of whom I was aware in the sixties mostly as somebody that Peter Selz felt was one of the leaders of the "New Humanism," which was figurative painting. Selz posited that the "New Humanism,"instead of Pop Art, was where we should be going in a post-nuclear, post-Holocaust world. And it makes sense. Peter was a German who came to America and who felt very deeply the devastations of the war and of the modern world. Pop looked like a kind of crass and superficial view of one aspect of American commercialism, whereas the artists whom he was working with, such as Francis Bacon and Giacometti, with their pain and anxiety, their Beckett-like frazzling of the nerve endings, made a lot of sense to him. For me, Golub looked like an artist who was creating distorted flat figures out of abstraction in a way that didn't seem to be generated naturally. It took the engagement in Vietnam and, more than that, the engagement in Nicaragua in the seventies, for me to realize how very powerful and important Golub is. I couldn't have seen that in the sixties. I didn't include him in the show. I think he was an important artist. I'm not sorry that I missed him because I couldn't see him. But I know now that he was doing important and beautiful work.

Another artist whom I didn't put in for a different reason, because his work crystallized after 1965, is Chris Wilmarth, whose sculpture work in steel and glass, bronze and glass, developed in the sixties out of Mark di Suvero, out of Brancusi, and, surprisingly enough, out of Edward Hopper. He had a magnificent show at the Museum of Modern Art about two years ago and I'm mentioning him because, again, I'm going to talk to you about the seventies and

what a dry decade in terms of richness of art it was—with Conceptual Art, Minimal Art, Earth Art. And yet, an example that goes against this rubric was Chris Wilmarth, who made, I think, very sensitive, poetic, and beautiful statements through the richness of the objects. So on the one hand we have Golub, who's terrifying us with the rawness of human anger, and then on the other hand we have Chris Wilmarth, who is projecting a poetry that he found in Stephen Crane and Wallace Stevens, among others. The sixties was a richly textured decade with the widest possible range of styles.

An artist that I wish I'd known was making such great work because he would have been in the show was Raoul Hague, who, it turns out, was producing beautiful sculpture in the sixties. I knew Raoul Hague's work from Dorothy Miller's 1956 "Sixteen Americans" show. I guess that one was *Twelve Americans*. They were very large tree trunks that he truncated, as it were, and made sculpture out of with a kind of biomorphic, biogenic, Georgia O'Keeffe kind of sensibility. Huge trees—I bought one for the Met shortly after in the early Seventies when I visited him and I found out this work was going on. How could I have known? I wasn't aware of their being exhibited.

Another artist who was working all through the period whom I should have known about because I knew her—but had no idea of the importance and beauty of her work—was Louise Bourgeois. I did a show with Louise Bourgeois at the DIA Center in Bridgehampton in 1988, I guess it was, and I did it because I found her work so troubling, even as late as the late eighties. I knew that she was receiving a great deal of attention. I knew that the work irritated me, that it got under my skin. But I couldn't quite deal with it. My instinct in a case like that is not to run and hide but to try to embrace it and see what happens. To be attracted only to that which looks pretty on the day it's made or the day you see it is to fall into a trap of believing artists when they ask you to love them. Of coursé, they need love, but you also need to be shook up and you also need to have your preconceptions reshaped from time to time. Well, I knew Louise because she was married to Robert Goldwater, who was the first director of the Museum of Primitive Art, an art historian whose

books I'd read and whom I knew professionally. Louise would sit next to me at dinner, at parties, and we would talk about her three children, about her work, but not so much about her work. Then she had that show at the Museum of Modern Art in 1982 and the whole Women's Movement thing came along.

There was one woman in my show in 1970. It was Helen Frankenthaler. I was burned in effigy for working with Xerox, hung in effigy outside, the night of the opening. And also picketed by the women. There was only one woman in the show—no question about that. I think that if I had my life to live over again, and had the education that I've had since then, I would have put in Louise Bourgeois, Joan Mitchell, and, I don't want to get into too many names, but of course, there were other women who could have been in the show.

There was Louise Bourgeois. It was even worse than that, because she'd had a reputation in the sixties, really kind of an anti-reputation. Her forms were so unlovely and so natural and so much of the body. My inability to deal with women on certain levels, I understand now, interfered with my ability to see what she was doing. There's a piece she did in 1980 called "Nature Study"—it's a bronze, a woman with several pairs of breasts, it comes out of the Brancusi *Mademoiselle Pogany* probably—it's about two feet high. I had it in my show in Bridgehampton and I have to tell you I found it hard to look at for the first year or so that I knew it. All of a sudden, something clicked and switched, the penny dropped, the scrim fell away and I found it beautiful. I told Louise this the other day. I just did an interview with her which is going to be in *Interview* magazine. We spent a couple of hours together. I said, "Louise, I went from finding your work difficult to look at, your work which made me squeamish, suddenly to finding it beautiful, an object of contemplation that I can revel in." And she said, "If that's true, I think it's a compliment." Well, it is true. And it's called "reification." And that's her whole psychological basis, reification. To take the feeling of being a woman, take the feeling of pregnancy, the feeling of motherhood out of one's self, put it out there and make it into an object. *Reification* comes from the Latin word *res*, which means

"thing." Making a feeling into a thing. It's the whole basis of fetishism, the whole basis of sublimation in literature and in the arts. We take the feeling which we somehow cannot account for or feel comfortable with, lift it out of ourselves, and contemplate it out there. All of a sudden, you have a relationship with it. I bless Louise for that.

Cy Twombly I didn't put in the show. He was in Europe. I had, myself, purchased a Cy Twombly from Leo Castelli in 1960, a ten-foot painting for $1,000, which I had to sell for $2,000 a year later. Goodness knows what it's worth now, but that's not the point. The point was that I was making $5,000 a year and I'd taken my bar mitzvah money and bought a couple of pictures, and I had to pay the rent.

I brought Kenneth Noland and Morris Louis from Washington into the show because I said that their exhibiting experience was in New York, therefore they could be in the show. I could have done the same for Cy Twombly, I could have done the same for Joan Mitchell in Paris and for Sam Francis and Richard Diebenkorn in California, all of whom were producing work at the same level as the people I put in the show. I didn't.

I think in the case of Twombly and Mitchell we might be influenced by the ways in which their work has developed since then and we project back into the sixties and think of them in a way we didn't think of them in the sixties.

Diebenkorn is a slightly different case for me. Diebenkorn, whose aesthetic was supremely confident in the sixties and seventies, now looks to me—and I still think they're beautiful pictures—a little mechanical, like he knew how to make a beautiful Diebenkorn. I don't think that's true of either Joan Mitchell or Cy Twombly.

The sixties point of view of the forties, fifties, and sixties, the point of view from which I did the show, still dominates the history books of the period and dominated the art world view of itself until the 1989 recession and auction crash. The crash made everybody think again, think again and again. I think it was salutary. It cleared the air, deflated the balloon. I think the prices now are probably

more realistic, but I don't think our views of the ways of the art of the period is going to change very much. Of course, they'll change. They'll modify. But I think, as with Barr and Cubism and Surrealism, we have an idea.

I talked about Greenberg and Stella and about a consensus that determined which artists and which pictures by those artists were going to be in the show at the Met. There's another aspect, too, which is my own nerve endings. Between the ages of twenty-five and thirty-five, between 1960 and 1970, I went out and looked at every private collection of quality at every museum and there were favorites that I wanted to see again. It had again to do with my continuing education. I wanted to put together the most beautiful and the most significant works that I'd seen done in America since 1940. It was like being given carte blanche, what David Hockney calls "carta blanca," but which I think is something else — to recover my own thrills which I figured others could share. It wasn't just my own puny little thrills. It was a dialogue through the work of forty-two artists with the great audience out there. I'm hoping it worked.

The art of the sixties, the abstract paintings of Olitski, Noland, and Frankenthaler and the work of the Pop painters, Lichtenstein, Warhol, and Rosenquist, will come in time to look like typical sixties New York work. I said this in 1970 in the catalogue. All had been concerned with a large canvas, the simple, flat close-up image of the movie screen, all had used the brilliant new plastic colors— Color Field and Pop. The aesthetic permission to project immense Pop images derives, in part, from these artists' awareness of advanced Abstract Art. I still think that that's true. We think of Delacroix and Ingres as being opposed to each other, Poussin and Rubens as being opposed to each other, but in time, their art is of their time. And 1960 looks like 1960.

In the sixties, there were back rooms where older classic paintings were resold. But the main thrust of the best galleries was in the new art they showed for the first time. The whole idea of the back room gallery being in the front, of which Larry Gagosian was one of the great proponents, came in the eighties. Now he has decided to engage himself with work that's being made today. He's taken on

David Salle, Francesco Clemente and several other artists, whom he's going to show with his great golden oldies exhibitions which are the best around.

Leo, I hope you understand the spirit in which I tell this story. One of my favorite memories of the early sixties was of Frank Stella and me in 1961 and 1962 sitting in the back room of Leo's gallery on many, many afternoons with a show by Rauschenberg or Chamberlain or Johns or Stella in the front and talking to each other, watching what's going on, seeing the pictures and Leo coming out in his shirtsleeves after about an hour, clapping his hands and saying, "Boys, boys, we run a business here." It's a true story.

I'm going to read you a little something, just a few sentences, from my introduction in 1970:

The 1964 and 1966 Venice Biennales and the 1965 São Paulo Bienal were the occasions for attacks on the art dealers because nearly all the artists chosen to represent the United States came from four galleries: Leo Castelli, André Emmerich, Sidney Janis, and The Pace Gallery. . . . [And those artists were] Louis, Noland, Rauschenberg, Johns, Stella, Chamberlain, Oldenburg and Dine, . . . Newman, Poons, Judd, Stella, Bell, Bengston and Irwin, . . . Frankenthaler, Olitski, Kelly, and Lichtenstein. . . . This should have been in no way surprising. In the past hundred years in which advanced art and the gallery system have coexisted there has never been more than a handful of galleries at any one time prepared to show the best, most innovative work of the moment. With the Impressionists and the Post-Impressionists the galleries were Durand Ruel, Bernheim Jeune, and Wildenstein; Kahnweiler was, at first, almost the exclusive dealer for the Cubists; the Abstract Expressionists . . . were launched by Peggy Guggenheim, then by Charles Egan, Betty Parsons, Samuel Kootz, and Sidney Janis. It is clearly more important to represent the United States at these international exhibitions . . . by the best being done than to be concerned with an equitable distribution among dealers.

That doesn't take care of the issue forever, but I think it's worth saying. Of course, the power is in the hands of the dealers who have the insight and the concentration to be in touch with their own time and with the great tradition. Which is how you judge what's going on.

Just off the cuff, there's a saying of Adolph Gottlieb's in 1947 which I would like to repeat. He said, "People are always talking about going back to nature, never going forward to nature. Sometimes you think they're more interested in going back than in nature." I think that's pretty good.

A decade can make a difference in your point of view. I was about ten years younger than Frank O'Hara. Frank came to the Museum of Modern Art in the early fifties. His friends were the second generation of Abstract Expressionists. He did shows of Pollock and David Smith and Reuben Nakian. He and his fellow poets of the period had very much a sensibility in common, a point of view, with such artists as Larry Rivers and Al Leslie. I don't have to remind you, you know that whole context. I came along in 1960, ten years later, ten years younger, and already it's a little bit uncomfortable because here I am with these Pop artists. Now, Frank O'Hara was very sympathetic to Pop Art. He was not that sympathetic to me because I'd come along at a slightly later date. Believe me, I've learned my lesson from that and I try very hard not to be the same way. It's not easy. But let me explain to you how that led to, for me, a momentous decision. When I was still at Yale in the late fifties, I went to the Episcopal bishop at Yale and said to him, "Is it possible, after you're thirty, still to grow and change and be interested in the new— the things that are coming along that you didn't know about?" He said, "It's rare, but it's possible." It's true.

In 1981, I was introduced to Diego Cortez and as part of my job description as Commissioner of Cultural Affairs, I oversaw the municipal funding of twenty-six institutions: the Botanic Gardens, the Zoos, Lincoln Center, Carnegie Hall, the Met, Brooklyn Museum. But also smaller institutions, one of which was P.S. 1 in Queens. And I was able to get them on the City budget in a very regular way. Alana Heiss, the director, hired Diego Cortez. He did

a show called "New York, New Work" in 1981. At the same time, there was a show in London called the "New Spirit in Painting." Through Diego in the first instance, I met Clemente, Schnabel, Chia, Basquiat, Haring, David Salle . . . I was suddenly aware that something was happening to me for the second time that probably wouldn't happen for a third. I was given another chance to get in on the ground floor, to know the artists and to have the thrill of uncovering their work with them. And there was the additional thrill of being one of the early translators of their energy into verbal terms. I quit my job as Commissioner. I got down on the ground with these guys. I spent my time in their studios. I learned. I really had to humble myself to clear my mind because I'd missed quite a bit. The reason I'd missed it was my sensibility was of the sixties and was for richly encrusted, for beautifully painted works that had inherent interest in their surfaces, *matière*, materiality. I come from a jeweler's background and maybe that's what it is. The art of the seventies, which came out of Minimalism, came out of a revulsion against the American decadent culture of the Vietnam period, against the obscene inflation in prices as it was seen by many artists in the hyped-up market of the sixties and seventies culminating in the Robert Scull auction. And the art that was dryer, that was more meditative (an exception—the art of Dan Flavin that has always seemed to me to be very spiritualized and doesn't fall into that category), the Conceptual Art, the Minimal Art, some of the Earth Art, just didn't speak to me on a nerve-ending level in the same way as the art of the earlier decade. And I was going to be sixty-five years old in the year 2000, I was born in 1935, so it was insane. The same person to be curator of twentieth-century art at the Metropolitan Museum for the rest of the twentieth century. I just didn't get it. Ed Koch offered me a job and I said, "Sure." I took it. I did it for five years. During the fifth year, art turned back to something I could deal with and there I was. I stepped back into the stream again. I consider it a very lucky second birth or awakening. And, amazingly enough, the artists were totally generous. I know Julian Schnabel has a reputation for not always being the easiest person in the world. I walked into his studio for the first time. I looked around. I said,

354 / MAKING IT NEW

"Julian, where does this stuff come from? I just have no context for it. It's new. What were you looking at?" He told me Antonio Gaudi, Sigmar Polke, of whom I'd never heard. He showed me some books of Sigmar Polke, Blinky Palermo, of whom I'd never heard, another German artist. I can't tell you how exciting it was. The same thing was true with Basquiat when I asked, "Who do you like?" This is supposedly a kid off the street doing paintings. He reeled off Twombly, Rauschenberg, Kline, Warhol. It was fantastic.

The "New Spirit in Painting" was in London in 1981. They combined the Europeans with some of the Americans. Let me just change the subject a moment, but not really. The will to lead internationally seems to have been sapped about the same time the Vietnam War began to attract our attention. The Kennedy decade began with a cultural sugar high and ended three years later with the missile crisis, and with the death of JFK. It ended with a crash as a cultural sugar high would end. The reaction to Vietnam created a cultural identity crisis. One aspect of this was a growing disenchantment with the material success of the art world. Di Suvero went back to Europe and didn't come back until the war was settled. Rothko committed suicide because he found the success to be so misguided, so obscene, so much concentrated on the wrong level of appreciation of what he was doing. It wasn't a jewel-like quality that he was trying to project. It was a rabbinical quality of existential doubt, of anxiety, of living in a world without clear edges and living in a world where you didn't create images of the Almighty because it said in the bible not to. But you did create equivalences to what the emanation and hovering of the divine presence might be in the world. The same thing, of course, is true of Barnett Newman. Rothko just couldn't deal with the fact that these paintings were coming up to be worth a million dollars but were unappreciated for their spiritual value. That he was disillusioned is hardly the word for it.

In one sense, we were fooling ourselves in the sixties because I, for one, didn't know about Joseph Beuys. I didn't know that Joseph Beuys was producing this work in Germany. We were so busy

marching up and down Madison Avenue saying that New York had replaced Paris as the capital of the art world that we missed what was going on in Italy and in Germany. Baselitz and Polke both came to New York in the sixties, took studios on the upper West Side and could make no connection with the New York art world at the time. I'm not punishing us for that or blaming us for it—it happened. We weren't ready for a New Art. As in psychiatry, you can't hear what you're not ready to hear. I remember I had a Freudian analyst. This guy would say something. I would say, "What? What?" And about three months later, I would say it. And when I said it, I would understand it. It's true. We can't hear something until we're ready to put it into a place in our brain and in our psyche where it makes sense. So, Baselitz and Polke were here. Then in the late seventies and early eighties, Chia and Clemente came to New York, Baselitz had shows, etc., etc.

I'm going to close this up with a few more remarks on the sixties. In an hour it's not possible to do the sixties justice. In the sixties, there were the Happenings, Underground Cinema, The Ridiculous Theatrical Company, the Construction of Boston, the Nine Evenings, New Dance, New Music with sets by Johns, Rauschenberg, and Warhol, the music of Lamonte Young, the music of Morty Feldman. There's a young woman in California doing a Ph.D. thesis on new studio practices of the sixties and how the ways in which Stella, Warhol, LeWitt, and Judd made their work with assistance, through fabrication, through factory systems, changed our idea about one of the ways in which art could be made—it was no longer only the lone practitioner grinding his own colors in the studio, but a postwar method of operating. Let's not ennoble the sixties as a magic moment, the equivalent of the High Renaissance or Cubism. But let us neither encapsulate or trivialize it. Let us do it the honor of allowing it to retain its ambiguities and complexities, its endings and its beginnings, its little deaths and its potent births.

Were the sixties as complex and joy driven as we tend to remember them today? Or was it just that I was twenty-five years old in 1960? The sixties mattered to us. They were our youth. Now, they

matter to us again, perhaps nostalgically. You can feel nostalgia for something you didn't live through. I feel nostalgia for Berlin and Vienna in the twenties and thirties, God help me, Tauber and Lehar and Marlene Dietrich. I'm sure others of you do, too. Were the sixties a golden age? To a younger generation, they seem to be that in music and art. Were they a new beginning? Maybe.

Andy Warhol

Virginal Voyeur

[1993]

About ten years ago I casually asked the lightning-quick American art historian Robert Rosenblum, "When you see a portrait of Marilyn Monroe by Andy Warhol, who do you think of first, Andy or Marilyn?" "I can think of two things at the same time," he replied.

And it's true. Andy and his subject matter remain identical in our minds. More than any other artwork of the sixties, Andy Warhol's are popular and instantly recognizable to a remarkably wide public. Yet in the rarefied world of the connoisseur and art professional he remains as controversial as ever—a tribute, I think, to the dualities he preserved throughout his career: open yet secretive, offhand yet canny, and accepting of society yet always somewhat subversive.

It is perhaps in the commissioned portraits that these dualities are most apparent. Is Warhol in his bespoke paintings dealing in tributes, essences, veiled criticisms—or mere superficialities? In what context did Warhol create some of the most distinctive portraits of the twentieth century?

The question of Andy's attitude to his subject goes back to the very earliest years of his career as a painter. By the mid-sixties, his work had come to be known in the European press, somewhat ironically, as Capitalist Realism. Those angry about or at least restless with the extent of American influence, especially culturally,

357

saw the "selling" of Campbell's Soup and Coca-Cola as a sort of cultural Marshall Plan. Hollywood was, of course, perceived as the leading offender, and Pop Music was not far behind.

I felt it was important that Andy respond in his work to this "charge" (it was really a description rather than an accusation), lest his art in particular and Pop Art in general be too easily dismissed as less fine art than propaganda. From 1960 to about 1963, Pop Art struggled to establish its seriousness in the face of both those who respected abstraction exclusively and those who had yet to accept it at all. There was altogether too much media attention, yet very few were able to articulate Pop's program.

Pop Art had been described and predicted in the writing of the English art historian and critic Lawrence Alloway and in the work of the English artist Richard Hamilton as early as 1956, but the American manifestations of Pop seemed to arise spontaneously in the years 1959–1961 in New York. Some of the conditions of English and American Pop were similar, especially the obsession in the postwar period with popular culture, primarily advertising art, film, and picture magazines. It was the pressure of this energy in the lives of a generation of artists achieving maturity in the late fifties that created the Pop movement.

That British, French, and American Pop Art shared a certain source and outlook did not, however, keep them from exhibiting national characteristics. American Pop arrived at a time when the current generation's respect for and immersion in Abstract Expressionism gave Pop artists a shared heritage and common "enemy." Slaying the father, something that every modern artistic generation does, meant for the new generation finding recognizable subject matter that had not been worn thin in previous art. So in New York in 1960, a wide range of artists (Claes Oldenburg, Roy Lichtenstein, James Rosenquist, Jim Dine, and Warhol prominent among them) came independently to create an art that was to become known under the rubric of Pop Art.

In this heady and even confrontational atmosphere, the Museum of Modern Art convened a symposium on Pop Art in December 1962. The weight that the MoMA symposium bore in our

(then) little art world was enormous, and I was terrified at the prospect of participating in this discussion with six noted colleagues (Leo Steinberg, Hilton Kramer, Stanley Kunitz, Bill Seitz, Dore Ashton, and Peter Selz). A twenty-seven-year-old assistant curator from the stodgy Metropolitan Museum of Art and a known associate and defender of the radical new movement, I prepared my remarks with all possible care. In the audience sat Marcel Duchamp, John Cage, Robert Rauschenberg, and many more idols and sacred monsters. Still, it can't be said that I was parroting the party line; as yet there was no party. The symposium was the first and perhaps only attempt to evaluate the new movement that was making such a ruckus.

There was a perceived need among the devotees of contemporary art in 1962 to choose a side, Abstract or Pop; fence-straddling was frowned upon, especially by the two not-quite-identical older camps: the Abstract Expressionists on one hand, the Greenbergians (partisan to Morris Louis, Kenneth Noland, and Helen Frankenthaler) on the other. Add to these a third and rival movement, Pop, and my position became even more delicate. I genuinely liked and thought I understood each camp and saw no need or advantage in taking sides.

My two best artist friends at the time, for instance, were Andy Warhol and Frank Stella and I was learning a lot from each of them. Frank and I made countless gallery and studio visits together, the most mind-blowing, both in 1962, to Ellsworth Kelly and Kenneth Noland. Andy and I, on the other hand, were spending several hours a day together at his studio, out and about or on the telephone. I strongly supported each: my mind with the Abstractionists, my natural nerve endings with the Pop movement.

To return to the question of Andy Warhol's art and intentions, in this potentially dismissive environment I brought to lunch with Andy on June 4, 1962, a copy of that morning's *New York Mirror*, a popular tabloid at the time. I said something like, "You know, Andy, they think you're not serious and that you and the other Pop Artists are just glorifying American consumerism—the Coca-Cola, Campbell's Soup culture. It's time to show that your work and

your attitudes are serious." "What do you mean?" he said. "This," I said, pulling out from under the table the front-page headline and photo illustrations of the wreckage of two planes that had crashed in mid-air over Brooklyn. "Not just life, but death, too."

As David Bourdon has pointed out, Andy had already done at least two paintings of newspaper front pages by then. It was not the idea of using that kind of image that I was driving at. It was the emotional content, the grimness. I wanted Andy to extend the range of subject and mood of Pop Art.

Ad Reinhardt said many years ago that credit-taking was the besetting sin of the New York art world. I've seen countless examples of it myself. Andy, however, asked everyone, both intimate friends and relative strangers, for ideas. In retrospect, it seems to me that, stripped of all his cunning and charming clowning, his pose of know-nothingness, Andy understood instantly what I meant and seized upon the idea with alacrity.

The next day Andy made a large hand-painted picture from the newspaper page I had handed him. He gave me the painting (129 *Die in Jet*, now in the Ludwig Museum in Germany); I believe it was the last hand-painted picture made amid the beginnings of his silk-screen oeuvre. Immediately afterward came his *Disaster Series*, the car crashes, tuna-fish poisonings, snarling dogs, and *Electric Chairs*. The media, shocked and amused, began to catch on.

I was amazed some years later when Barnett Newman told me the *Orange Disaster* (1963) by Warhol, an electric chair painting, was his favorite of the 408 works in the "New York Painting and Sculpture" show at the Metropolitan Museum in 1969. Of all the Abstract Expressionists only Barney Newman actively encouraged the next generation of painters. (Elaine de Kooning once said that the electric chair was the only American contribution to the history of furniture.) The Abstract Expressionists, whose styles of painting and expectations of life grew from attitudes endemic to the nineteen thirties, never expected to be famous or financially secure in their lifetimes. Then along came Pop Art, which seemed to be instantly popular and successful. To the Abstract Expressionists it was an art without roots, made by callow artists who had never experi-

enced the pain of struggling unsung and alone in the studio. In fact, in a reversal of the nineteenth-century romantic artist's expectation of solitary pain, several artists kept an entourage, companions who were often present even when they painted; Robert Rauschenberg and Andy Warhol come to mind. To the older artists it didn't look like serious art. Too much was happening for these young artists too soon. No other art movement had ever garnered so much attention, especially in its first eighteen or twenty months.

Of course, the heroic work of the Pollock and de Kooning generation prepared the way, alerting the world that art in America was important; but it wasn't until the early sixties that the print and television media had understood the journalistic implications of art's potential shock value. It was Pop Art's destiny to elevate the humble and ordinary in our lives, the refrigerators and automobiles, to permanence through their depiction in fine art at the very moment that the media were ready and eager to record and disseminate news of a brand-new art movement.

Avant-garde innovators such as Marcel Duchamp and John Cage greeted Pop Art with a kind of detached amusement; they sensed that something new was afoot. Sidney Janis, always canny, never afraid of the new, mounted in 1962 the first international Pop Art show, called "The New Realists," in a large gallery he rented for the occasion on Fifty-seventh Street. It was the first time that Warhol, Oldenburg, Lichtenstein, and the other Americans were paired with the Paris critic Pierre Restany's team, Yves Klein, Arman, Martial Raysse, and César and others. The Janis exhibition and Restany's enthusiasm for the new art on both continents marked the beginning of American Pop Art's successful reception in Europe, where less passion was invested in the idea of abstraction as a type of religious commitment. And so it happened that, curiously, Europe was better prepared for something new out of America than was America.

How does portraiture fit into the totality of Warhol's work? Much of his subject matter, after he started painting seriously in 1959–1960, can be broadly categorized under four headings: food, sex, death, and glamour. His pictorial sources were photographic and

from the various media (newspaper, film, television, and video) except when he made them himself, as he did with his Polaroid camera for the commissioned portraits choreographed at the Factory. Andy's introduction of the photographic silkscreen into the fine arts in 1962 as a means of "drawing"—that is, furnishing the skeletal information for a work—set him apart from other Pop artists. In a sense, Andy's use of photographic silkscreen was his most important technical contribution to painting. David Hockney pointed out to me that Andy's use of photographic silkscreen made him unique in the field of printmaking as well. He was, in fact, the first artist for whom there was literally no difference between his work in painting and printmaking, except the material used to support the image; Andy used the same screens on canvas as he used on paper. In both cases color came along, at first slowly, after a preliminary period in which he limited himself to black and white.

The question of Warhol's decade-long career in advertising has been much discussed. He came out of art school, the Carnegie Institute of Technology, in 1949 and moved immediately to New York. There he quickly found work. He was able to support his mother as well; he brought her to New York and she was to live with him until a year before her death in 1972. Andy won several important awards for his commercial work, primarily as an illustrator of shoes for Sunday newspapers. His infatuation with Hollywood stars in particular and fame in general is evident quite early on in his 1950s shoe drawings of celebrities such as Judy Garland, Elvis Presley, and Mae West; and in line drawings of others such as Joan Crawford, made, it would seem, from a fan photo Andy might well have sent away for himself, as was his habit since childhood; and also in Carmen Miranda's tiny four-inch high-heeled shoe that I noticed the first time I visited him in his studio. Yet Andy's ambition remained what it had always been, even in his pre–art school years: to be a fine artist.

The uncertain reception he found in the New York art world in the early sixties, together with the responsibility to support his mother and his own basic psychological and financial insecurity, made him quietly keep up his more lucrative commercial work well

into 1963, even as he was creating the paintings that would launch his career as a fine artist. Andy always felt, not altogether inaccurately, that his commercial work was considered a strike against him by the many committed art world professionals who had an agenda of their own for dismissing him and his work.

Throughout the sixties Warhol's attitude toward portraiture evolved rather rapidly. The first portrait, if memory serves me right, was a small single silk-screen image in black and white, painted in 1962. Andy chose to portray Troy Donahue, another in his selection of overly familiar images rendered blank through overuse, a sort of soft-drink or soup-can made in Hollywood, famous in spite of his blandness thanks to the almost mindless studio publicity machine. The stars that came along a bit later, the Elvises, Lizes, and Marilyns, were, of course, true stars, not only to the potential international art market, but to an adoring Andy Warhol as well. With *Troy Donahue*, though, there was, I think, a sly implication that anyone can become famous. On another level (since we all knew the rumors that Donahue was gay) Warhol may have been indulging in a timid sort of self-identification, a whimsical wink at self-portraiture, which later became an important part of his activity. Andy's self-portraits were really a form of camouflage, quite literally in the works of 1986, an act of sleight-of-hand to divert other people's curiosity about his own personal life. A drawing of the fifties also comes to mind: an idealized Cocteauian boy with a rose in his teeth. Rather than a portrait of a specific person it strikes one as the artist's *beau ideal*, or—is there any difference?—an idealized self-portrait.

The movie-star portraits were a quick success, immediately assimilated into the iconography of Pop. The *Campbell's Soup Can* was the *Nude Descending a Staircase* of the Pop movement; a bit later the *Marilyn* portraits were quickly perceived as the most potent symbolic image of Andy's work, and perhaps even of all Pop Art.

Colorful, large, repeated almost hallucinatingly on enormous canvases, the movie-star portraits were eminently saleable. Andy was on to something of both artistic and commercial value. Noth-

ing could have pleased him more. He had been raised in poverty and all his camping about money as the years progressed was rooted in the insecurity that kept him wary through all the financial success that followed. He came out of art school and at twenty was working, at twenty-five was earning a good living, and by the time he was thirty felt strong enough psychologically to make the scary career switch to painting, but only because his annual earning power in advertising was assured. He had been so traumatized by his impoverished youth that the speculative atmosphere in which he felt the New York art world was run inspired him with a fear that all could be lost "in a minute," as he liked to say, and that he could be left once again penniless and miserable.

As money poured in after the middle sixties I observed him putting his money in several different banks so that, in order to satisfy his neurotic need for potential failure, he could induce himself to concentrate on the account with the least funds in it and declare, justifiably, that he was almost broke. Another such spur and defense mechanism was to calculate how much money he had made in his best year and, perhaps even adjusting for inflation, point out that he was doing terribly by comparison.

A lot of confusion that has whirled around analyses of Andy's personality, his camp attitudes, his cosmic lack of consistency when it came to his philosophy or any revelatory remarks, was the result less of a conscious attempt to cultivate a "weird" persona than a refusal to probe his own motives and values. Matters such as personal history, sexual escapades, psychological insights, indeed anything he would deem "too personal" (another catch phrase), added to the mystery in which he reveled; he avoided them all not only to keep himself from us, but, perhaps more dynamically, to keep Andy from being forced to look within. The oft-quoted dictum of Nietzsche, "Look not into the abyss lest the abyss look into you," can account for a great deal of Andy's busy-ness, his workaholism, his refusal of the personal, his compulsive need to prove himself in one field after another.

Andy resisted, indeed resented, direct questions, personal or professional, almost as much from friends as from collectors and

journalists. On the second day we met I said, "Andy, I didn't know you'd traveled around the world. Who did you go with?"

Andy: "Umm."

Henry: "What was your favorite place?"

Andy: "Umm, the airport in Cairo." This was followed immediately, in order to shift the attention away from him, with "Oh, you're so smart, teach me a new fact every day and in ten years I'll be smart too."

It took me several years to realize that in every daily conversation with Andy, both in person and on the telephone, he was siphoning all the gossip I had heard and all the information that interested him without, almost literally, volunteering anything insightful that he knew either about himself or anyone else. He loved to talk and fantasize about relationships, but at the end, you knew nothing. All this was in the service of keeping his wig and his mask unnervingly in place.

Andy's first commissioned portrait came in 1963 from Ethel Scull. Rather than accepting a picture already taken, as he had done with *Troy Donahue*, Andy posed Ethel in a Times Square photomat and art-directed her to move her head, arch her neck, etc., exactly as if at a modeling shoot. At this time Andy had not yet started carrying a camera everywhere so the photomat solved many of his problems: it was funky, anonymous, and automatic and it quickly delivered photo likenesses that were suitably bland for his purposes.

The jump from that first work to his commissioned portrait of Watson Powell, the retiring president of a Midwestern insurance company, was short in time but long in style. The result was the most straightforward, offhand sort of painting, unglamorous in the extreme. Andy took what was obviously the "official" photograph provided by the man's colleagues and gave him the look of Mr. Anyone, a portrait of a man, a specific man perhaps, but with no memorable or distinguishing marks, hence Andy's generic title, *The American Man*.

With the Ethel Scull and Watson Powell portraits, Andy began to realize the financial potential of the commissioned paintings.

But only a decade later would he truly take advantage of it through the urging of his manager and friend Fred Hughes, whose charm and connections moved Andy in the seventies and eighties into another social sphere.

In the sixties Andy and his crew were at the heart of the funky underground avant-garde. But after he was shot by Valerie Solanis in 1968 he retreated, emerging a few years later into the gilded world of stars, tycoons, ladies who lunch, the wealthy, and the well known (often, as the saying goes, for being well known). Andy never made any secret of the fact that these commissioned portraits were money-makers. They kept him feeling financially secure, and, as the Factory staff got bigger, enabled him to pay the "kids," as he always called his employees.

Andy was obsessed all his life with the idea of fame. Being close to fame made him more excited than riches, although the wealthy, merely by virtue of their wealth, seemed to him important people. It was the same "star" quality that induced *People* magazine to have Princess Diana, Michael Jackson, and Barbra Streisand on the cover as sure sellers that turned Andy on. "Wow!" his favorite word and accolade, was reserved for them.

In 1965 Andy and I went together to Truman Capote's Black and White Ball. Tallulah Bankhead, among several hundred stars, was standing a few feet away from us; awestruck, Andy said, "Look, we're the only nobodies here." To be "somebody" was Andy's highest aspiration. In an effort to give him a more realistic idea of fame I said to him one day, "You know, Andy, no one is famous at four o'-clock in the morning." Andy always was an insomniac, equating sleep with death, I think, or at least with letting go; giving up control was always painful to him.

From 1963 to the moment he was shot, the films that he made at the Factory were excuses for an almost pathologically shy Andy to spend time with people he considered handsome, lovely, and unattainable (an underground elite), to whom he could relate only through a mechanical translator, that is the baffle of a machine, tape recorder, Polaroid, or movie camera. In Andy's mind, to record these encounters made them "real." The portraits in film of this pe-

riod are consequently more erotically sincere than anything that came before or after. Making them served to keep his libido in check and enabled him to concentrate his energy on making art. Thus he maintained the persona with which he chose to face the world, the "naughty boy" syndrome, you might call it, not unprecedented for a man who chose to live with his mother into his fifth decade.

In the later seventies Andy for the first time in his paintings began to blur his self-set boundaries between the private and the acceptable with his *Sex Parts Series* and portraits of transvestites, *Ladies and Gentlemen*. Through it all Andy maintained his virginal stance as a voyeur: never a participant, he just "observed." He wasn't seeking sexual partners here, but rather surrounding himself with a cloud of glamour. Lovely young things with whom he had never felt comfortable were now under his influence, in his charge, and like many a Hollywood magnate before him, he always had a few more "stars" around than he could use, creating tensions that made the Factory crackle.

I introduced Fred Hughes to Andy in 1967. They got along so fast that I always said, "And I never saw either of them again." This was an exaggeration, but surely there was a need on both sides that was satisfied through this friendship and business partnership that lasted until Andy's death in 1987. The Warhol Factory was, if not out of control, wilder and woolier than a business should be. Fred organized all this, saw the strengths and the foolishness, and managed to create a sense of order out of a semi-hippy chaos.

Always elegant, Fred came from Houston, Texas. He was well enough connected, especially with the de Menil family for whom he had worked, to get Andy on the road, if not to respectability (which would never have worked), to a position where he was being taken seriously as an artist by a worldly international crowd who found him titillating. Fred worked hard to get Andy portrait commissions of Andy's peers among the rich and famous. Though they scrapped and shouted along the way, in the end they always worked things out.

Andy's natural and aesthetic instincts could never allow him to deliver portraits with which he was dissatisfied. In 1974 he decided

to trade portraits with David Hockney and, as I was visiting David in Paris, Andy took a Polaroid of me as well. Several mo...hs later he unveiled our portraits to us at a lunch at the Union Square Factory and I said, "But Andy, I don't want it, it's nothing but a blown-up version of the Polaroid. You've left out the art!" "Oh," Andy said, "I knew I forgot something."

A few years later as the Whitney exhibition, "Andy Warhol: Portraits of the Seventies," was approaching Andy said, "Let me do your portrait again, I'll put the art in this time." That is why his picture of me has so many juicy brush strokes on it. He was teasing me—or perhaps we were teasing each other. This anecdote shows that Andy was in control of his intentions. Although his chatter and seemingly casual manner were intended to make his art seem off-hand, Andy in fact never did less than his best; and his best portraits were of those he most respected and admired.

The secret of Andy's portraits is not difficult to discover. He gave "movie star" treatment to the talented, rich, and famous as well as to anyone who could afford the twenty-five thousand dollars for a forty-inch square portrait (and fifteen thousand dollars for each additional painting from the same screen). Yet there is no question that the portraits worked better when Andy himself was turned on by the subject. The point was always to accentuate the positive, eliminate the negative, and come up with a likeness that was recognizable but that existed in a "world that never was," a sort of lusty yet ethereal limbo where everyone was a star, not only for fifteen minutes, but, in this incarnation caught permanently on canvas, "forever," as in "Diamonds are forever."

This page constitutes an extension of the copyright page.

1960s

"The Art Audience and the Critic," *The New Art,* ed. Gregory Battcock (New York: A. Dutton Paperback, 1966). First published in *The Hudson Review,* 18, no. 1 (Spring 1965). "Happenings: Theater by Painters," in *The New American Cinema,* ed. Gregory Battcock (New York: A. Dutton Paperback, 1967). First published in *The Hudson Review,* 18, no. 4 (Winter 1965–1966). "Some Notes on *Sleep,*" *Film Culture,* no. 32 (Spring 1964). "Andy Warhol," in *Americansk Pop-Konst* (Stockholm: Moderna Museet, 1964). "Robert Rauschenberg," in *Robert Rauschenberg: Paintings, Drawings and Combines, 1949–1964,* exh. cat. (London: Jewish Museum, Whitechapel Gallery, 1964). "George Segal," in *Recent American Sculpture* (New York: The Jewish Museum, 1964), pp. 25–31. "An Interview with Ellsworth Kelly," in *Ellsworth Kelly,* exh. cat. (Washington, D.C.: Gallery of Modern Art, 1963). "Suite of Twenty-Seven Color Lithographs, 1964–1965," in *The Paris Prints, 1964–1965,* exh. cat. (New York: Susan Sheehan Gallery, 1992).

1970s

"Creating a New Department," in *The Chase, The Capture: Collecting at the Metropolitan* (New York: Metropolitan Museum of Art, 1975), pp. 219–34. "New York Painting and Sculpture: 1940–1970," in *New York Painting and Sculpture: 1940–1970,* exh. cat. (New York: Metropolitan Museum of Art, 1969), pp. 15–38. "David Hockney,' previously published as the introduction to *David Hockney by David Hockney,* ed. Nikos Stangos (New York: Harry N. Abrams, 1977). "A Commencement Address," given at the School for Visual Arts, New York, June 5, 1976.

1980s

"Approaching Clemente," in *Fr. Clemente Affreschi,* exh. cat. (Madrid: Fundación Cajade Pensiónes, 1987), pp. 14–30. "Sandro Chia," in *Sandro Chia Prints 1973–1984,* exh. cat. (New York: Metropolitan Museum of Art, 1984), pp. 3–7. "An Interview with George Baselitz," *Interview* (April 1984): 83–89. "Jean-Michel Basquiat," *Interview,* no. 13 (January 1983): 44–46. "Isamu Noguchi: What Is Sculpture?" in *What Is Sculpture?,* exh. cat. for 42nd Venice Bienale, 1986, American Pavilion. *Willem de Kooning: Abstract Landscapes, 1955–1963* (New York: Gagosian Gallery, 1987). "Alice Neel." *Interview* 15, no. 1, (January 1985): 86–88. *Lichtenstein's Picassos: 1962–1964,* exh. cat. (New York: Gagosian Gallery, 1988). *Andy Warhol Prints: Catalogue Raisonné,* eds. F. Feldman and J. Schellmann (New York: Ronald Feldman Fine Arts, and Editions Schellmann, 1989), pp. 9–12. "Hockney: Young and Older," in *David*

Hockney: A Retrospective, exh. cat. (Los Angeles: Los Angeles County Museum of Art, 1988), pp. 13–23. "Pop Art 1955–1970." Catalog for the show, International Cultural Corporation of Australia, Ltd., 1985, A Museum of Modern Art, New York, International Program Exhibition.

1990s

"Louise Bourgeois," *Interview* (March 1992): 103, 127. "Myron Stout: Pathways and Epiphanies," in catalogue published by Oil & Steel Gall, Kent Fine Art, Barbara Flynn, (New York, 1990). "An Interview with John Chamberlain," in *John Chamberlain, Recent Work*, exh. cat. (New York: The Pace Gallery, 1992). "Keith Haring," in *Haring: Catalogue* (Saint Louis: Philip Samuels Fine Art, 1990). "Dale Chihuly as of 1993," compiled from *Chihuly: Color, Glass, and Form* (Tokyo: Kodansha International, Ltd., 1986), pp. 10–14; *Dale Chihuly Japan*, exh. cat. (n.p., 1990); "Dale Chihuly as of 1993," in *Form from Fire* (Daytona Beach, Fla.: The Museum of Arts and Sciences, 1993), pp. 13–17. "What I Know about Photography," lecture delivered on May 14, 1992, at the Monterey Museum, Monterey, Mexico. "The Sixties: As They Were." Lecture delivered on September 22, 1991, at the Guild Hall, Easthampton, New York. "Andy Warhol: Virginal Voyeur," in *Andy Warhol Portraits*, ed. Robert Violette (London and New York: Thames and Hudson and Anthony d'Offay Gallery, 1993), pp. 13–29.